CULLMAN & KRAVIS
interiors

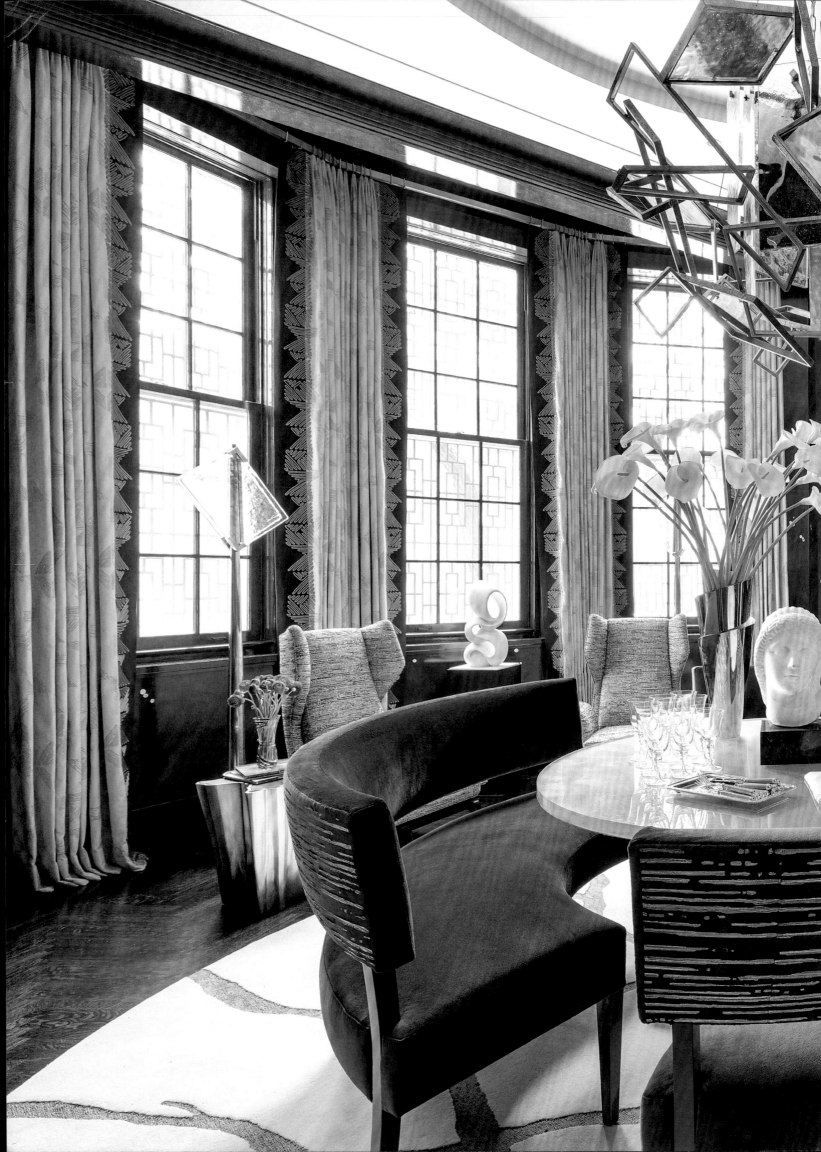

CULLMAN & KRAVIS
interiors

ELISSA CULLMAN

LEE CAVANAUGH, SARAH RAMSEY, ALYSSA URBAN

Written with Judith Nasatir

RIZZOLI
NEW YORK

New York · Paris · London · Milan

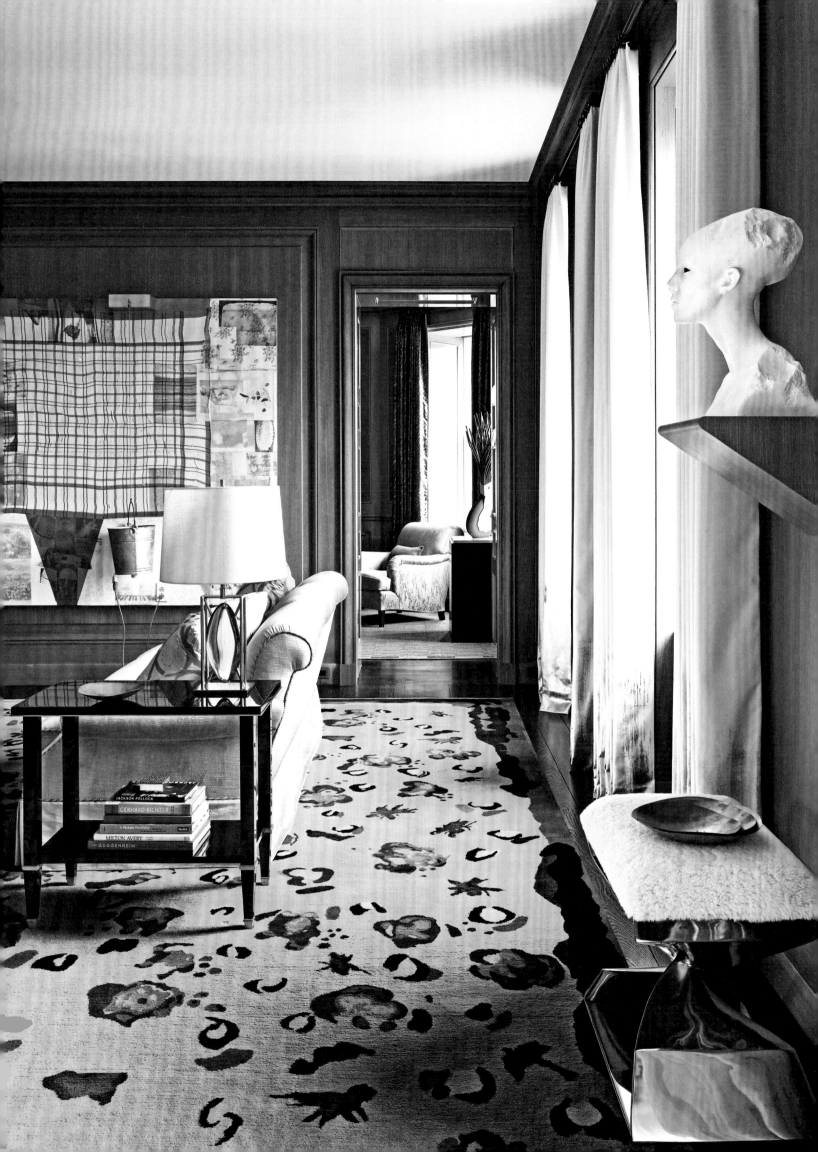

CONTENTS

TRADITION REDEFINED

It's almost impossible to believe that forty years have passed since Hedi and I first opened the doors of the office and began this ongoing adventure in the decoration of houses. I feel so fortunate for what we were able to accomplish together. And I am so gratified by the way my partners—Alyssa, Lee, and Sarah, all of whom have been with Cullman & Kravis for at least two decades—and our amazing, dedicated staff are collaborating to lead the way forward through the maelstrom of change in our culture and the lifestyles that it creates.

So many factors affect the ability of any undertaking to evolve with the times. When the office was just Hedi and me and two assistants, she and I would sit at our table and dictate design directions. The assistants would carefully take notes. Now, Alyssa, Lee, Sarah, and I encourage the next generation of our teams to have their own points of view, and to weigh in on every project. We do regular critiques, laying out schemes and samples on the studio's two islands. The entire office reviews them, makes suggestions, offers up alternative options for this or that. And we all delight in helping one another. Someone once said that we are like a sorority—or Miss Ellie's Finishing School—that we teach by example a way of being in the world, of working harmoniously with people, of creating a community of shared goals, aspirations, and standards. Collaboration is important, as is autonomy. But because all our projects are under the firm's umbrella, we take pride in supporting each other to do well. As some famous brethren memorably said once: We are one for all, and all for one.

Creating a home is the ultimate exercise in teamwork. The long, complex process of translating a client's dream into a sketch, developing it into a plan, and then nurturing it into the nuanced, richly layered reality of the material living environment involves many different sets of skills and talents. This is why we treasure our working relationships. Everyone from the architects to the artisans shares in our joint effort of bringing a realm of beauty from the ether of inspiration into tangible existence and the experience of delight.

Since we set up shop four decades ago, our fundamental approach has stayed constant even as our clients' aesthetic sensibilities have evolved and our own tastes and team have grown and become more diverse. We first get to know our new clients and start to envision how to create their home through the Rorschach test of what we call our initial "love/hate" meeting. We listen, translate, and collaborate—

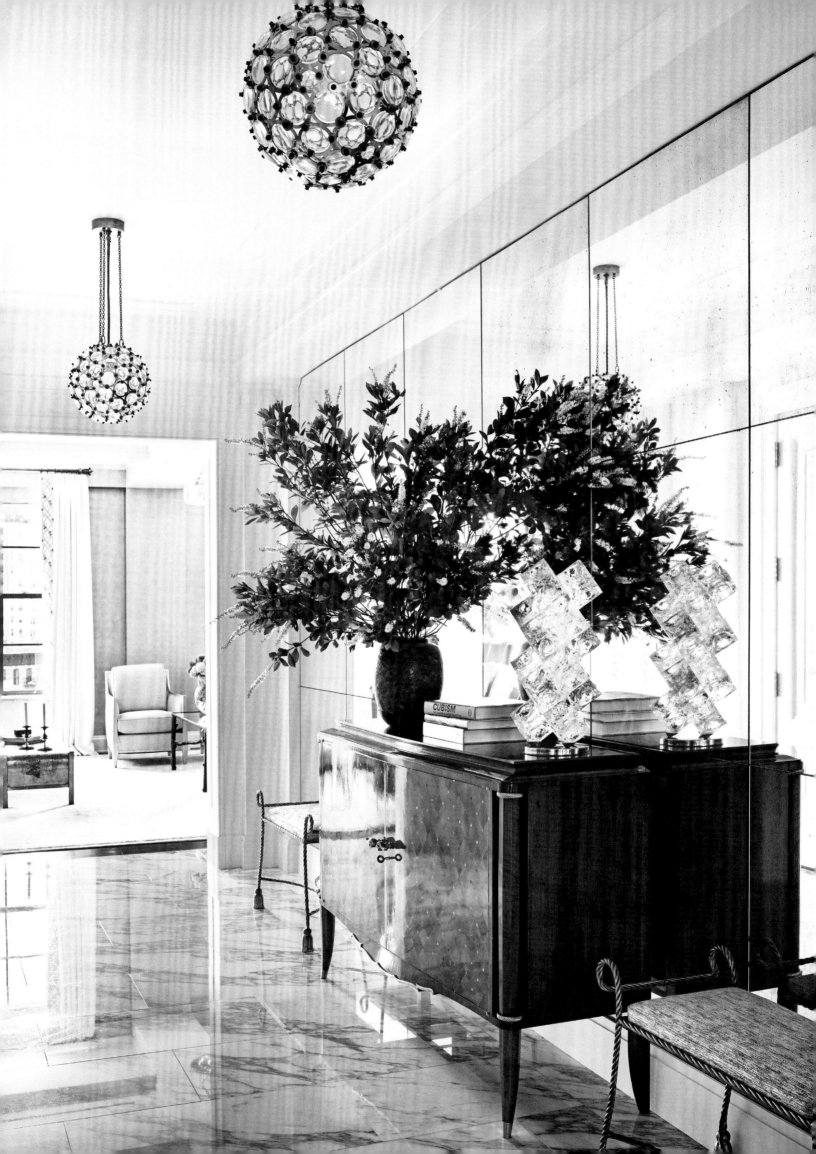

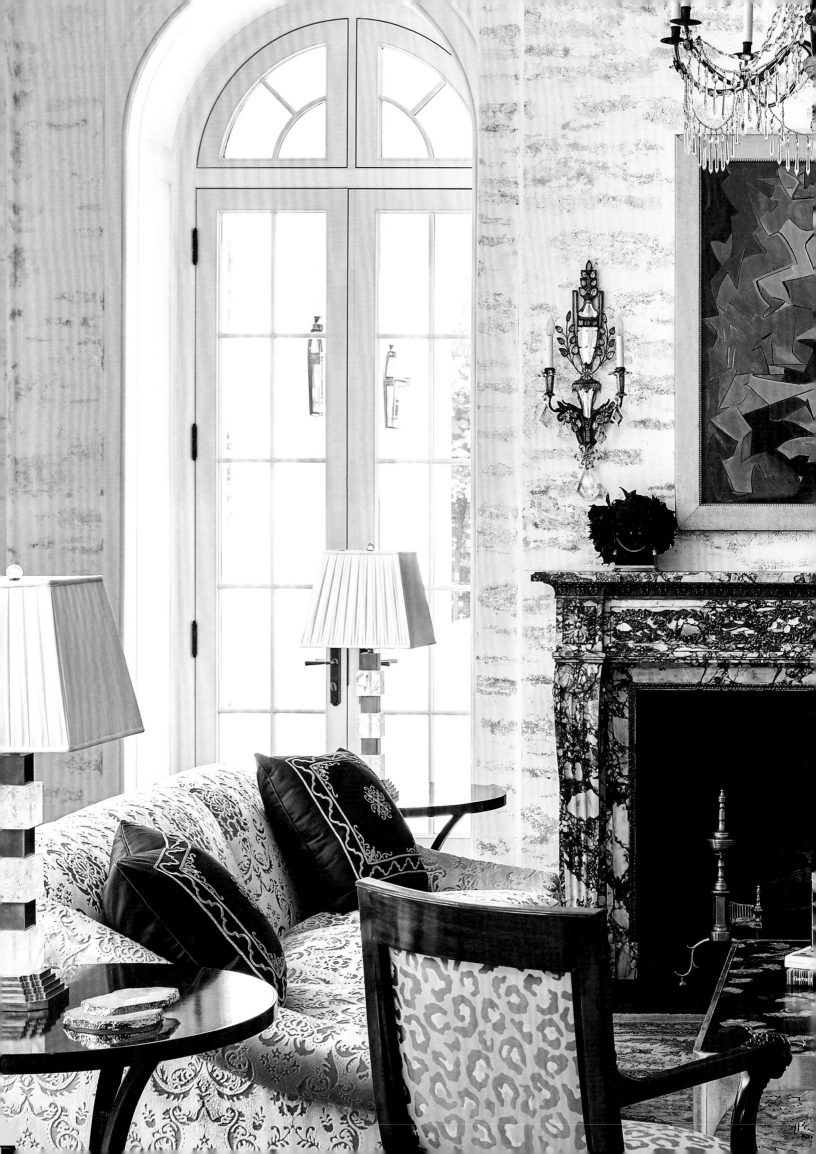

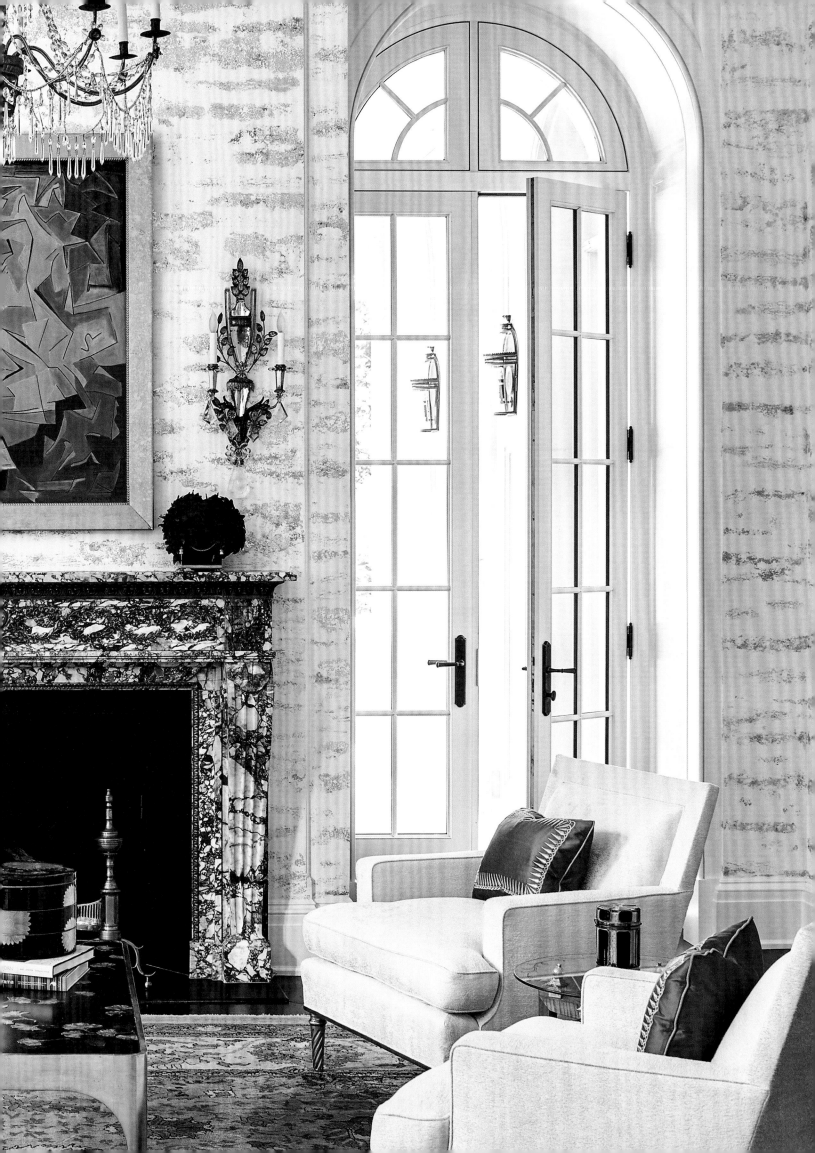

putting our skills to work to create homes filled with design elements all uniquely personal to the individual clients.

In decorating today, anything goes. We embrace freedom of expression happily, but we know from decades of experience that creativity makes sense only when it comes from and embodies a consistent, coherent, cohesive point of view.

Time is its own form of perspective. Change? It's the flip side of constancy. And good decorating needs both.

Yes, interiors have grown lighter and more streamlined to reflect today's more casual lifestyles. But more casual doesn't have to mean less luxurious. Standards of quality haven't changed, only their materials and expression. And mistakes have become incredibly costly. When I was first married, I hired a decorator and we put a wallpaper up in my kitchen. I came home from graduate school one day and had an epiphany: the wallpaper was hideous. I marched to the hardware store, bought a paint roller and tray, and painted right over it. In our projects today, the possibility of that kind of quick change just simply isn't an option.

The decorative arts teach us that in the language of design, truly new elements rarely appear but new combinations of familiar objects and materials are infinite. We obsess about doing something no one's ever seen before, including us. But we also have a passion for the antique and the vintage, and for making the old new again. This is who we are from a practical and an aesthetic perspective. And it is in line with the firm's philosophy of sustainability. But how do we make what earlier generations considered chic look cool enough to retain in a room today? How can we translate the traditional so it reads as contemporary and sexy now? Is it the use of color? The mixing of patterns? The complex layering of forms, textures, and materials? The inclusion, or not, of antiques? The answer is a paradox: less is more, but less is a bore.

The modern application of details from the past, and the mixing of old and new—this is what makes each space look fresh and right for now. And this has been our underlying philosophy of forty years. Practicing anything for that long—decorating included—changes the experience of problem-solving from a process of following "the rules" to one that feels much more instinctive, and, we hope, more creatively free.

For decades, we adhered to the C & K "bible" that Hedi and I developed in our first years together. This was our code of decorating dos and don'ts, macro and micro, and we didn't deviate from it. When Alyssa, Lee, and Sarah first joined the firm more than twenty years ago, we didn't, for example, mix metals. The bed height had to be twenty-four inches, and end tables, twenty-eight inches. Interiors were dressy and formal. But because we all knew and agreed on the formula for achieving the desired effects, the actual decision-making process was easier.

The most potent youth serum in our arsenal of enchantments today may actually be twentieth- and twenty-first-century art and photography. We all know the stimulating

visual fireworks that can occur when contemporary art hangs close to a Louis XVI chandelier and the way this tightly curated relationship shifts our perceptions of era and history. Making these juxtapositions look effortless and natural involves tremendous work, however. We still refer to our last-century rules, and the solid foundation they've given us. I think we will always and forever start a room with the grounding rugs and textiles, for example. But we live by only two imperatives now: always delight the eye, and try never to repeat ourselves. The only necessity today is creative invention.

Each of our choices has always depended on the client, the location, and the nature of the project. These considerations are eternal. An art lover's apartment in a landmarked Manhattan building will simply need a different approach than the modern glass-box architecture of an indoor-outdoor family retreat on the Florida coast. Conversely, a turn-of-the-twentieth-century stone mansion in Connecticut revitalized for multigenerational living will ask for a different solution than a ground-up country home for a young family in New Jersey.

Our goal is always to create real homes for real people—homes that will still feel filled with life after the kids go off to college, homes that can accommodate the kids when they come back for a weekend with all their friends. This pushes us always to prioritize the practicalities of function. Where are the kids all sleeping? What about when they get married, and the grandchildren start arriving? We're always projecting needs into the future because of the significant investment decorating requires.

What's the point of a beautiful room if it's not comfortable, or if it feels too formal to use? We all want to enjoy every inch of our homes today, which means making sure that however luxuriant or dressy the spaces we design, none of them should feel unwelcoming. One of our longtime clients expresses this as: "Mess it up!" Really, this is so important.

We believe strongly that everyone—everyone—should have access to the beauty we have the privilege of creating. Giving back to the community is one of the most gratifying things we do. Whether creating a women's shelter downtown after 9/11, designing the Garden of Hope in Brooklyn for Bette Midler's New York Restoration Project, or completing various projects at Mount Sinai Hospital, the Culinary Arts Center at the Kips Bay Boys and Girls Club, or, the Hauser Patron Salon at Alice Tully Hall and the Café Paradiso at the Elinor Bunin Munroe Film Center at Lincoln Center—projects that bring good design to a broad range of society lift our spirits more than we can say.

Forty years of practice have taught us how to interpret each client's personality through the arts, crafts, and materials of decoration. It's not a style we espouse, it's a way of thinking about the realities of home, realities that are unique to each family. The joy we take in what we do inspires us to keep searching, learning, discovering, and challenging ourselves to exceed our own expectations, and those of our clients. This is the legacy we hope to pass on to everyone we've worked with over the years, and all those with whom we so look forward to discovering—and creating—what's next.

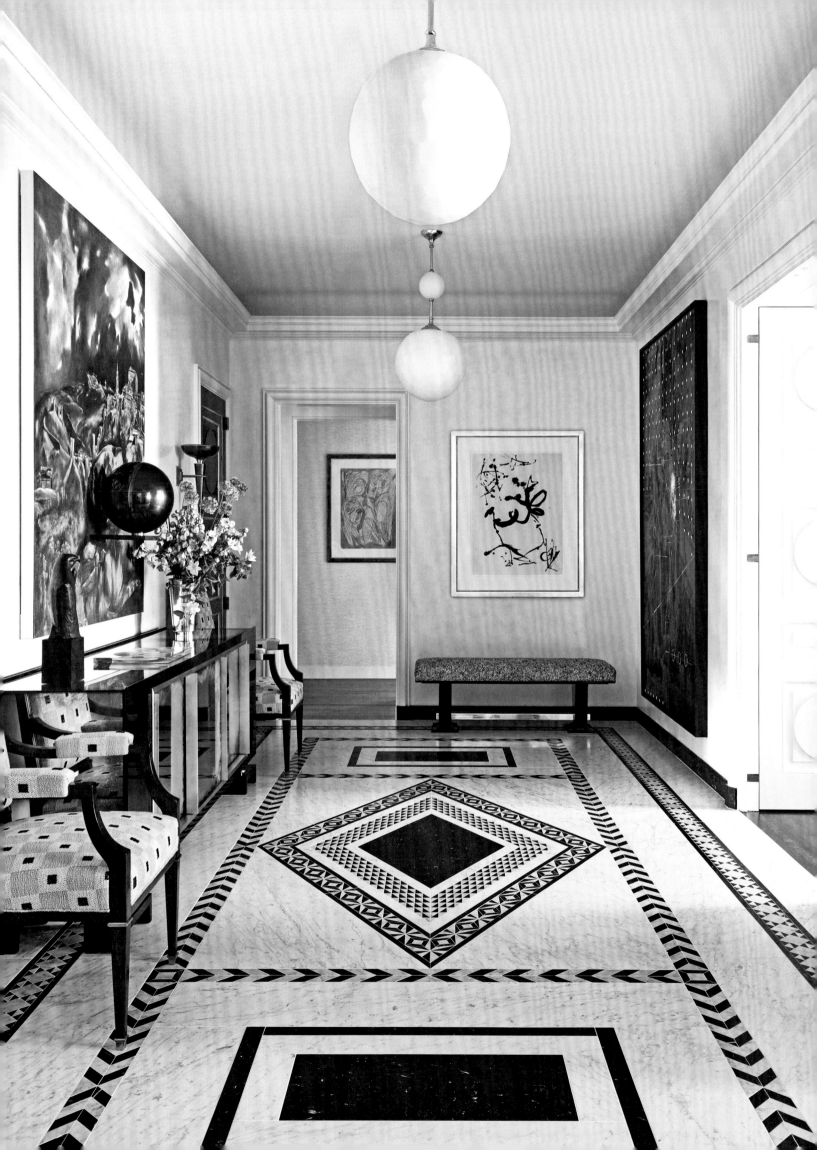

PUTTING THE ART
IN ART DECO

Design and decoration may play a cameo role in the grand arc of human history, but they take center stage in the continuum of how we actually live. Terms like "iconic" and "authentic" continue to matter, no matter their chronic overuse. The story of this Upper East Side residence exemplifies just why. When these longtime, Houston-based clients decided to leave behind their two-bedroom Manhattan pied-à-terre because their expanding family had outgrown it, they fell in love with a four-bedroom beauty in a nearby Rosario Candela–designed art deco classic. Completely entranced by the building's surviving original details, they asked us, with Ferguson & Shamamian Architects, to reenvision its existing unsympathetic English-style interior back to its original 1930s glamorous glory.

Discerning art collectors, these clients knew from the start which of their pieces, many of them quite large, they wanted to live with in this apartment. These choices brought the palette and details to the fore in unexpected ways. Their previous apartment, for example, was tonally subdued, not surprising as a backdrop to vibrant abstract art. Yet here they were interested in enhancing the power of their art by mirroring the vibrant hues of their collection in the décor and setting it all off with reflective shimmer that was such a quintessential feature of the building's original era.

The entry gallery, with its crisply layered geometrics in graphic black and white, presents the opening salvo of the apartment's period vocabulary, but also serves as a jumping-off point for the riot of color and eclectic finds from far-flung travels to come in the contiguous rooms. We found vintage art deco pieces, including sconces and

OPPOSITE: When a residence is intended to house a major art collection, every detail of the interior should be a match for the collection's quality and enhance its visual impact. The entry gallery, striking in bold black and white, sets off artworks by Damien Hirst, Jeff Koons, and Jackson Pollock on walls that shimmer with a mica overlay finish. This space also serves as the grounding spot for a kaleidoscope of color that radiates through the apartment.

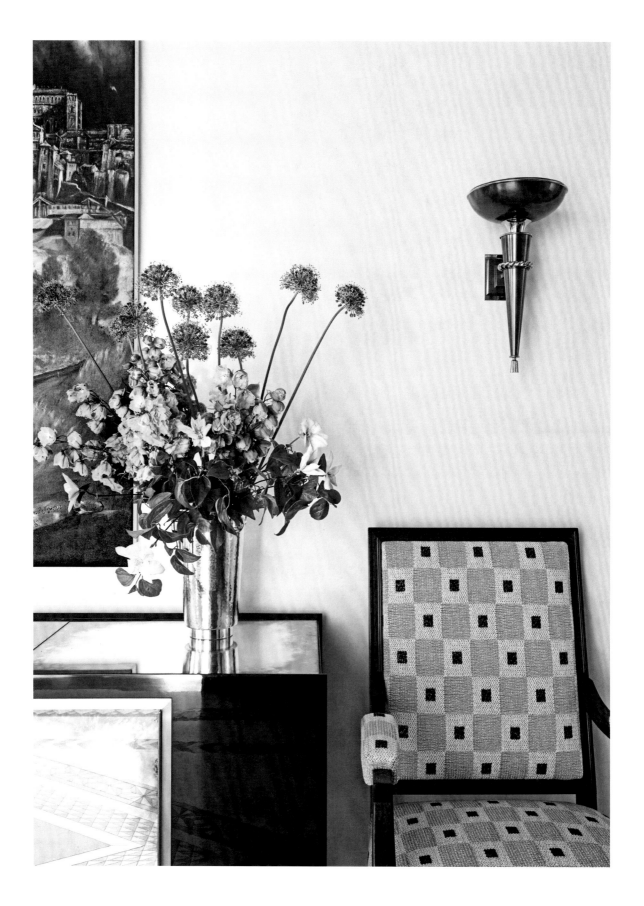

ABOVE: French 1950s bronze-and-brass sconces add dimension to this space's lighting scheme. The multitalented French artisan Marc du Plantier inspired our design for the lacquer, antiqued mirror, and bronze console, one of the gallery's key features. The chair fabric repeats the floor's mosaic motif in the same color palette. OPPOSITE: Torchères by Emile-Jacques Ruhlmann anchor the corners. The console's bronze sculpture is by André Derain.

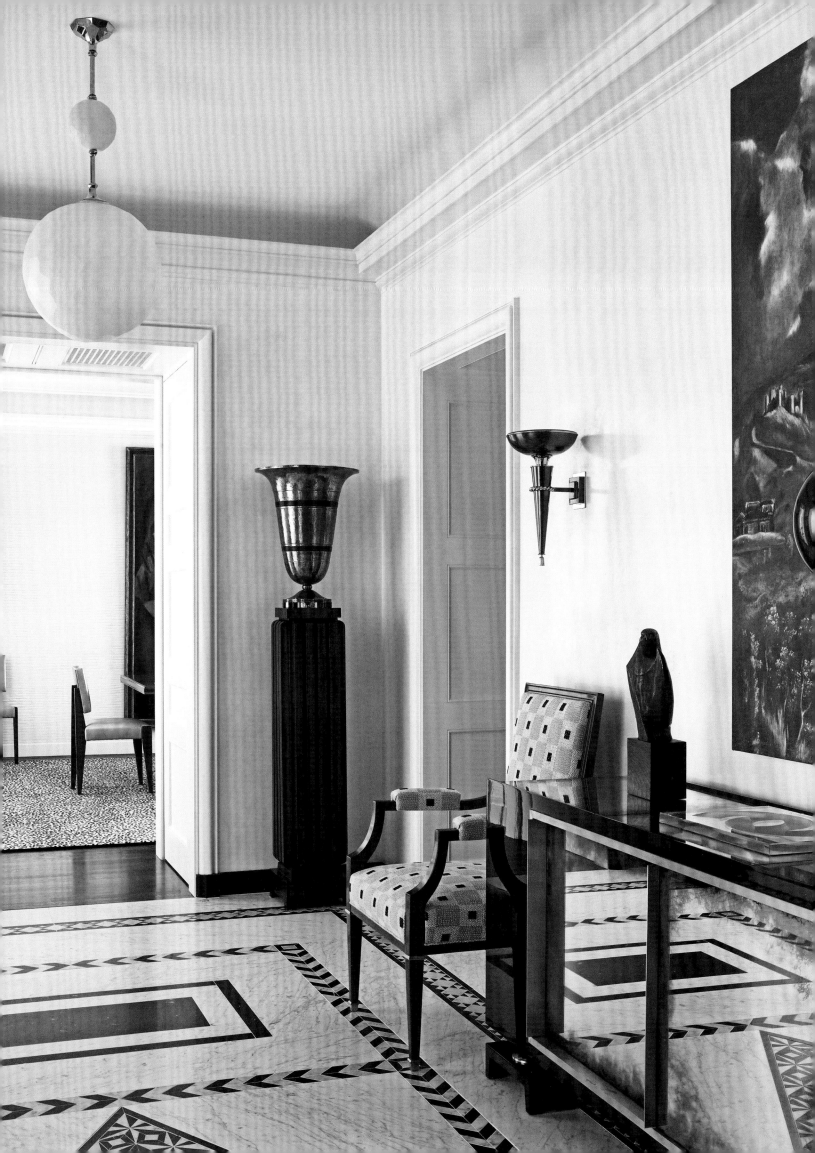

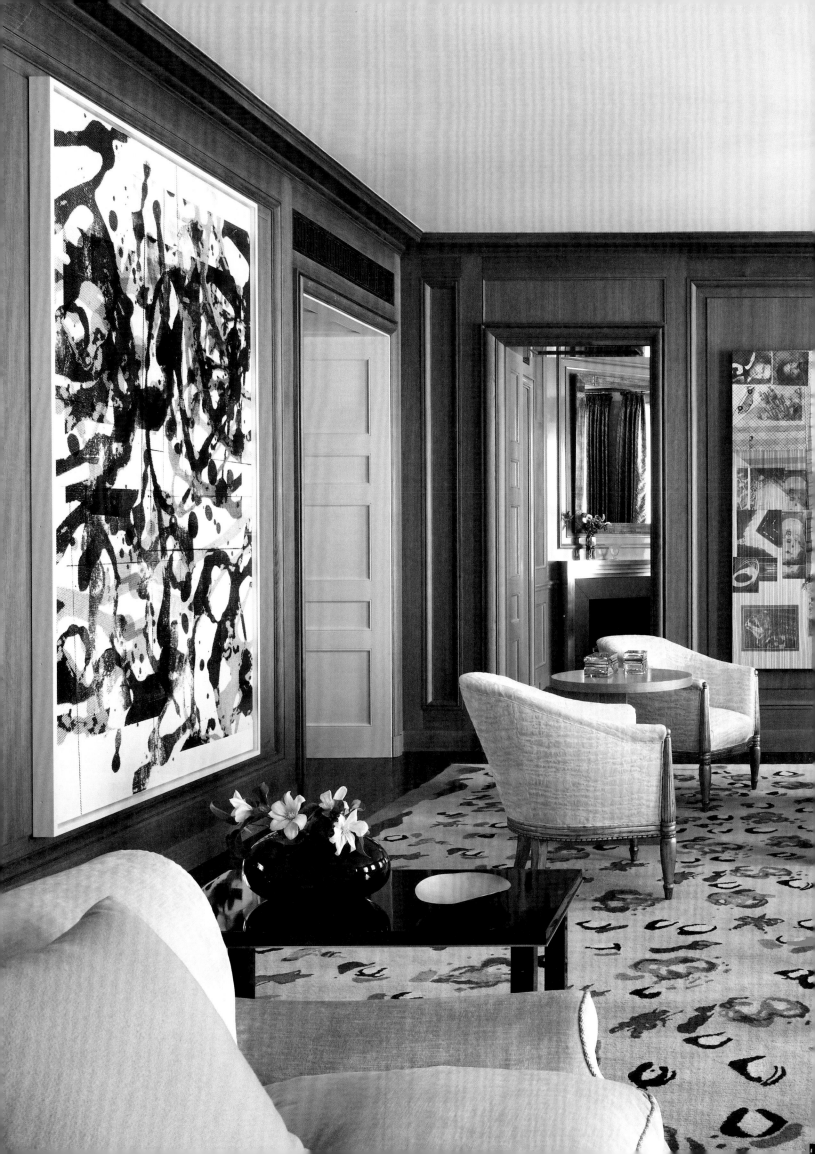

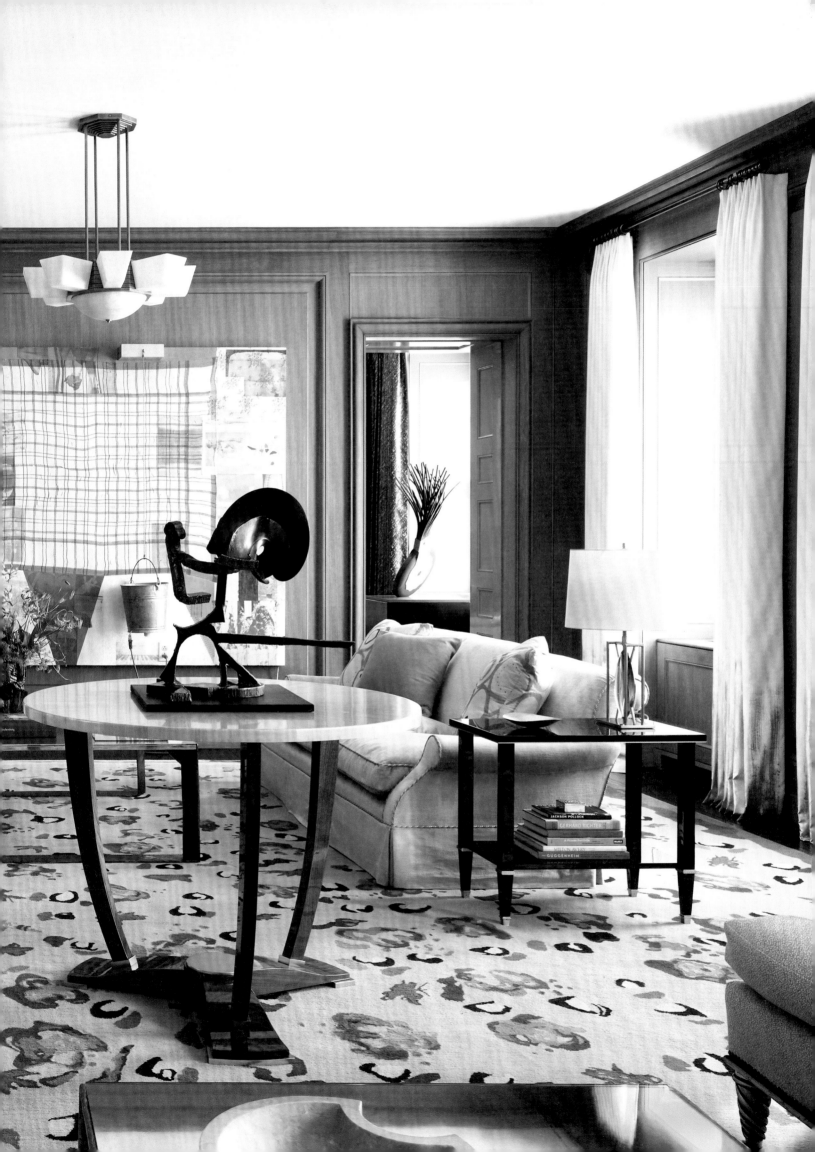

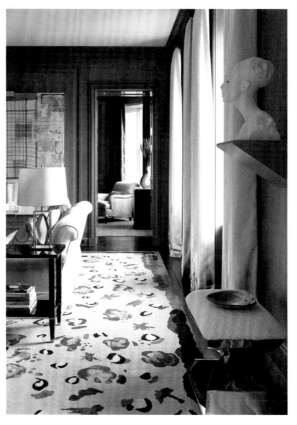

PREVIOUS PAGES: The living room's art deco pieces, including the Jules Leleu center table, converse with a sculpture by Mark di Suvero and a painting by Robert Rauschenberg. A painting by Christopher Wool, left, carries in the entry's palette. ABOVE, CLOCKWISE FROM TOP LEFT: Anne Truitt's painting centers the fireplace wall. The eye finds enchantment as it travels through the enfilade of rooms. Handwoven cut-velvet upholstery refreshes period art deco chairs. OPPOSITE: In this dialogue of eras, a 1950s Italian mirror meets a 1970s Philippe Hiquily console and a contemporary Hervé van der Straeten light. The painting, right, is by George Baselitz.

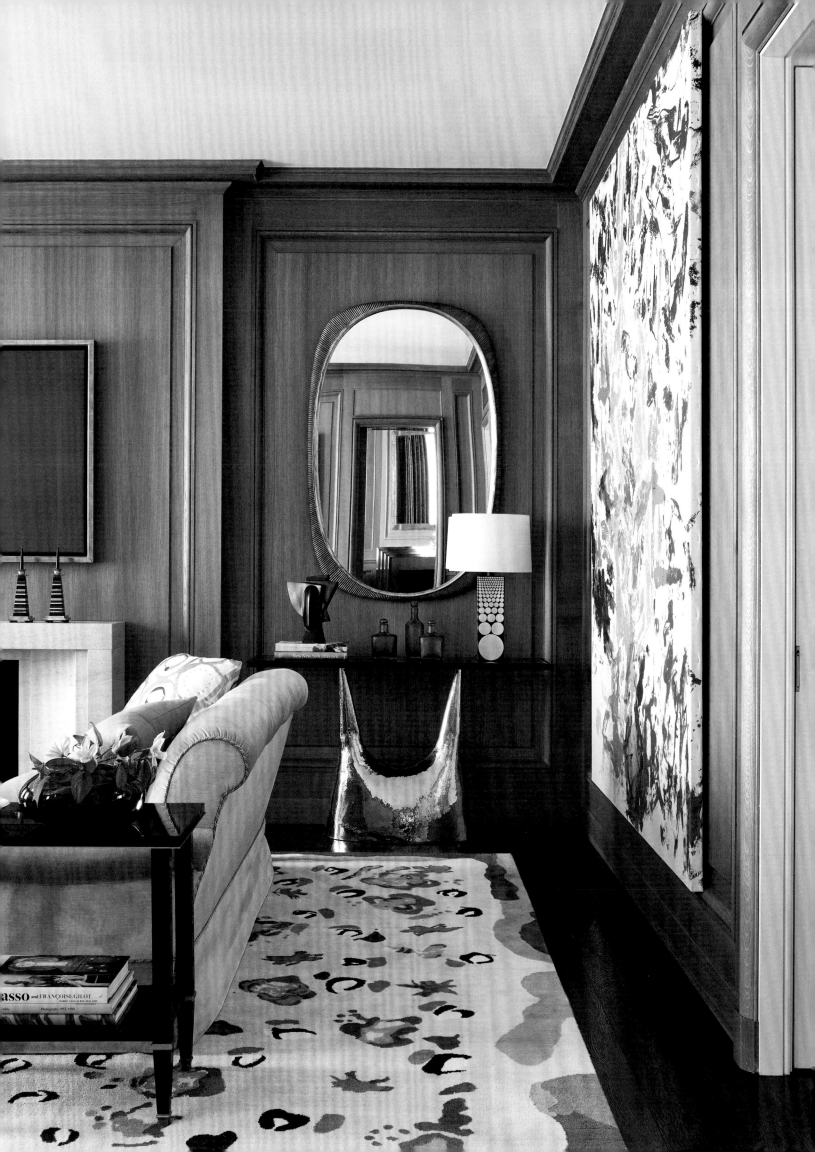

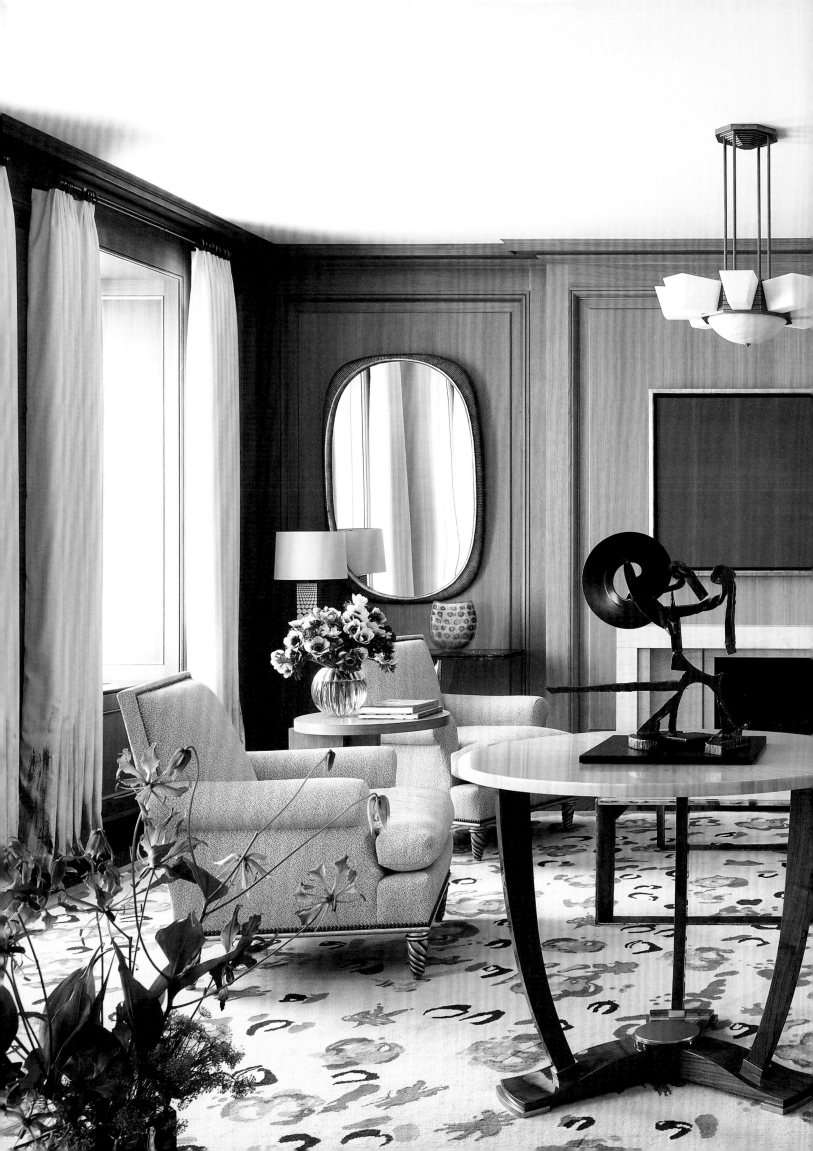

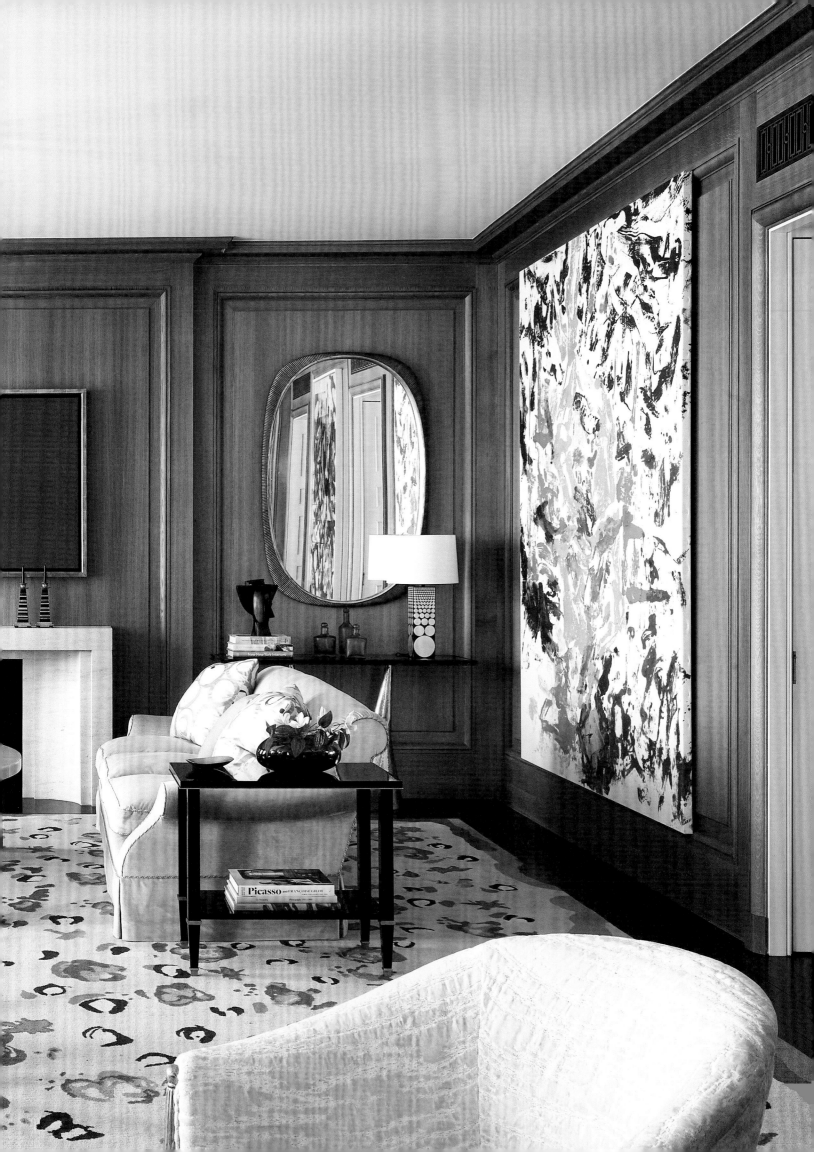

EMBELLISHMENTS

Baubles. Bangles. Beads. Where would decorating be without its "jewelry"? Lamps, curtains, hardware, pillows, trims, embroidery—these are the grace notes that make interiors sing. We prefer embellishments to add subtle intrigue, not shout "look at me!" But like all things, they also follow the theory of relativity.

Curtains should be given considered thought in every room, if for no other reason than because our eyes are constantly drawn to windows. Like a dress, the right curtain style depends on proportions. Width, height, spacing, frame, muntin, and mullion styles factor into our thinking. So do their relationships to the windows in the home's other rooms. Obviously, the color and texture of the walls affects the curtains, and vice versa. There's just one unbreakable rule: never, ever cover the view.

Decades ago, it was practically de rigueur to overdress windows with swags, jabots, valances, tails, pelmets, tassels, beads, paillettes, you name it. This ballgown-like voluminousness covered a lot of wall surface area, and often the curtains weren't even operable to draw. Now we aim to enhance a room's verticality above all. Really, who doesn't want to be taller and thinner? The more tailored the panels, the higher the rods and poles can go. Plus, poles, finials, and rings still present endless opportunities for ornament.

When matchy-matchy rooms were considered the height of style, we had a calculus for the way a room's curtains, upholstery, and pillows should share patterns, colors, and details. Today, we might decide that a red cuff would flatter a red tabletop, that a panel with stripes in two widths will add necessary energy, that a hem of gold brushstrokes will provide an understated Midas touch. We continually rethink how we treat the fabric and the detailing in order not to default to just a few stalwart treatments.

Enchanting the eye is one thing. Honoring its need to rest, take in the whole, and gradually discover the specifics is another. We adore embellishments, but we live by balance. This applies not only to the windows. But to everything. Everywhere. All at once.

PREVIOUS PAGES: Working with superlative craftsmen such as Charles Burnand always sparks mutual creativity; together, we envisioned this contemporary overhead fixture with art deco overtones. La Manufacture Cogolin's multihued rug pays homage to Christian Bérard's design for Jean-Michel Frank's Rockefeller apartment, this room's inspiration. OPPOSITE: The woven cream curtains, hand-painted by Le Studio Anthost, and vibrant rug serve as a glinting foil for the wood-paneled envelope. The bust of Nefertiti is by Damien Hirst. The stool by Carol Egan inserts another reflective note. OVERLEAF: The library presents a stimulating contrast to the adjacent living room's palette. English Regency end tables from the clients' previous apartment add history on both personal and decorative levels. The art deco armchairs were purchased in Paris. The chandelier is a vintage art deco piece. The sofa wall's faux shagreen panels and lacquer woodwork create an unexpected framing device for a painting by Günther Förg. The maquette of Claes Oldenburg's iconic typewriter eraser sculpture inserts a whimsical note.

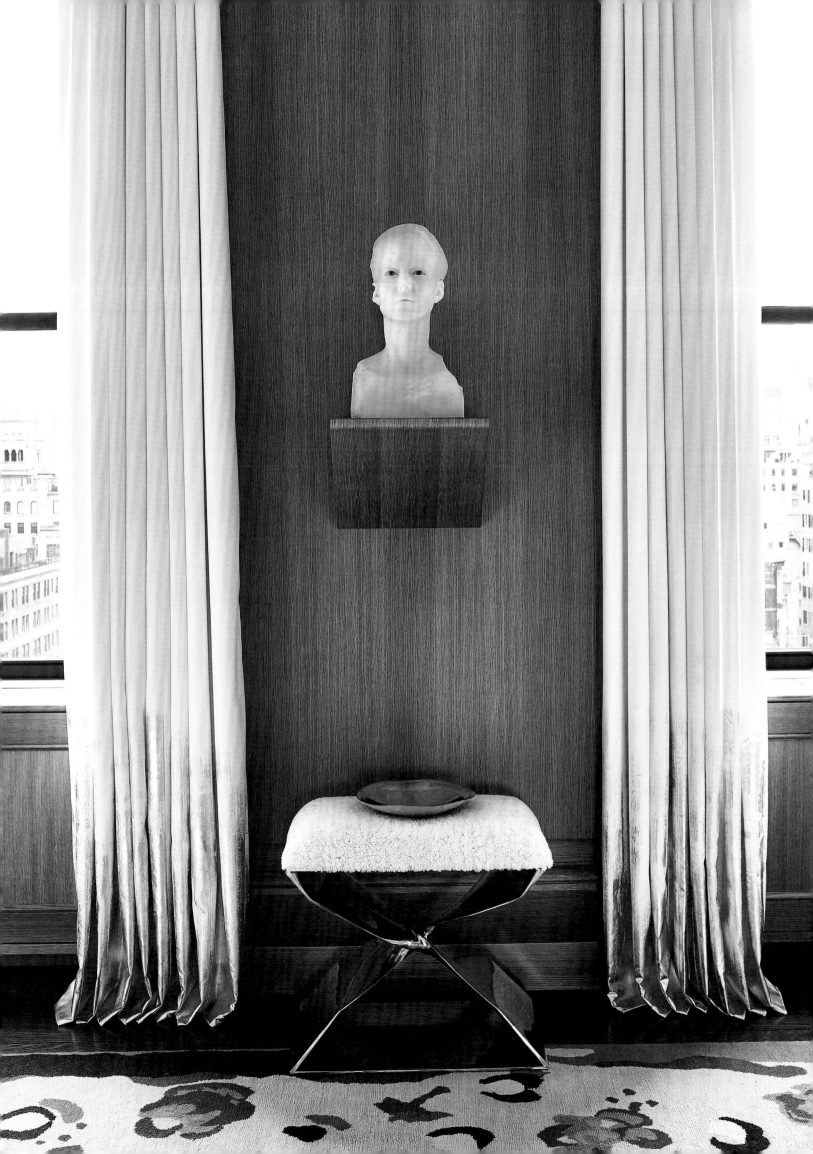

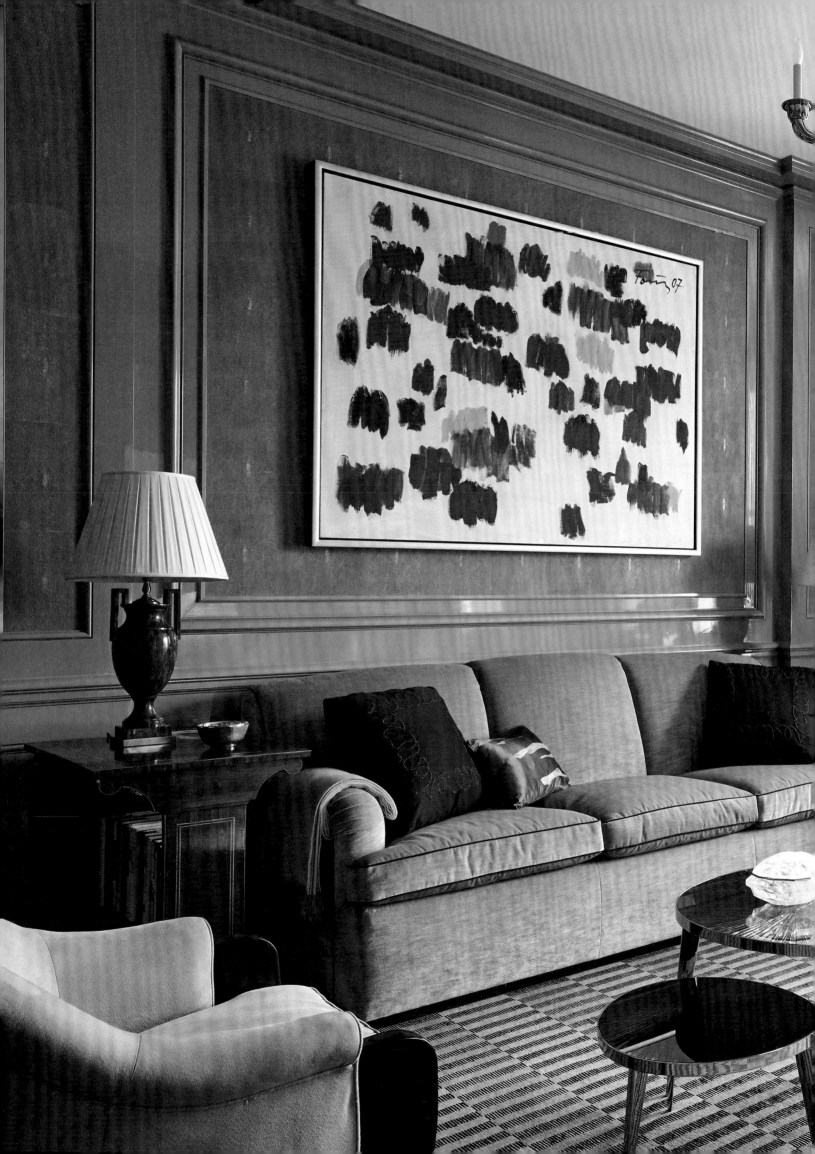

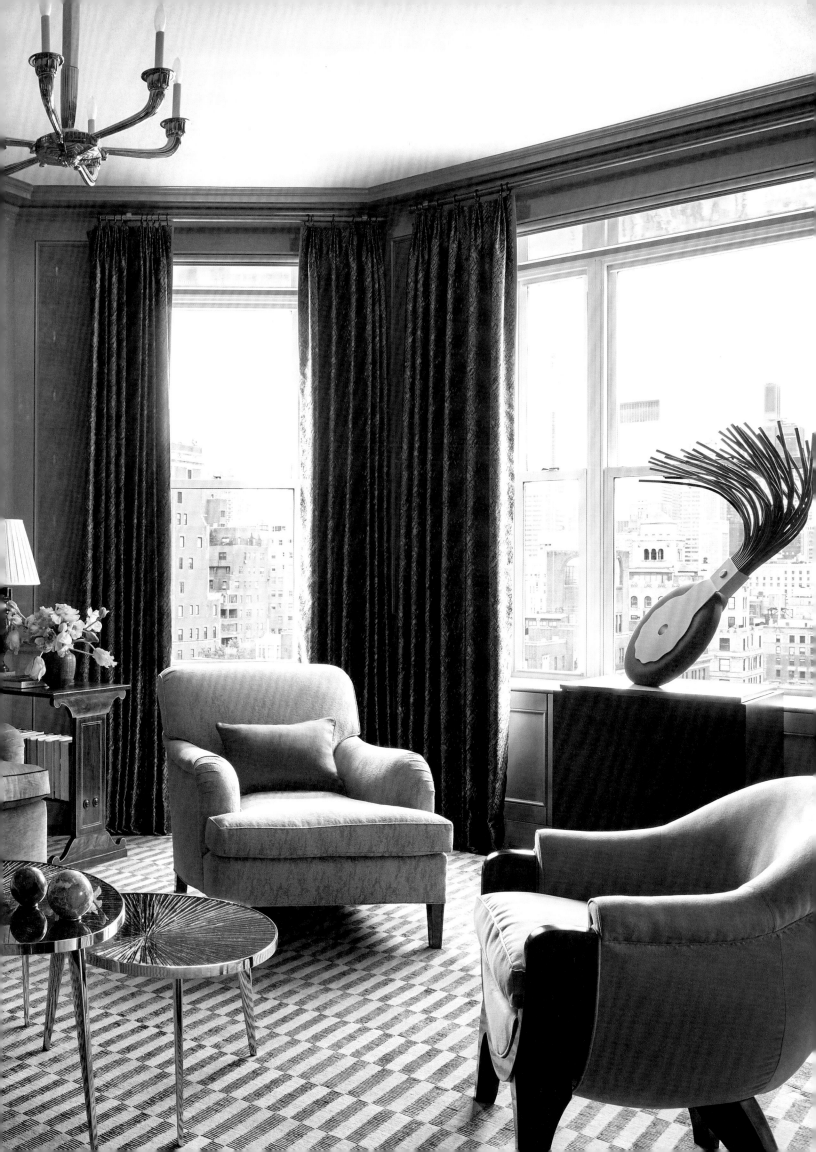

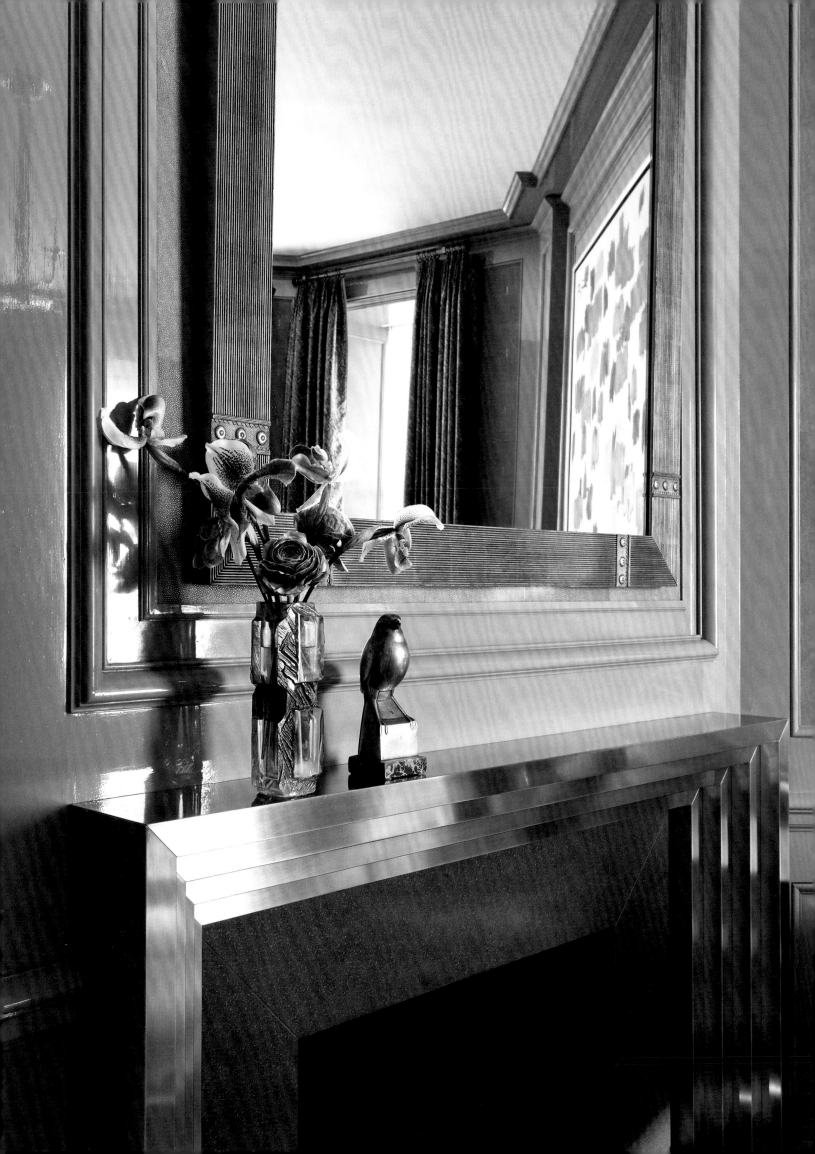

OPPOSITE: The mirror's reeded detail picks up one of the interior's subtler motifs.
ABOVE: Luminous molded glass and brass nesting coffee tables custom made by Ghiro Studio radiantly reiterate the understated circle pattern that reoccurs throughout.

torchères, to establish the essential decorative mien, and had the furnishings made in the same spirit—among them the antiqued mirror-fronted lacquer cabinet, dangling hand-carved glass orbs, and a custom fabric that practically dances on the chairs. The new marble floor was inspired by a similar mosaic the clients had seen in the rotunda of the Kunsthistorisches Museum in Vienna. Mica overlay energizes the walls, glinting light onto every surface.

From day one, the clients envisioned a wood-paneled living room. We introduced them to the form's art deco apogee through photographs of the New York triplex Jean-Michel Frank had designed for Nelson Rockefeller in 1938. They were enchanted by it, so we included as many nods to it here as we

27

could. The console tables that flank the mantel, for example, were created for and originally lived in the Rockefeller apartment. We designed the rug in homage to Christian Bérard's famed floral original and had it made by La Manufacture Cogolin, the same firm he used. The rug's palette became the source of the blues, raspberry, deep pink-red, and understated tangerine that segue variously from room to room. Because this wood-wrapped room is so expansive, resolving the algebra of its finishes—which tone of wood and where to place molding to accommodate paintings, as well as the proportions of glass, brass, and mirror—took much painstaking deliberation. So did the mix of the furnishings themselves. We needed to fill the space, so in addition to re-covering some of the clients' existing pieces, we also commissioned more to find balance. The artwork here was far from the least of the challenges: with some pieces in potent monochrome, others powerful in black and white, still more exuberantly multicolor, and all abstract, choreographing their placement and collective force was essential.

We decided to go darker for contrast in the adjacent library. Here multitextured shades of blue complement the living room's yellow, gold, honey, and cognac tones. By orchestrating the point-counterpoint of matte and sheen, we articulated the walls and the space they envelope and, in the process, created a framing device for a vibrant abstract painting above the sofa. Bronze nesting coffee tables with ombré glass tops, another commission, are true embellishments and flourishes of practicality at the same time.

These clients entertain often. From the outset, we envisioned the dining room with an art wall as a focus—an expanse sizeable enough for a piece as substantial as the painting they purchased mid-project, André Derain's *Last Supper*. With a silver glaze, the walls read almost as white. Yet they endow this room with pure glamour, heightened by accents of warm raspberry at the windows and in the faux porphyry tabletop. The design for the curtain cuffs is a tale in itself. We derived the motif from the ornamented door of a 1930s elevator that the clients had seen on a trip to the south of France. The clients also purchased the vintage chairs in France, further deepening the strata of history.

OPPOSITE: It's so important to balance the elements of decoration to create both cohesion and differentiation from room to room. The dining room's silver Venetian plaster walls in a horizontal treatment that we affectionately call "razor clam" take the gallery's mica overlay finish to another level of shimmer, while the cheetah rug weaves in a variation of the gallery's palette. The dining chairs are by André Sornay. OVERLEAF: The ruby hue of the porphyry-inspired custom tabletop meets its match in the curtain's custom trim, and the gem tones are reflected in André Derain's *Last Supper*. Charles Burnand's custom octagonal alabaster pendant, which marries this interior's underlying geometric motifs, casts a magical glow.

28

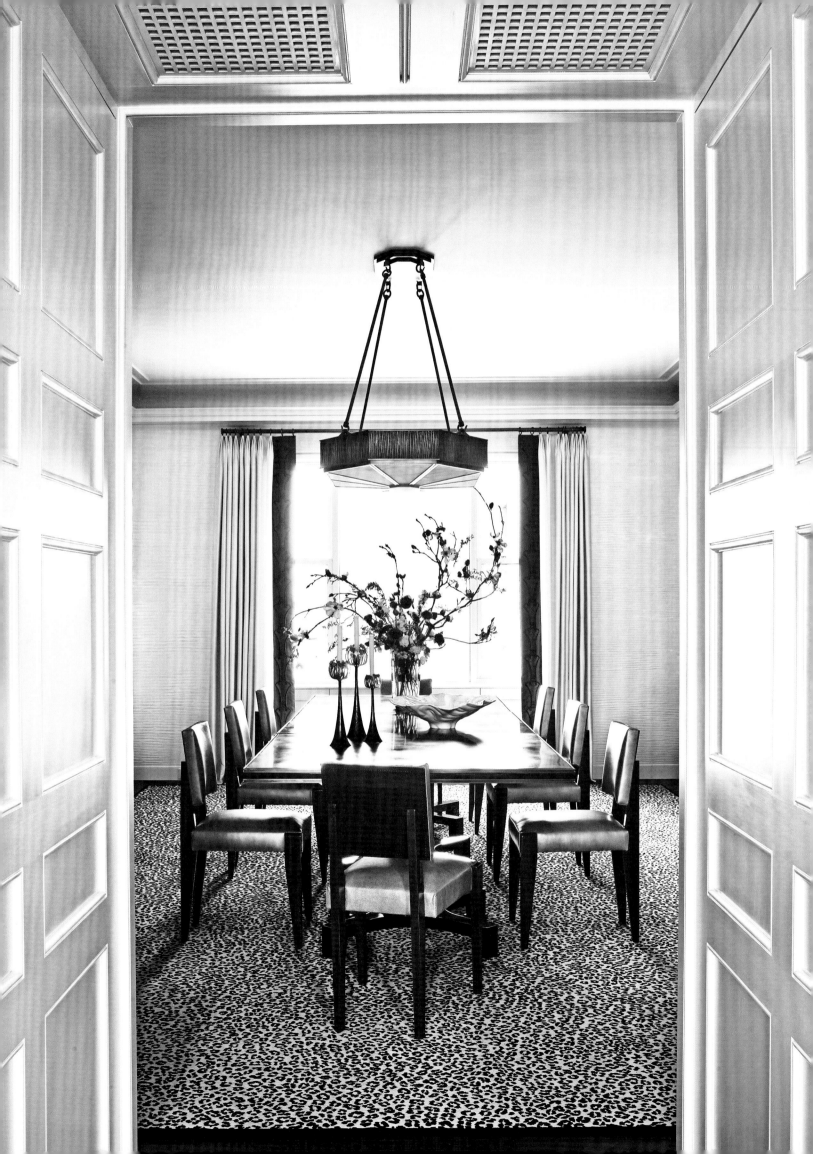

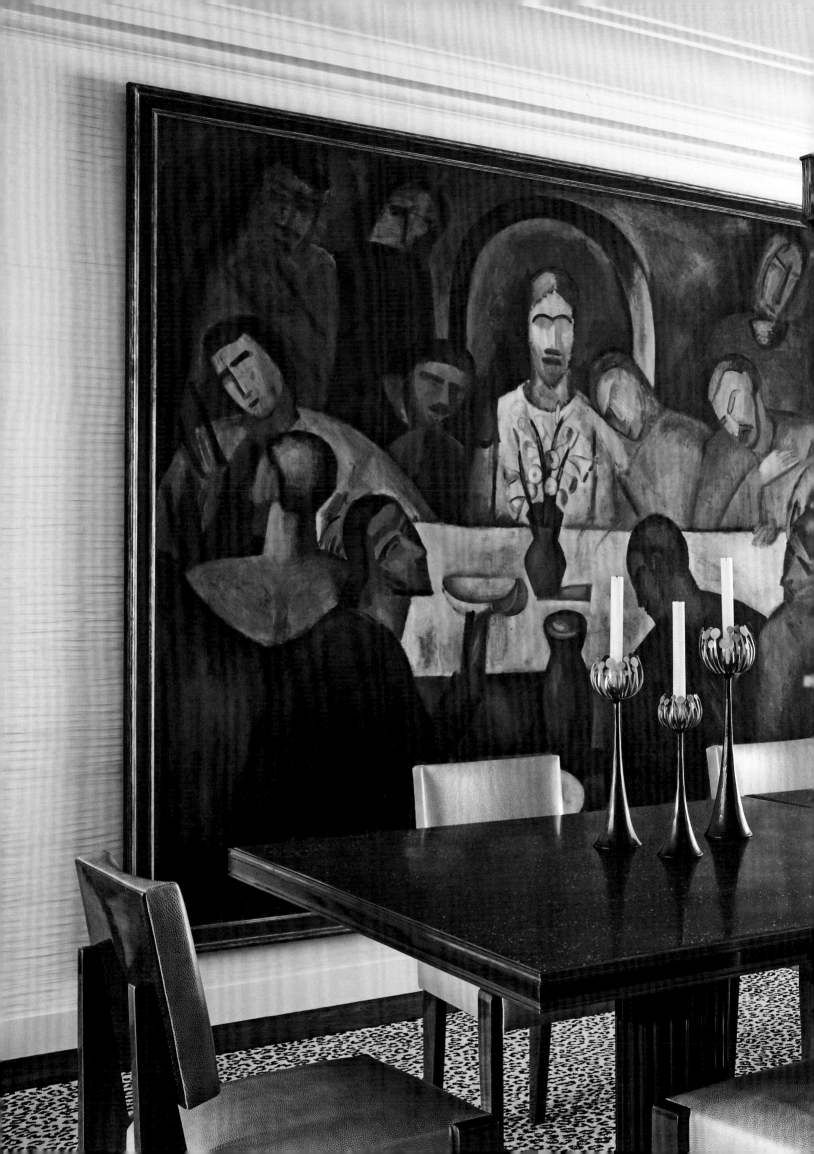

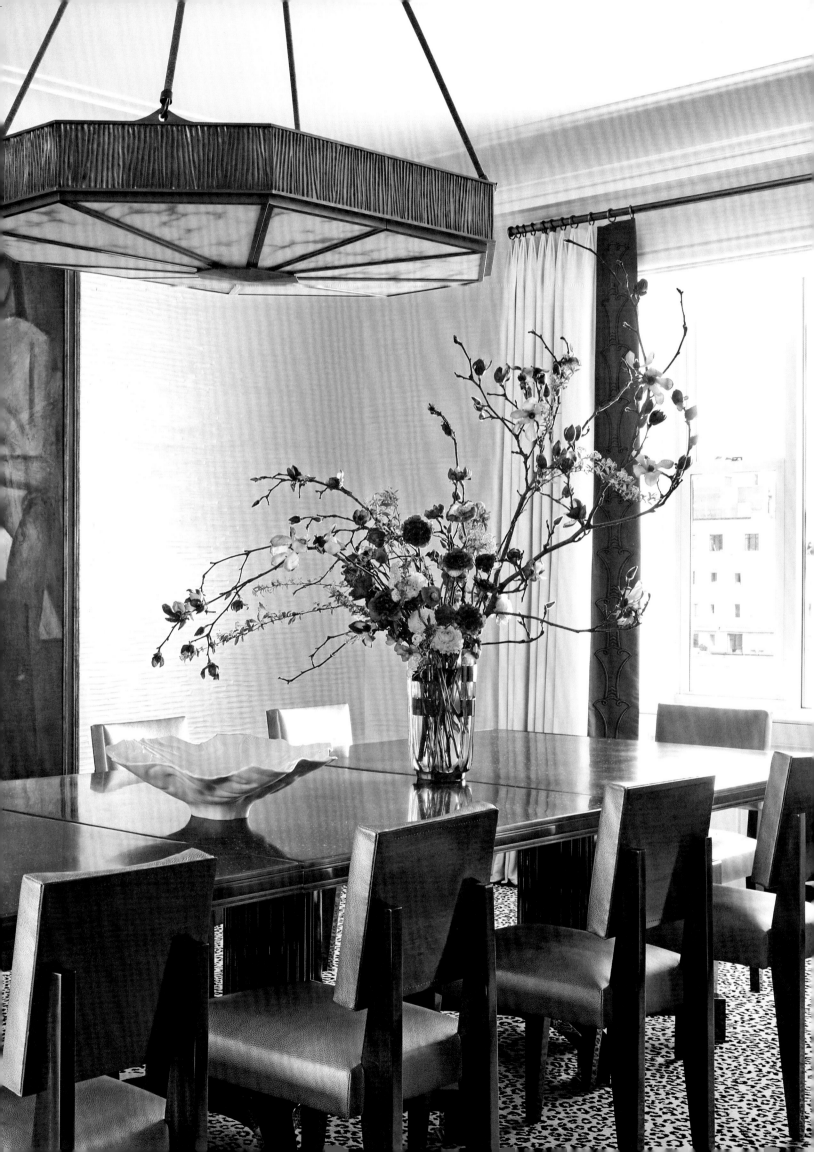

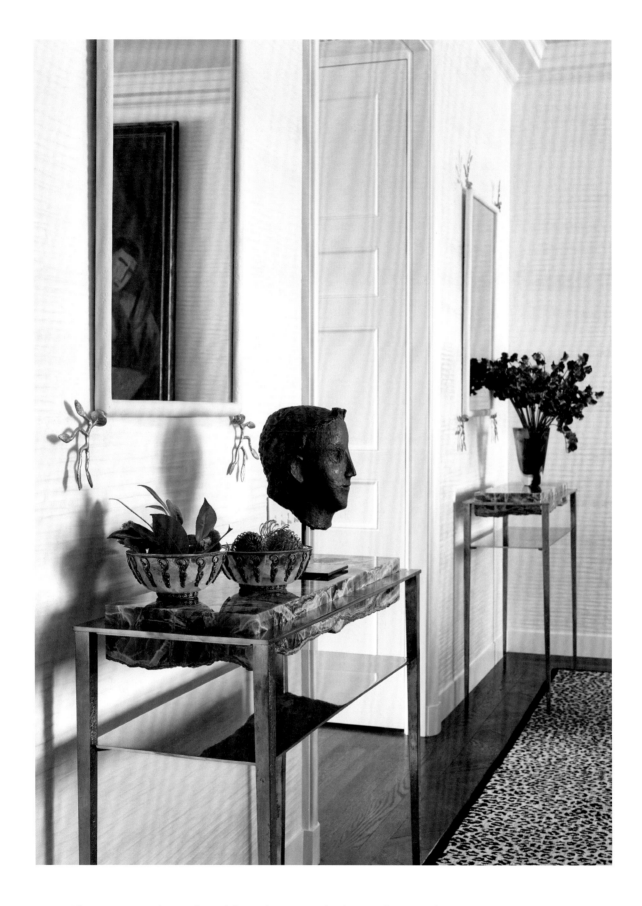

ABOVE: The onyx-topped consoles celebrate the owner's background as a geologist; the reflection of the live-edge on the shelf below adds a quiet layer of intrigue. The bust is by André Derain. OPPOSITE: Jules Leleu's 1945 walnut marquetry sideboard was the first purchase specifically for the apartment. The painting is by Helen Frankenthaler. The 1950s Belgian glass vase reinforces the ruby tones of the tabletop.

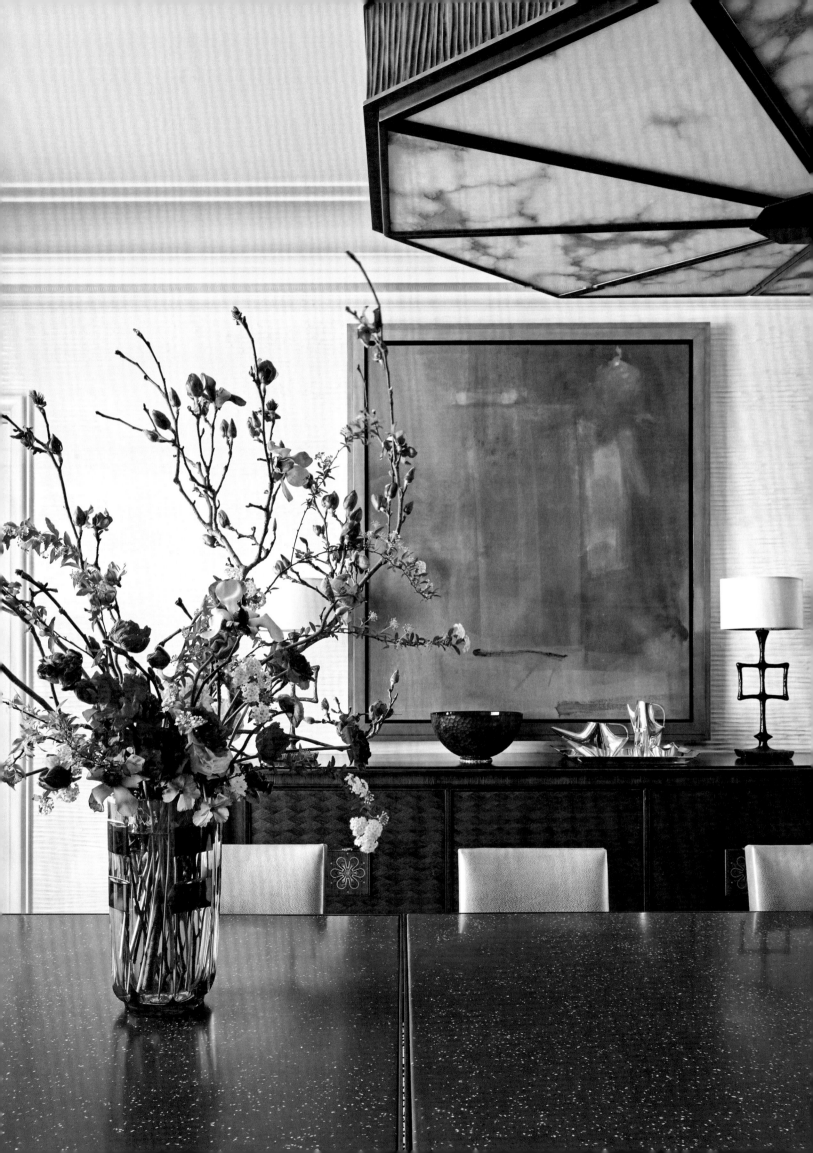

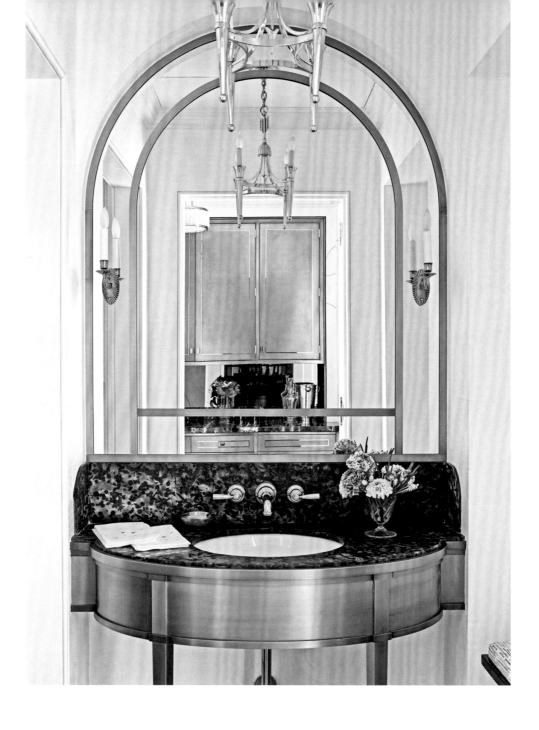

ABOVE: The arch of the art deco mirror repeats in the bow front of the metal sink below. OPPOSITE: The combination of silver-painted cabinets with metal inlay, smoked glass mirror backsplash, and hand-painted silver sgraffito walls plays a vital role in dressing up the bar. The lapis countertop carries through the blue that the owners love, which makes repeated appearances in the apartment.

The bar and butler's pantry perform as a matter of course, but they're a theater of transition also. The sgraffito plaster walls—layers of plaster with choreographed swoops of silver swirl inlay—wittily lighten the cabinetry's right angles and visually expand a narrow space, while the lapis of the countertops hints at the color of the walls in the family room beyond.

As for the kitchen, the clients originally wanted it to be blue. Since this would have turned the room into a dark hole because of the small windows, we opted instead for silver with some rays of sunshine yellow to recall the living room. We accommodated the request for blue in the adjacent family room, which, though saturated and cozy, is still bright thanks to its ample natural light.

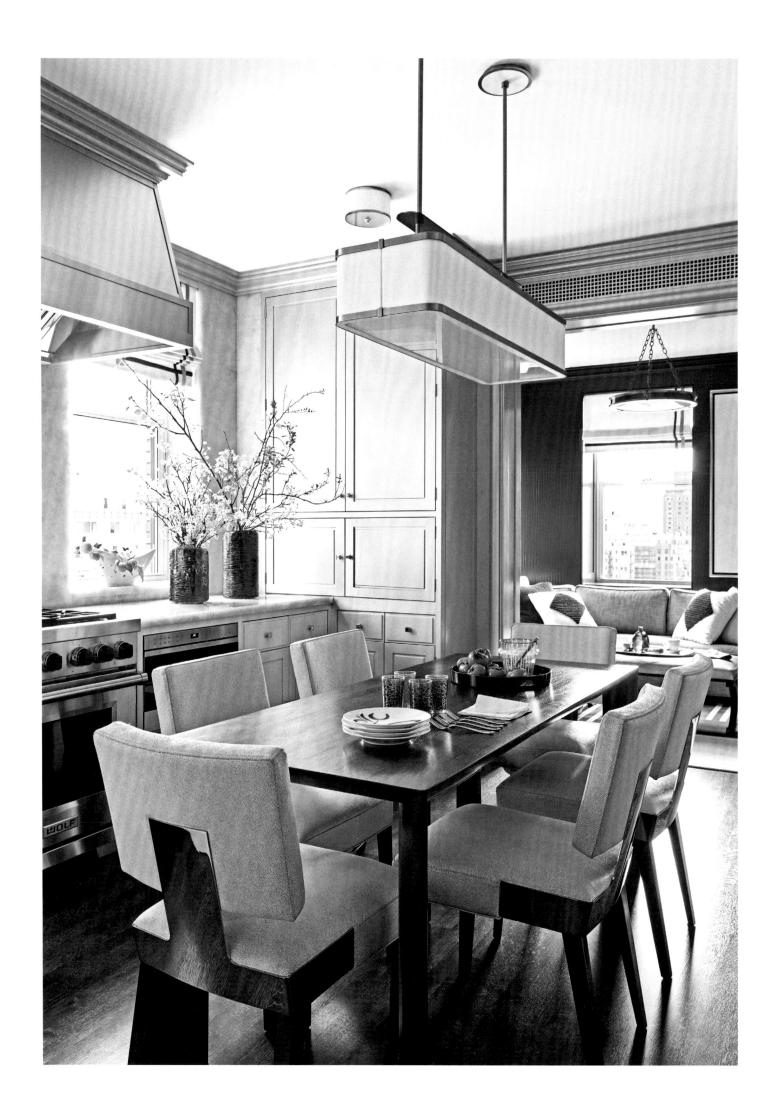

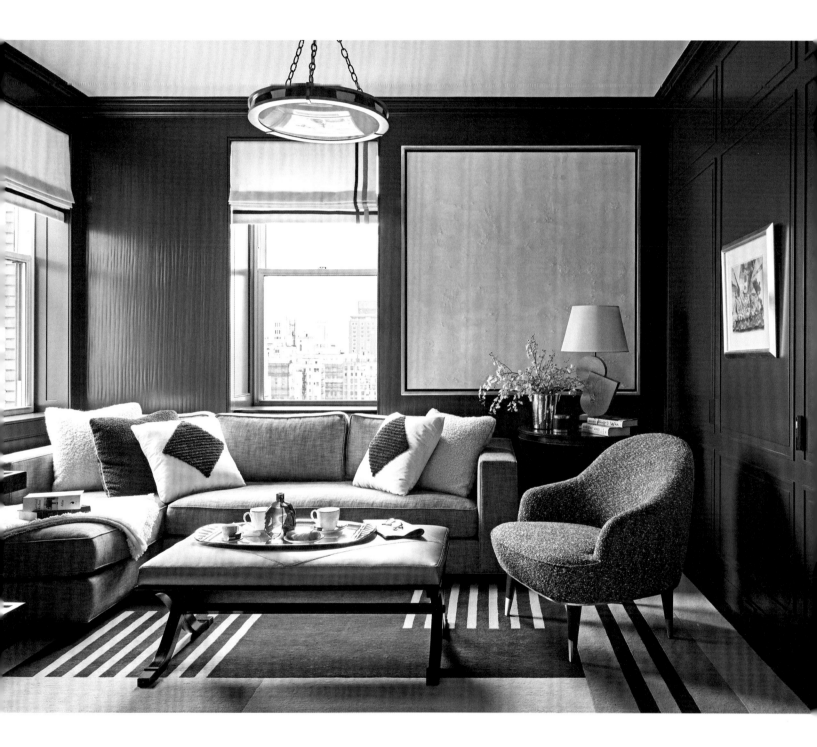

OPPOSITE: To brighten the kitchen, we opted for white and shifted our initial idea of blue walls to the adjacent family room. The dining area acknowledges how everyone congregates here. ABOVE: The family room's striped rug and vertical plaster treatment draw the eye up and add textural interest. Swarovski crystals in Heimo Zobernig's painting add sparkle. OVERLEAF: Careful calibration went into the placement and width of the curtains' contrasting bands: the bottom edge of the upper band, for example, meets the top of the windowsill in a way that suggests a waistband encircling the room. Roberto Rida's bedside lamps insert a teal accent picked up by the room's other table lamps. The painting above the bed is by Gerhard Richter.

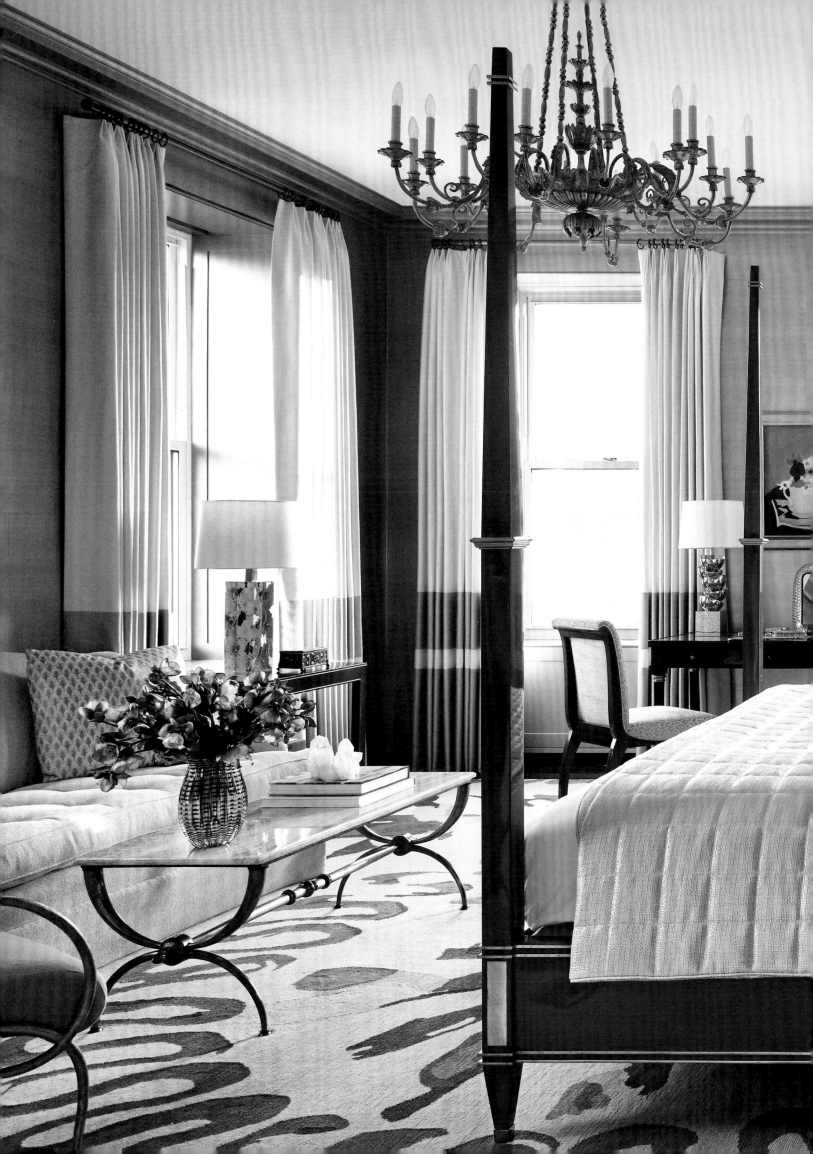

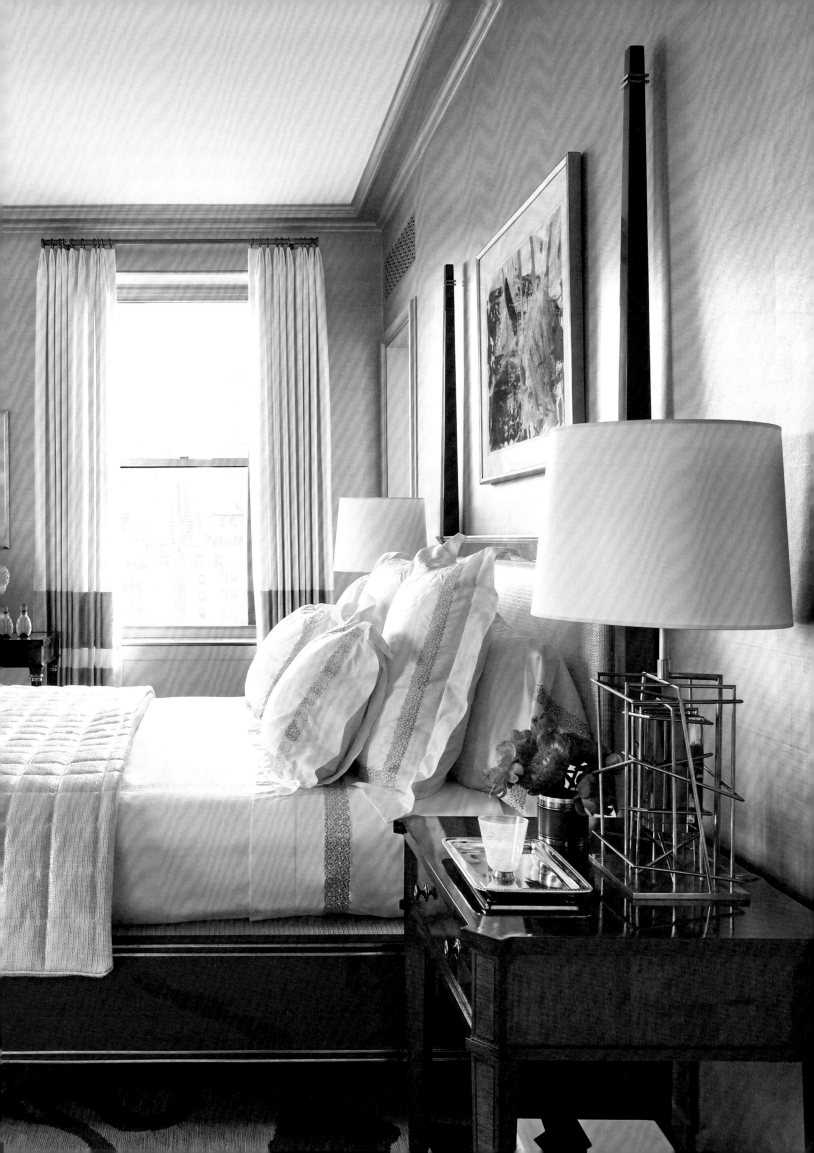

ABOVE: The rose gold of the wallpaper matches the rose gold of the wood trim to create a cohesive envelope. The still life by Milton Avery is one of only a few representational artworks in the clients' collection. OPPOSITE: With its sculptural personality, René Drouet's art moderne chair from the 1940s always enhances its surroundings.

The primary bedroom is another forward-looking throw-back altogether. It began, funnily enough for us, with the bed, not the carpet–our usual point of departure. Remembering a Kips Bay Show House room of ours from more than ten years ago, the clients asked for many of those same elements here. Using that scheme as inspiration, we covered the walls in a rose gold–colored wallpaper with a pattern of squares that mimics the effect of the actual gold leaf we used at Kips Bay, and de-fined the perimeter with contrasting trim, softer now than then. The rug grounds the mix with a quintessential art deco design, bringing this room, and the entire interior, full circle.

Time does not stand still. Neither does design or decora-tion. And neither do we.

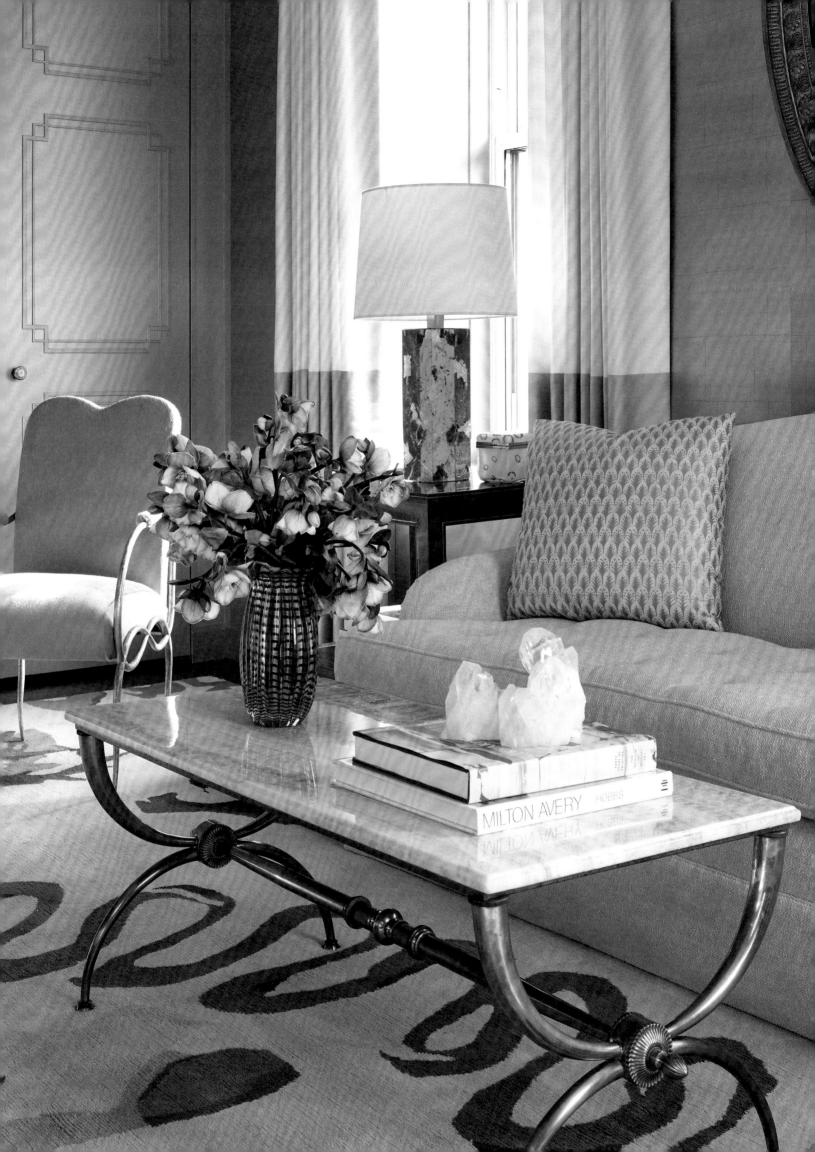

MILTON AVERY HOBBS

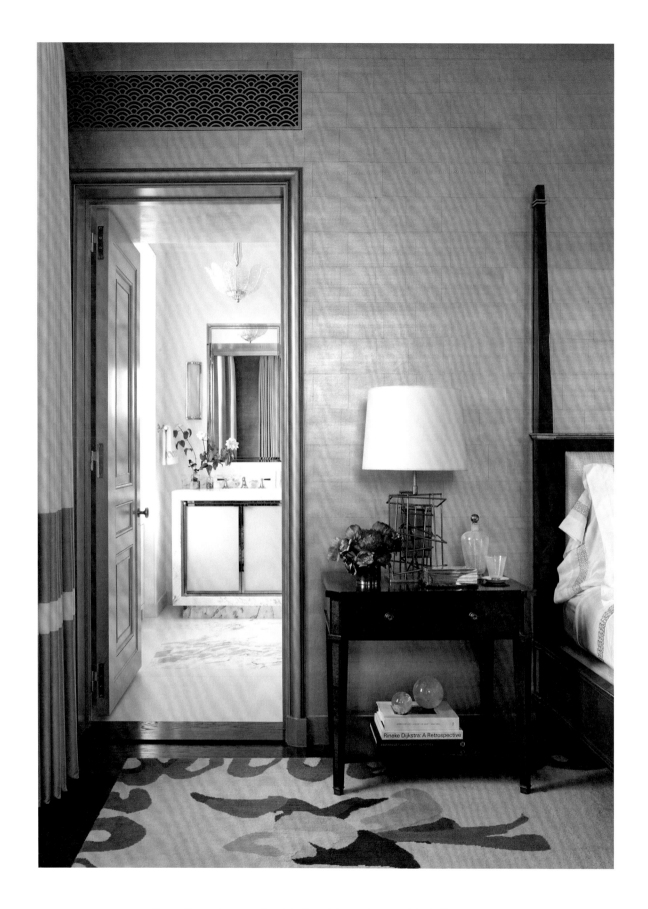

ABOVE, AND OPPOSITE: One unique element, like this Swedish art deco molded glass light fixture, can bring a special note of decorative consideration to a room where such details might be less expected, like this primary bath. The vanity's metal trim and inset milk glass panels suit the function of the space while referencing the art deco details and contemporary design motifs that are part of this interior's decorative DNA.

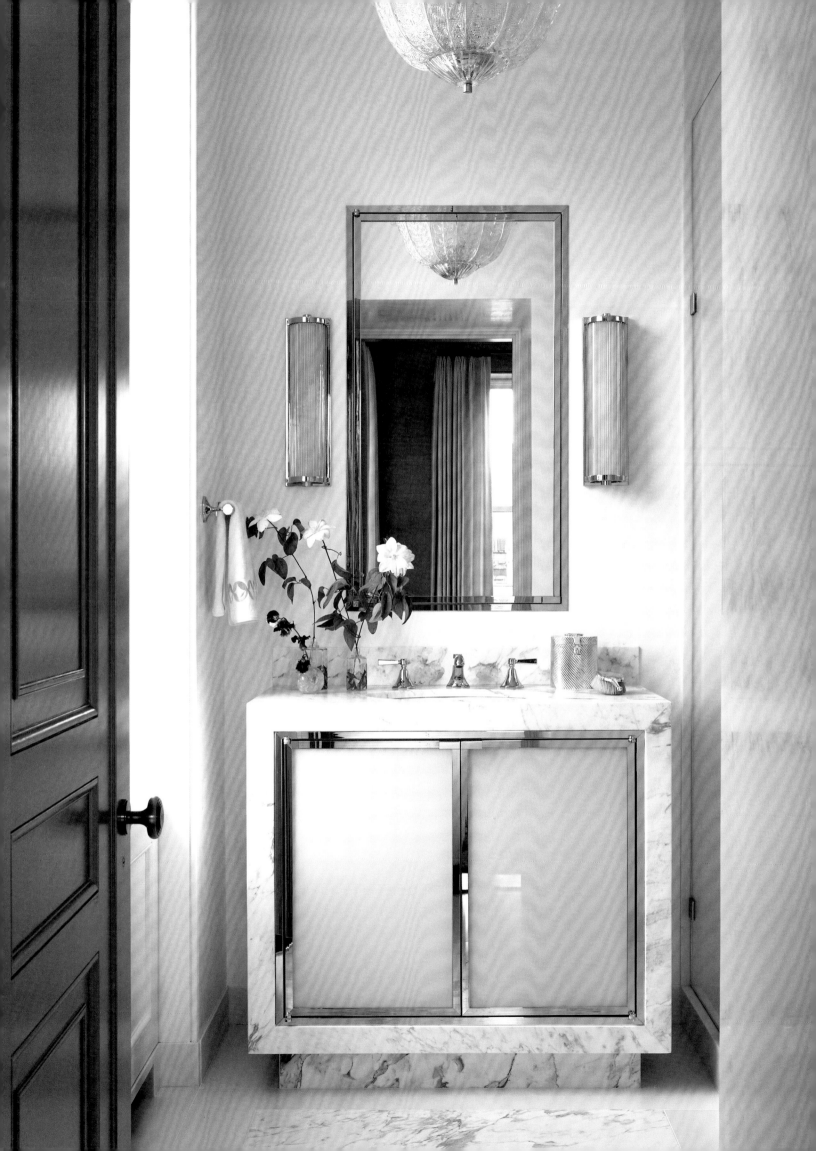

BEACHFRONT MODERN

For us, very little exceeds the joy of collaborating with families over decades to create homes that suit the various phases and facets of their lives. These longtime clients, and now their grown children, have given us that privilege time and time again. This guest house, a recent addition to their beachfront estate in the Hamptons, is just the latest example.

When the lot contiguous to their main house became available, the couple worked with their longtime architect, Tom Kligerman, to build a four-bedroom retreat for their children and their friends. The "upside-down" layout here—bedrooms housed in the four corners off the entry and living and entertaining spaces upstairs—realized an earlier dream. Years back, while they were in the process of designing the main house, they had considered this floor plan to take advantage of the best views, but ultimately opted for a "right side up" house with bedrooms upstairs so they could be closer to the beach and the ocean. Now, with two houses, they can experience the wonder of both worlds.

They wanted the guest house to feel fairly informal and youthful. To that end, we decided to include the work of young contemporary artisans and emerging fine artists rather than the gilt-edged pieces that fill the main house. The spaces, though relaxed, became quite stylish—a noticeable reflection of their refined taste.

These clients also asked that the two houses speak to each other, design-wise, so that the expanded property would feel cohesive. Textured plaster walls, a limed-oak ceiling, and grayed floors are among the unifiers. The couple's initial idea was to fill the entire house with bright, saturated colors for contrast with the main house's muted neutrals. In the end, they opted for an expanded palette, but in soft shades of blue, gray, lavender, and seafoam.

OPPOSITE: Venetian plaster walls and an oak plank ceiling give the entry to this guest house an air of casual elegance that feels just right for the upscale beachside location. Joseph McDonnell's contemporary chandelier cues in seaglass tones that play an important role upstairs. Nicolas Aubagnac's center table exudes youthful freshness and quintessential classicism, an interesting paradox at the heart of the decorative choices here. Hung on the diagonal, the spinning painting by Haegue Yang—its bells chime if it's turned—exemplifies the exuberant spirit of the art collection.

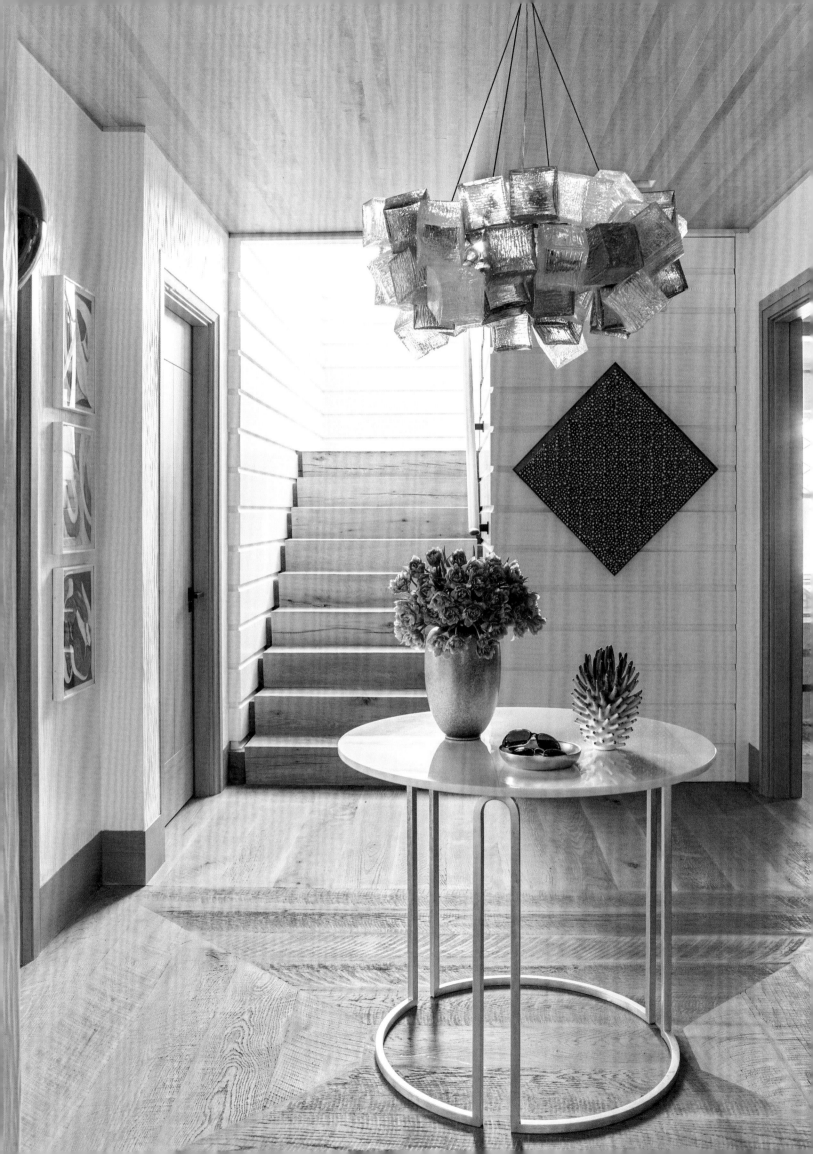

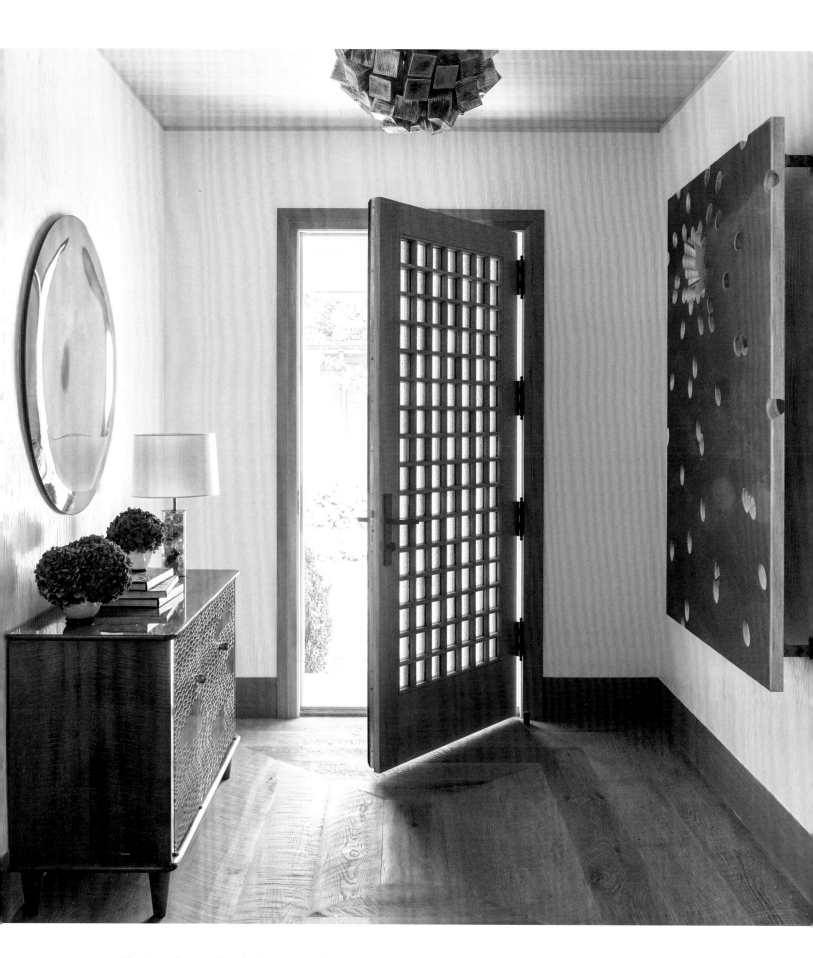

ABOVE: The front door's colored glass inserts relate it to the main house's detailing. Donald Moffett's painting was hung several inches from the wall, per the artist's instructions. OPPOSITE: The organic strié plaster finish developed for this space hints at the patterns of sand at low tide; Nancy Lorenz's remarkable gilded console doors suggest the waves.

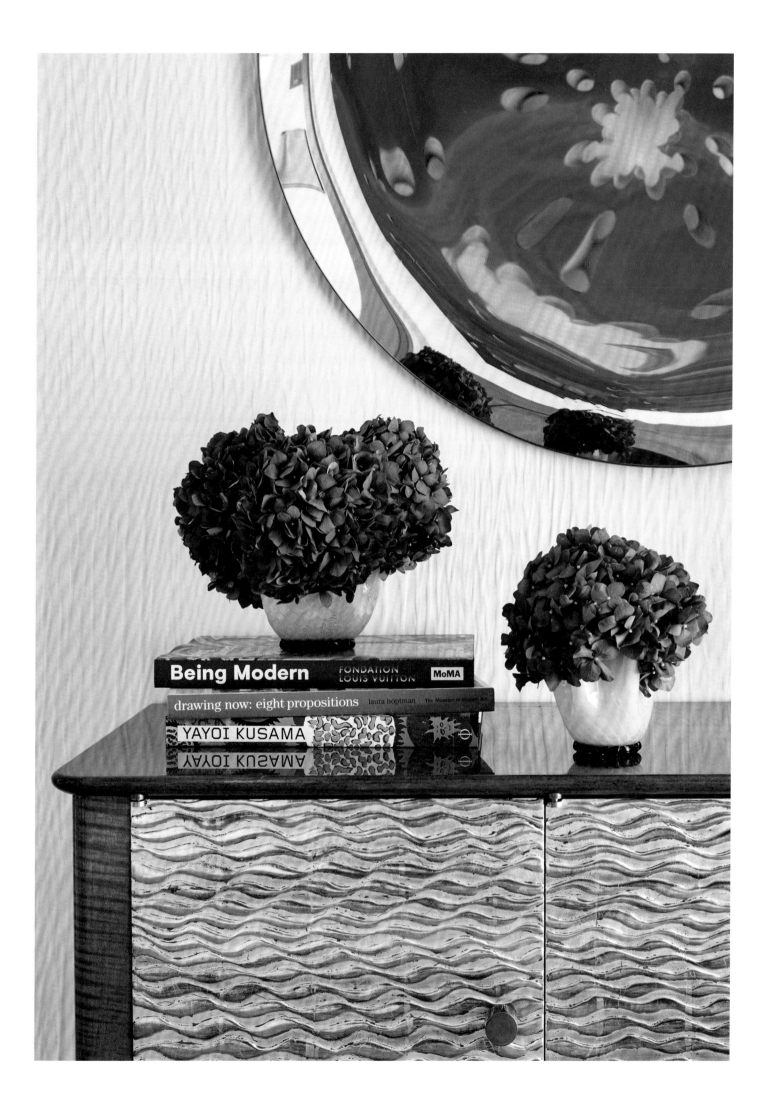

We decided to heighten the confluence in the entry with a grid of textured glass on the door, a nod to the Stanford White–inspired doors of the main house.

Upstairs in the living and dining area, which we spanned with built-in storage and bookshelves for this family of avid readers, we used pattern to fill the space with energy. The rug lays the groundwork. We resolved its design over many months of trial and revision. Its genesis was a small fragment, perhaps six by eight feet, seen at a Sotheby's auction, that entranced us with its asymmetry and dimensional potential thanks to different pile heights. As the weaver worked with us to refine the pattern, the office received Xeroxes of the squares in various scales. We'd then try out possible variations with the client. The mathematical process was complicated. How many squares, how many different shades of blue, how many textures—all to avoid creating an obvious repeat.

In the lime-washed barrel-vaulted great room, a ribbon of a light fixture enlivens the space overhead, rippling across the room like a line of whitecaps shining in the sun. Pieces by artists and artisans add bronze, brass, and gold into the mix in different degrees and applications. The dining table, discovered in a Paris gallery, is itself another feat: the polished brass columns of its base pierce the stone top in the most whimsical spray of polka dots imaginable. The coffee table with each leg in a different metal—and an ombré top—happens to be another fun find. The copper side table with its custom-colored resin top yet another.

Then there's the powder room at the top of the stairs, where ceramic paillettes transform the walls and ceiling into a subtle, glimmering, sculptural canvas, adding the allure of dimensionality. The artisans placed the hand-made, hand-gilded discs very specifically after drawing elevations to work out the ebb and flow of the groupings and the scatter of connecting rills.

Guest houses very often repeat the same recipe in every bedroom, but that's not our way. We spend a great deal of time and thought creating individual identities

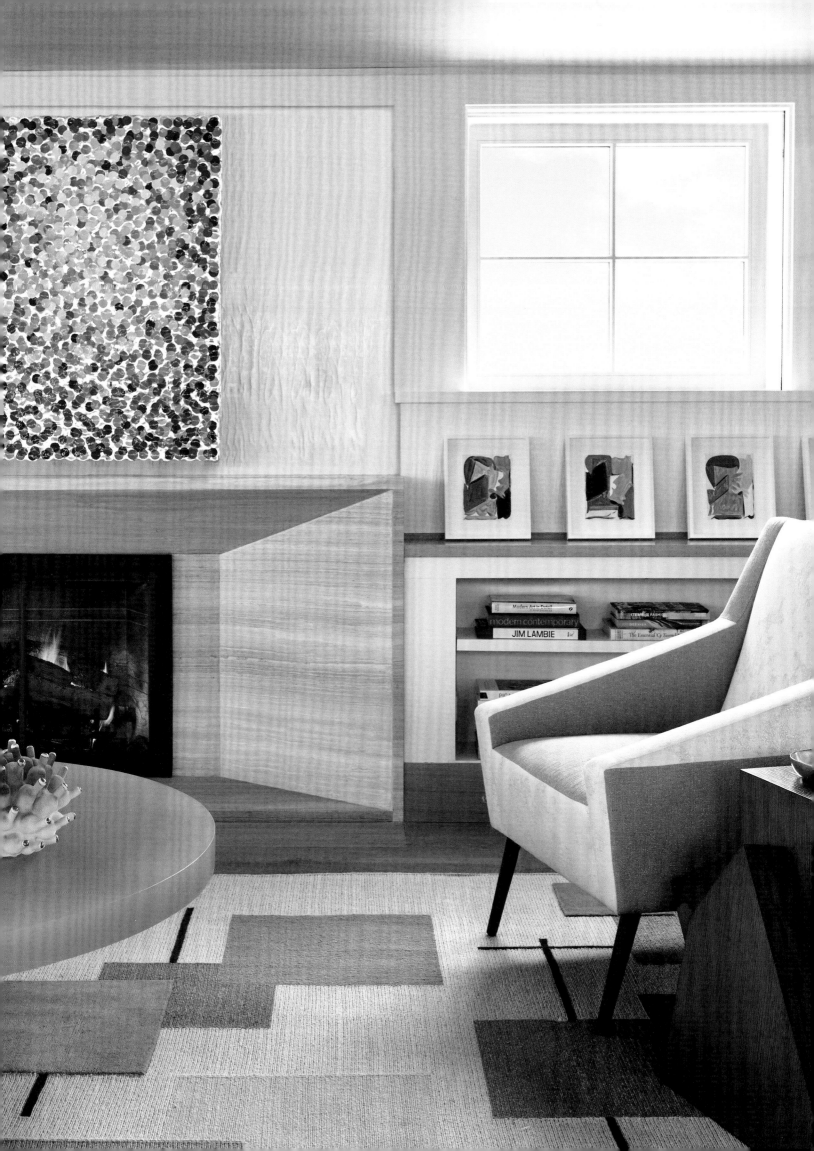

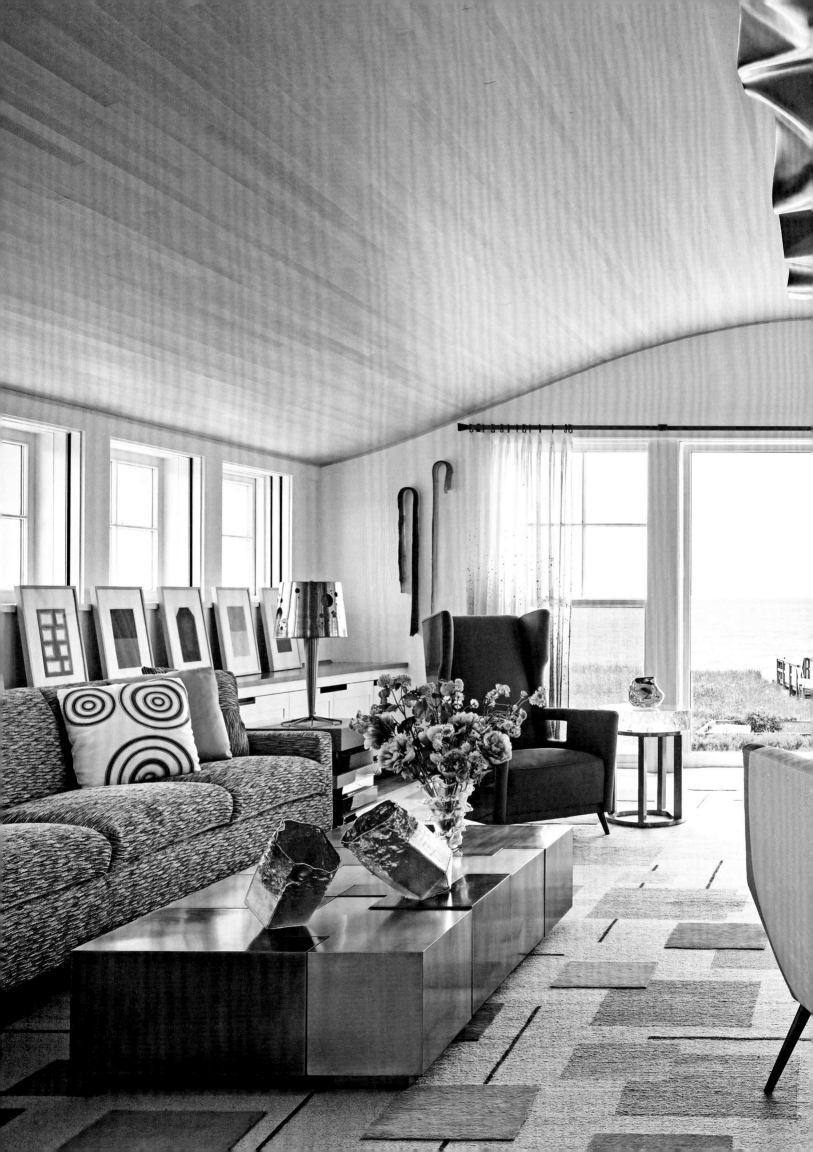

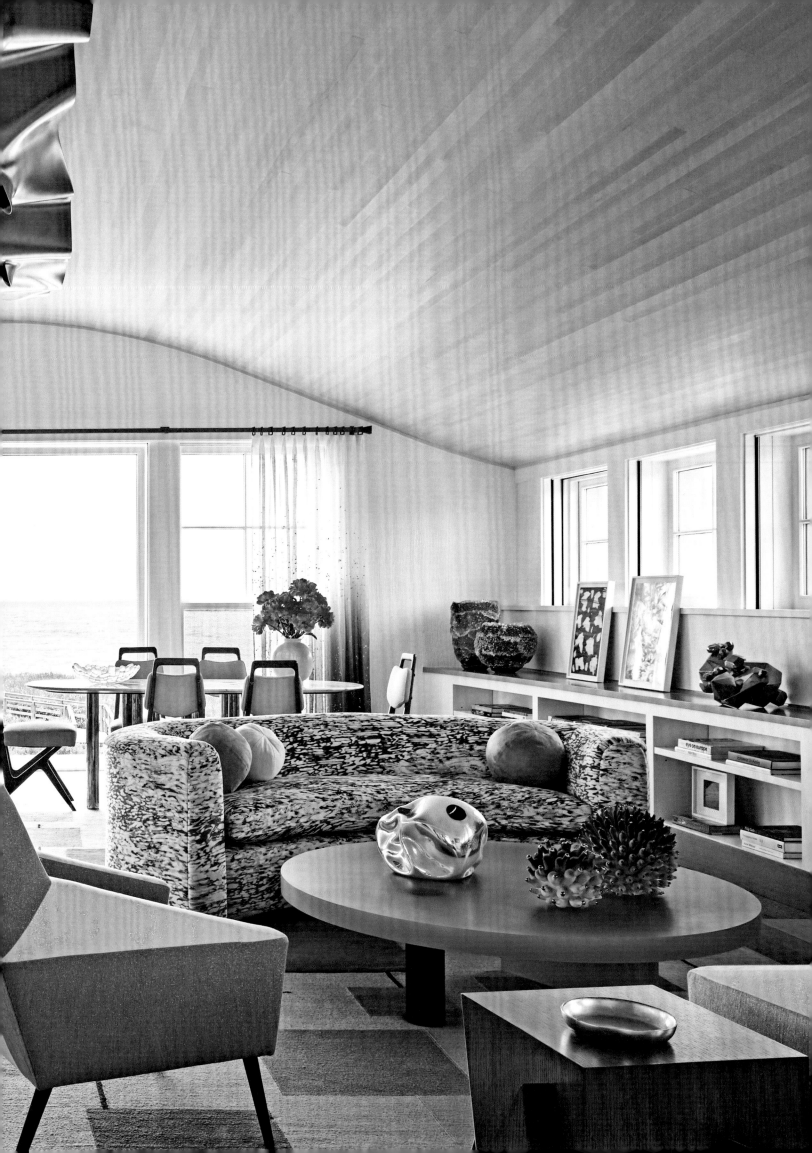

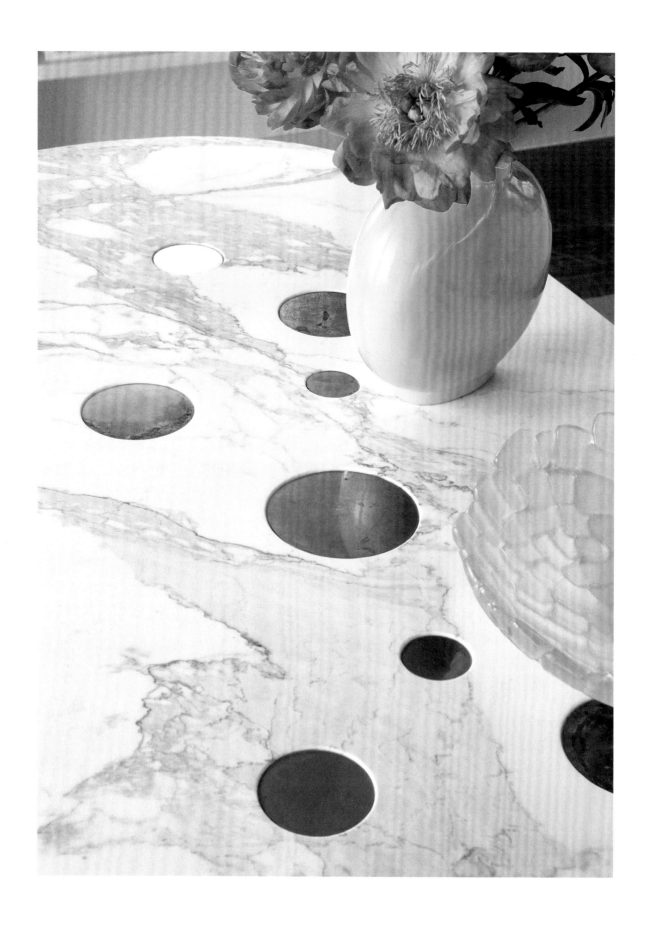

ABOVE: The Constellation Table by Hervé Langlais lives up to its name. Jeff Zimmerman's textured bowl is a foil for the turquoise Peking glass vase, amplifying the oceanside palette. OPPOSITE: Ico Parisi's 1950s dining chairs insert triangles into the room's geometry. Glass vessels by Fabio Maria Micucci command the corner. Artwork by Jim Hodges slips in a gleaming note beneath the small side windows.

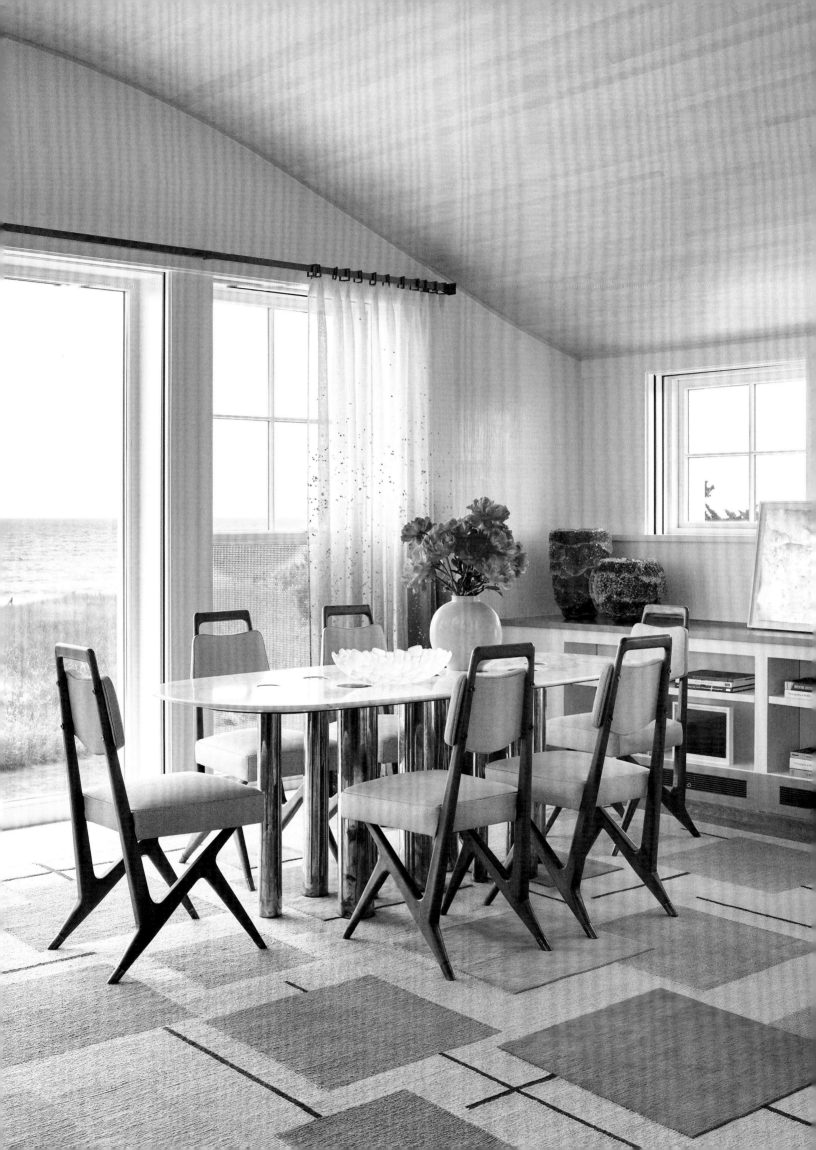

for each of the bedrooms to ensure all the guests feel equally cared for. The challenge here was to make sure that each room feels comparable in terms of closets and bed size, and to ensure that when the room doesn't face the ocean, it incorporates a feature that makes it special and distinctive. It was exciting working with plaster artists who gave us so many new options to make each room more interesting in its own way. The hand-plastered walls that add depth and richness incorporate everything from aggregates with precious stones or abalone or mother of pearl to strié variations that almost resemble ridges of sand.

Each bedroom needed a place to sit, a king-size bed, ample lighting, space for a future crib, and its own gracious

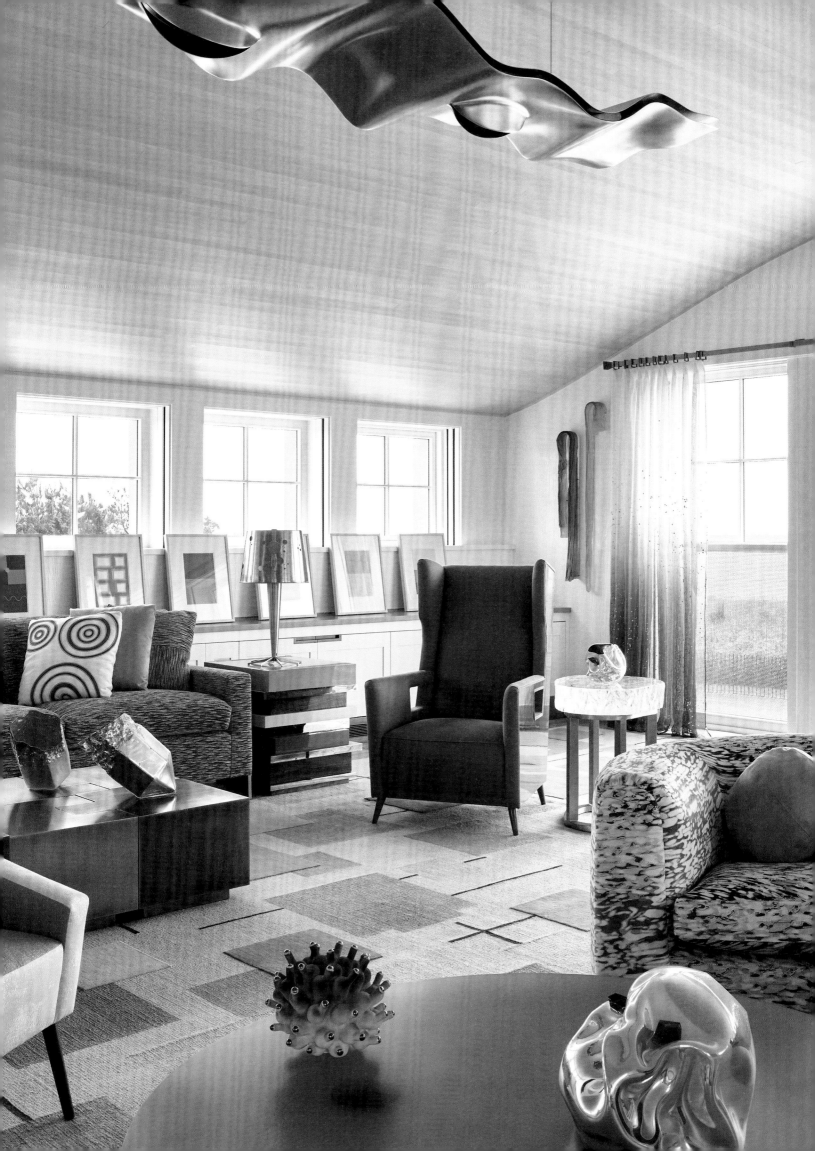

ART AND COLLECTIONS

Every home may begin as a blank canvas. But no home is finished until it's layered richly with meaning. The sofas, chairs, and tables are in some respects the easy part of decoration. But the art and collections? These items speak directly and profoundly of the individual sensibility of the owner, and how that eye develops overs time.

With art, the learning curve can be steep. But it can also be a thrilling ride, especially with an expert along for guidance. Fundamentally, though, we believe art in the home should connect to the heart and reflect a personal point of view. Pieces needn't be cutting edge, by the "it" artist of the moment, or august art with a capital "A." We love prints and photography, Asian art of all kinds, antiques, and so much more—all the infinite glories of human expression. If the highest standard of whatever period or genre happens to be beyond the present financial reach, there are endless possibilities out there at approachable levels. Upgrade later.

The deep dive of research is one of our passions, and a wellspring of inspiration. In years past, when our interiors focused heavily on antiques, we would attach sticky notes to photos of each piece we were recommending to a client that outlined its history and our reasoning on why it suited the particular purpose and setting. In those days, the collections we assembled with clients tended to the classic and so often centered on a profusion of decorative arts for the table. Now, all of us revel in the diversity of covetable objects and using a signature piece rather than a plethora. Now, less is more.

Do we group like with like? Do we elevate the mix? That's a favorite challenge, especially in a library, where numbers make a difference—and not just the number of books. Contrast, form, material, finish, scale, proportion—all come into compositional play to create appealing shelves. Spectacular things come in small packages and large. Arranged just right, they're the enchantment that holds our eye and transforms our experience.

OPPOSITE: The aim of every decorative choice should be to achieve cohesiveness. The kitchen's unfinished wood planks carry the entry ceiling's materials up to the second floor, but their vertical orientation is in sharp contrast to the front entry's horizontal boarding. The painting is by Serge Alain Nitegeka. The ceiling fixture is by Jiun Ho.

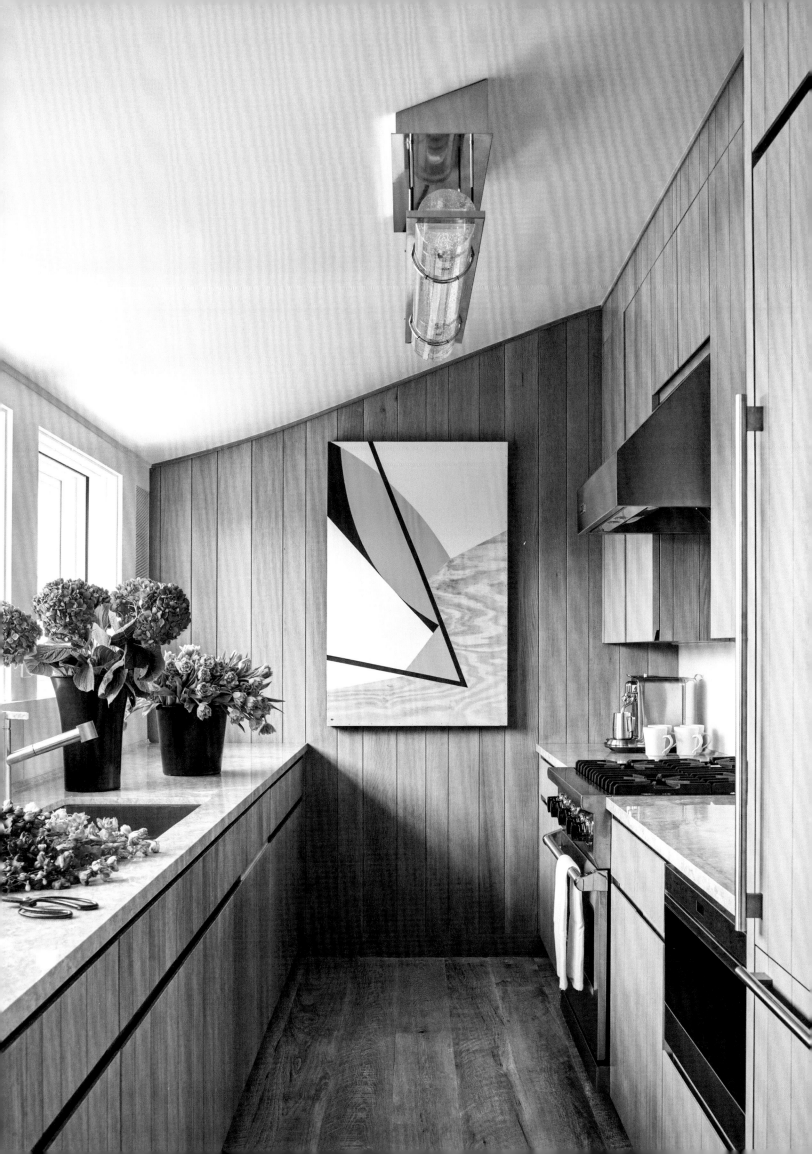

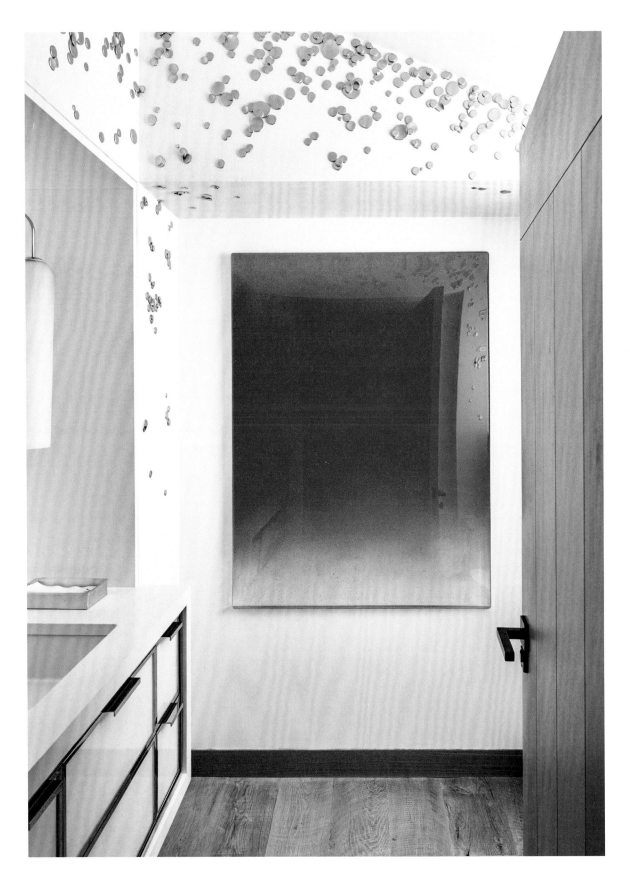

ABOVE: The brightly conceived powder room incorporates Mika Tajima's colorful painting and references the beachside location in the handmade, hand-placed ceramic paillettes, appropriately called *Ebb and Flow*, that move in a tidal pattern across the wall and ceiling planes. OPPOSITE: In the entry gallery, the story of angles meeting curves rises to another level thanks to art. A color block painting by Stanley Whitney commands the wall on the left while a light sculpture by Spencer Finch animates the wall on the right. A spiral chandelier creates an eddy over the stairwell.

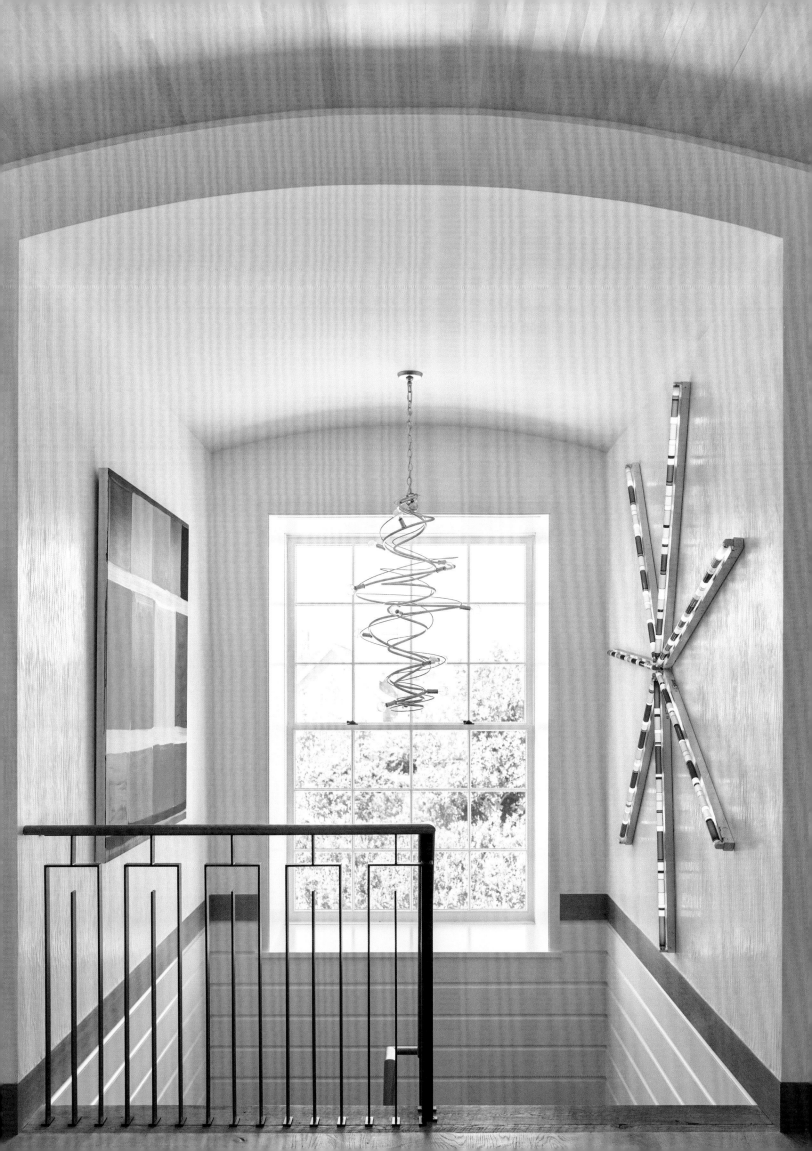

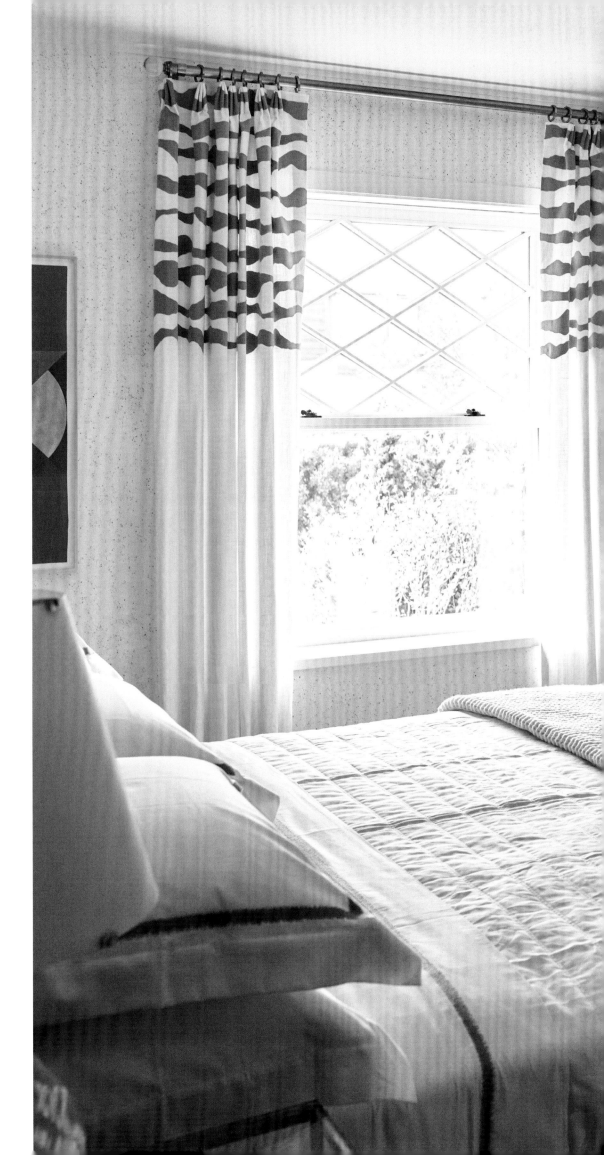

RIGHT: This guest bedroom elaborates on the house's recipe of natural wood and subtly enhanced walls; here, pieces of shell are set directly into the plaster. The adjustable arms of the vintage light fixture overhead allow for reconfiguring. The custom ornament on the curtain panels speaks to the ocean beyond. The artwork is by Claudia Wieser.

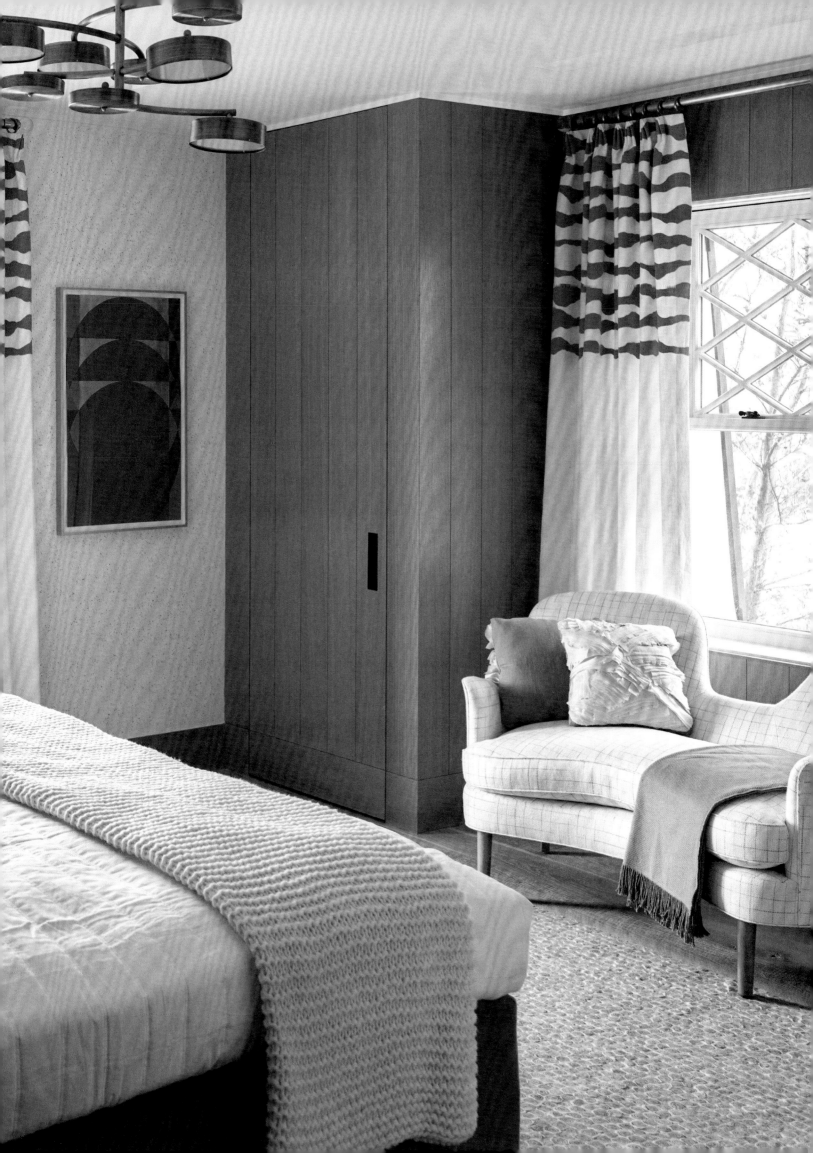

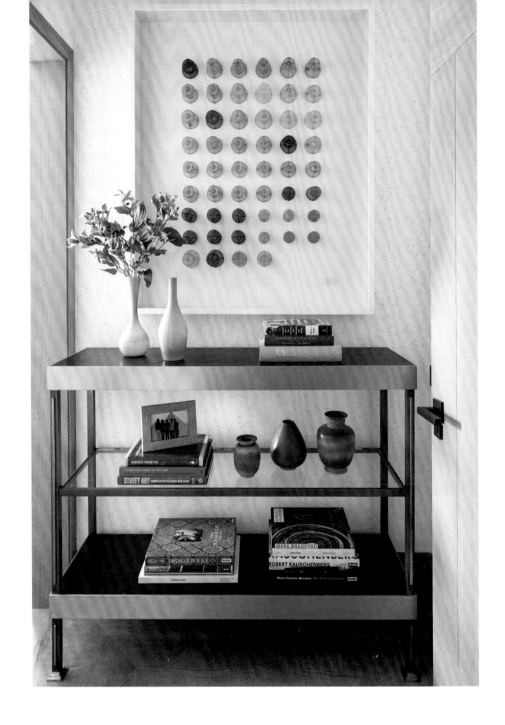

bathroom—so important as the next generation here were getting married and on the verge of starting their own families. We found vintage pieces, including Italian 1960s chairs that we re-covered, to balance the mix of new and old. It made sense to use sheers at the windows because of the magical way they filter light. But each set of panels received its own decorative treatment—pieces of shells, patterns in silicon, appliqués—to set it apart.

Style is one thing. Couture is another. And that's really the story of this beach house. Each detail on its own is artistic. Together, the small touches become more than the sum of their parts.

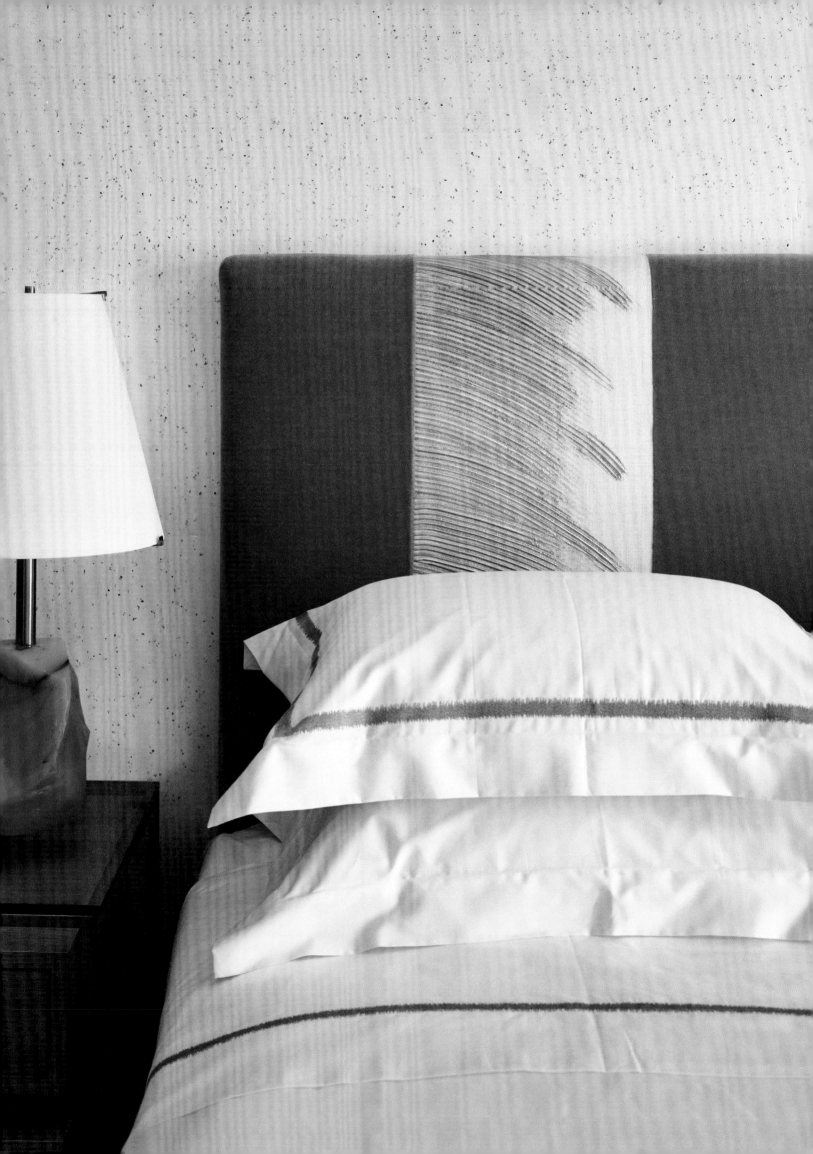

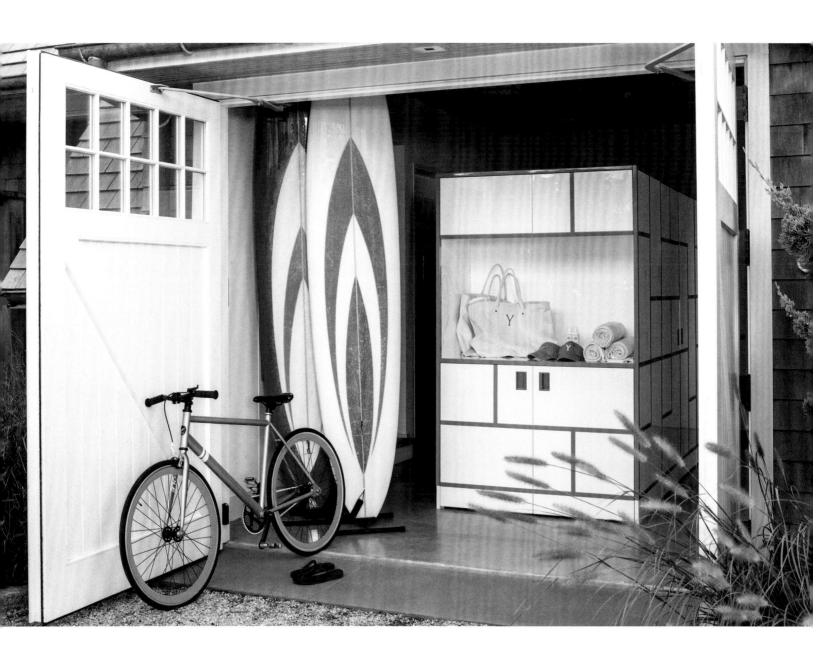

ABOVE: Even the garage is a space for decorative articulation and fun, with a bicycle and surfboards custom-colored for the house. Custom tote bags and hats in the same shades of orange and blue complete the accessory scheme. OPPOSITE: This family wanted art to be visible from every vantage point. Working with landscape architect Ed Hollander, the team found a home outdoors for this signature flower sculpture by Yayoi Kusama.

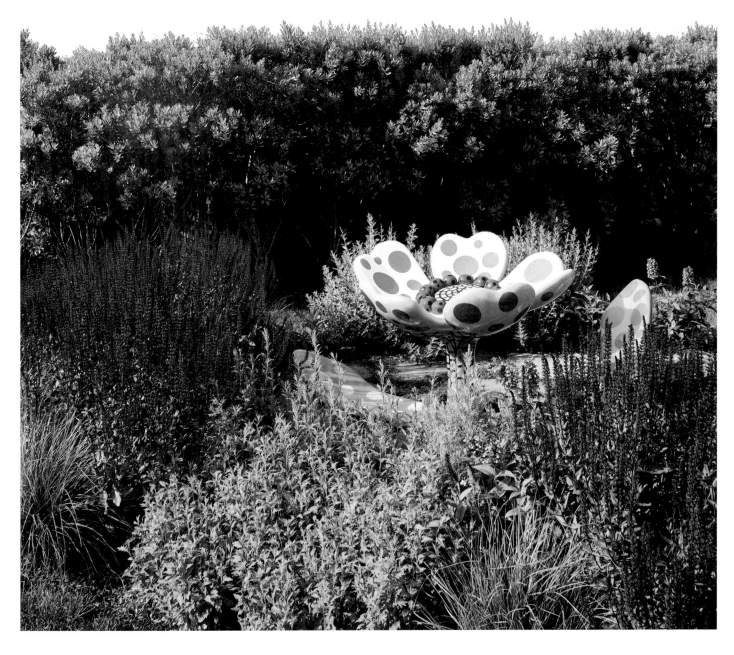

A REVERENCE
FOR CRAFT

Each collaboration teaches us a new way to listen, look, and learn. This enduring truth of the creative process resonated deeply with us for these clients and this house. This couple, detail oriented in the extreme, wanted as a matter of course not just to know, but to grasp in full not only the thought behind each decision, but also the rich microcosm of nuances behind every detail. The drive to understand our design process at such an analytical level was inspirational. Because the husband grew up in Norway and the wife shares his passion for nature and craft, northern European traditions flowed organically into the matrix through which we examined all our decorating decisions. This aesthetic—and a wonderful art collection—propelled us to the peak of refinement in the rustic vernacular. This direction felt organic because of the spectacular site, proper for the style of dynamic house that architect David Scott Parker created, and suited to their lifestyle.

The request was for cozy, embracing decoration that didn't compete with the stunning views. They were deeply interested in finding unique elements or having pieces custom made, not to be fancy—the couple shies away from the flashy or ostentatious—but because they care passionately about craftsmanship and the revealing touch of a distinctive artisan's hand. And so, as a result, every piece here, including antique and vintage items, carries a soulful story.

OPPOSITE: Earth tones, woven textures, and wood give the sunroom a classic porch-like feeling. The lava-topped table brings in a splash of the family's favorite red hue; it was so heavy it had to be pieced together in segments. The coffee table was fashioned from a wrought-iron architectural ornament. OVERLEAF: Flanking the passage to the living room, a pair of sculptural consoles by the distinguished bronze artisan Ingrid Donat house early twentieth-century Danish and Swedish pottery. The Orrefors lamps date to the 1950s. The living room's custom chandelier echoes the sweep of the branches beyond. Designing the rugs occasioned a deep dive into early twentieth-century Swedish textiles and carpets, then reinterpreting their vocabulary into the family's favorite color palette.

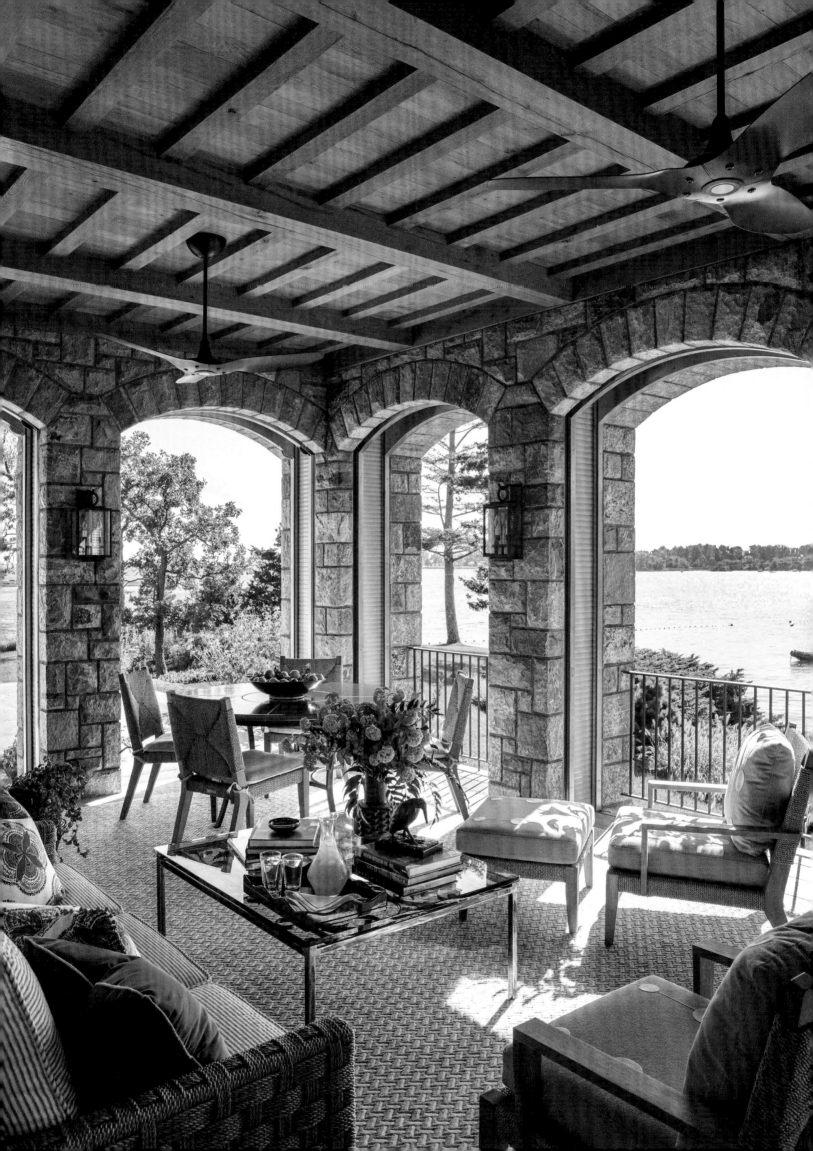

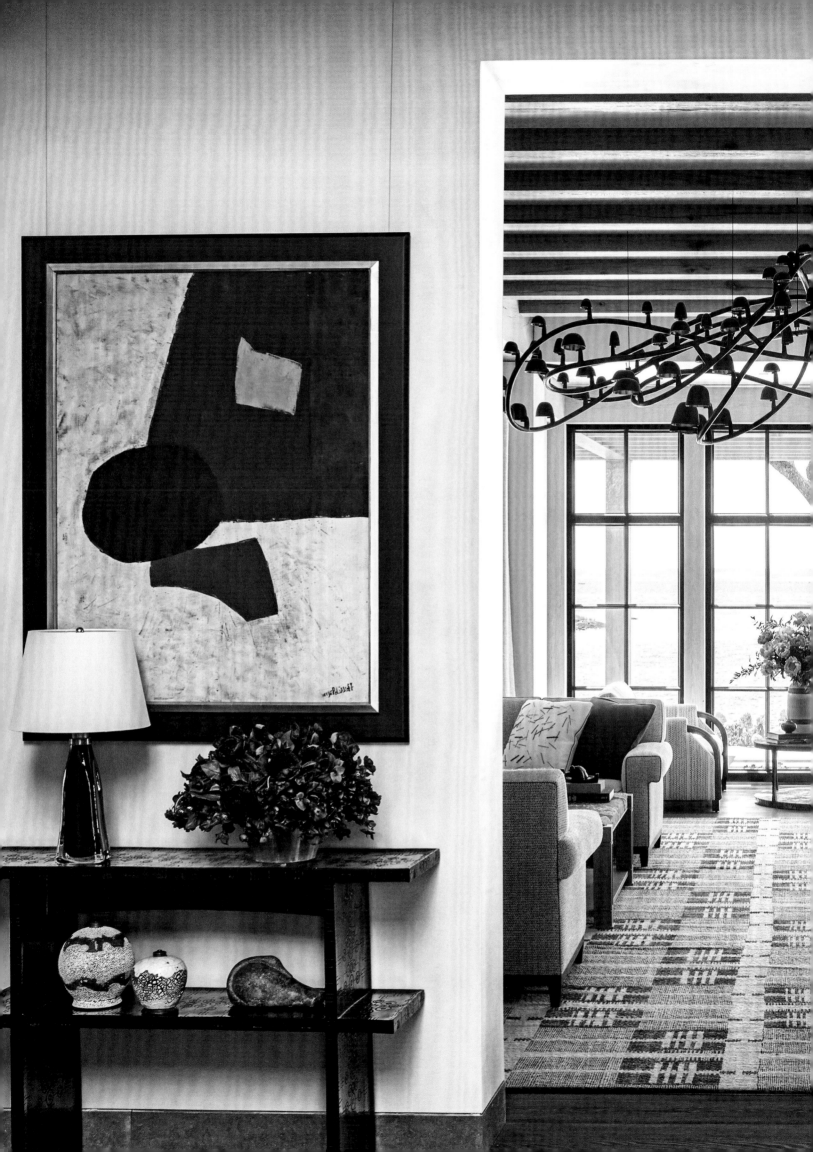

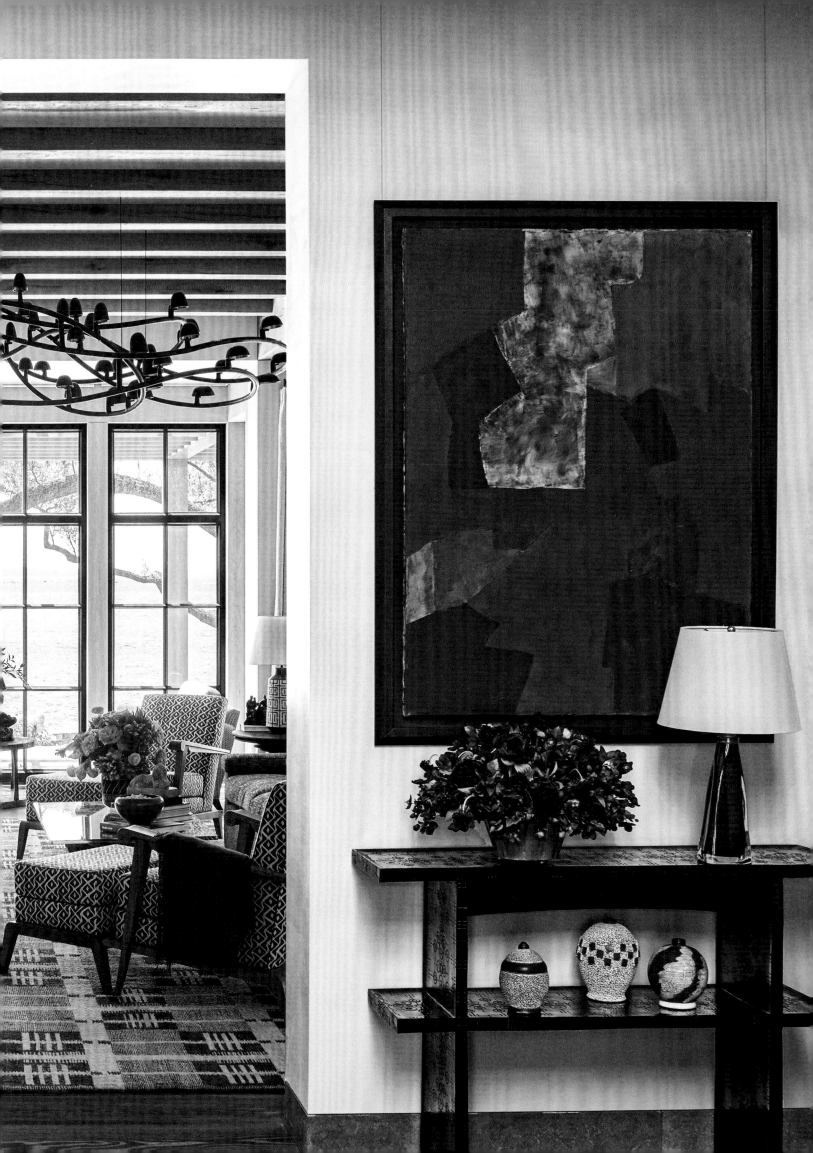

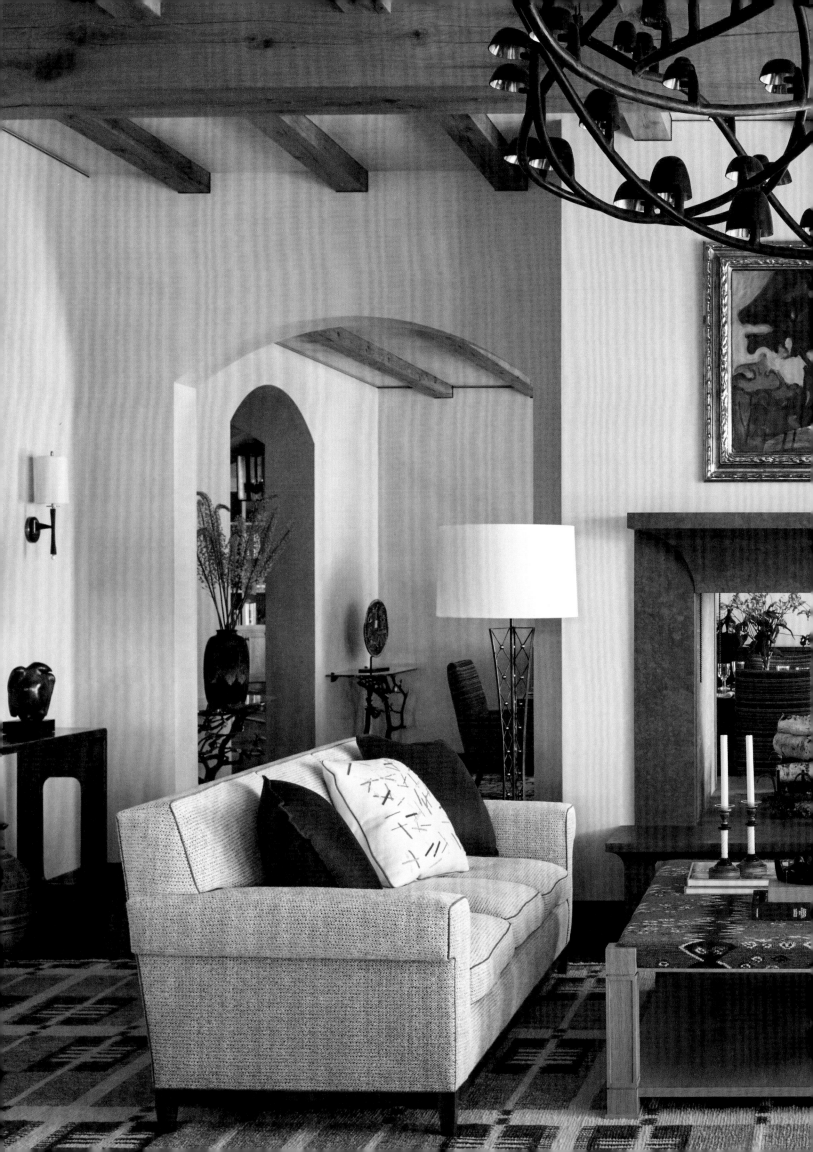

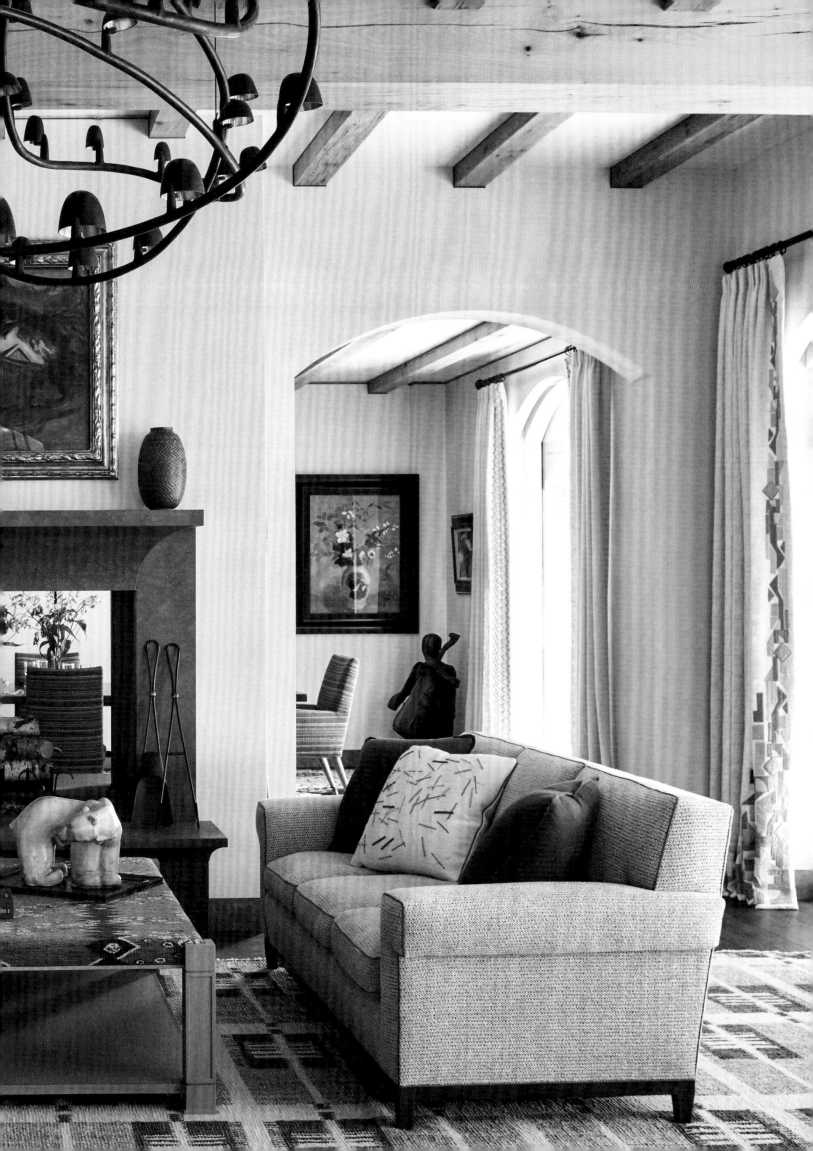

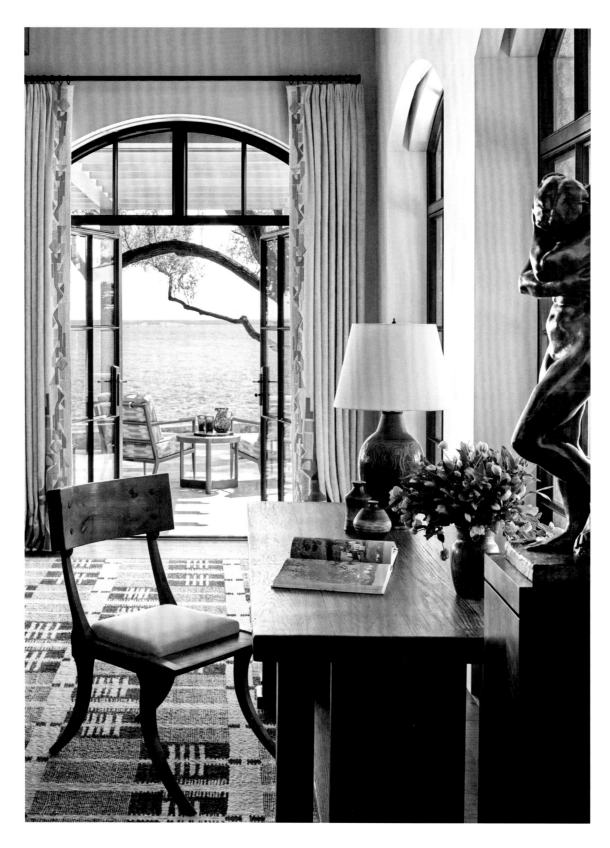

PREVIOUS PAGES: The artisanal touch abounds. The ottoman's design responds to the notion that comfort is always paramount; its fabric replicates an early twentieth-century Swedish textile. Hand-embroidered pillows feature a contemporary motif. Andirons by Jean Royère emulate the form of the double-sided fireplace. Animal imagery, like Michael Schilkin's stoneware polar bear, reoccurs throughout. ABOVE: A midcentury Danish klismos chair converses with a library table Frank Lloyd Wright designed for Unity Temple. OPPOSITE: Hand-loomed textiles by Tara Chapas dress the upholstered pieces. The coffee table is by Philip and Kelvin LaVerne.

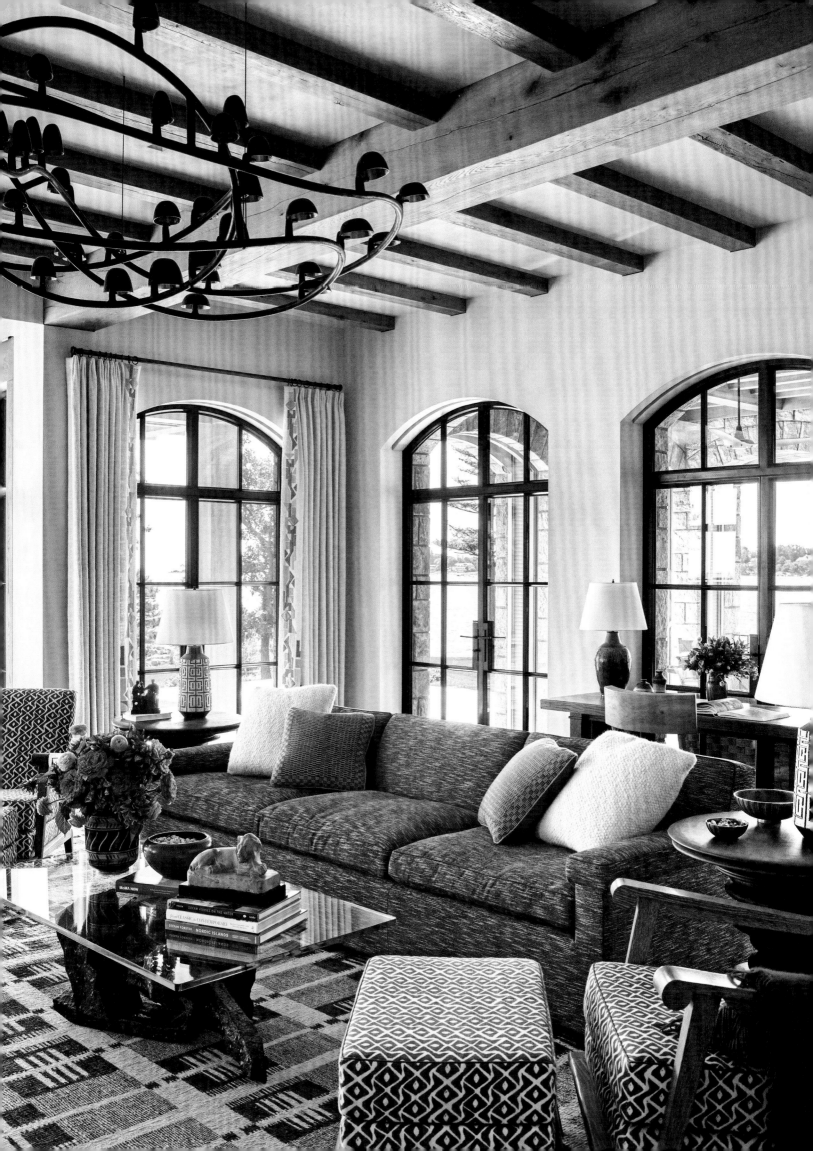

ABOVE, CLOCKWISE FROM TOP LEFT: This coffee table brings together the interior's bronze and wood motifs. Oscar Nilsson's geometric commode dates to the 1940s. This hand-crafted "stepping-stone" table is a smorgasbord of American wood species, including black walnut, ash, cherry, and white oak. Hand-stitched in Mumbai, the curtains' cubist embroidery uses raffia in many colors and textures. OPPOSITE: The Rodin sculpture reinforces the bronze elements throughout.

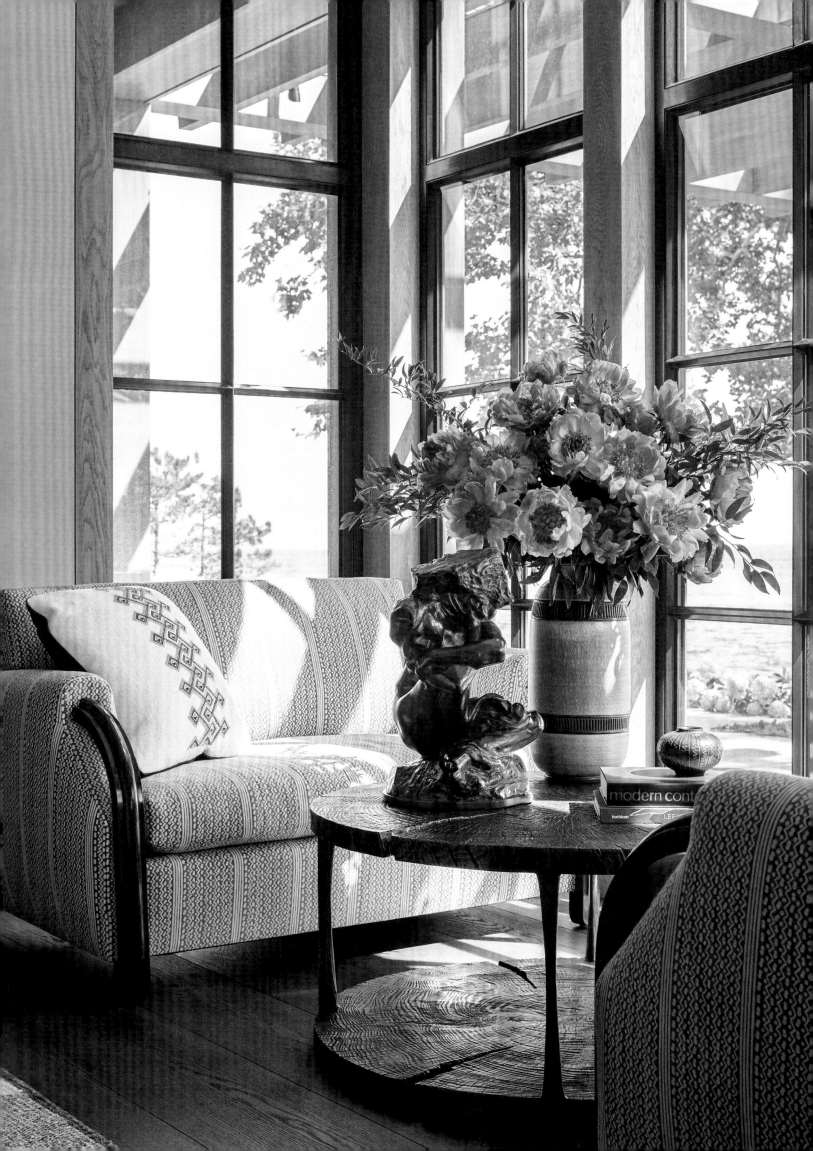

The sunroom, which opens off the living room, quite literally melds into the landscape thanks to expansive high-tech glass panels that can rise and descend at the press of a button. White walls, the universal donor for displaying art, were not for this couple who prefer environments shaped through texture and materials of earthy richness. They also favor a very specific, rich, warm palette of nature's hues, heightened by occasional contrasting notes of blue.

The living room's generous dimensions tested our creative mettle. One major challenge was finding an artisan who could create an overhead light fixture that would suit the scale of the surroundings, have sculptural interest, yet still hug the ceiling closely enough not to interrupt the breathtaking vista on entry. We wanted it to be centered in the beams to serve the room's two seating areas equally, which involved careful determinations for length and breadth. It took a while to find the right craftsperson, but the result—a functional work of art that speaks idiomatically to its surroundings inside and out—was more than worth the wait.

Our starting point in each project is typically the living room rug. Here, creating the design involved a deep dive into twentieth-century Swedish textile history. This carpet became the lynchpin for the rest of the many rugs in the house, all but one of which are Scandinavian-inspired.

These clients have a passion for detailing, but not in the more usual language of beading, paillettes, glitter, gold, or brass. This led us to develop an entire vocabulary in their aesthetic dialect: curtain embroidery in natural raffia that resembled cubist filleting, Swedish pottery of all shapes and sizes with a handful of French pieces besides,

OPPOSITE: This chair fabric is hand-woven in leather, wool, and the lightest touch of Lurex—perfect for just a glint of shine. The custom sideboard incorporates multicolored acid-etched bronze panels by the London firm Based Upon. Glass artist Alison Berger created the light fixtures on pulleys. The custom carpet reinterprets a classic Swedish pattern. OVERLEAF: In the firm's first red kitchen, black granite accents provide a chic counterpoint and keep the palette natural.

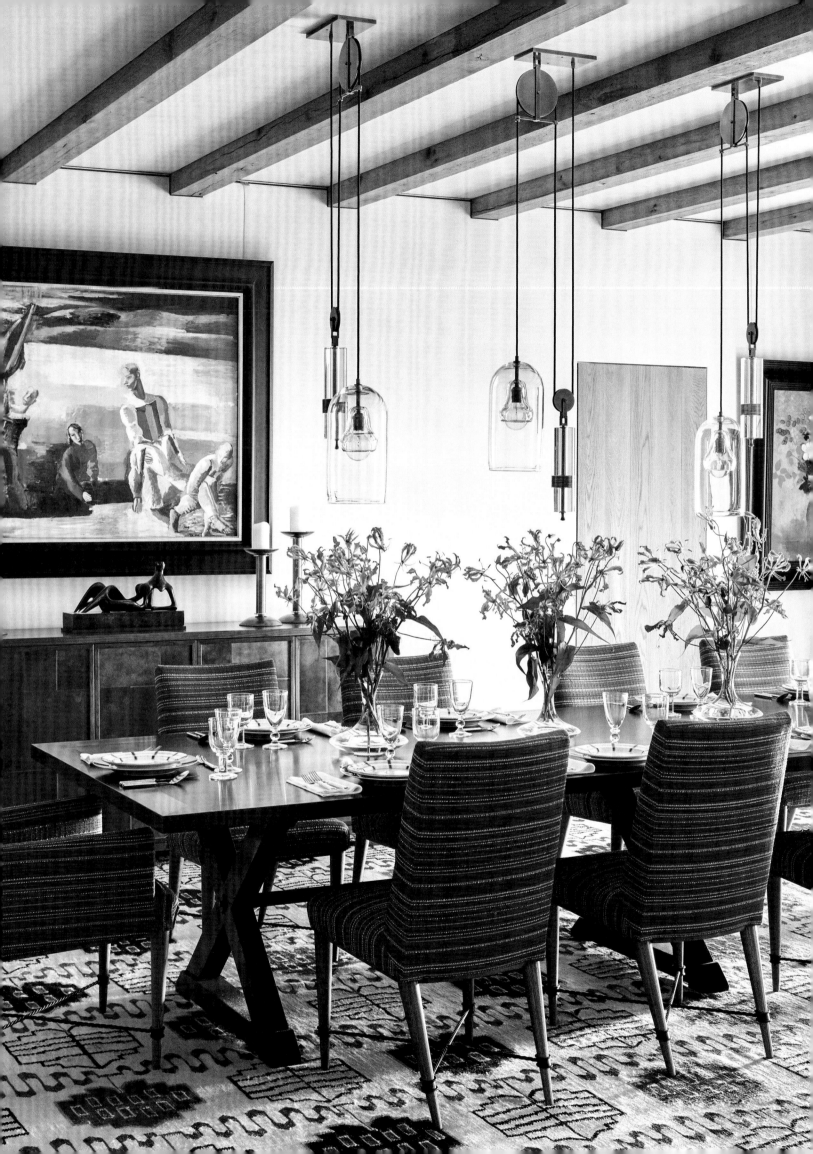

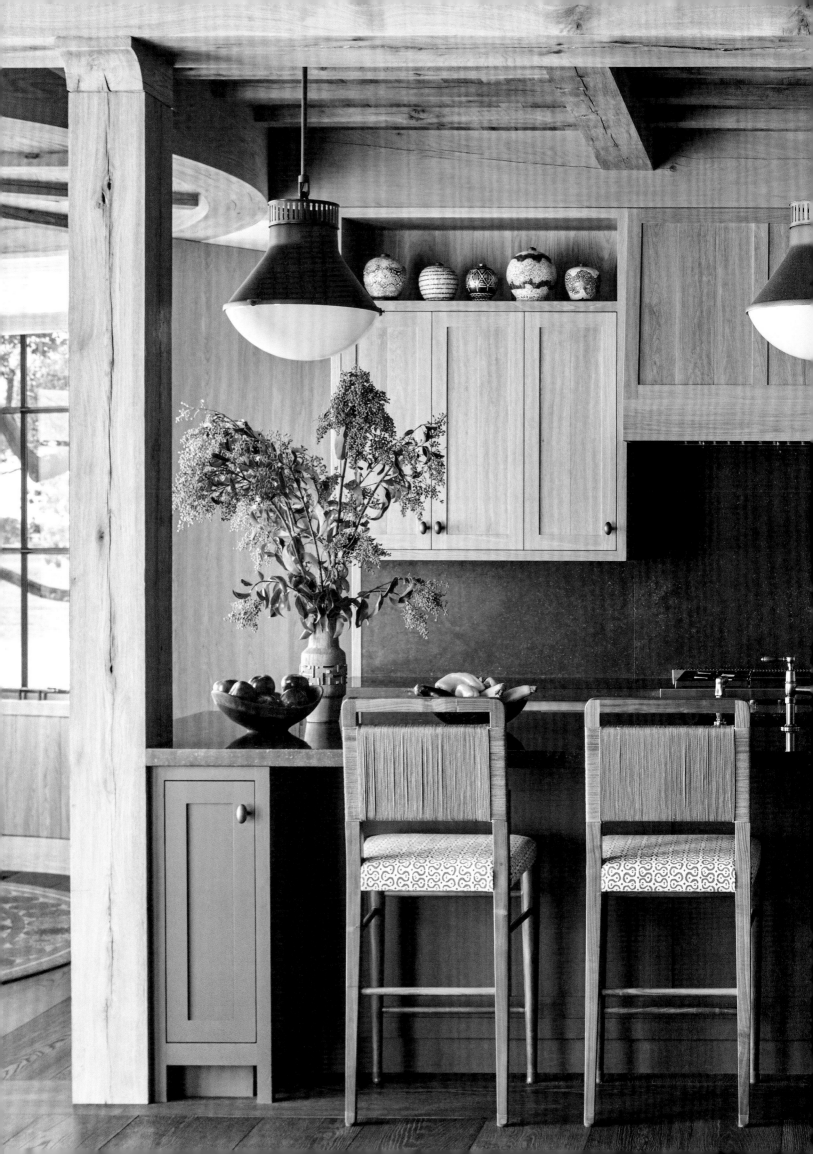

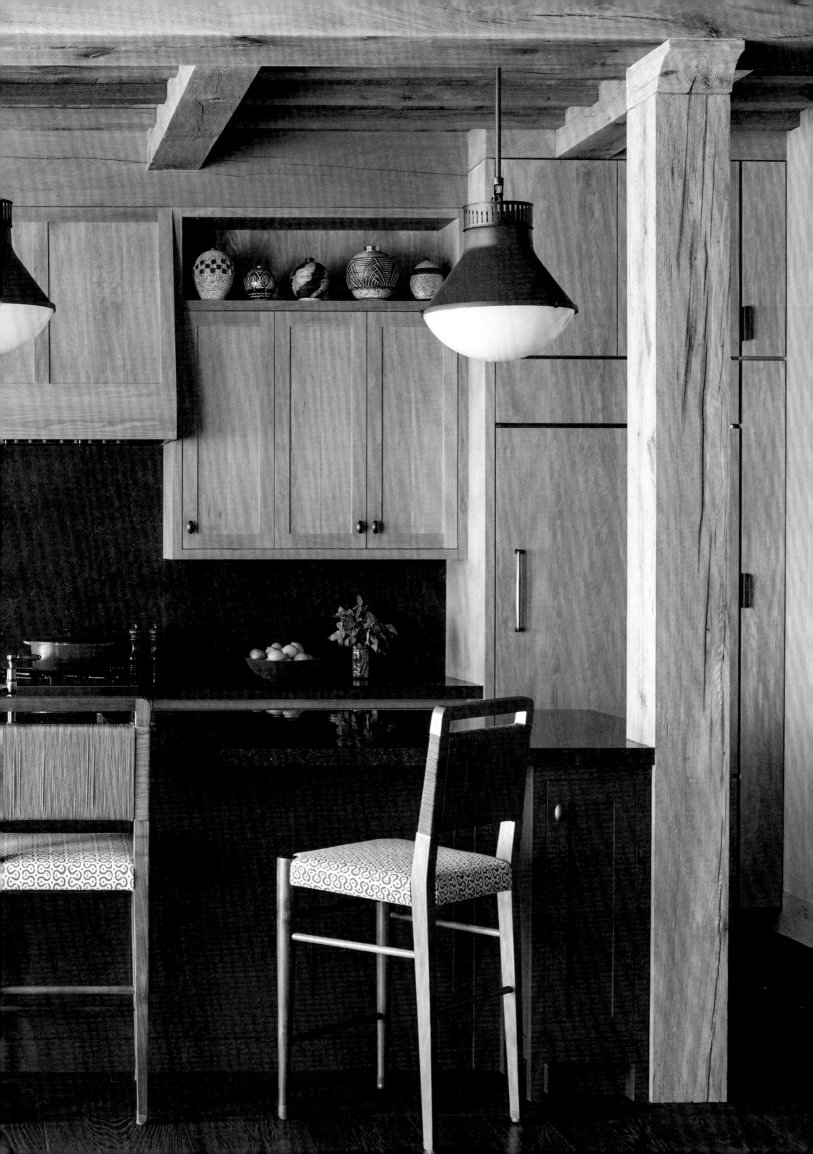

ABOVE, AND OPPOSITE: There's nothing more durable than a hand-tufted rug for houses with dogs; this is one of the interior's few floorcoverings not inspired by the Swedish rug tradition. OVERLEAF: The kitchen and breakfast room flow into the family room, where another Swedish-inspired rug in the family's beloved palette fills the space.

bronze animal sculptures, and other works of naïve art. The bronze table in the window bay, which the artist cast against an actual tree trunk to capture the grain and bark, is just one of many commissions. The skipping-stone end table fabricated from seven different woods is another. Bringing patina to the space are a pair of eighteenth-century Chinese consoles flanked by a rare set of Swedish Grace side chairs. A Frank Lloyd Wright library table adds yet another distinguished note to the space.

The dining room extends the interior's blend of traditional, modernist, and contemporary. The Swedish rug commissioned for the floor grounds the room in a strong foundation of pattern and color. The handblown glass

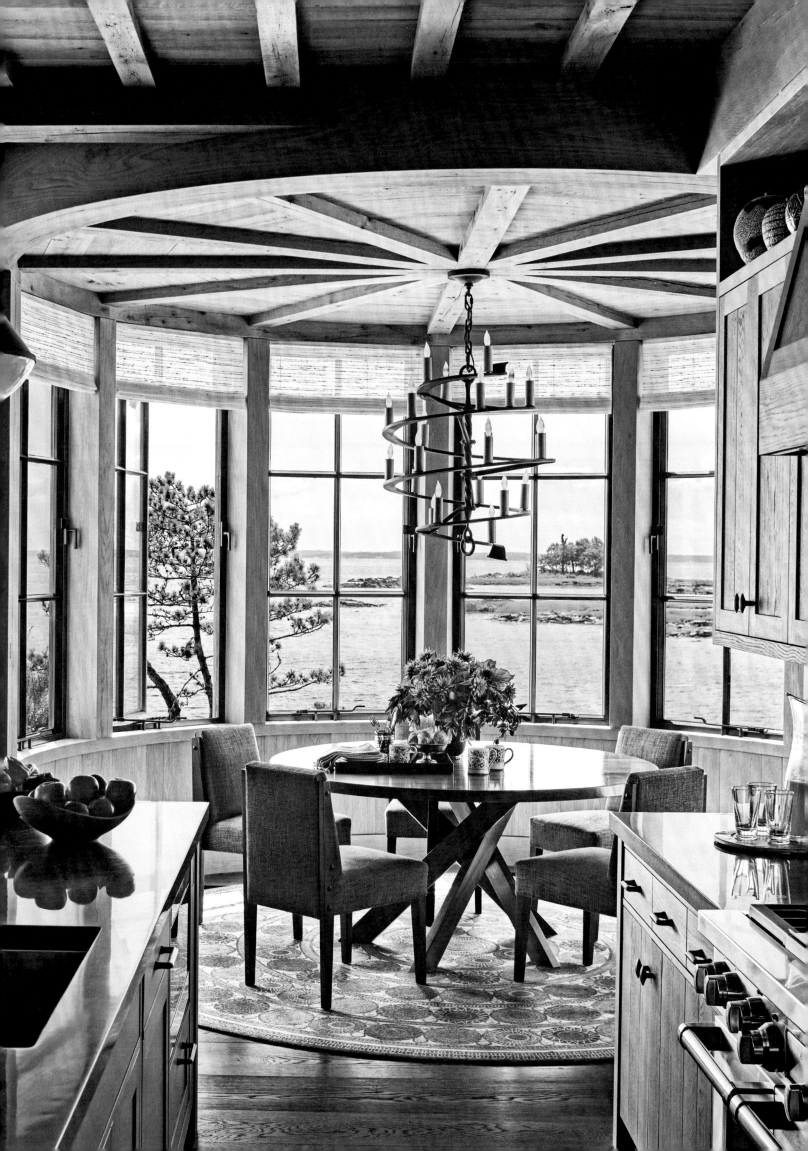

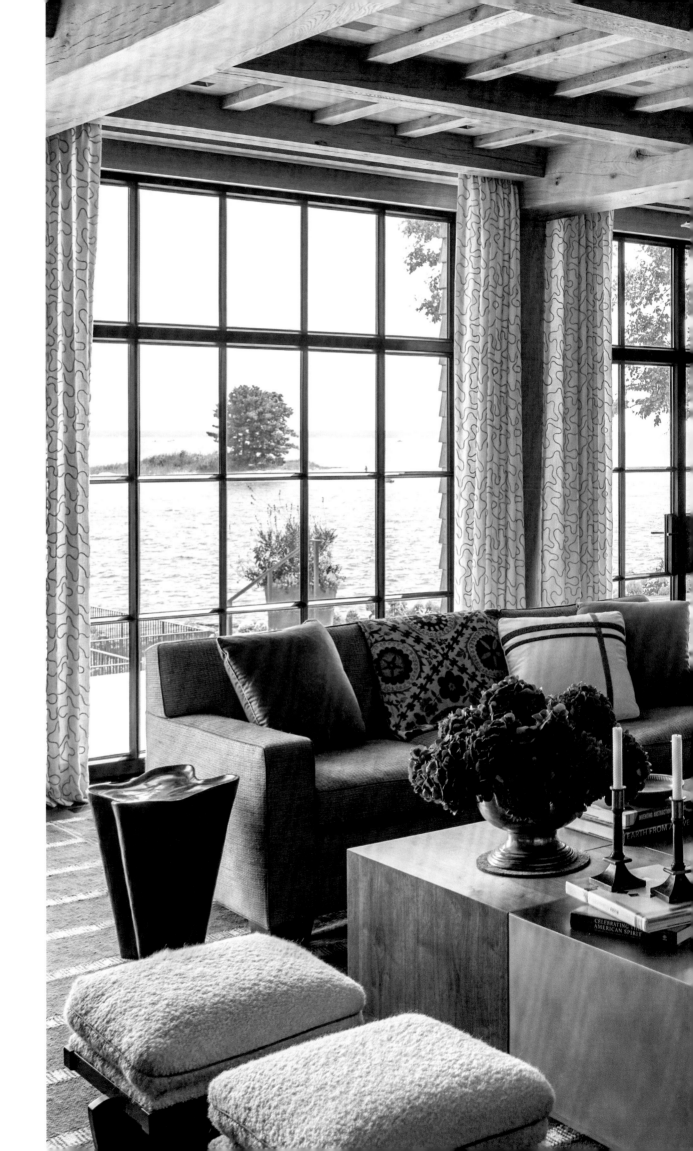

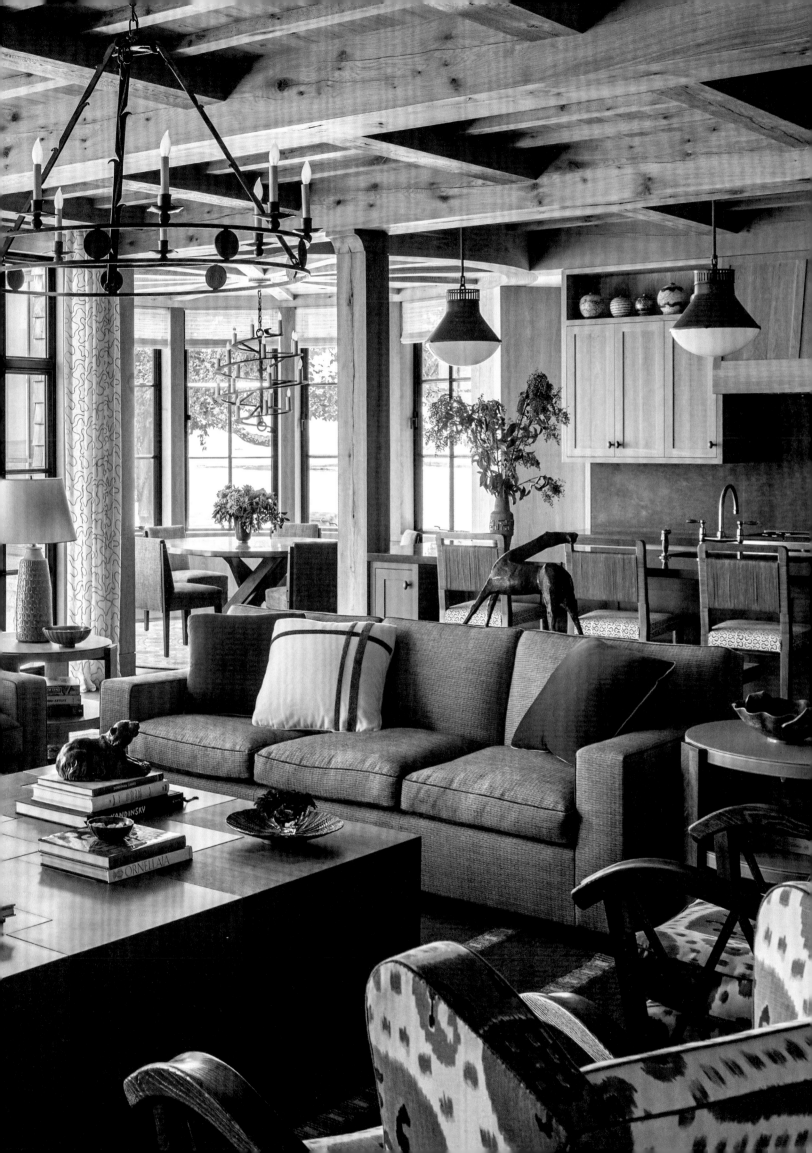

CARPETS AND FABRICS

Design is all about affinities. We've always used our initial "love/hate" meetings to unearth the broad strokes of individual preference. Along the way, we've discovered that some people respond immediately to carpets while others leap to fabrics first.

Years ago, antique oriental carpets were our sine qua non. No longer. Antique and vintage carpets will never stop resonating with us—not least because they offer instant space-filling gratification—but with rug production going gangbusters in China, Nepal, Guatemala, Romania, and elsewhere around the world, why leave any option off the table? Handmade rugs created by experienced artisans here in the United States further expand today's possibilities. And custom designs provide yet another way to go. It's exciting to draw and redraw patterns by hand, play with them on the computer, then work closely with the fabricator on the minutia of fibers and colors until the vision gains clarity (when necessary, planning for toddlers, naughty pets, or the occasional clumsy relative). Three months pass at a minimum before the first sample arrives, and then comes the fine tuning—or a complete revision.

As we determine which is the client's "zip code," as it were—antique, vintage, reproduction, contemporary, custom colored, or custom designed from scratch—we're also thinking about the adjacent rooms. If a handwoven silk rug from Tibet glows in one space, the next room will probably call for a foundation of pattern for contrast.

The universe of fabrics truly is endless. There's the cosmos of existing print patterns, both new and iconic designs, as well as classics reimagined in a contemporary palette. We also have our own arsenal of fabric printers and weavers who work magic in palettes tight or expansive, with any kind or combination of fibers. Always, the room's function filters the choices first. Fabrics for a bedroom, for example, should be restful to the eye and sensual to the touch.

Our taste is always for variety, with restraint. We're not ones to cocoon an entire room's soft surfaces in the same chintz or toile de Jouy. Even with the classics, we may use the pattern only on the headboard, chair, or curtain. The point is visual excitement, and to see everything in a new way—as a very fresh mix.

OPPOSITE: Nubby handwoven carpet and loopy bouclé fabric create a special textural dialogue. In their lovingly architected structure and joinery details, wood stools by George Nakashima reflect the epitome of artisanship and the natural aesthetic the entire project aims to reflect.

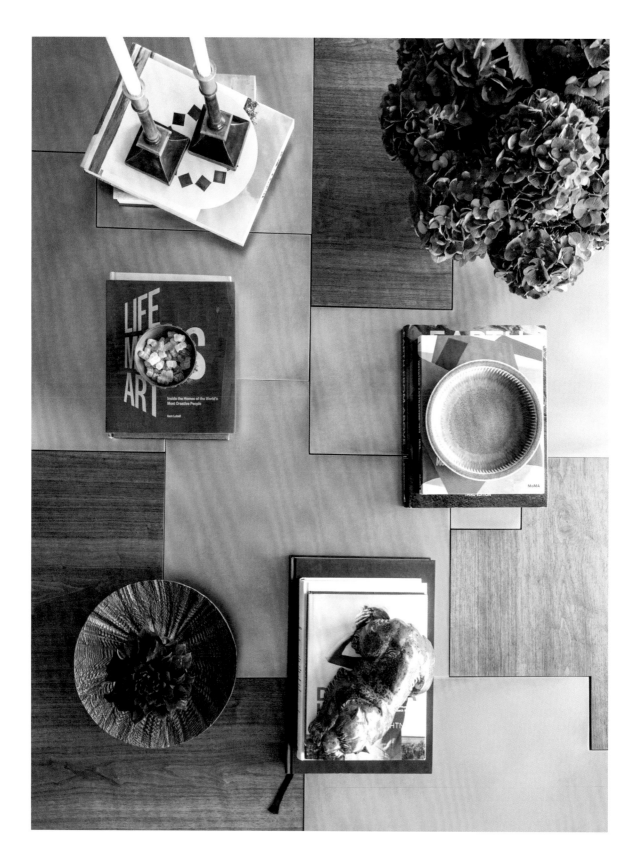

ABOVE: The brass and walnut sections of Gulla Jónsdóttir's puzzle table can be separated at will, enhancing its form and function. OPPOSITE: Mantels at least seven inches deep make for viable display surfaces. The painting is by Gerhard Richter. OVERLEAF: With a 1932 console table by Axel Einar Hjorth, midcentury Italian club chairs, and custom end tables, the furnishings span continents and eras; a simplified palette and devotion to natural materials keep harmony throughout.

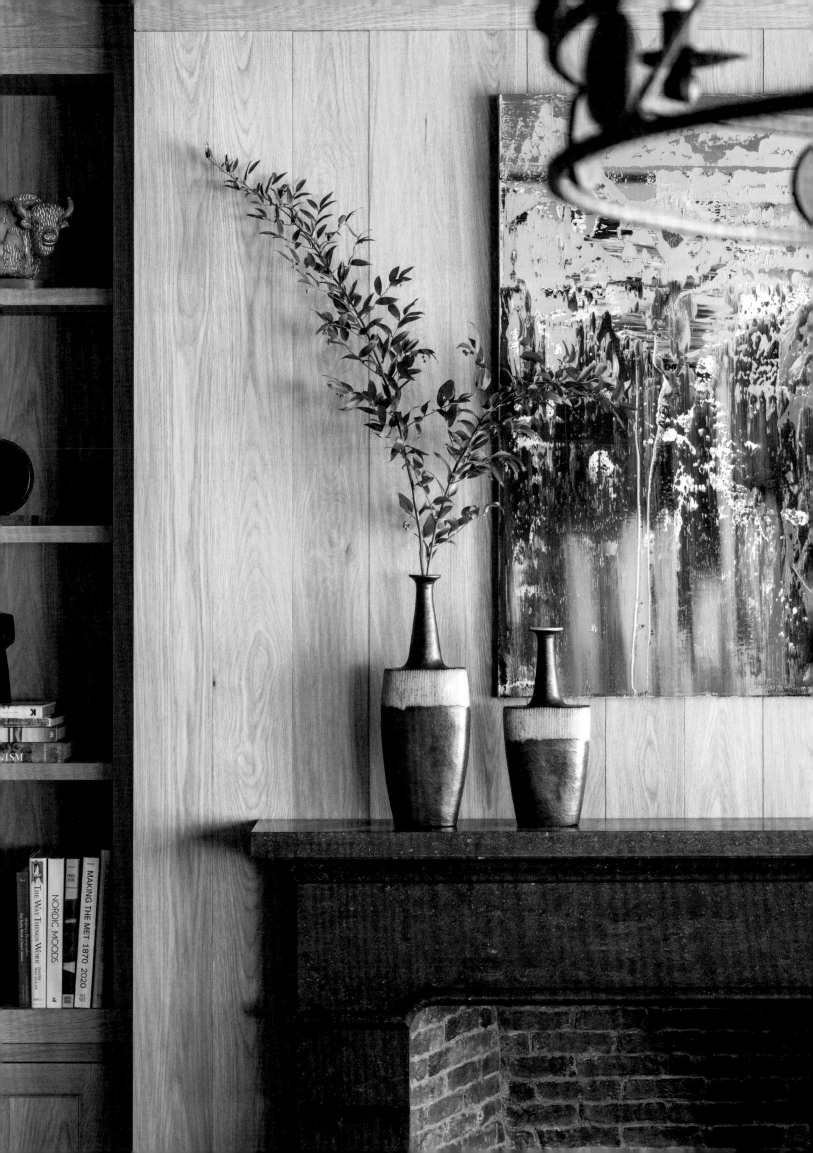

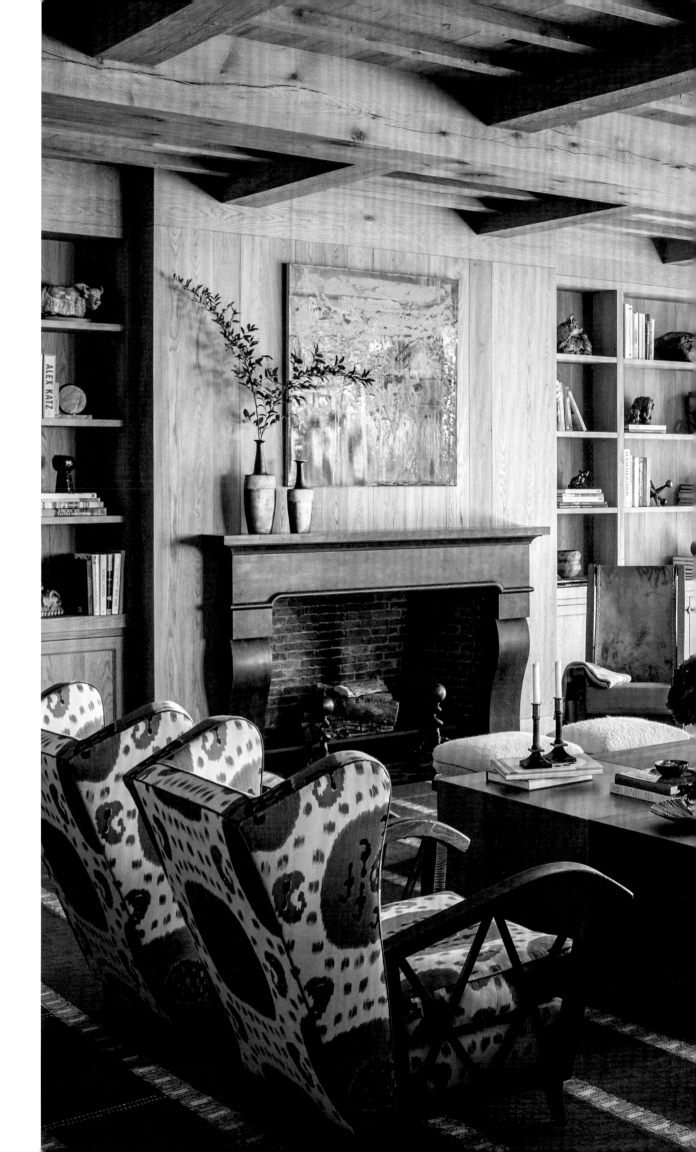

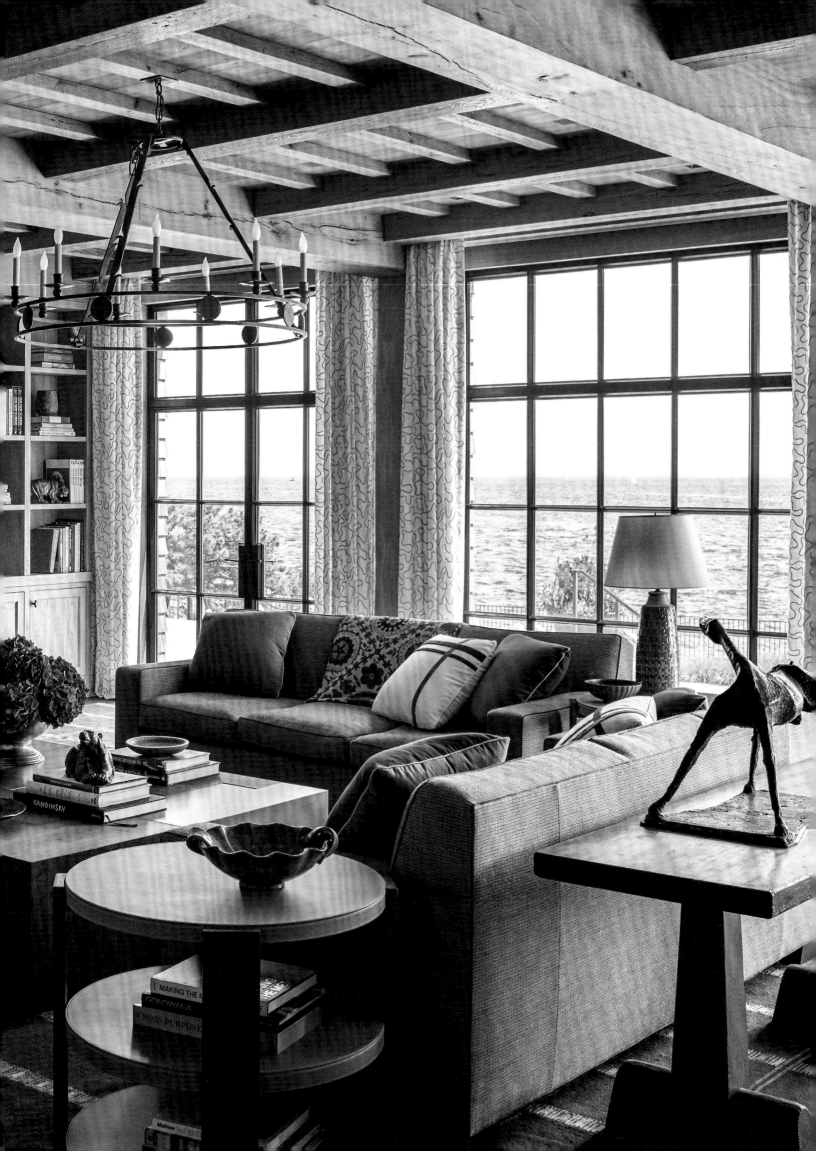

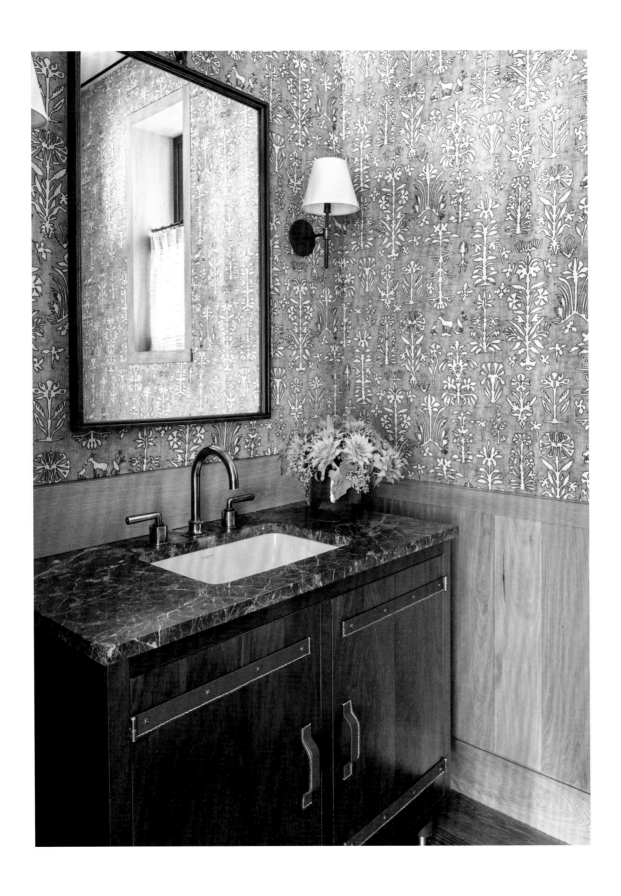

ABOVE: Our design for the powder room vanity pays homage to Jacques Adnet. Its red details climb the walls in stitching that outlines the printed linen. OPPOSITE: Instead of the more usual green, this family opted for red in their mudroom. The vintage hand-carved weather vane looks just like their golden retriever. The chairs are a 1954 design by Franco Albini.

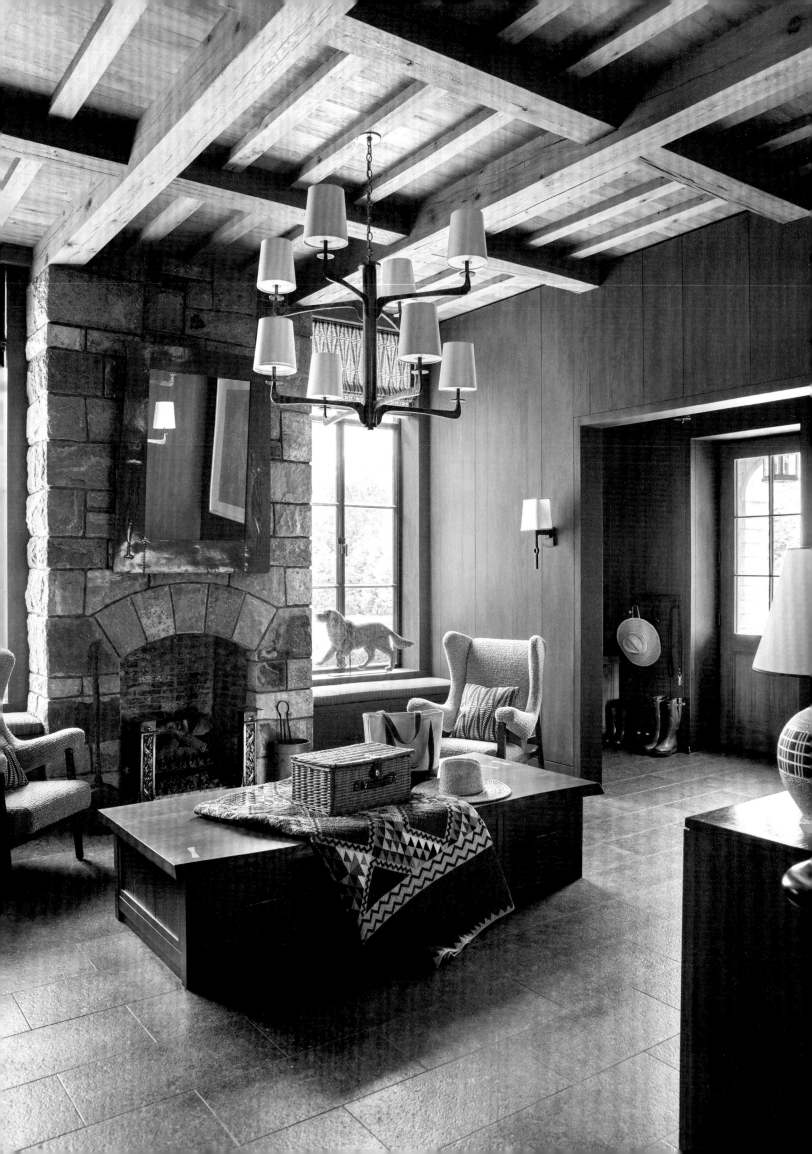

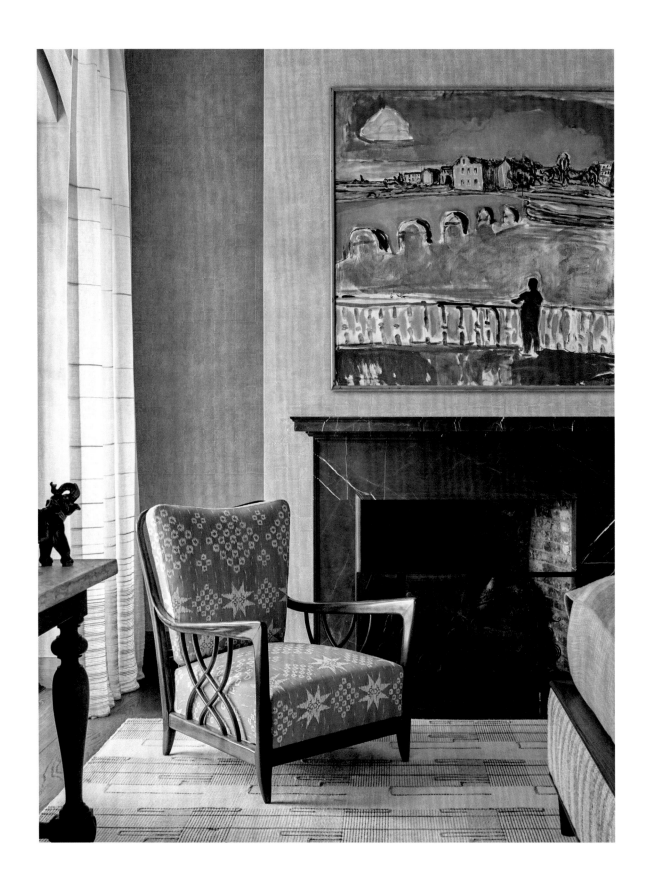

ABOVE, AND OPPOSITE: Blue and green veining in the marble top of the Swedish nineteenth-century table inspired this guest room's entire color palette; it was the first piece purchased for the project. Incised and stenciled plaster adds subtle texture to the walls. The mid-twentieth-century chairs, reupholstered in a folk-inspired snowflake pattern, are by Paolo Buffa; the ceiling fixture is from the same era.

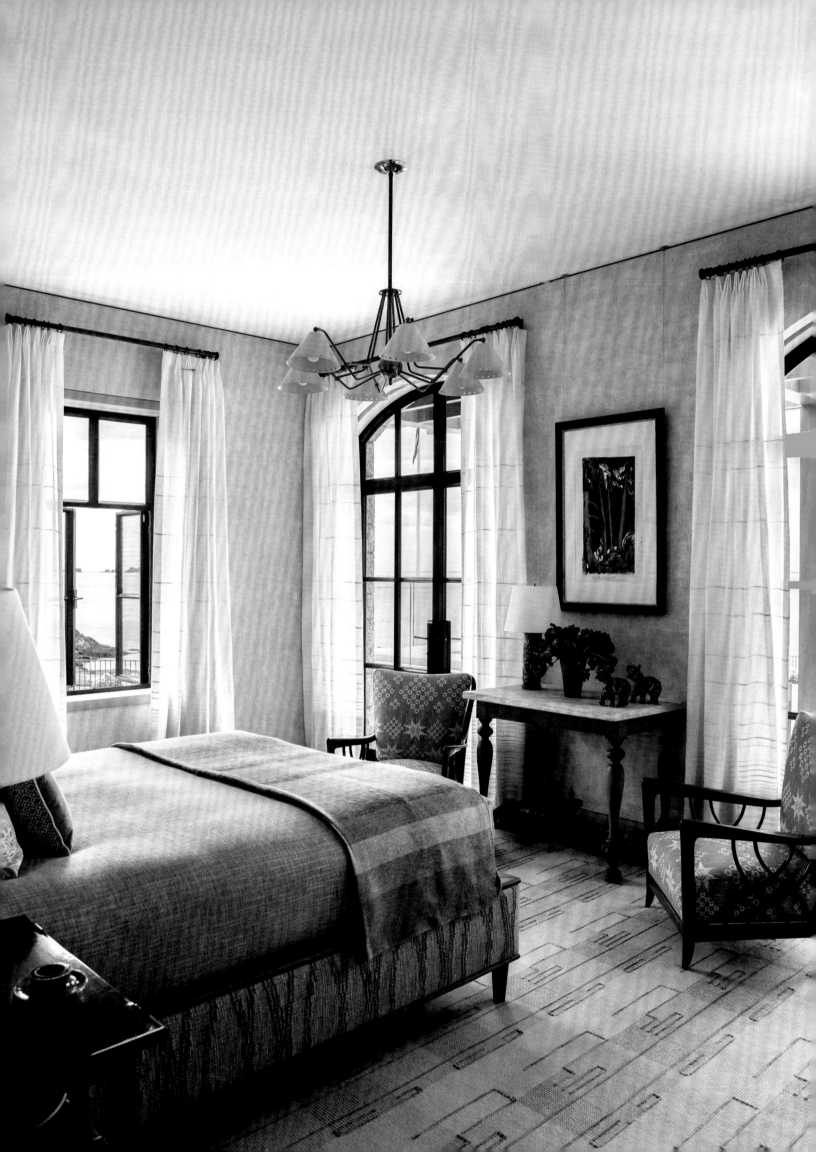

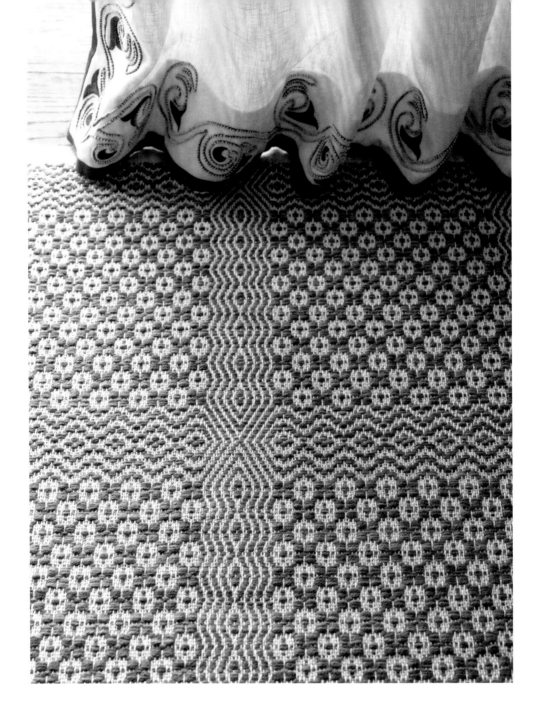

ABOVE: A nineteenth-century American coverlet inspired the pattern of the primary bedroom's rug. The curtain embroidery was appliquéd and hand stitched in Mumbai. OPPOSITE: Walls upholstered from floor to ceiling in soft fabric woven by Sylvie Johnson in Paris give this space its luscious feel. A cashmere-and-silk bed throw adds a pop of color into the neutral environment.

lantern lights on pulleys, centered artfully over the large table and anchored between the ceiling beams, infuse interest into the space, quietly.

Red is the wife's favorite color—and a warming hue for the kitchen and the mudroom beyond. We decided early on that a red island would create a needed visual pause to help break up the surrounding envelope of oak paneling. To make the barstools more distinctive, we had their backs wrapped in leather cording and covered the seats in a custom-printed fabric.

The round breakfast room centers on a commissioned table inspired by a Pierre Chapo cubist design. We custom colored the rug to harmonize with the bold, traditional,

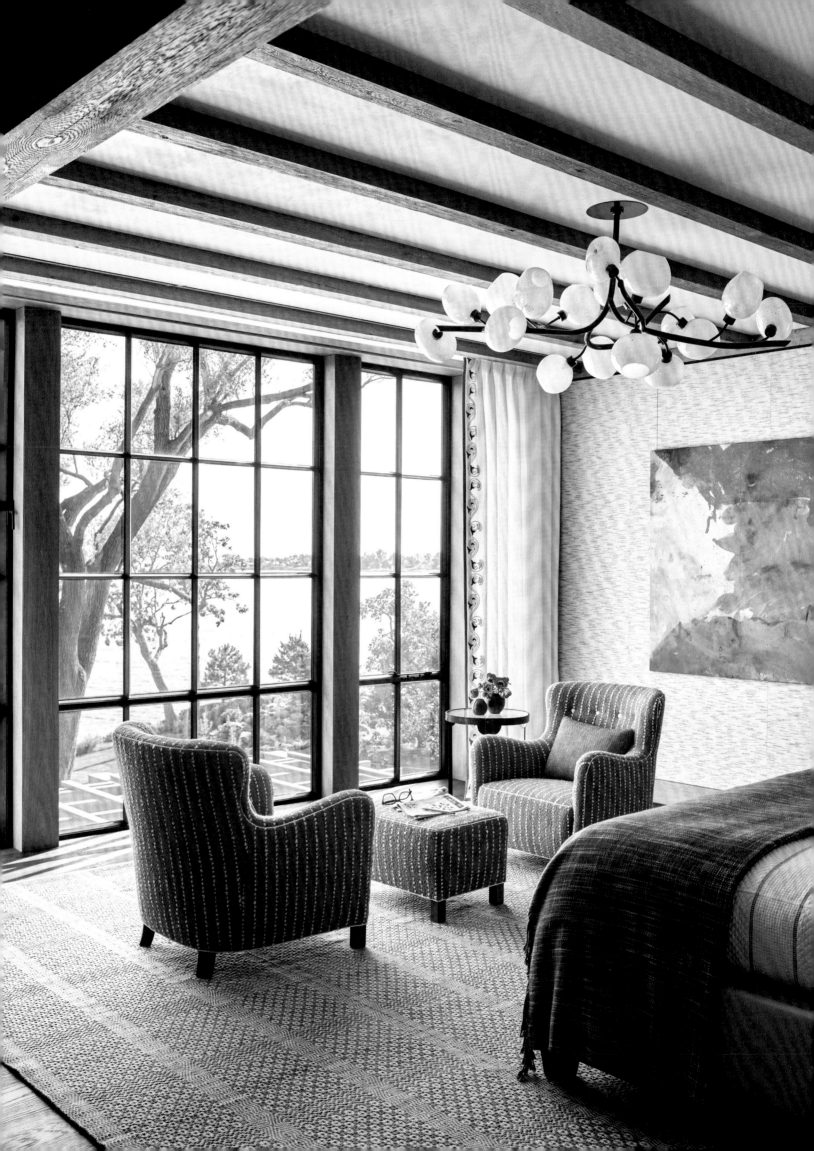

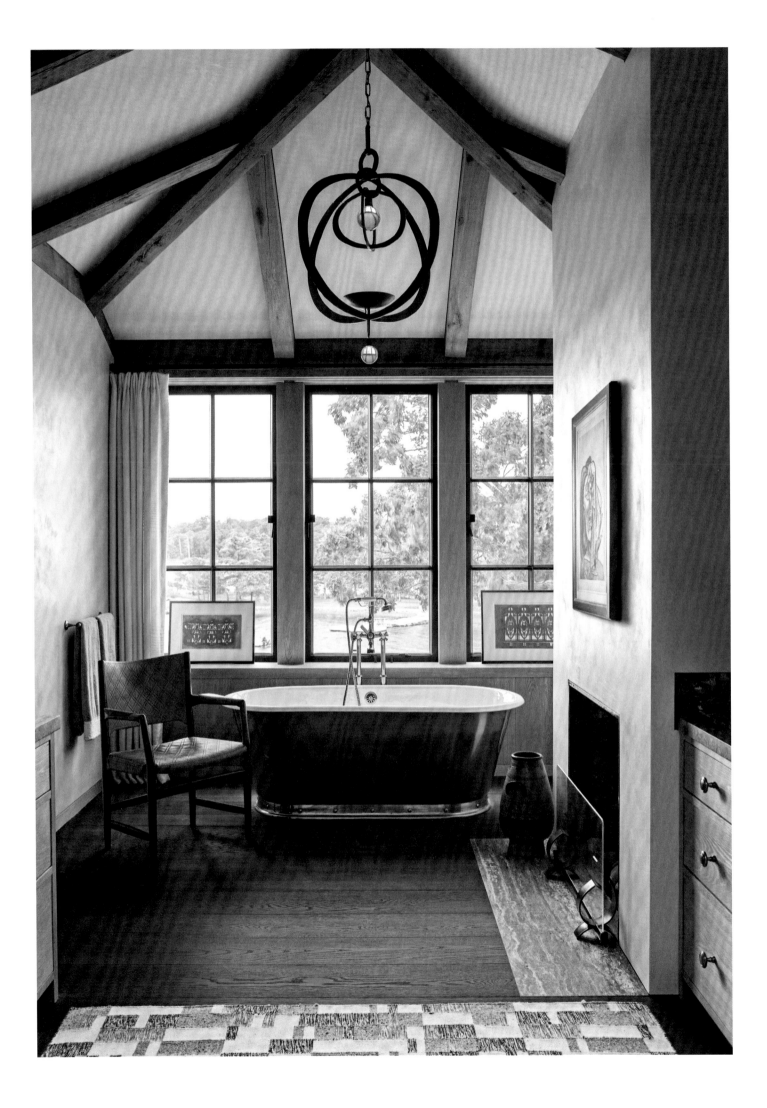

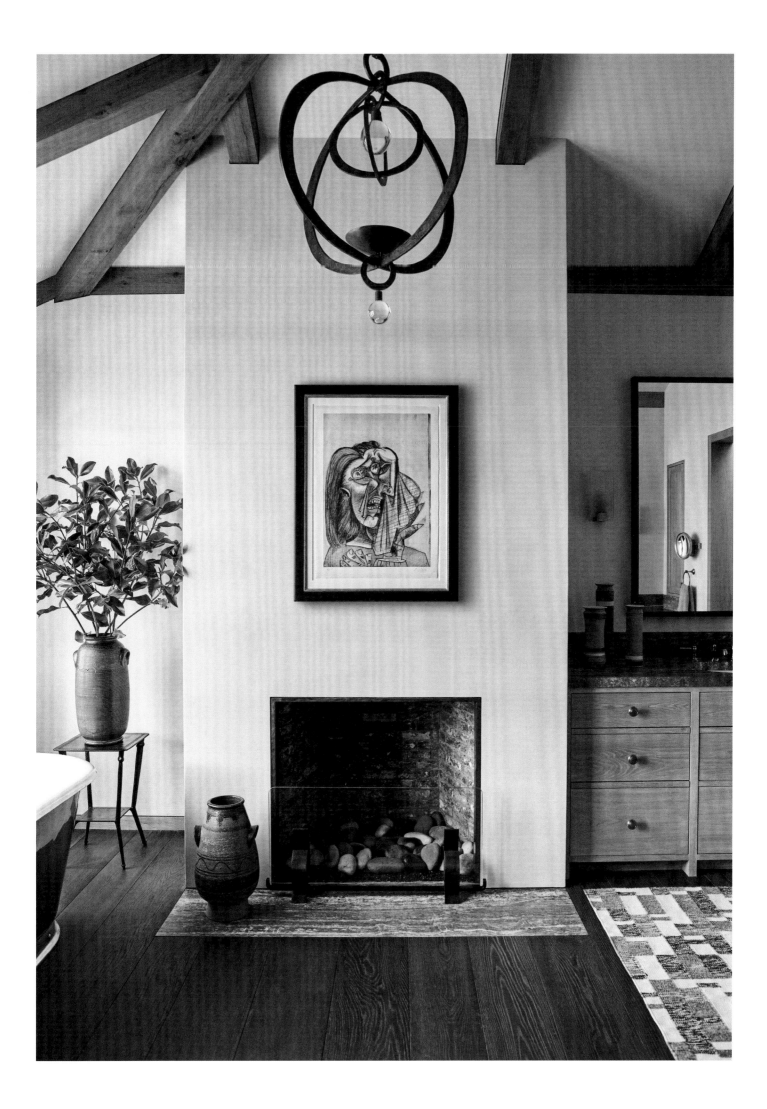

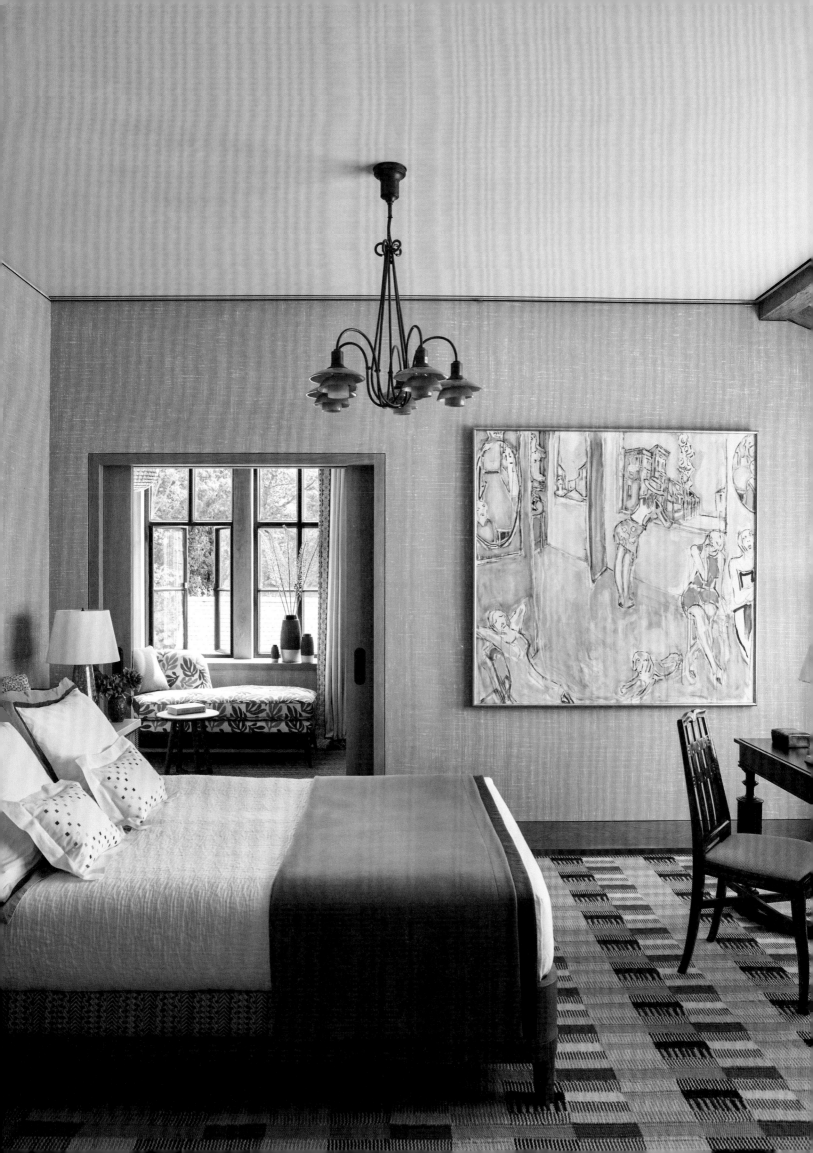

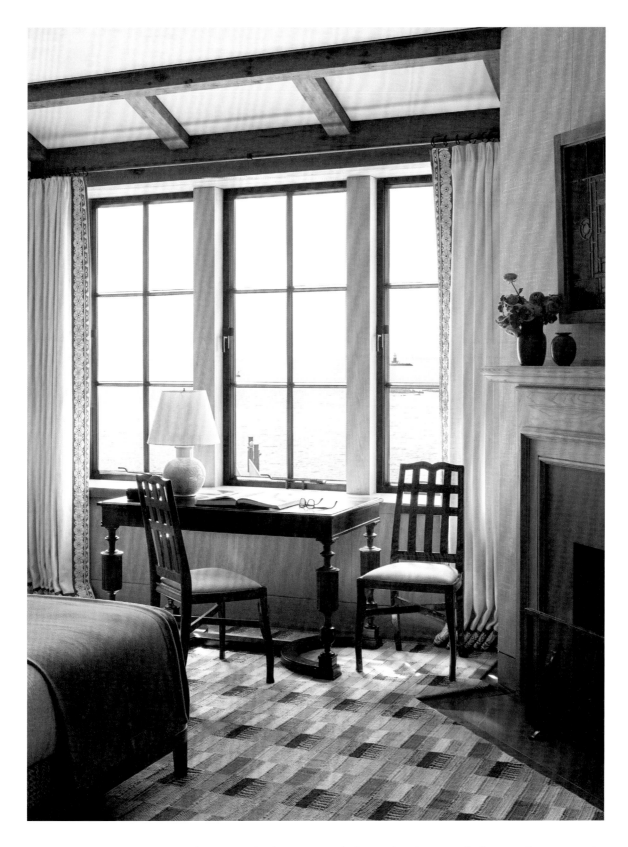

PREVIOUS PAGES, LEFT AND RIGHT: The primary bath's quiet vocabulary makes the space feel especially connected to the outdoors. A Picasso above the mantel and Hervé van der Straeten's bold pendant fixture provide artistic accents. On the windowsill are drawings, ca. 1915, by the American Prairie School architect George Grant Elmslie. OPPOSITE, AND ABOVE: Danish designer Poul Henningsen's rare 1930s basket ceiling fixture gave birth to the primary guest suite's palette, including the Matisse-inspired upholstery fabric on the daybed in its sitting room beyond. The backs of the Swedish Jugendstil chairs mirror the fenestration uncannily.

Swedish geometric rug in the adjacent family room. Together, the two establish a happy groundwork of noncompeting pattern. The furnishings for the family room take on a slightly different accent: a bespoke "puzzle" coffee table in a mellow mix of various woods and patinated brass; ikat textiles; ottomans by George Nakashima; a vintage commode by Oscar Nilsson; and, for a twist, a pair of exuberant Paolo Buffa chairs.

We've always loved swathing primary bedrooms in fabric because the softness creates such a warm embrace. In a testimony to the trust developed over our collaboration, these clients, who normally eschew white walls, were smitten with a custom tweed textile we presented in cream with a sprinkling of beige. They were astonished that one element could so profoundly change the feeling of a room. We gave the guest rooms individual palettes to differentiate them. One, perhaps the coziest room in the house, incorporates its own sitting room so it can serve as a grandmother's suite.

The small den off the main entry happens to be one of this house's most dramatic spaces. Cheekily called "the cave," it is anything but—rather, it's the Platonic ideal of a room with a view. The landscape felt so present in this space that we avoided curtains to bring the spectacular vista even closer.

This home honors the past, is flexible for the future, and is comfortable now. It pays homage to nature, to artisanship, and above all, to this family's Scandinavian heritage, aesthetic sensibility, and twenty-first-century lifestyle.

OPPOSITE: Every design collaboration requires the team members to honor their colleagues' points of view. Here, we left the window bare to celebrate the surrealistic view of the landscape beyond. The pattern of the rug acts as reinforcement with stripes directing the eye outward. OVERLEAF: Given a site as intimate with nature as this, our design decisions inevitably factored in the breathtaking surroundings.

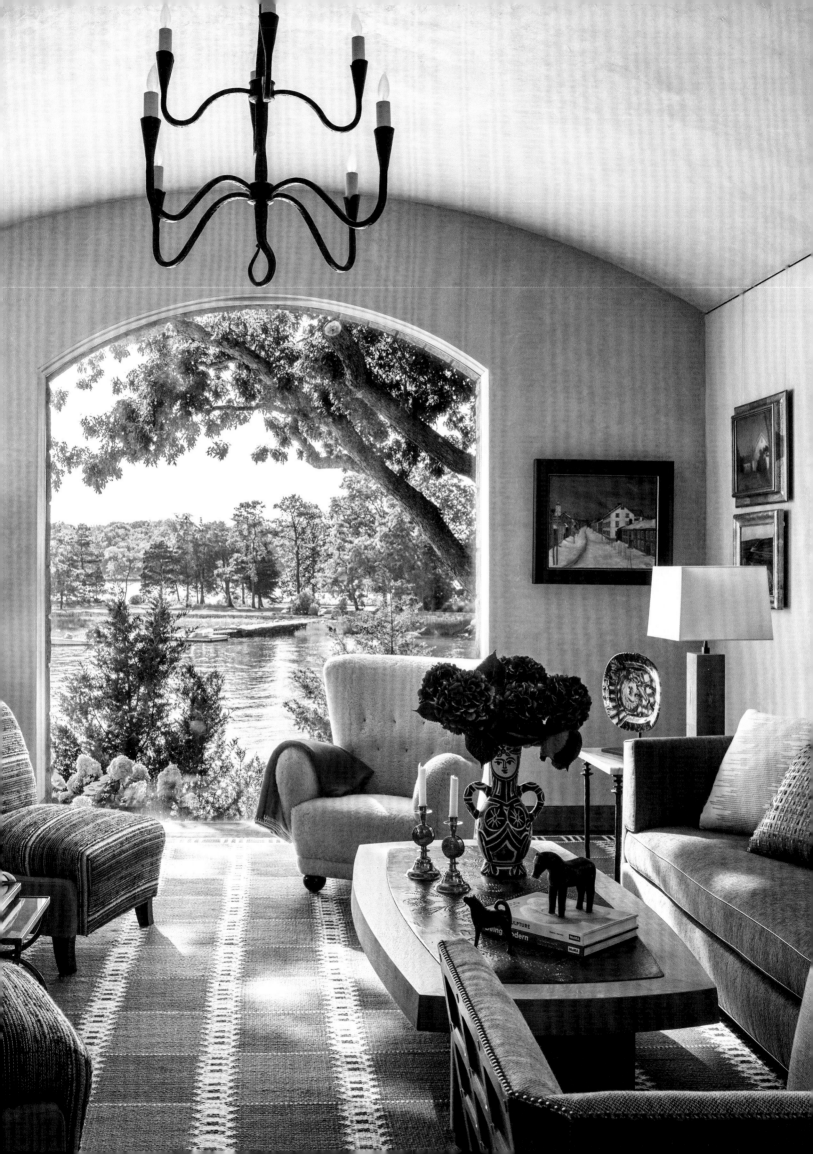

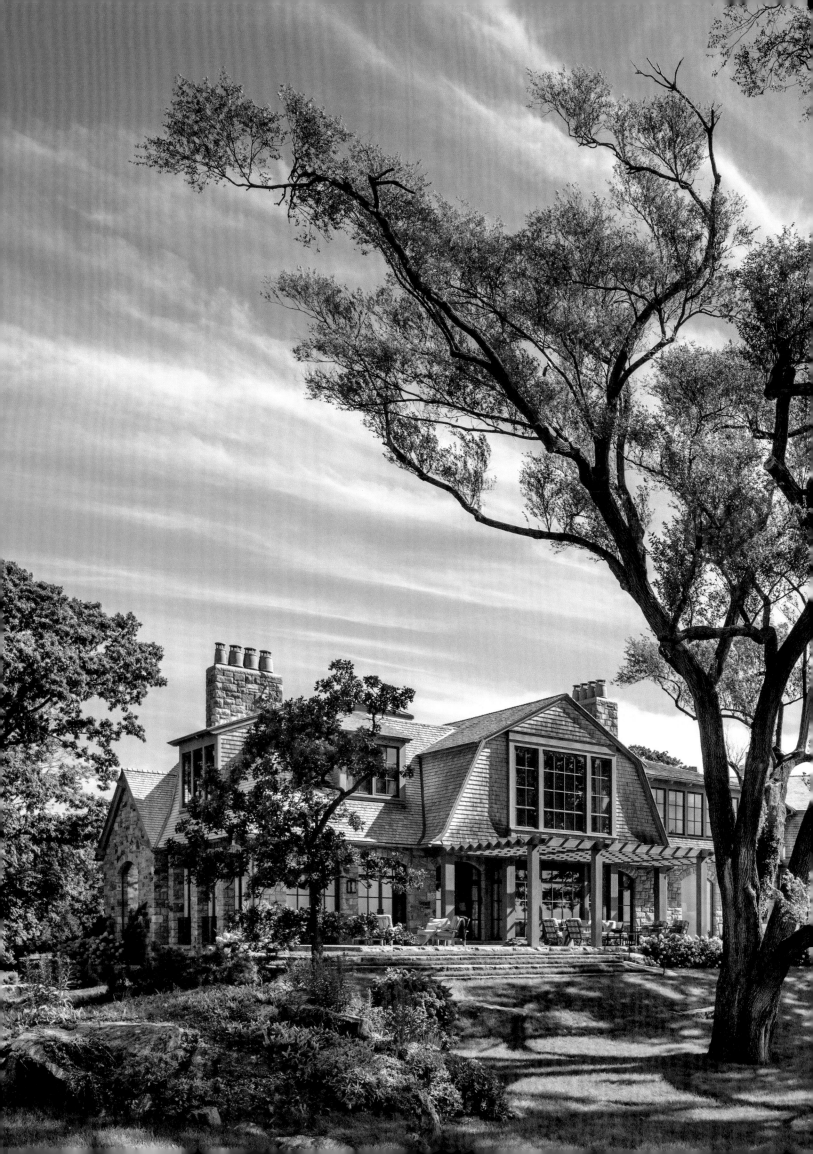

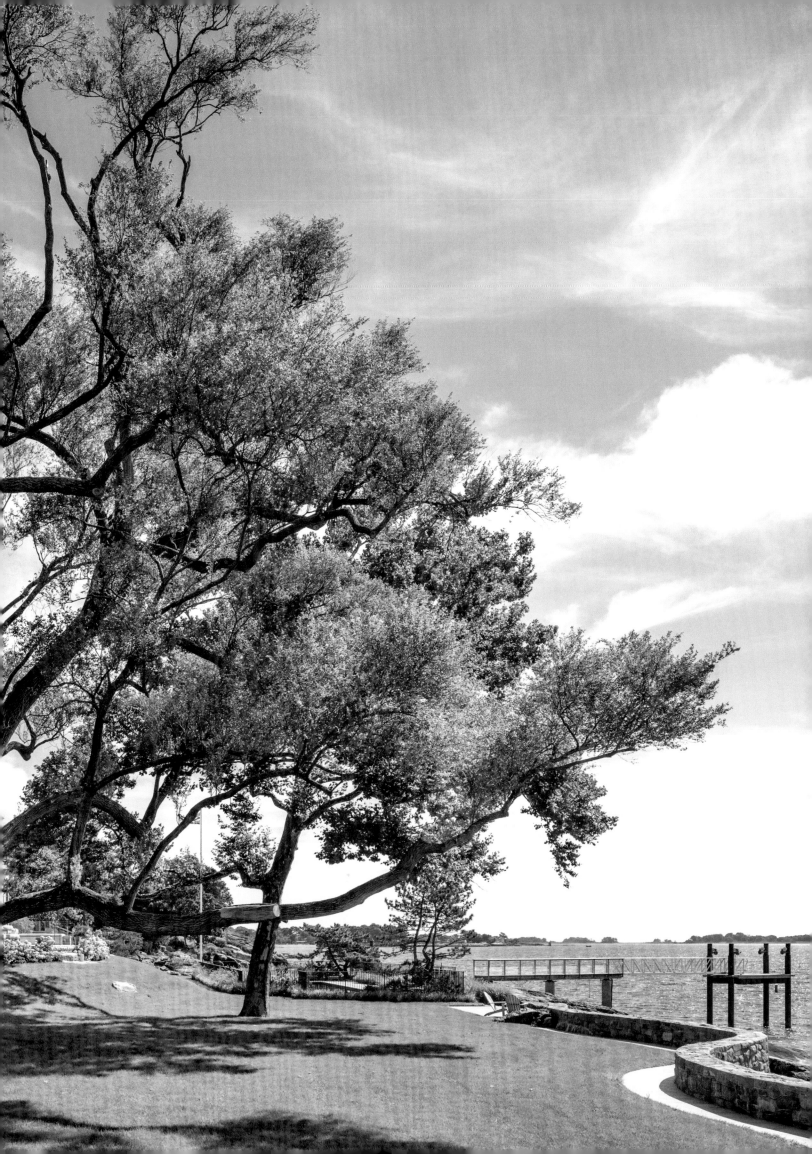

DELIGHTING THE EYE

With longtime clients like this family, each collaboration to discover what's next and bring it into being feels like a privilege—and a homecoming. They recently moved from their Connecticut residence of thirty years and previous New York pied-à-terre into this gracious, high-ceilinged apartment in one of the city's landmarked 1920s buildings. Because of our history together, we had a deep knowledge of their furnishings, collections, and art. Our process began with what to include from previous homes, what to cull, and what to add to the mix in order to express the way they wish to live now.

They vetoed a formal dining room, preferring instead to combine living and dining in one space. To that end, one of the first challenges we tackled in collaboration with architect John B. Murray was repurposing the apartment's original dining room into a sitting room/library and choreographing the existing living room for multiple functions. Widening the connecting doorway between the two spaces allowed for light to flow more easily through both areas, enhancing the perceived expansiveness of the entire apartment.

Our goal has always been to delight the eye, to keep it interested and engaged not just within each room, but along the transitions between. But it's not just the obvious showstopper pieces that matter. Wall finishes profoundly affect the atmosphere of any space, so creating a narrative as surfaces and colors unfold from room to room takes

OPPOSITE, AND OVERLEAF: Beloved longtime favorites like the blue-and-white zodiac figures from a trip to Hong Kong, dining table from a former family home in Connecticut, and exceptional nineteenth-century Austrian chairs meld with pieces found or created for this dining area, including the Chinoiserie-style rattan sideboard, custom rug inspired by a waterfall seen at Fondation Louis Vuitton in Paris, and the contemporary painting by Chinese artist Wei Legang discovered at New York's Winter Show. Creating the installation for the zodiac figures involved not only designing the individual mounts but close coordination with the lighting designer so all the figures are evenly lit and none casts shadows on any of the others.

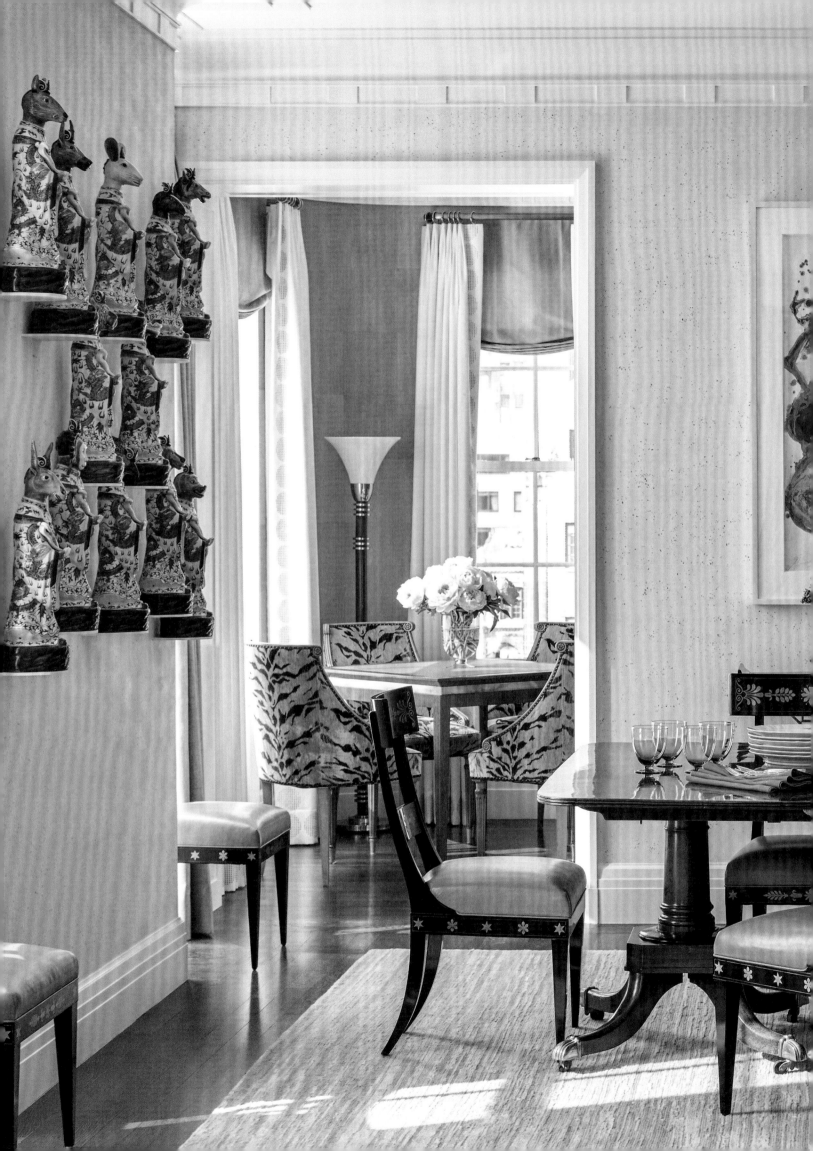

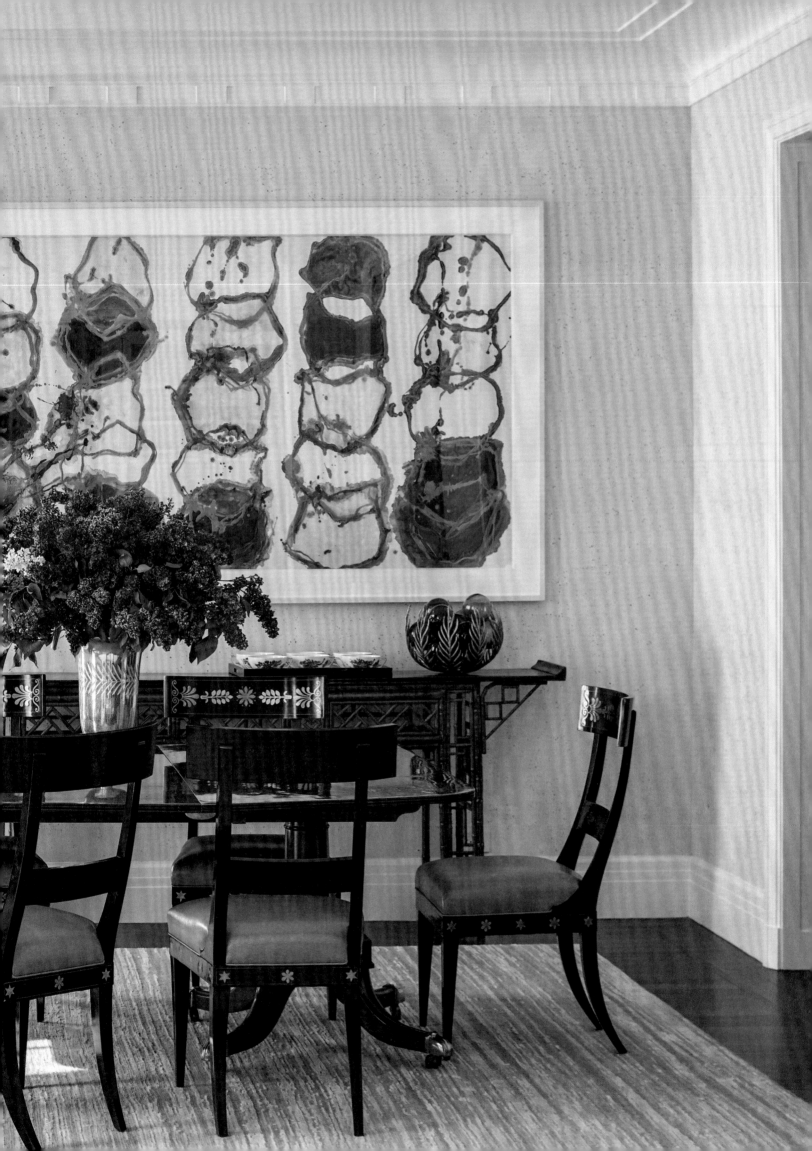

ABOVE: In the sitting room/library, the ornamentation on the curtains' leading edge incorporates a repeating decorative motif screen-printed in metallic silicon by Le Studio Anthost. Italian movie theater chairs from the 1930s newly dressed in tiger-printed silk velvet originally had individual pull-out ashtrays, now removed. OPPOSITE: Centered between the long curtain panels is a shorter draped panel, a more modern interpretation of a valance.

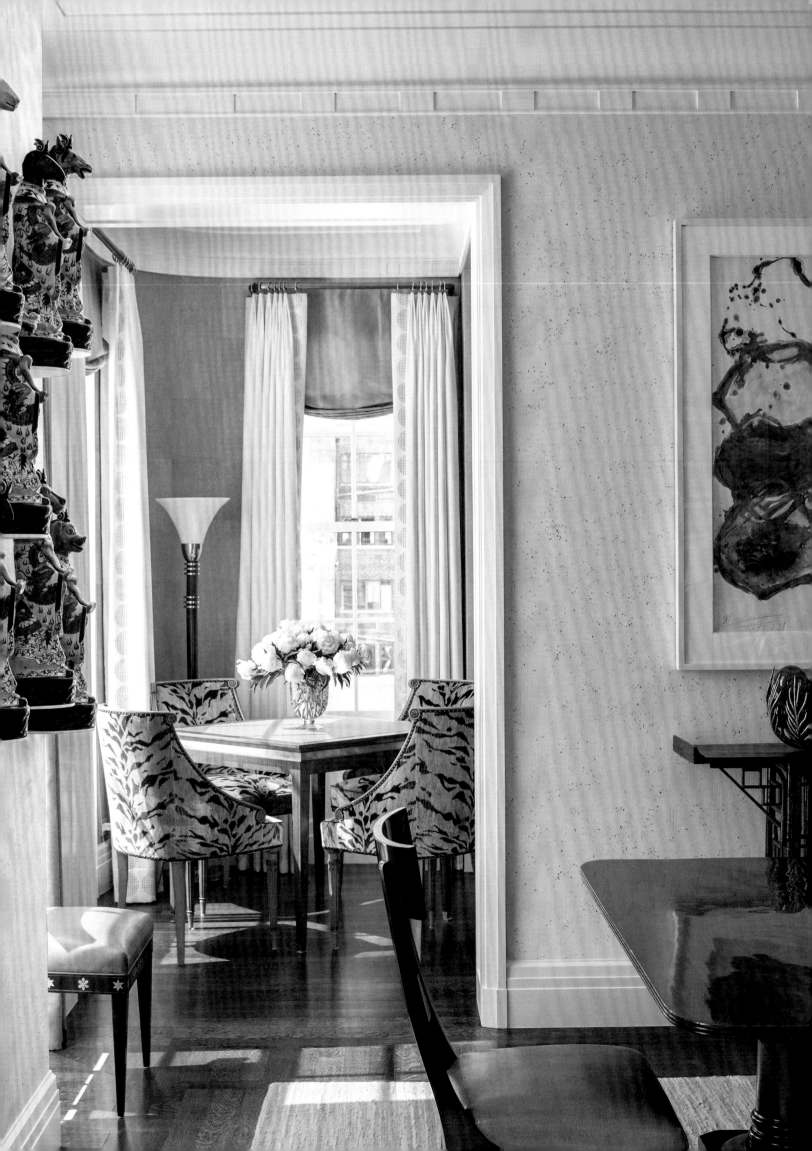

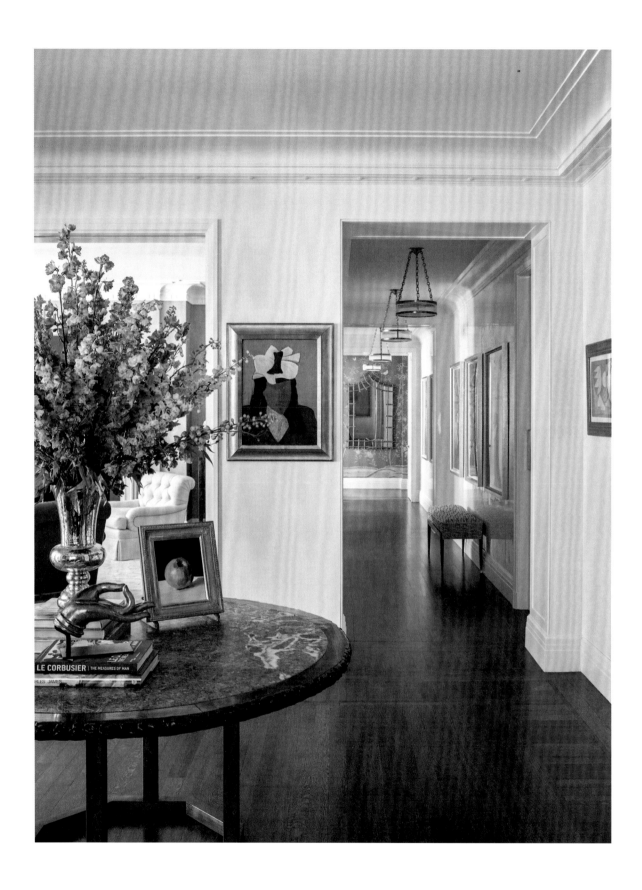

ABOVE: The entrance hall's nineteenth-century Chinese center table, made of hongmu, or "red wood," hints at the Asian influences to come. OPPOSITE: A variegated faux shagreen wall treatment that imbues the sitting room/library with intense character was the invention of Mark Uriu, and a first treatment of its kind for the firm. The carpet, an in-house design, lays down the circle motif underfoot.

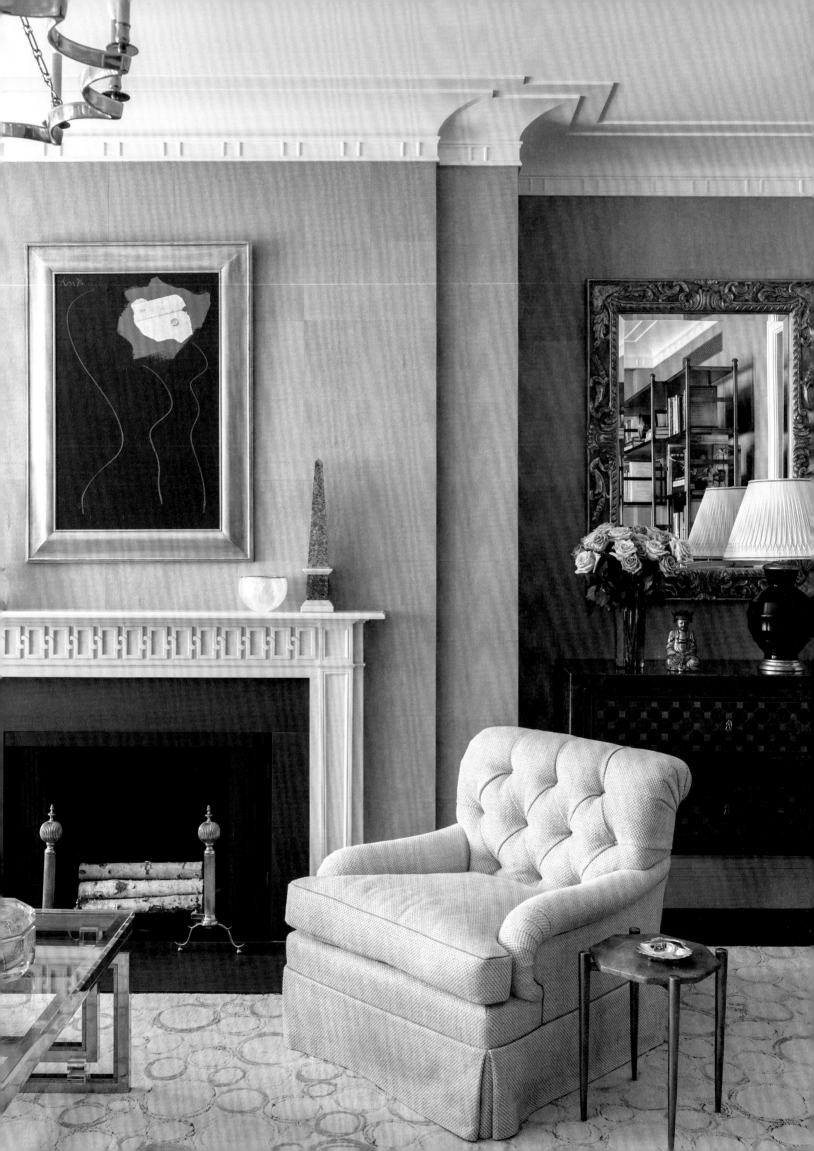

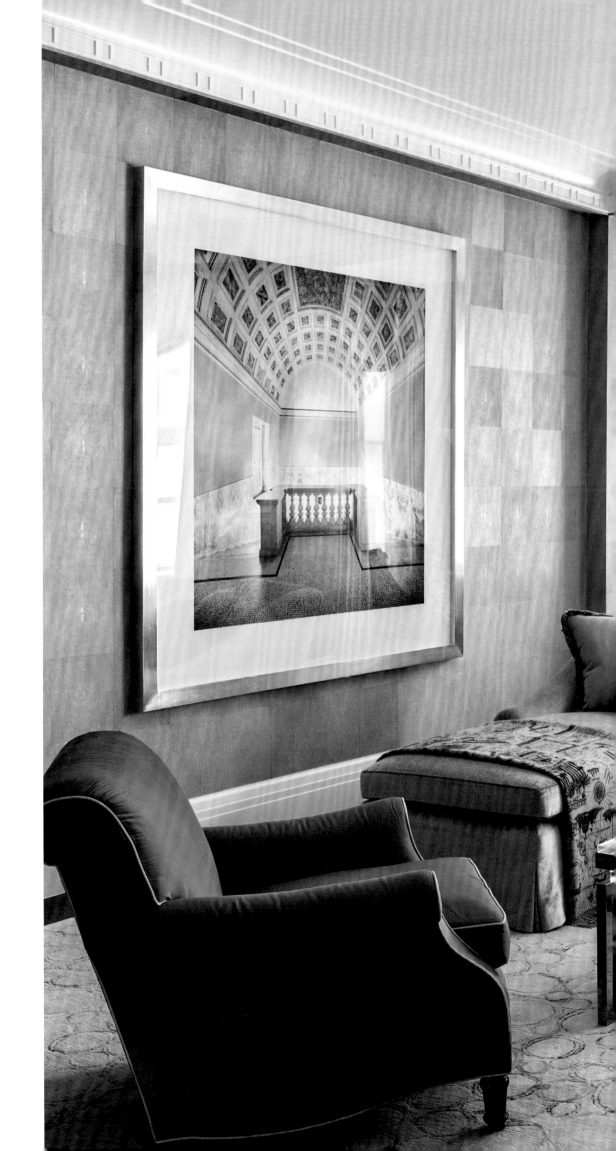

RIGHT: Positioned for TV watching, the capacious L-shaped sectional couldn't be more inviting. The Lucite-and-brass coffee table is a vintage midcentury design that feels timeless even today and keeps the center of the seating area visually open. The photograph is by Candida Höfer.

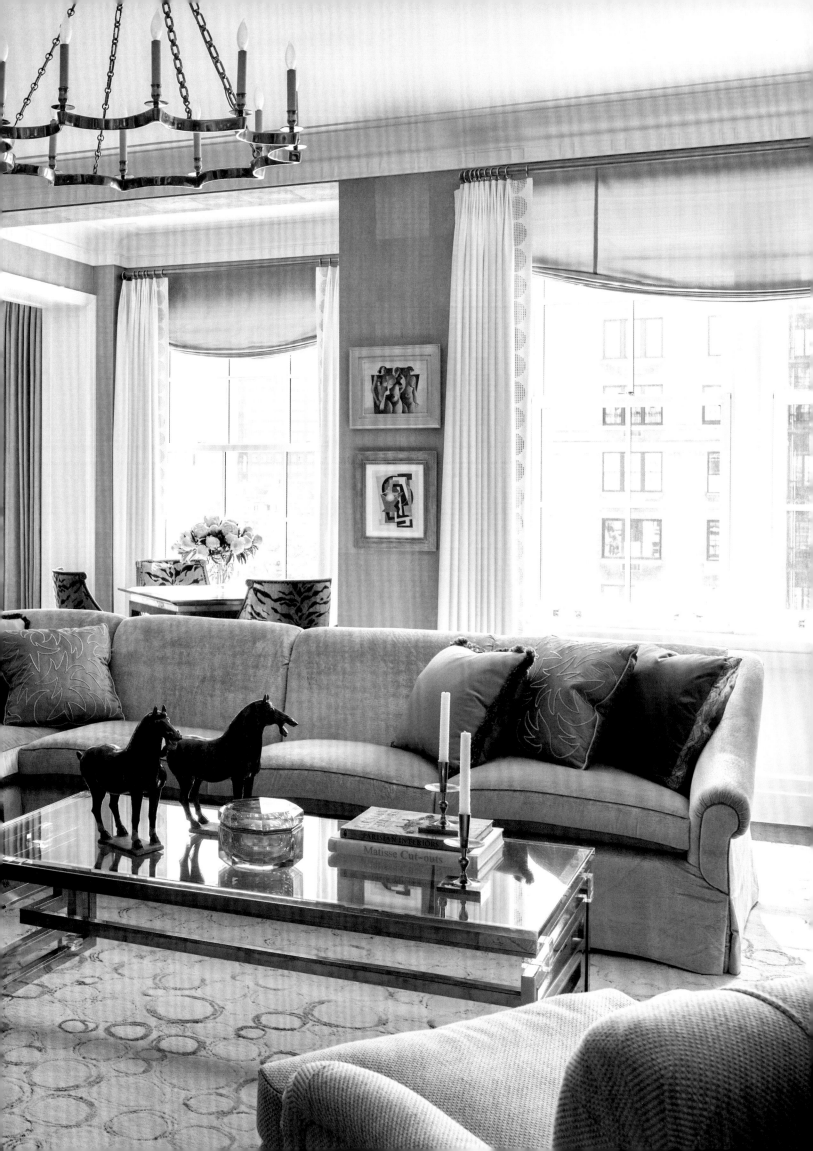

FUN AND FUNCTION

Every room has the potential to be a place of uplift. We try to layer as much beauty as possible into each space, whatever its function in the grand scheme of things, because to do otherwise would be a sin of decorating omission.

Working rooms—the kitchen, butler's pantry, bar, powder, and bath—are a class unto themselves. They tend to be separate and distinct from the main living areas and are often segregated behind closed doors. Many are wet rooms, which present specific technical and engineering challenges and require a particular set of materials to meet pragmatic needs. Even so, we study and analyze these spaces just as we do all the other rooms, obsessing over floor plans, hard and soft materials, lighting, and all the other details with an eye to maximizing the layering of décor each will permit in terms of its designated function.

Over the decades, as kitchens, in particular, have moved from the back of the house to the heart of the house, their character, function, and needs have completely metamorphosed. Most families today come together in their kitchens for casual meals and so much more. For children, kitchen tables and islands often become the spot for homework and hanging out with friends. Many people now gather with friends in this space as they prepare a meal—think dinner theater, at home. Most kitchens now incorporate a dedicated desk-type workspace as well. Always, kitchens must include the necessary storage for the basics, the everyday ware of dishes, linens, glasses, utensils, and so on. Butler's pantries, depending on the size, can display or at least house all the company china, silver, glassware, and serving utensils.

Baths are perhaps the home's most intimate, private worlds. As such, they couldn't be more deserving of the same deep consideration and intent to delight as the rest of the home. Powder rooms? In design terms, they're the jewel boxes of the interior—rooms ripe for fantasy, and of course, reality.

Nothing is out of bounds. And nothing is off limits. Given the time everyone spends in these spaces, they should be designed to savor with the same quality of décor as the rest of the house.

OPPOSITE: Wallpaper by de Gournay ties the powder room to the exterior, where ginkgo trees shower the city in gold every autumn. The sconces were purchased in England. Reinventing the Swedish Grace commode for a vanity also involved a height adjustment. Typically, these pieces are a rather low 25 inches high; we added a base and a collar to elevate this one to today's desired 33 inches.

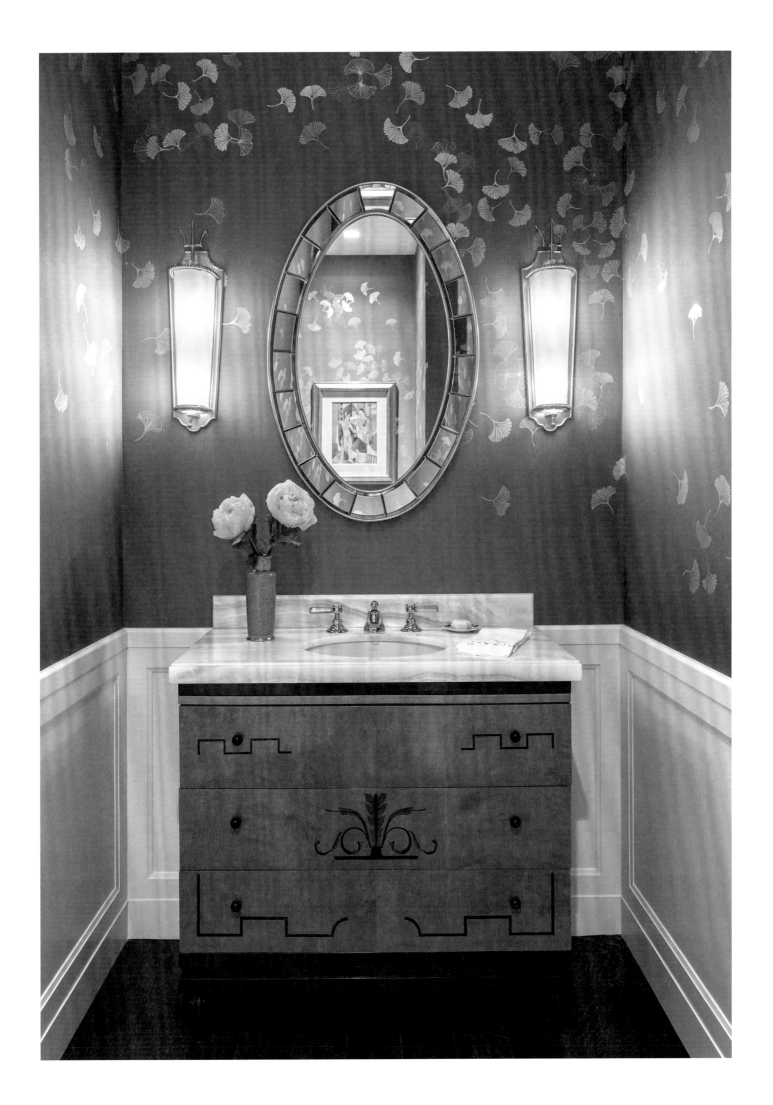

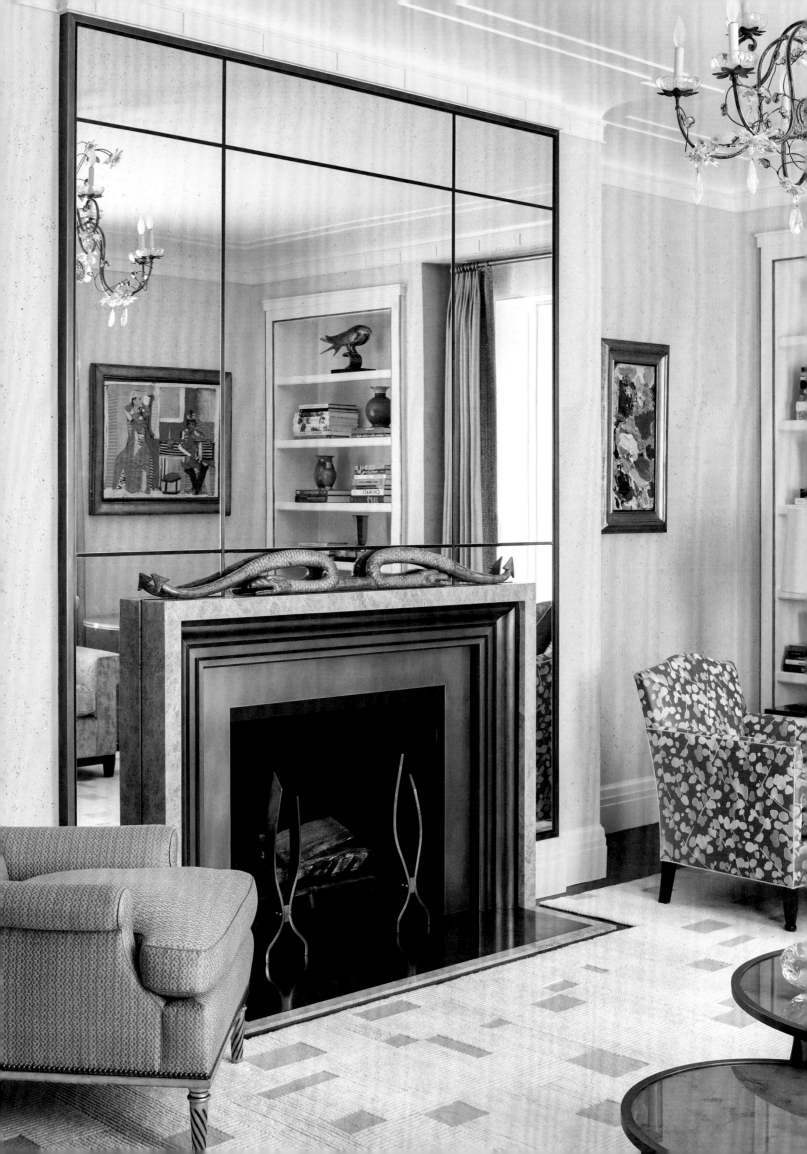

on real significance. These clients happen to love color and texture, which gave us great range.

Adjacencies like the one between this apartment's living/dining room—its shell-flecked Marmorino walls radiate a soft shimmer—and its sitting room/library—swathed in a faux shagreen—naturally become major plot twists in the tale of thematic hues, wall materials, and their variations. The turquoise that adds such flavor to the living and dining areas, for example, clearly connects to the faux shagreen walls of the sitting room/library but exudes a much cooler energy, so the touches of orange provide the spice of contrast. Here, great classic upholstery forms beckon alongside contemporary pieces and beloved family items. With this mélange of forms, textures, finishes, patterns, and art—not to mention the chandelier—the living area takes on a character that's distinct, yet cohesive with its neighbors.

The dining area has its own related identity, one that, through its furnishings, harmoniously blends the cross currents of the family's previous lives. The dining table from their Connecticut house, an extremely unusual set of nineteenth-century Austrian chairs found at a Greenwich Village shop, an abstract work by a contemporary Chinese artist seen at the Winter Show, and the wall installation of blue-and-white Chinese zodiac figures purchased by the owner years ago on a trip to Hong Kong—all create a harmonious conversation.

Our client firmly believes that every room should say: "Welcome. Please come in and sit down." The sitting room/library's large sectional sofa exemplifies that sensibility. So do the table and chairs in the little alcove where there is always a puzzle in progress. The 1930s chairs, from a movie theater in Milan, are more recent favorites purchased for the previous small apartment; the faux

OPPOSITE: Finding andirons at an appropriate scale to today's rooms is always a journey; modern décor adds to the challenge as there's less variety available. The rug in tones of light beige is unexpected for city living; interspersed cut-loop and woven sections alternate high and low piles, which add texture and pattern without an obvious repeat. OVERLEAF: With classic upholstery forms, a coffee table by Max Kuehne, corner table by Jules Leleu, nesting contemporary Japanese-inspired coffee tables with glass tops we had reverse painted in metallic turquoise, a French 1940s rock crystal chandelier, and contemporary art and accents, the living room captures these clients' eclectically contemporary taste.

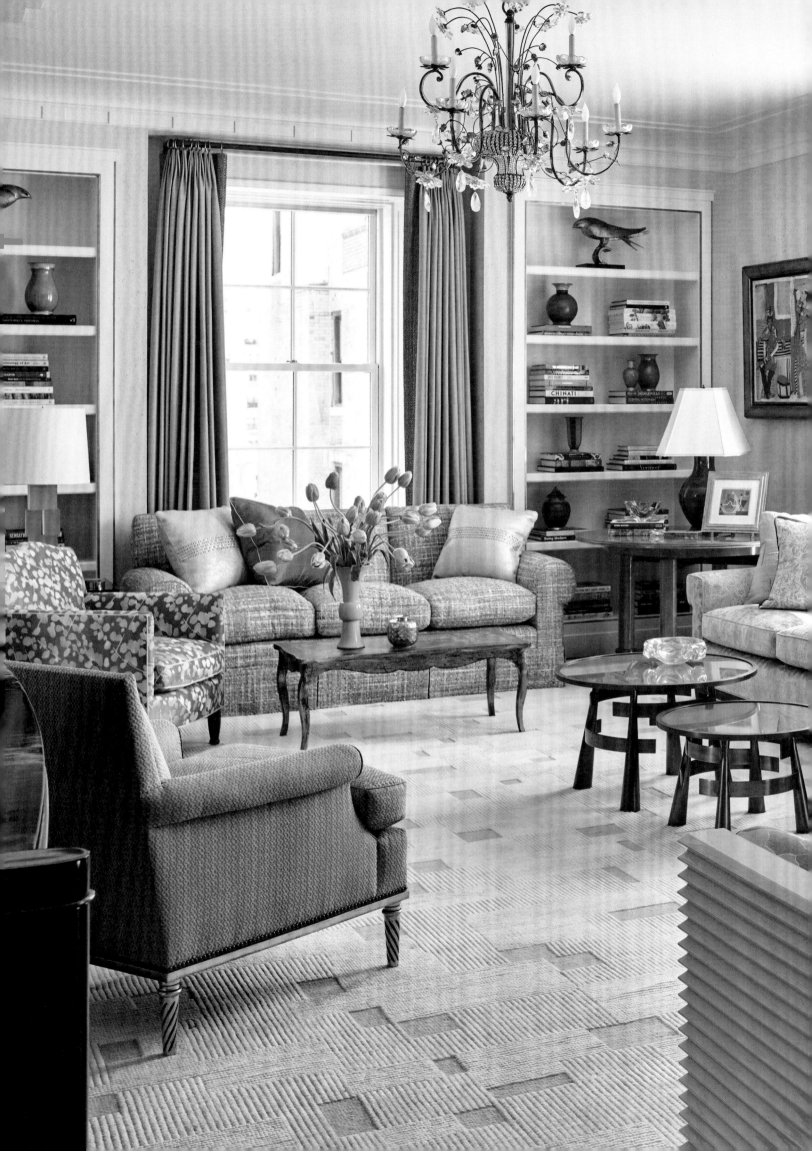

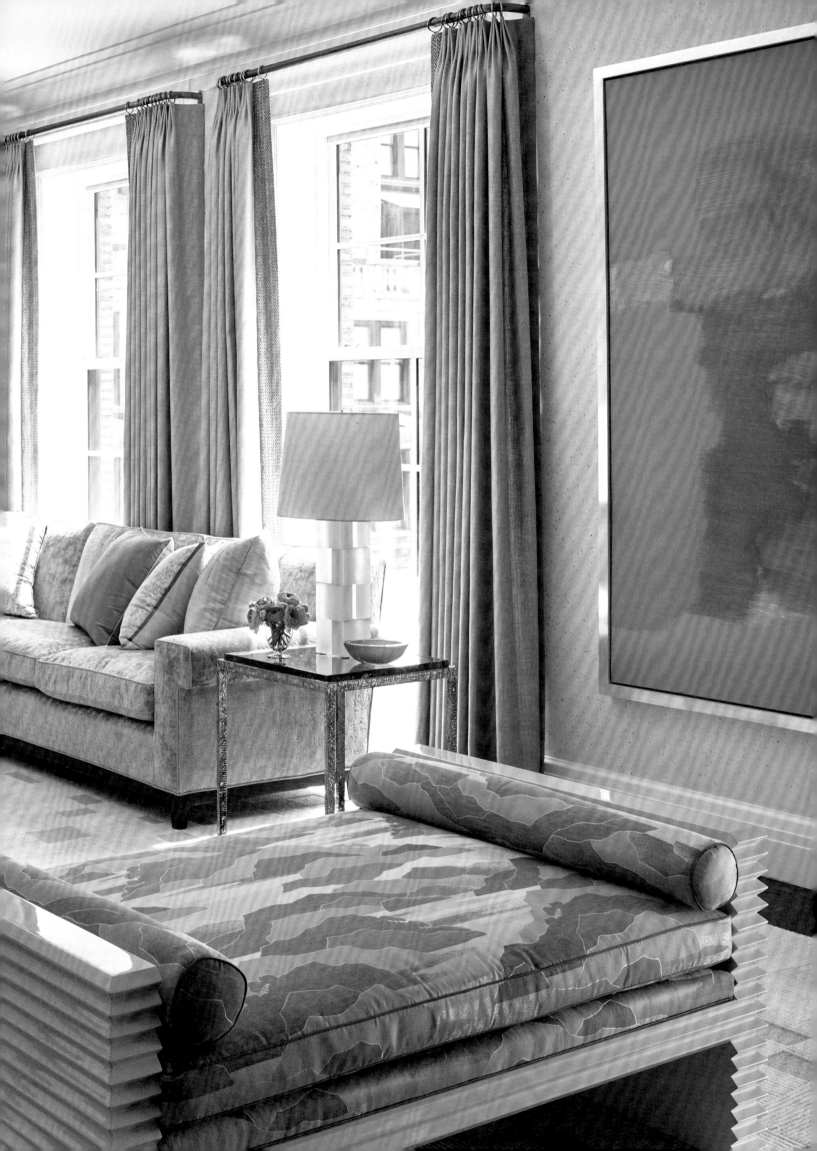

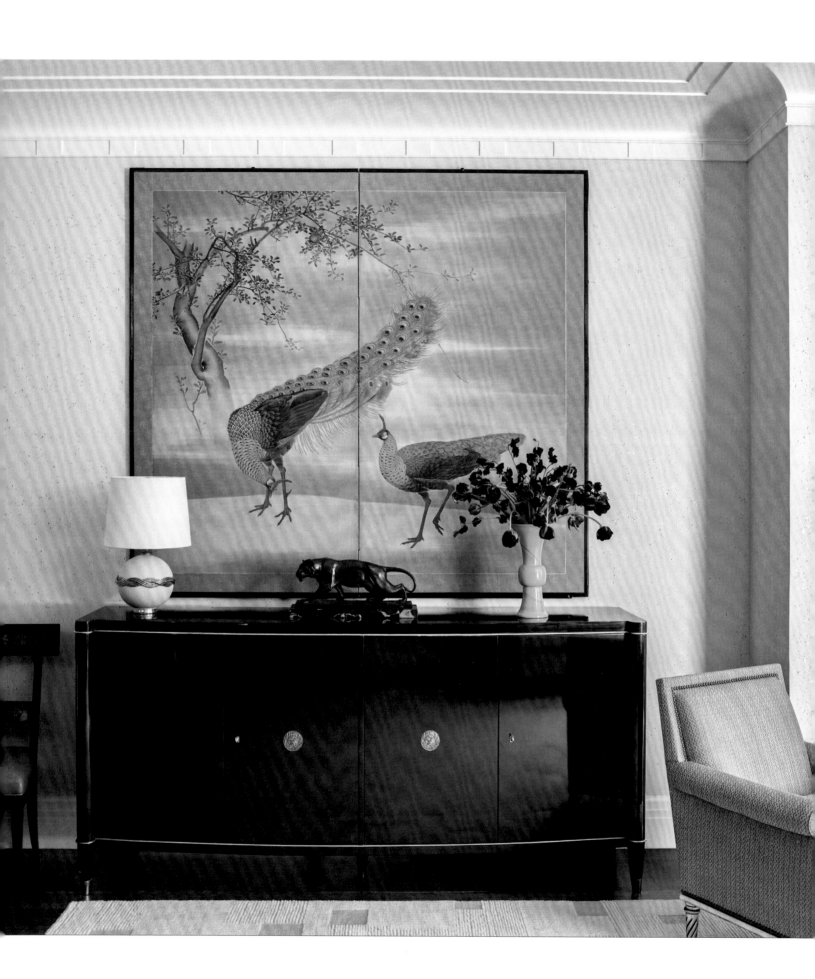

tiger print that dresses them is, surprisingly, one of the animal prints that are decorating's universal donors. But it's the wall finish that gives this room its ineffable embrace. It was a first for us—and for Mark Uriu, our beloved painter, who figured out a way to imprint pieces of latex and then tint them to mirror nature's variations. The pattern on the curtain's leading edge, which is screen printed in metallic acrylic, emerged from a similar desire to stretch the details in unexpected directions.

The powder room gave us an opportunity to explore another form of decorative fantasy. The Swedish Grace commode, repurposed as a sink, anchors the space. It brings with it a 1920s refinement that resonates with the building's

original architecture. The mixed metallic finishes of the wallpaper's ginkgo leaves insert a dreamy echo of the foliage on the street outside. With a Murano mirror in a delicious shade of honey, this little room becomes its own complete world.

The apartment faces east, so the sun blazes in in the mornings. All in white, the kitchen and breakfast room make the most of the brilliant rays. Flashes of cinnabar, including in the custom lacquer table and an artwork just as fresh as the color choice, inject both vibrant energy and joy.

For the study, we took another tack, looking at many different flannels for the walls but eventually deciding to cocoon them in corduroy. Going gray here was a leap of faith, but the key was finding just the right tipping point between too dark and too light. The pops of orange that warm up the neutrality take their primary cues from the artwork; since they also echo the accents in the living room, they form a subliminal thread that ties the two spaces together.

The primary bedroom basks in an array of mauves, creams, and taupes, which exude their quiet glam-our under a ceiling coated in high-gloss lilac paint and a delicate bouquet of a pendant fixture, a new acquisition and such a timely find. We wrapped this room's walls in the same Chinese-inspired design we had used in the primary bedroom of the clients' former apartment. This is the only time in our long history of working together that the wife had ever asked us for this kind of repeat. Perhaps because

RIGHT: Nothing is cheerier than a splash of cinnabar lacquer in a bright white space like this kitchen. The embroidered chair fabric, called Terrazzo, was an irresistible choice to pair with the artwork, which, cheekily, is all four-letter words, both naughty and nice. We affectionately call the light fixture over the island the "Tootsie Roll."

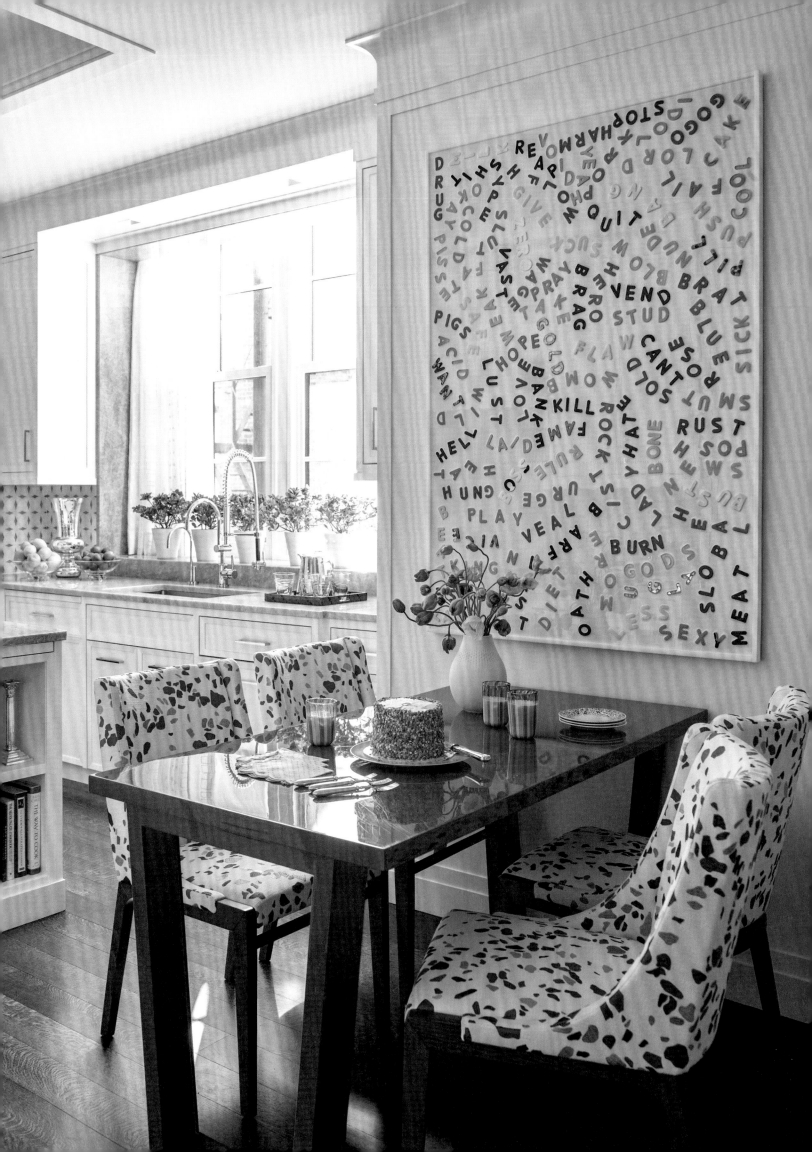

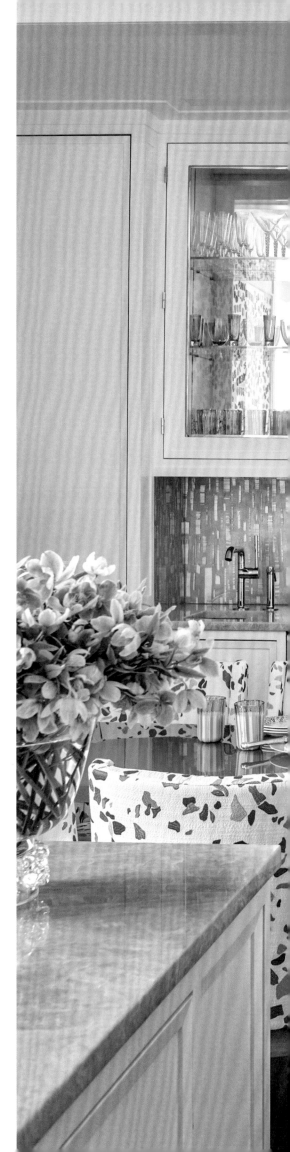

ABOVE: Upholstered chairs in the kitchen ensure comfort for this heavily used family space. RIGHT: Two types of backsplash materials add interest and variation to the room: an églomisé backsplash behind the bar brings the shimmer, while a laser-cut tile pattern activates the area behind the cooktop.

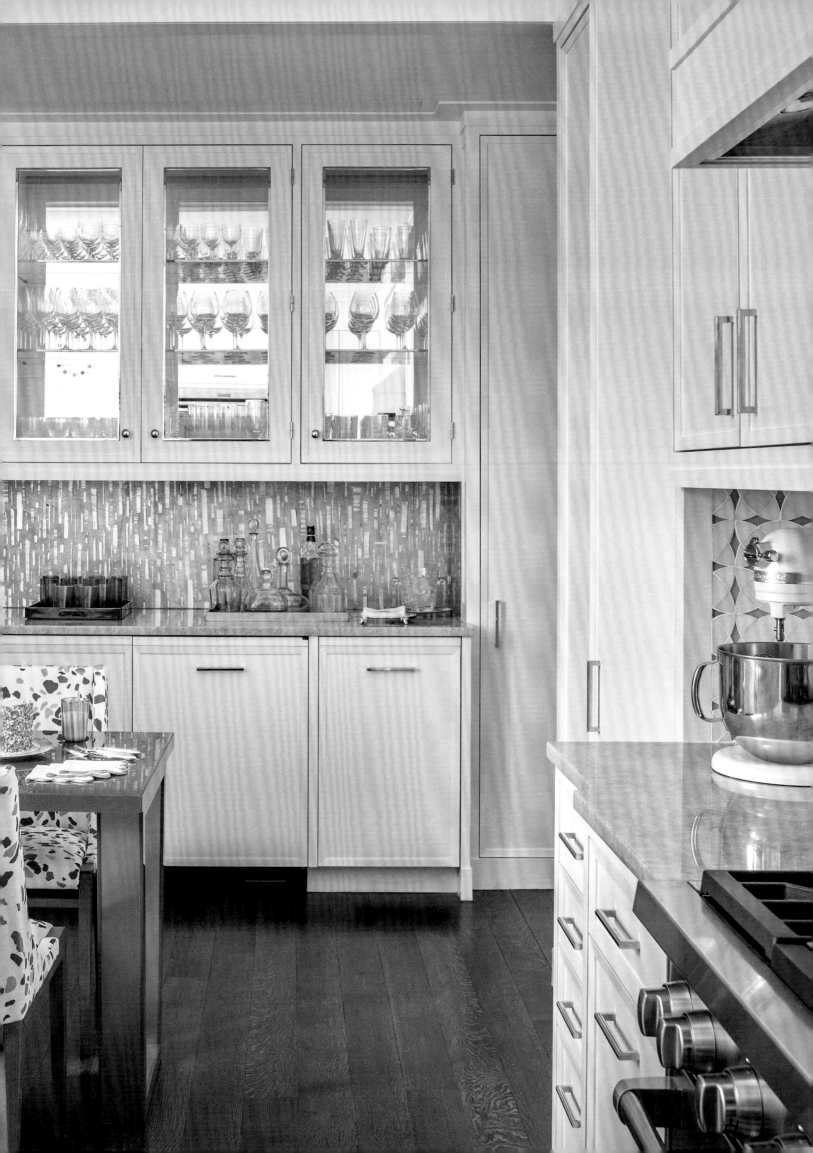

RIGHT: Corduroy-wrapped walls cocoon the study in comfort. This room is the exception that proves our rule of almost never repeating the curtain fabric in the throw pillows; here it made sense because even when they're closed, the panels never show the pattern in full. The rock crystal motif that carries through the apartment continues in the studs that ornament chandelier's bronze corona. Asian influences recur in the patterned velvet, called Sozan, that upholsters the club chair; channel stitching gives the back a distinctive differentiation.

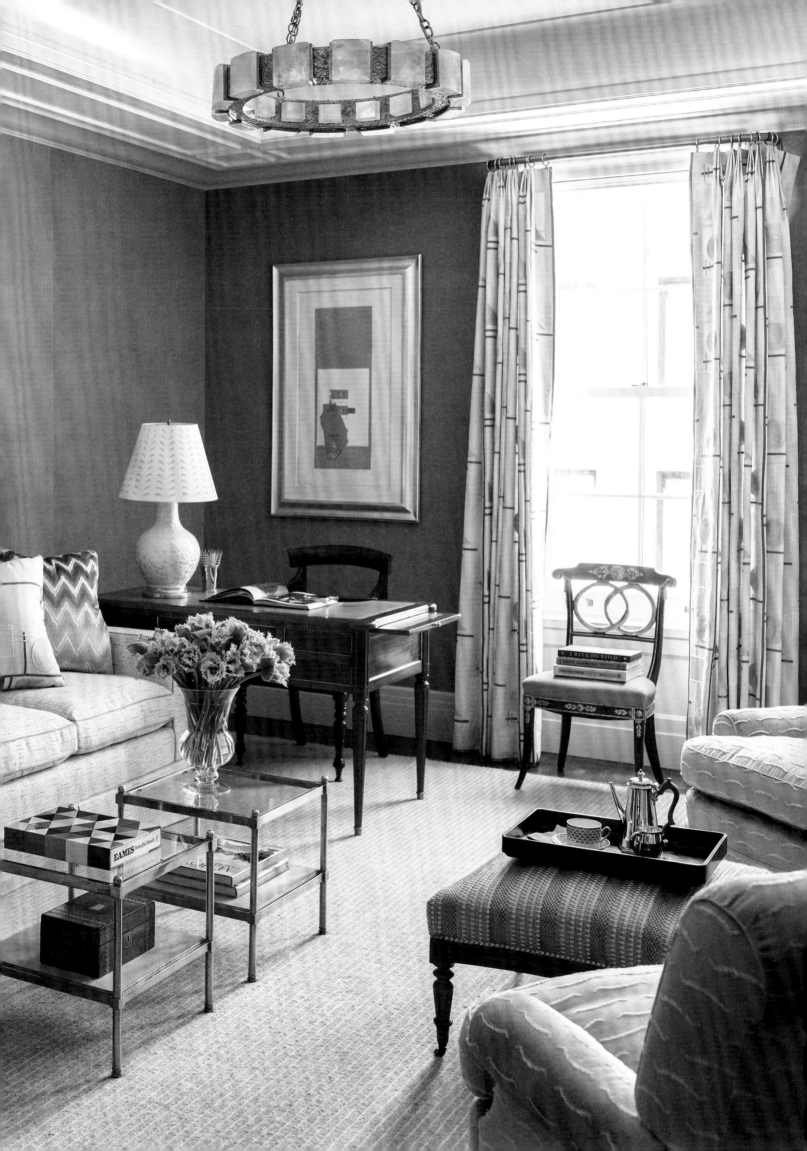

The balance between matte and sheen factors into a room's every decorative choice, and it evolves throughout the interior. When walls are upholstered, patterned, or textured, a ceiling finished in a high-gloss paint not only creates a mesmerizing reflective effect, it also completely transforms the room's quality of light.

she'd only been in the previous apartment for a few years, she felt she didn't have enough time to enjoy the pattern sufficiently.

This home, like every home we design, began with an honest appraisal of the clients' lives, history, and taste. In this case, we also started with a deep understanding of their individual preferences in terms of comfort, ideas of beauty, and favorite possessions that carry memories. Along the way, we hunted for the harmonious additional pieces that would transform the flavor of the existing elements and reflect their evolving taste and personal style now.

We so often talk about layering rooms with decoration. But our purpose, really, is to layer them with meaning.

RIGHT: In this primary bedroom, we broke our own rule about never using three different upholstery fabrics on three adjacent sofa pieces. All these fabrics play with the lilac hues that endow this space with its special glamour. A Chanel-inspired tweed covers one armchair, while a Fortuny fabric dresses the other. The sofa luxuriates in lilac velvet. A French 1950s chandelier with cut glass flowers and crystal beads is the jewelry overhead.

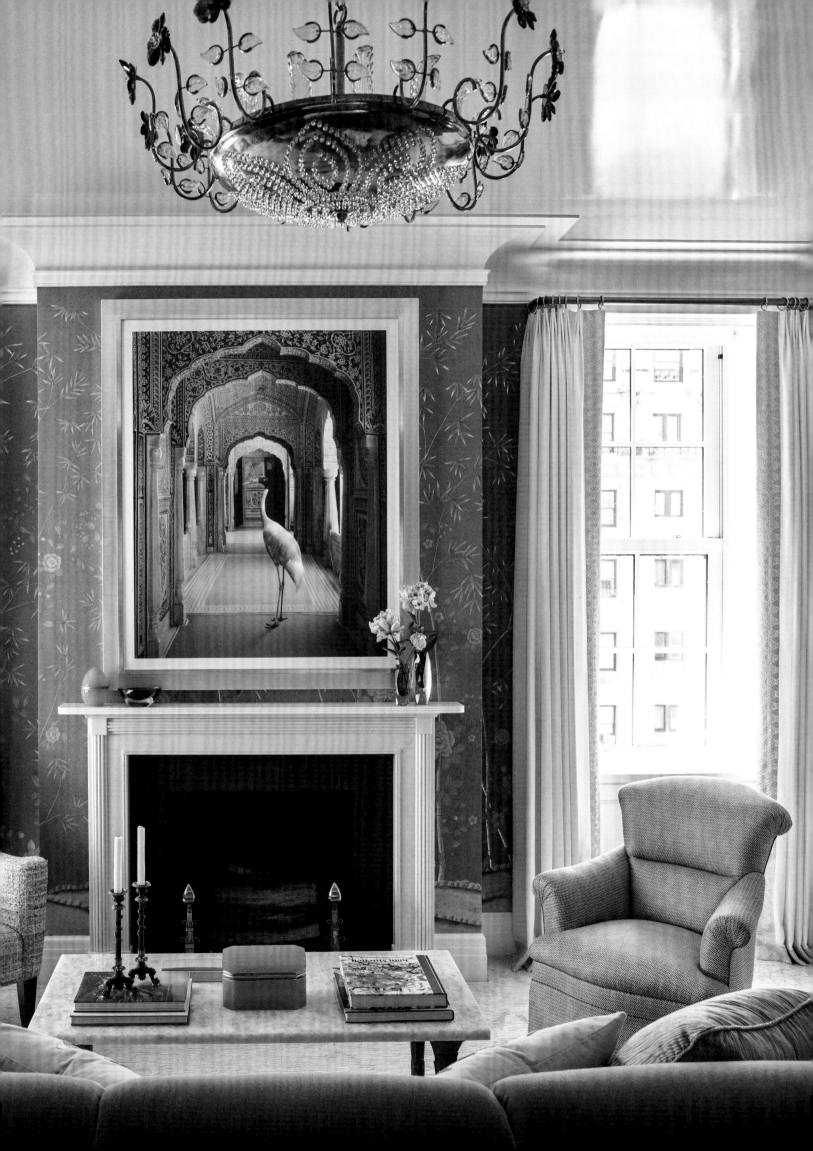

RIGHT: In this spacious 30-foot-long primary bedroom, it's possible to create both a generous sleeping area and a gracious sitting area. These clients are serious readers, so it was important to make sure that every room, including this one, incorporated book storage. There's no reason to fear hanging art on a patterned wallpaper. In this space wrapped in a garden scenic, black-and-white Matisse drawings work well above the bed. A pair of Japanese appliqué pillows on the sofa layer in more pattern. OVERLEAF, LEFT: This combined bath and dressing room repeats the amethyst glass detail. Inlaid silver accents in the floor of the bath echo with the contemporary light fixture overhead. The artwork is by Rinko Kawauchi. OVERLEAF, RIGHT: Occasionally, as in this dressing room, it's necessary to float a mirror in front of a window. An églomisé top adds ornament to the central island.

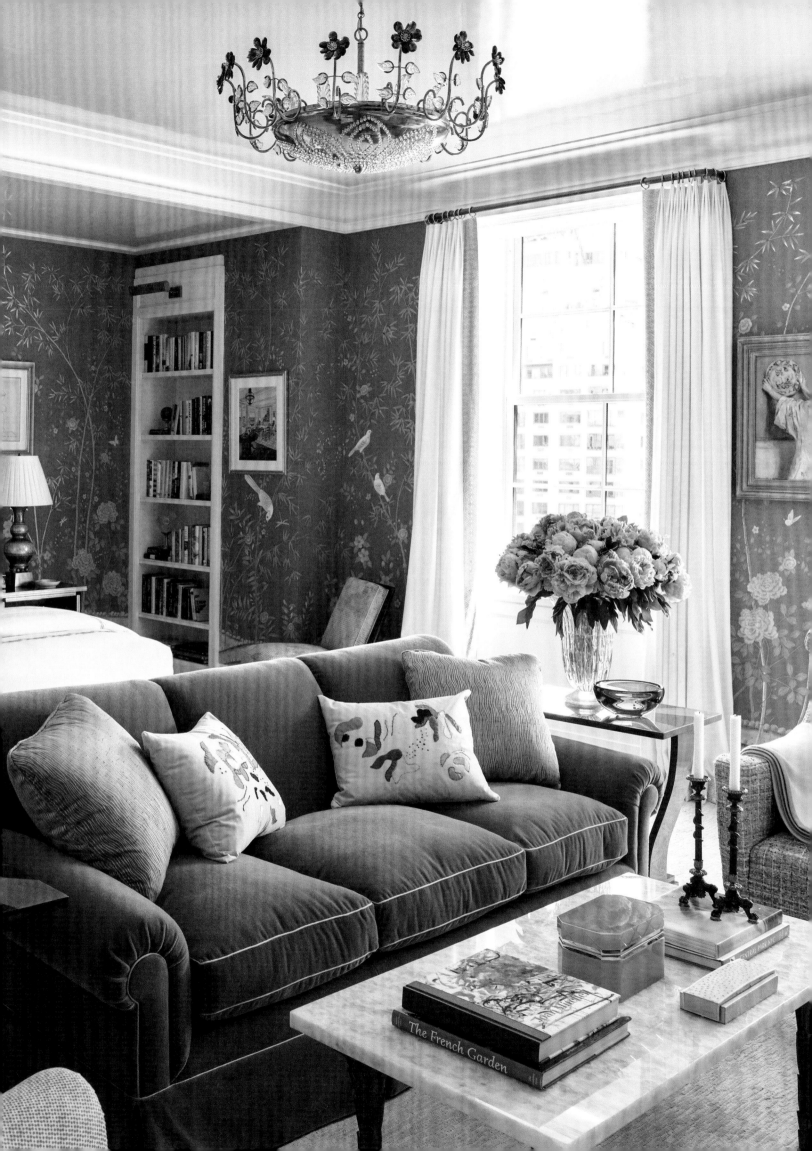

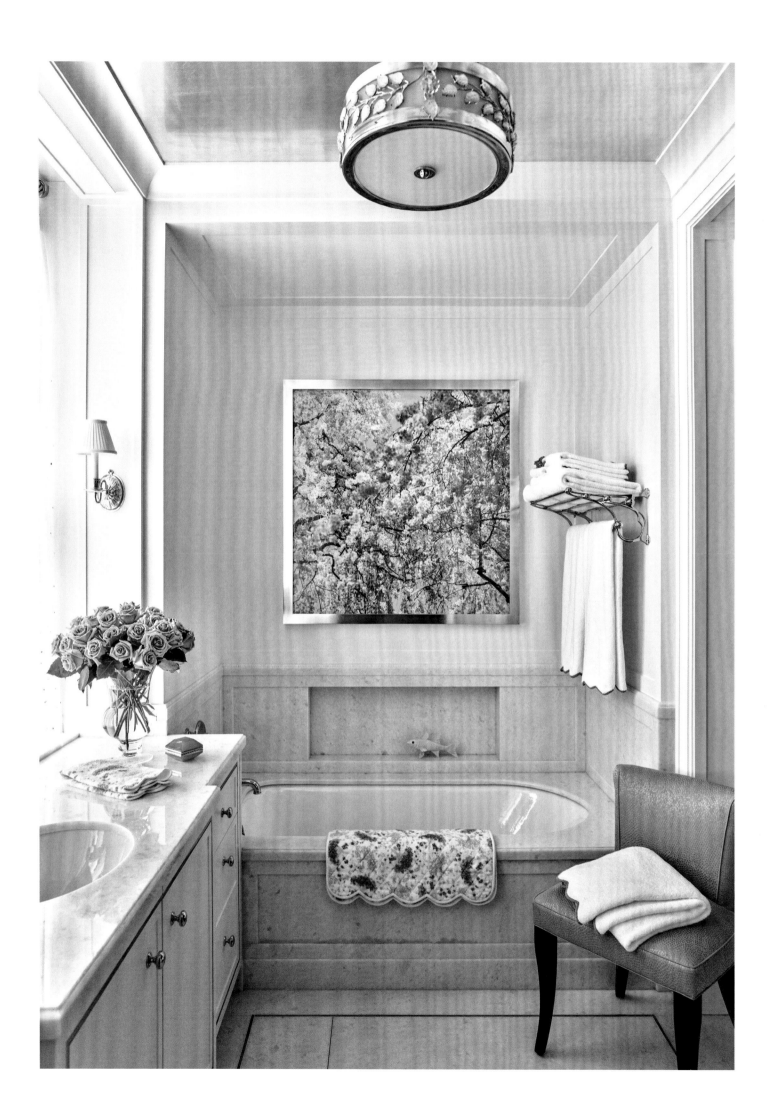

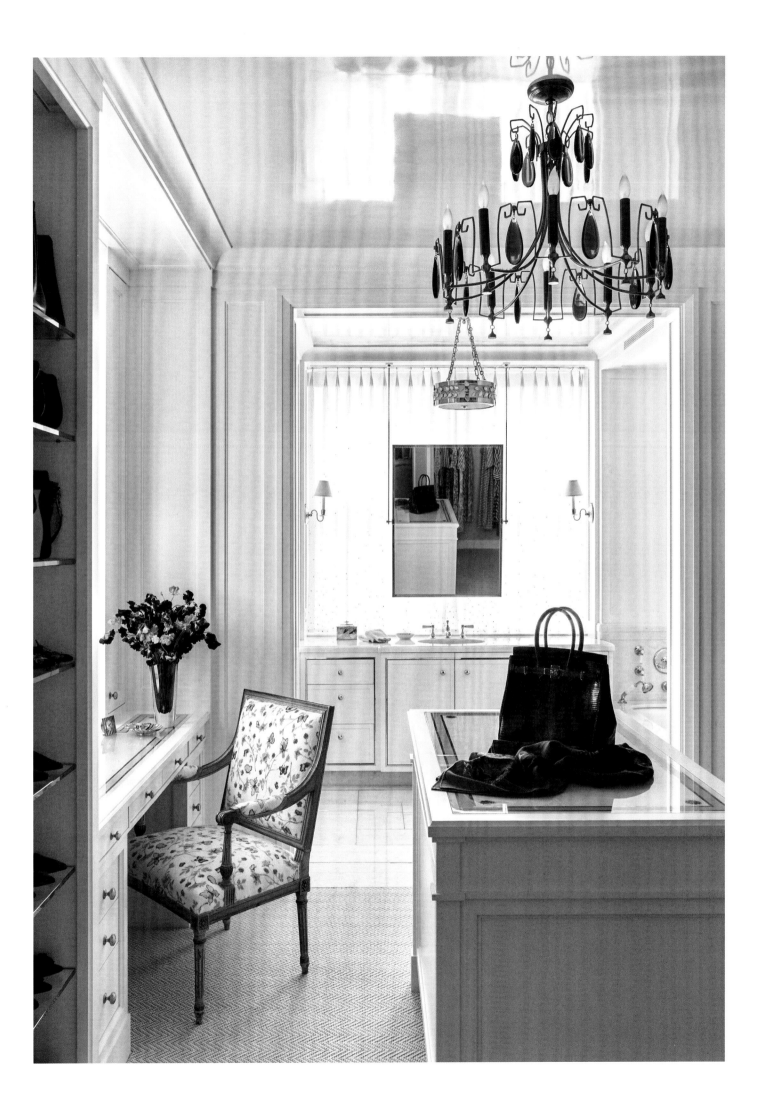

COMING HOME

Houses, in their way, are living beings. They capture our hearts. They carry our memories. Sometimes, just like us, they need a change—a new look—to help them age gracefully, or to embrace eternal youth and renewal. This rambling, well-loved clapboard cottage on the Massachusetts coast, called Wide Windows, was in just that state of comfortable frumpiness when it passed into the hands of one of our favorite longtime clients. Built sometime around the turn of the twentieth century by the wife's grandparents, the house hadn't really been updated since her father made some changes to it not long after World War II. She was keen to keep the spirit of this place she'd cherished since childhood alive for generations to come. She was also determined to bring it into the twenty-first century and to interject her own preferences in terms of color palettes and juxtapositions, all without erasing the cottage's essential architectural character or replacing much of its treasured contents. Douglas C. Wright, the architect, subtly finessed the modernizations, including a new kitchen and a porch addition.

As this project was getting underway, the couple also decided to move out of their Connecticut home of many decades, giving us even more possibilities to factor into our decorating matrix. The client's brief was to reuse as much as possible. Recycle, repurpose, re-edit became our modus operandi. We gave the traditional upholstery forms new life with new fabrics. We incorporated many of her favorite quirky pieces from her various houses—she's always had fantastic taste and an eye for items with lots of personality—as well as furnishings her mother had acquired over the years when she worked with the renowned Dorothy Draper. We mixed in favorites that she couldn't bear to part with, like her grandmother's dining table, Regency center table, and set of Anglo-Indian nineteenth-century breakfast chairs. To ensure this melting pot of memorabilia

OPPOSITE: In the same family for three generations, this rambling home on the Massachusetts coast, called Wide Windows, recently received a refresh for the present generation and those to come. The goal was to bring it up to date while keeping its character intact. OVERLEAF: Living room paneling in considerable disrepair was re-created as it figured deeply in the family's collective memory. The space naturally divided across a center aisle into two extremely comfortable seating areas that relate without outright matching. The newly restored library table, a piece from the client's grandmother, takes pride of place. This room is one of several with the expansive windows that gave the house its name.

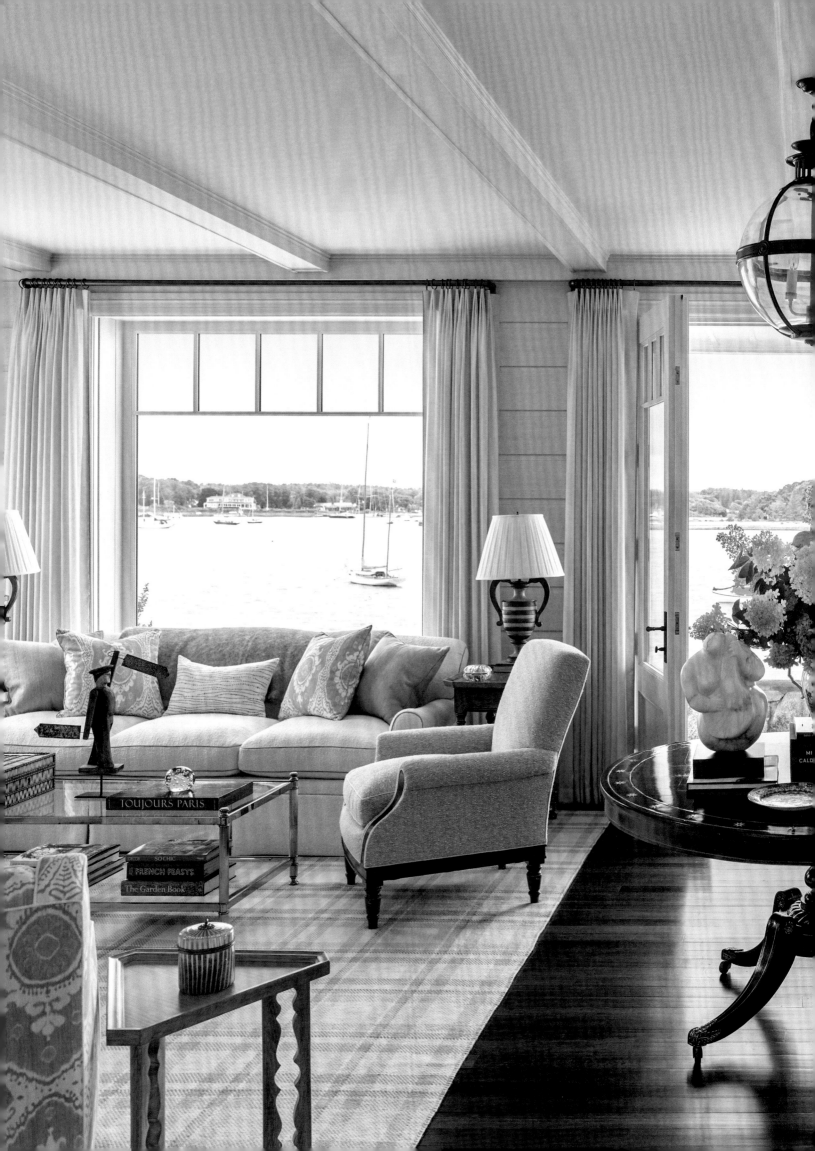

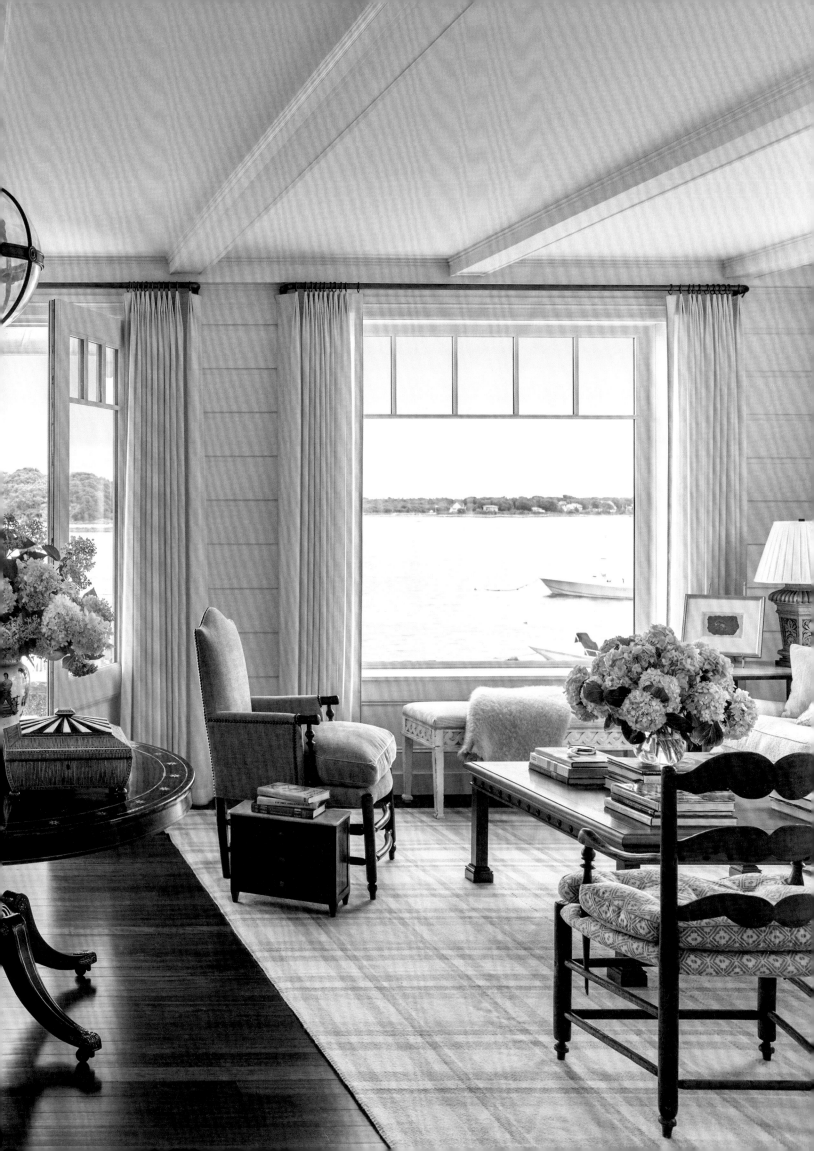

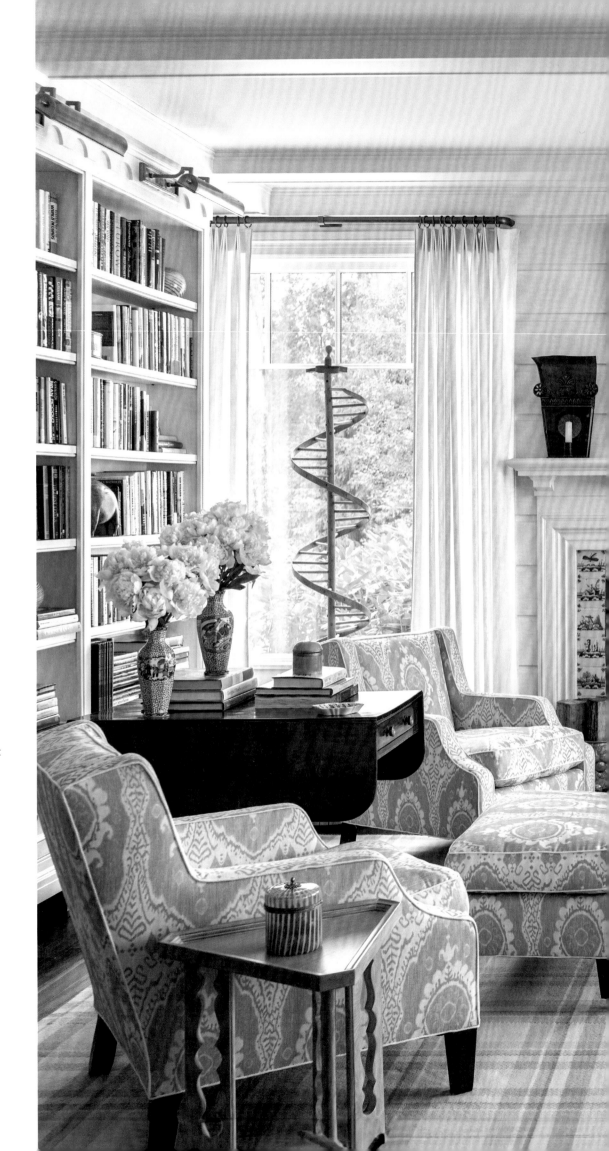

RIGHT: A tried-and-true technique for creating visual harmony is to repeat a complementary pattern in different concentrations on opposite sides of the room, as here with the lounge chairs, ottoman, and sofa pillows. In this room so full of memories, the addition of reproduction seventeenth-century Delft tiles around the fireplace layers in another subtle reference to history, and also to the waterside location. The artwork above the mantel is by David Hockney, one of the family's favorite artists.

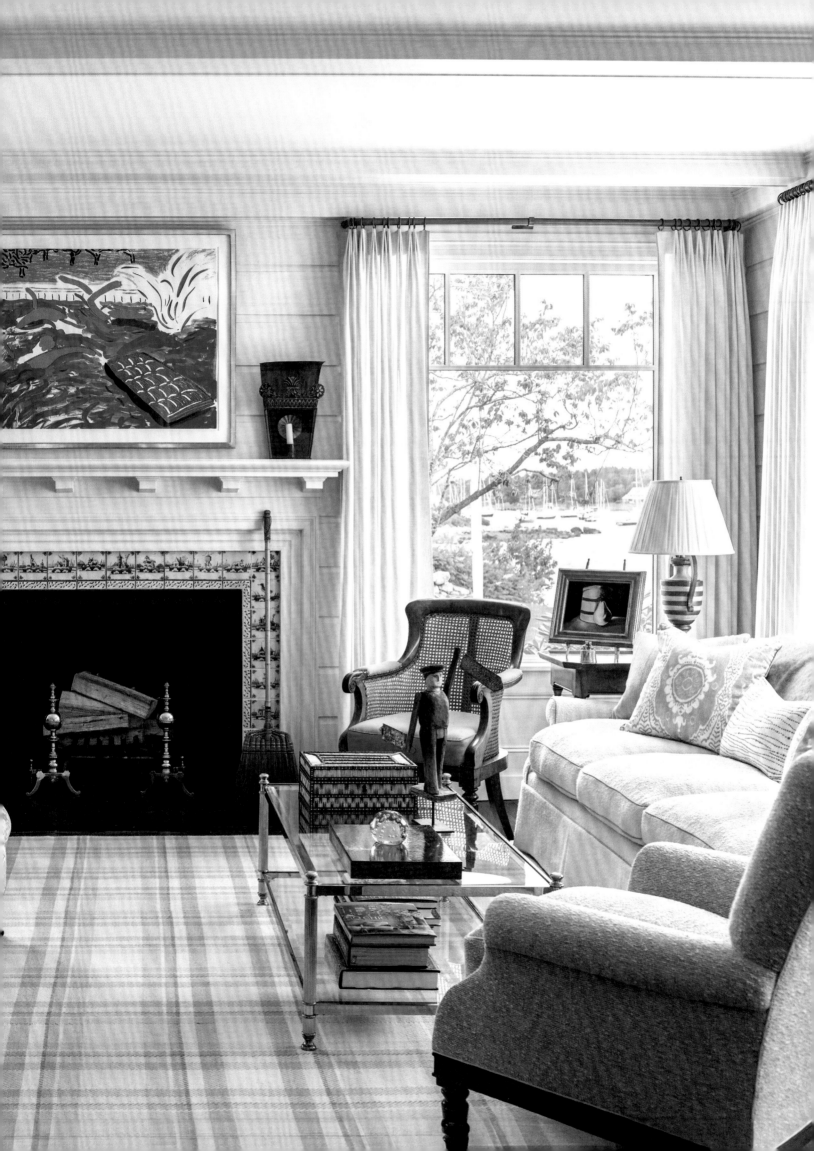

was cohesive, we aimed to make sure the rooms looked as if they had come together over many years instead of saying, "Look at me. I'm freshly decorated!"

For the entrance hall, she wanted something that the kids could congregate around and have fun. Hence the daring decision to center the space around an enormous billiard table that now greets all comers—a first for us.

The living room's low ceiling posed a challenge. Since the existing paneling was not in good condition, we replicated it. The room divided naturally into one seating area by the fireplace, another with magnificent views of the harbor, the two split by an aisle with a central table. When we bisect a living room in this way, we often prefer to underscore the differentiation with contrasting carpets. These clients were keen to use the same rug on both sides, for cohesiveness. We kept the palette consistent across both zones for the same reason, but distributed the fabrics so that the two sides, like first cousins, share a family resemblance but don't twin.

Swathed in olive green grasscloth, the small sitting room exudes a quietly contemporary aura. Strategically scattered pinpoints of the same color give the space energy. What really brings this room into the present, though, is the repetition of the rug's pinwheel pattern in the curtain's chain-link variation. Both echo the artwork above the sofa, which, like so much of the art in these rooms, was brought from the clients' other homes.

Many clients today believe that in a house with antiques, modern art is a must because it's the juxtaposition that gives the house life. Here the thinking was just the opposite. This client felt that period pieces grouped in a modern way—items that her mother or grandmother could have collected, such as the nineteenth-century sailors' woolworks we assembled for the entry—would create just as much aesthetic energy.

RIGHT: The new woodwork is painted white, but lightly antiqued to give it a patina that speaks to the house's age. Curtains are light and sheer to feel summery and to keep the views open.

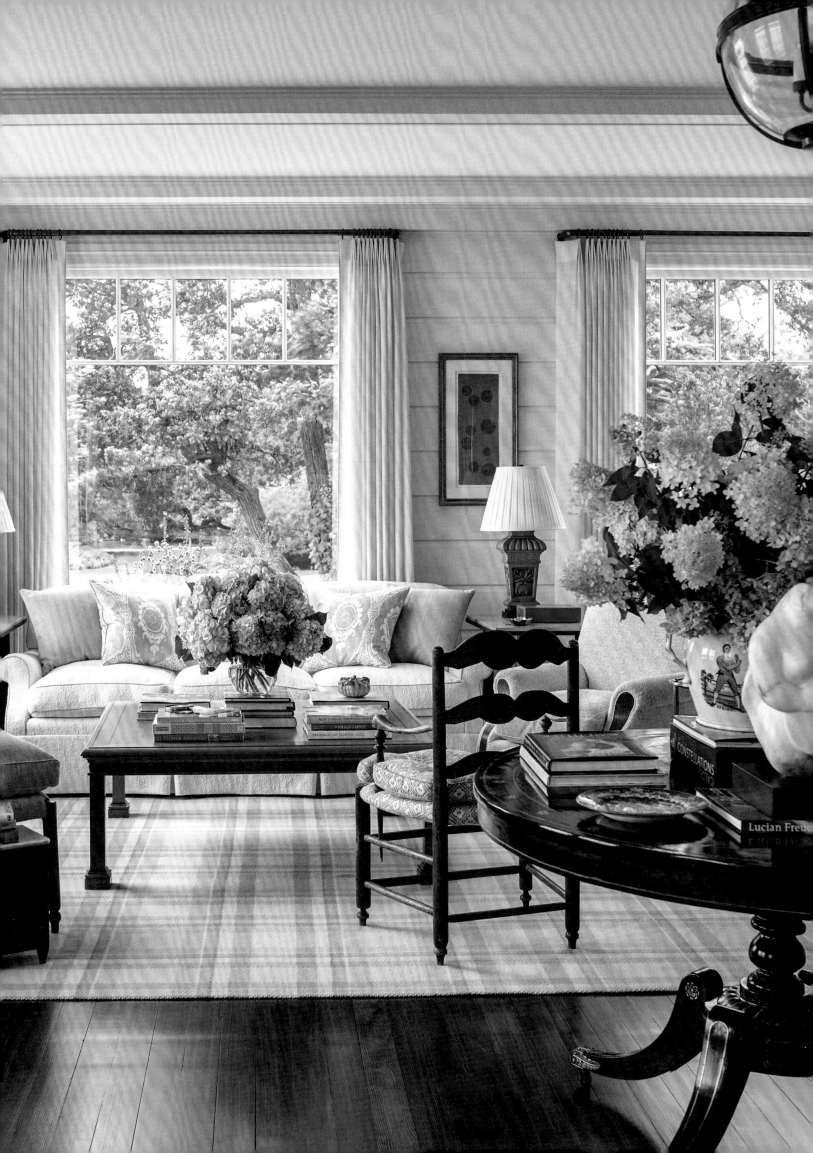

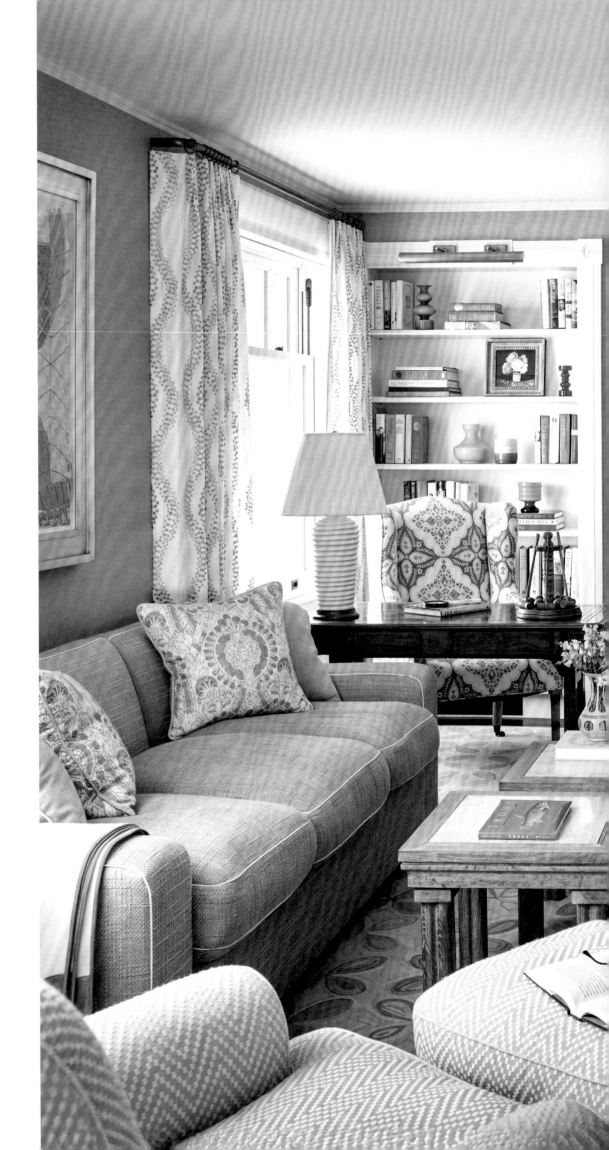

RIGHT: Updating interiors that hold a great deal of family history means the decorating should feel invisible, which presents a true challenge. For rooms to look relaxed and as if they've been collected over time, every element needs to appear to be unobtrusive and inevitable. What matters is that the items that are fresh and those that carry memories blend seamlessly.

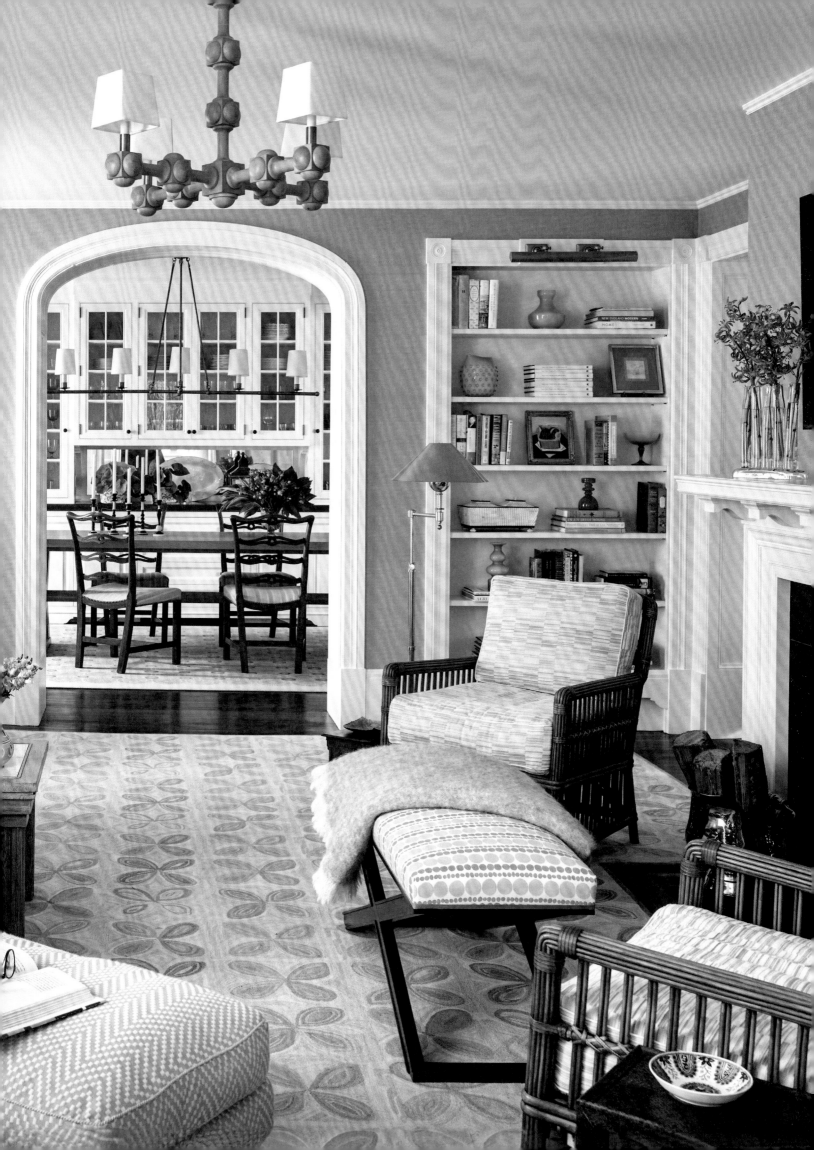

The new kitchen and breakfast room incorporate features of the original design, yet the radiant aquamarine hue freshens the traditional forms. In the former iteration, the upper cabinets divided the two spaces, with an eighteen-inch gap between the upper and lower cabinets serving as a pass-through. With its open plan, high-gloss walls and cabinetry, Jasperware pottery, and the twentieth-century prints, which had been center stage in their Connecticut family room, the combined area translates the past forward.

The primary bedroom is a wonderful paradox of a space with its lofty ceiling and harbor views, but its eccentric rooflines meant we had to toss our usual reliance on symmetry right out the wide windows. On the other hand, it's this very asymmetry that gives the room its dynamism.

We've long championed variety for each guest bedroom, and lean into the importance of this when two of them share a Jack- and-Jill bath, as here. We upholstered the walls of one in a graceful, old-fashioned print that would have felt at home in this house decades ago. In the other, we installed a pair of twin beds from the original house. The semicircular bath, part of the renovation, takes on a nautical air with its bow of windows and lantern overhead. Just beneath the bath, the new semi-circular screened porch adds a key recreation space the original house lacked.

The "Think House," a separate building originally constructed for the current owner's father, had long been languishing as a storage unit. With ingenuity, a fresh coat of paint, plus furniture and a rug from the Connecticut house, we turned it, just like that, into her husband's special private hideaway.

We tend to measure each project by whether tears flow when the client crosses the threshold for the first time after we've intervened. In our many projects with these clients, we've found it's usually the husband's eyes that tend to well up. Here, hers did. Knowing we restored this special place in a way that kept its spirit and memories intact, and better yet, made room for more—that's the best feeling ever.

RIGHT: Furnishings that meld rather than match help make a room feel collected over time. The wood chandelier overhead gives the low-ceilinged space a virtual lift. OVERLEAF: Traditional chairs with contemporary fabrics feel livelier—like your mother in a new dress. Practical and pretty, an abaca rug offers endless design possibilities. The sailors' woolworks add a historical flourish with a note of nostalgia for this seaside community.

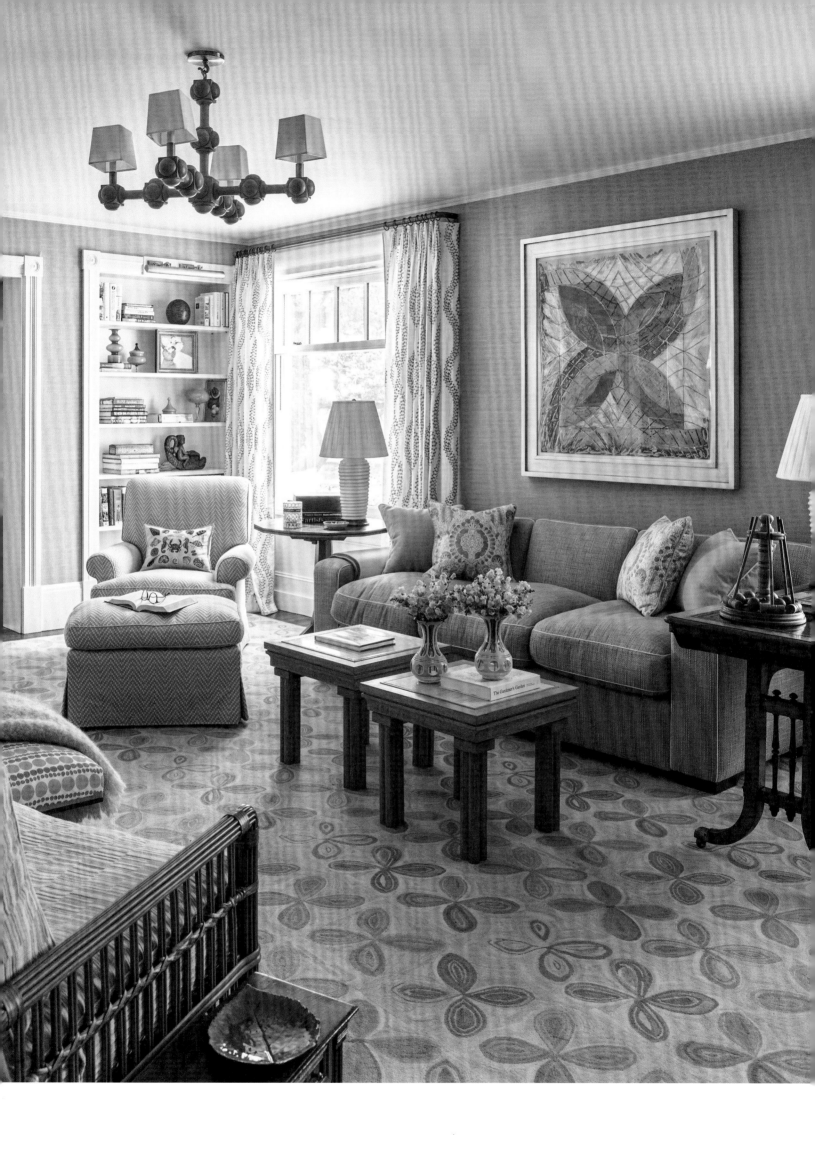

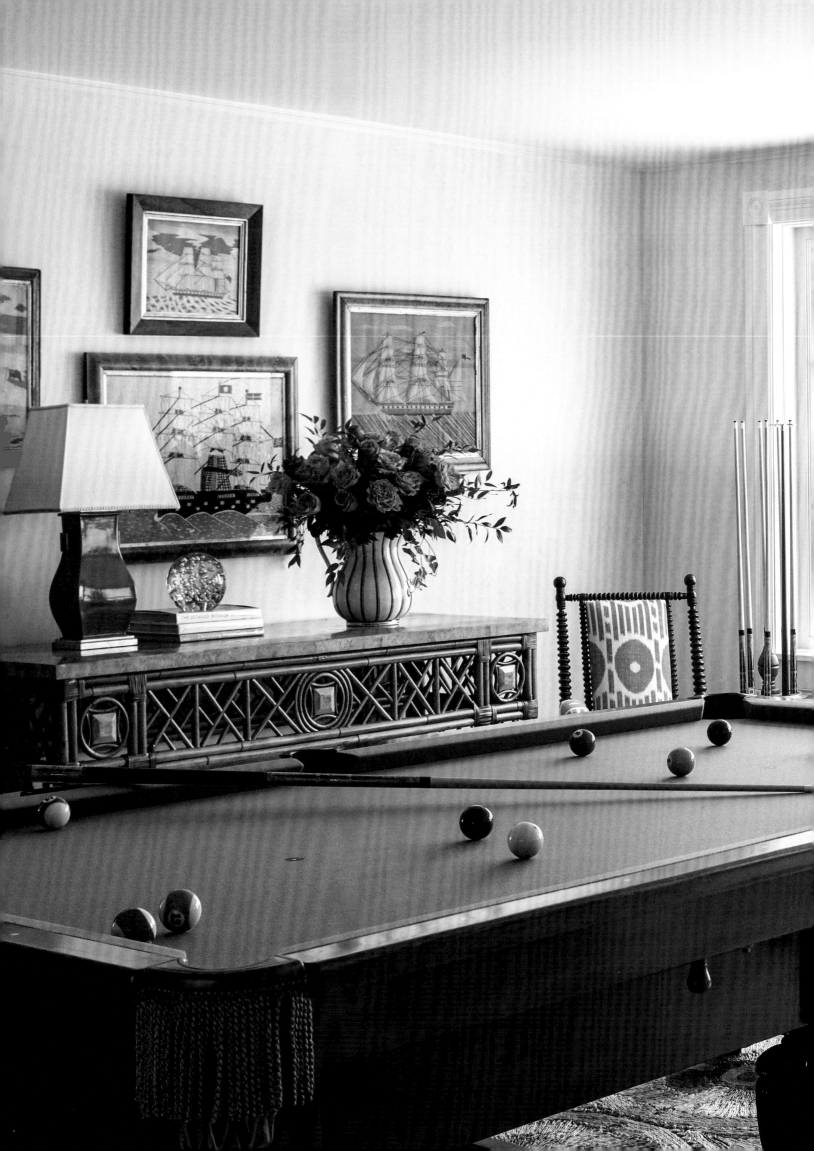

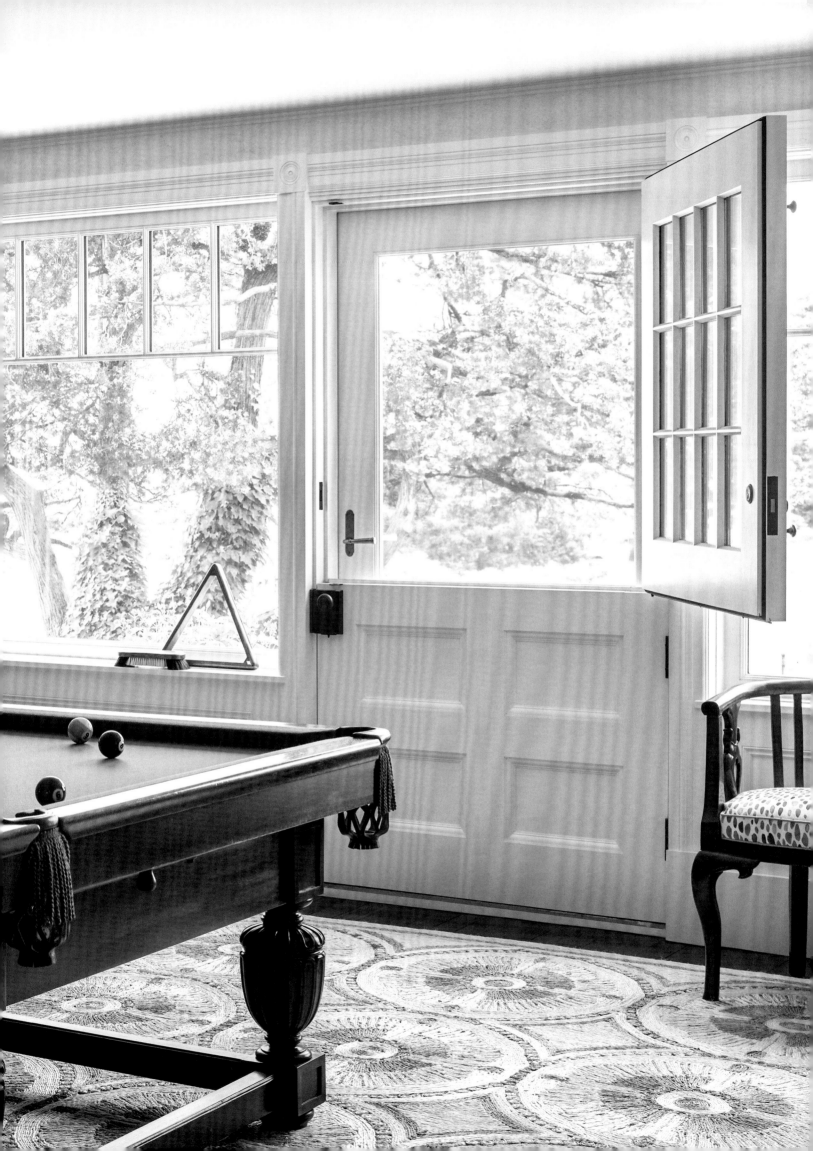

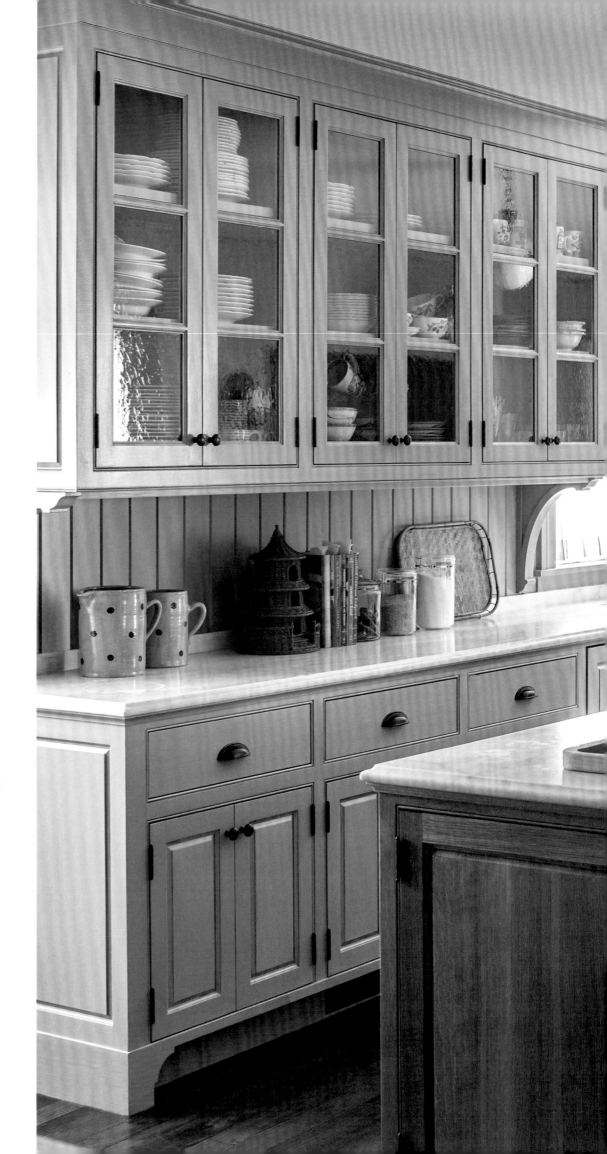

RIGHT: Most kitchens have a plethora of downlights, which create cones of illumination that aren't especially functional or flattering. With careful planning and the right pendant fixtures, it's possible to provide the necessary task and ambient lighting in a way that is also aesthetically pleasing. High-gloss paint finish helps make the planked walls and traditional cupboards here feel modern while reflecting light through the space.

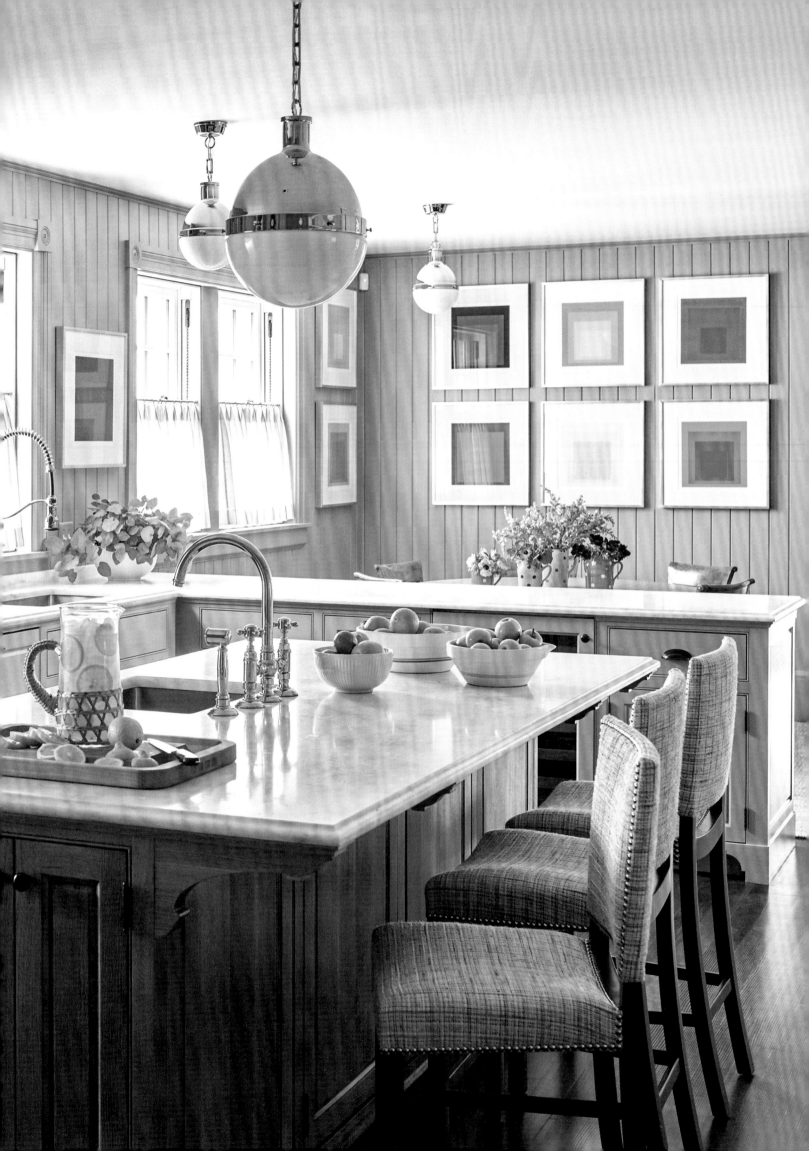

COLOR

Imagine the world without color. Dull. Bland. Boring. It's fascinating how personal the connection is between the spectrum and our species. Each of us sees and feels color in our own way. Even if we're mesmerized by the same red hue, my definition of carmine is different than your scarlet. Factor in the sensations that the spectrum with its shades of red, orange, yellow, green, blue, indigo, and violet conjures in each of us, and we're back in the land of decorating's greatest mysteries.

Years ago, we derived our palettes by pulling mostly from hues found in antique oriental carpets or porcelain. Today, the sky's the limit—and not just for inspiration when it comes to the visual splendor of tints, light, and shine. Each client teaches us a new appreciation of pigment and its possibilities, as well as its application to a room's function. We used to think pink suitable only for little girls' rooms. Now we love it everywhere, but we call it "blush" to appeal to men as well as women. The color purple? No longer outside our consideration. All-white kitchens couldn't be more classic, but we're over them—as are many of our clients. And when we cloak spaces in white for our art collectors, we find other elements to generate excitement.

Specific shades have always cycled in and out of style. Clients' tastes obviously span the spectrum. Some may want mostly blues, or predominantly earth tones. Our challenge is to balance the chosen palette, whatever it is, in ways that please the eye, transform each room into its own experience, and create the most interesting segues.

It's the memory of color's flow through the interior that creates comfort. If there's a raspberry room here, and the adjacent spaces tend to taupe and spring green, that shade of berry needs repeating elsewhere to create cohesion without being obvious. We make color charts to track the movement of each hue through the space, and we draw palette choices directly on floor plans to fine tune the balance of hues and their repetition. The same goes for wood choices—each type an entire color family of its own.

Unusual requests are our favorites. Everything under the sun goes, because color goes with everything.

OPPOSITE: The vertical planking in the kitchen and breakfast area nods to the horizontal paneling in the living room, a visual tie that joins this addition to the original architecture. The British Colonial dining chairs and nineteenth-century French pottery pitchers are in keeping with the romance of the house's past, while the Josef Albers prints bring the space into the now.

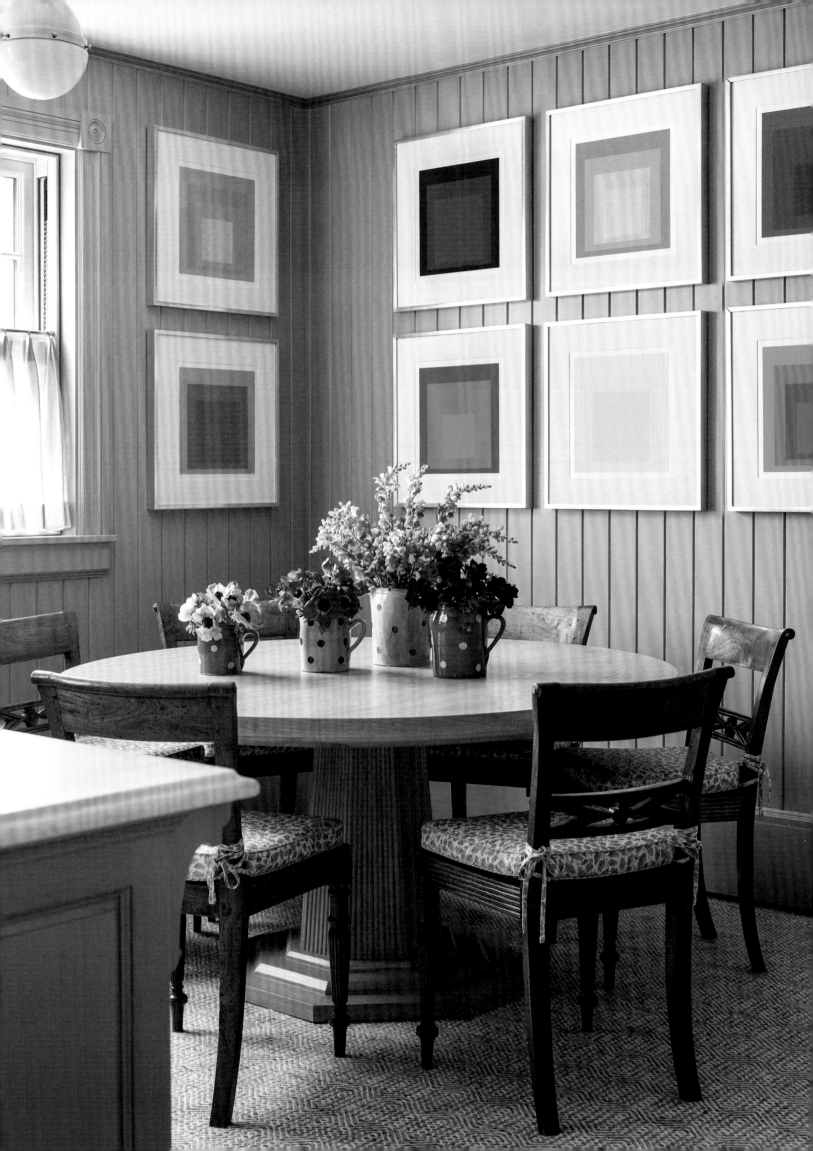

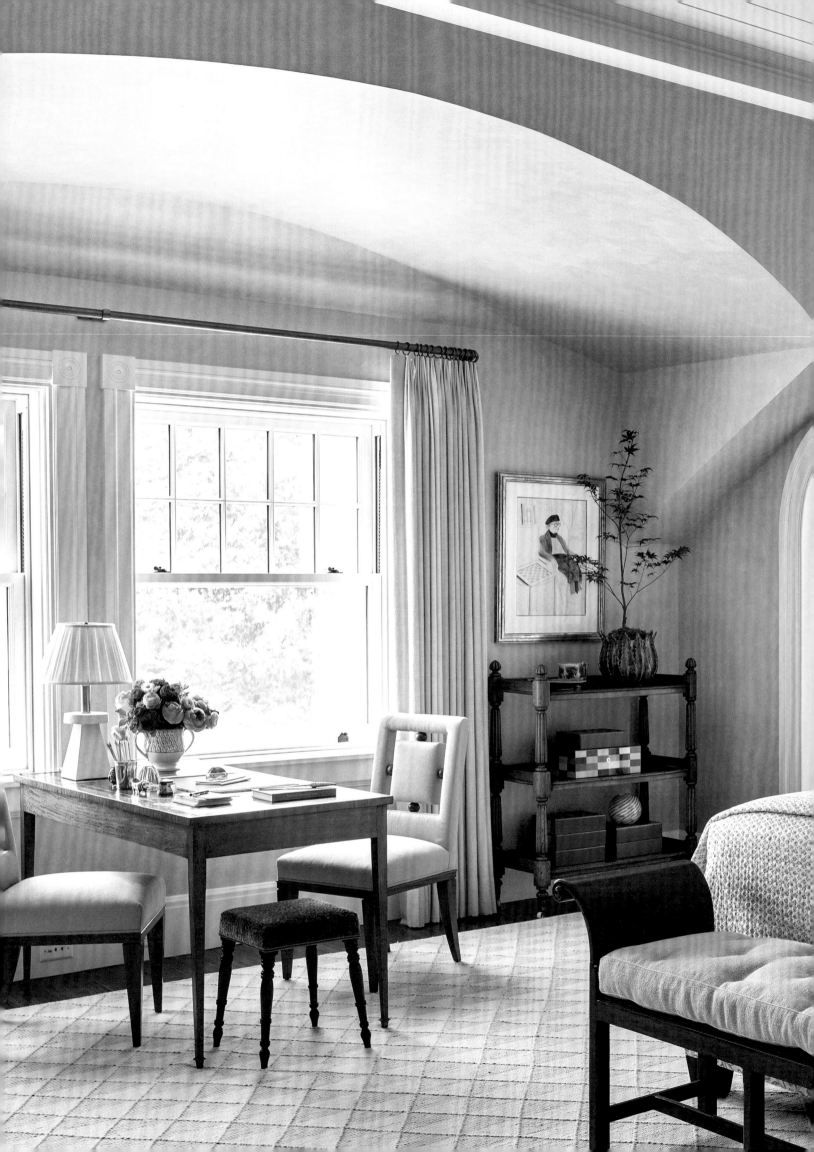

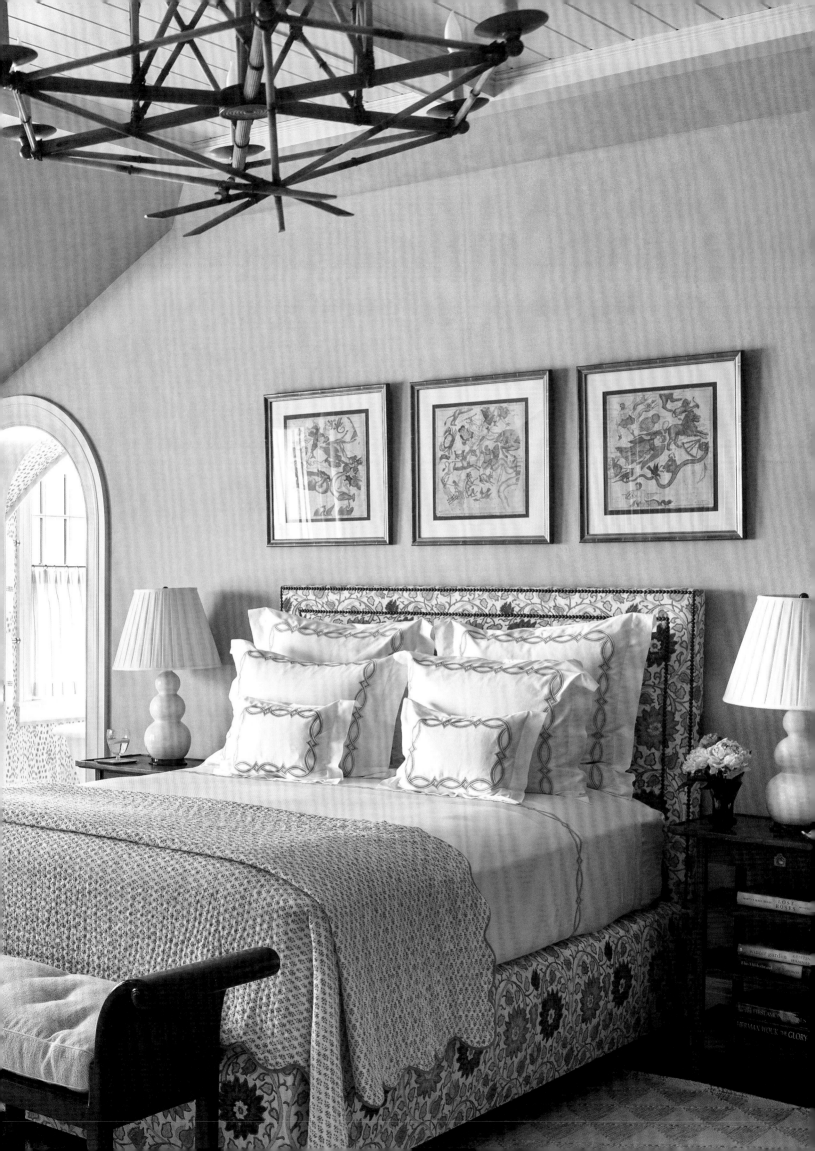

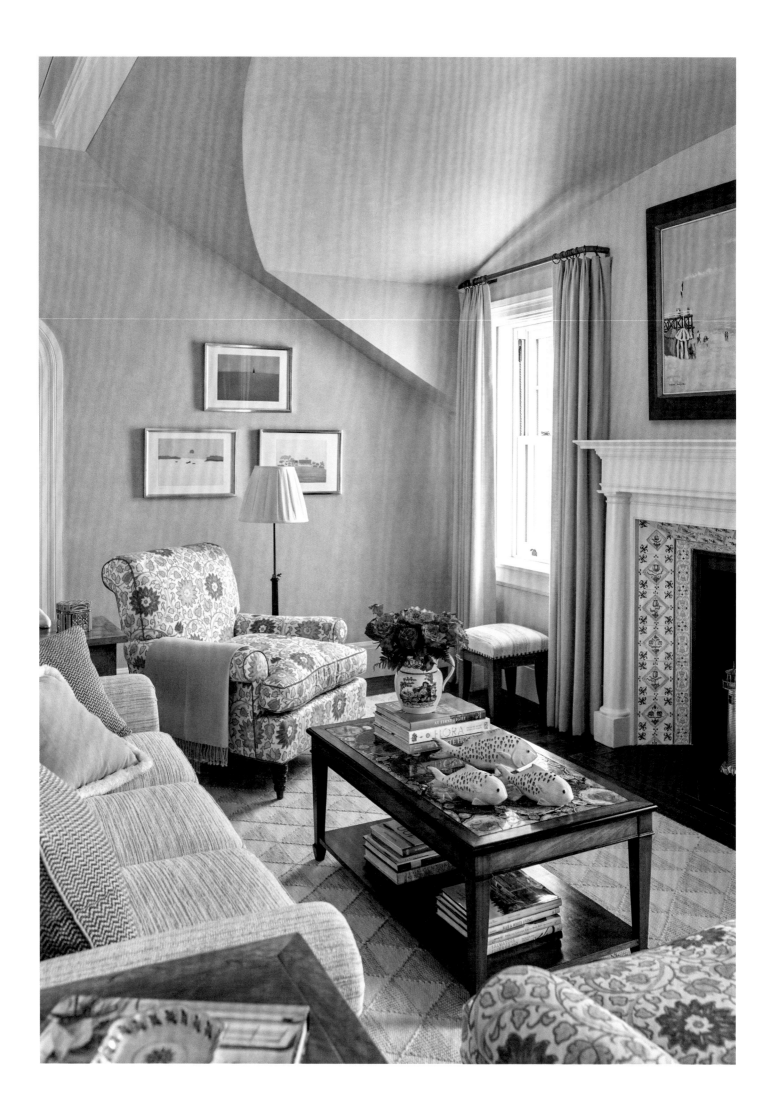

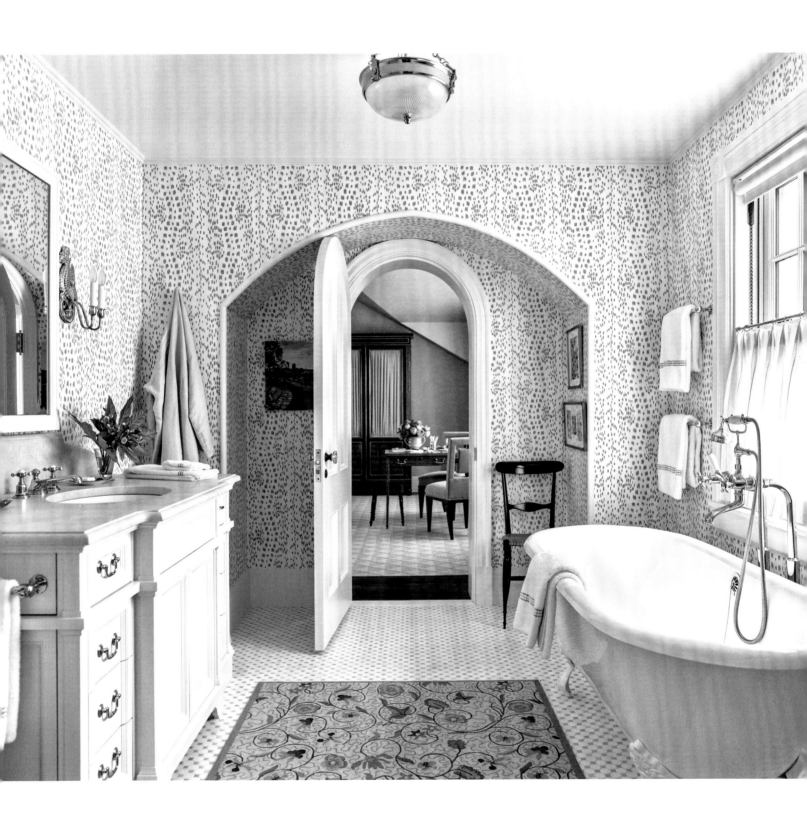

PREVIOUS PAGES: Embracing the eccentric rooflines kept the room's character intact. The cheery wall color repeats in the bed throw. OPPOSITE: The lounge chairs' lively linen print, which was the catalyst for all our choices, recurs on the headboard. The living room's Delft tile reappears here, in coral. ABOVE: An eighteenth-century fabric fragment found in the Paris flea market inspired the design of the bath's carpet.

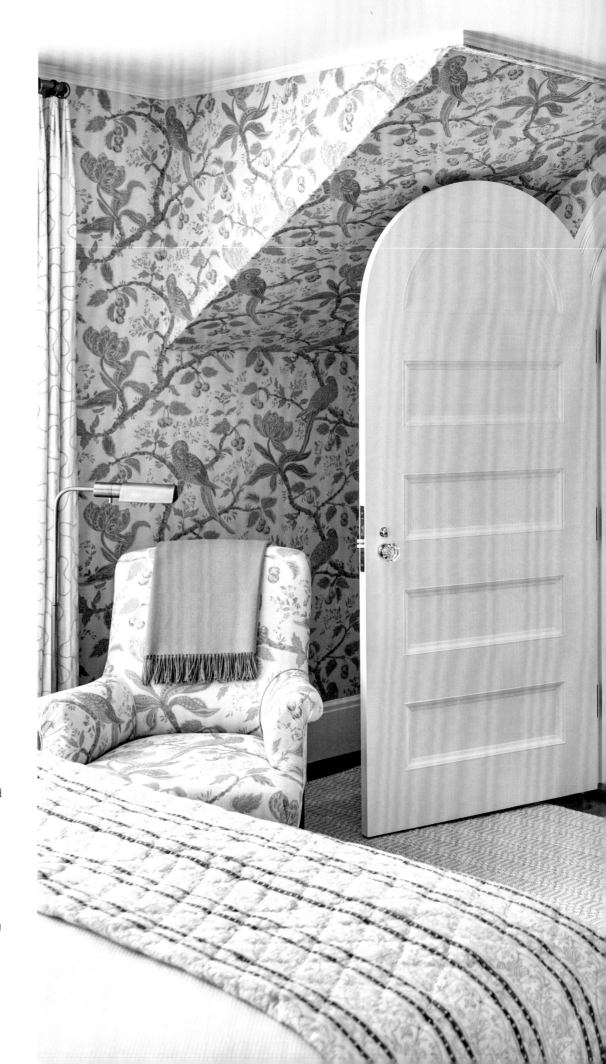

RIGHT: Nothing feels more cocooning than being enveloped in a bedroom of patterned fabric: the effect is like an amazing lining in a jacket. For continuity, we pulled the pattern off the wall and onto the armchair. Quilted bedspreads in soft voile provide a calming foil for the walls.

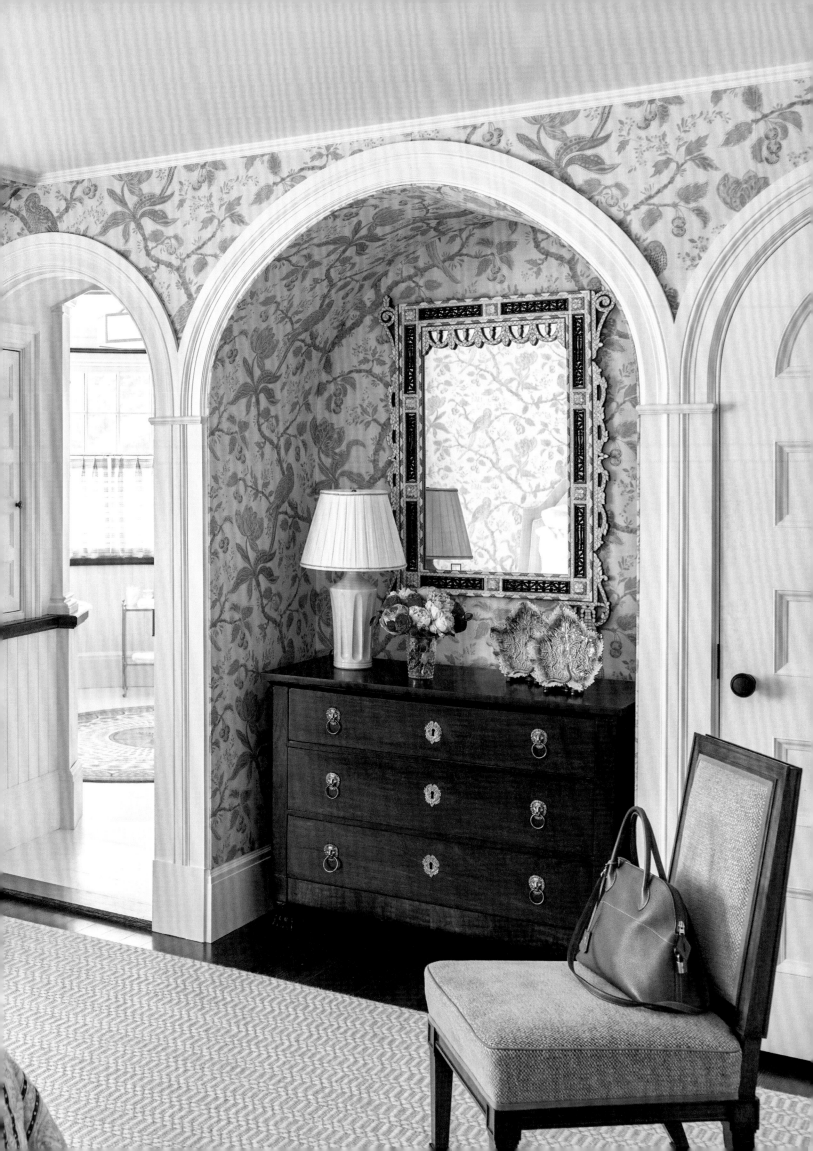

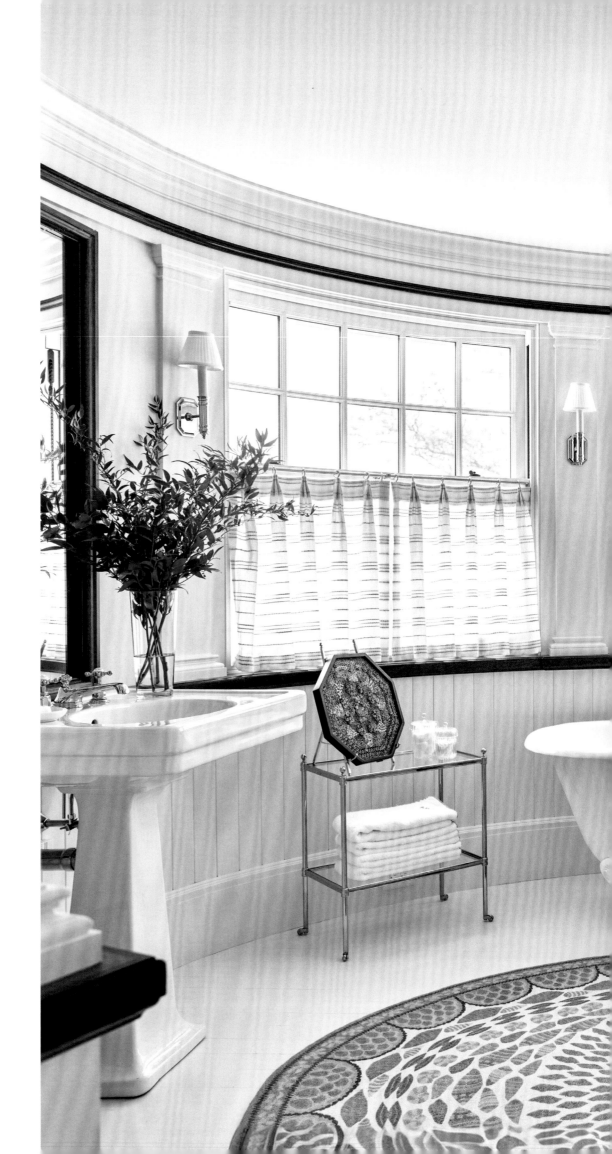

RIGHT: To brighten this capacious bath, we painted the floor with white deck paint. Wood trim, an antique bobbin chair, and mahogany accents add warmth and coziness, while the patterns of the rug and sailor's valentine reflect and play off one another and the room's unique geometry.

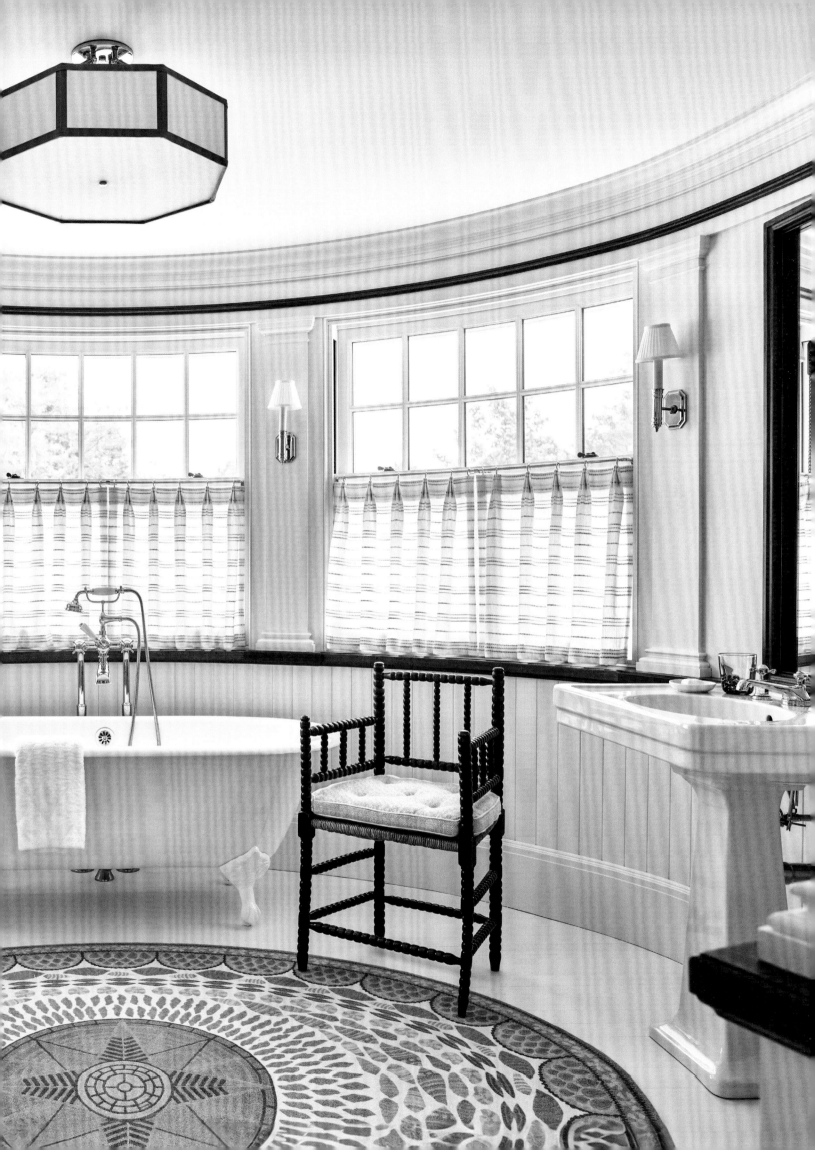

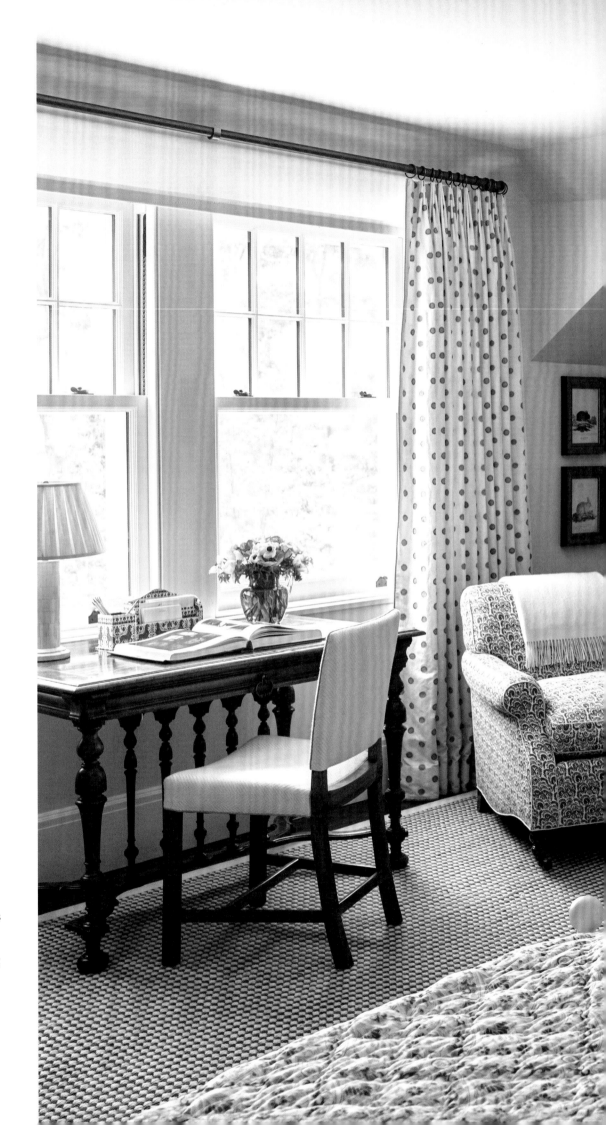

RIGHT: The second connecting guest room off the round bath keeps pattern to the windows and bedspreads—and box springs upholstered in a crisp stripe. The bedframes have been in the family for generations; a fresh coat of paint gave them new life.

OVERLEAF: This porch addition is the hub of summer living for the family. At one end is a dining area that seats twelve. Spanning the remainder are two separate seating areas; one is furnished for lounging, the other for conversation.

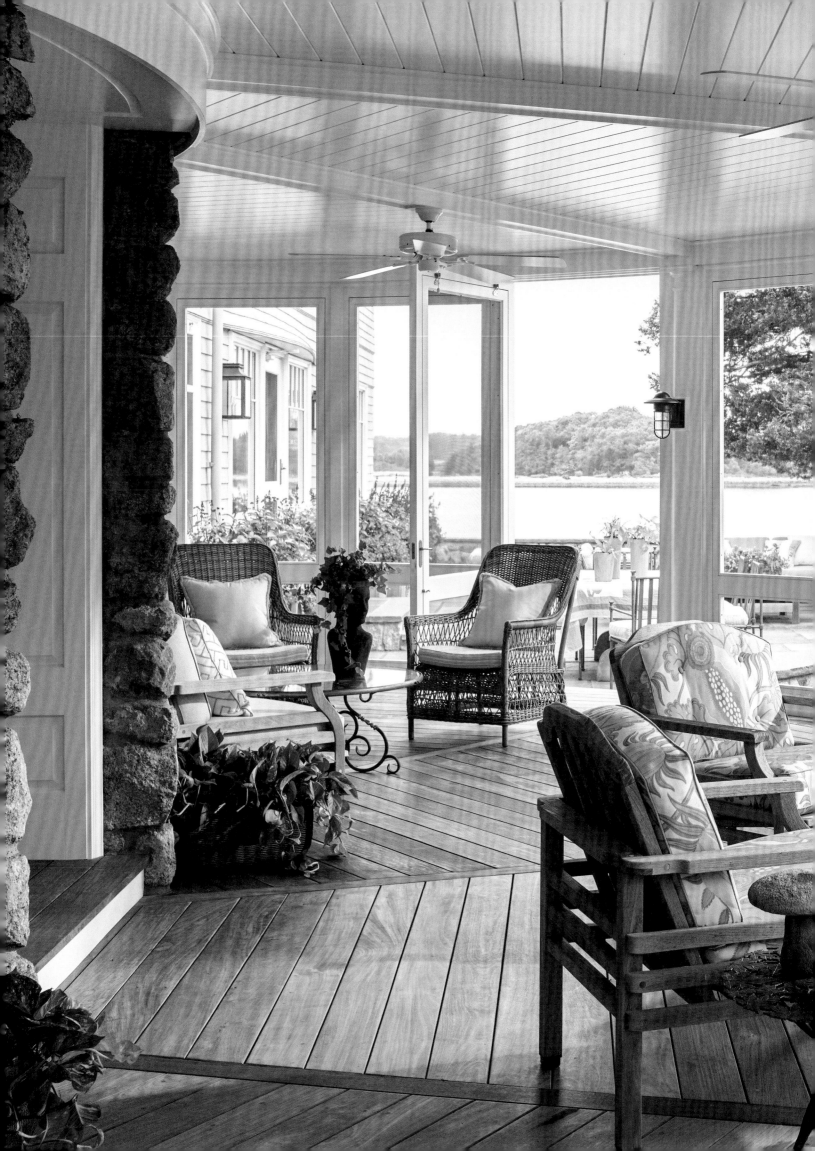

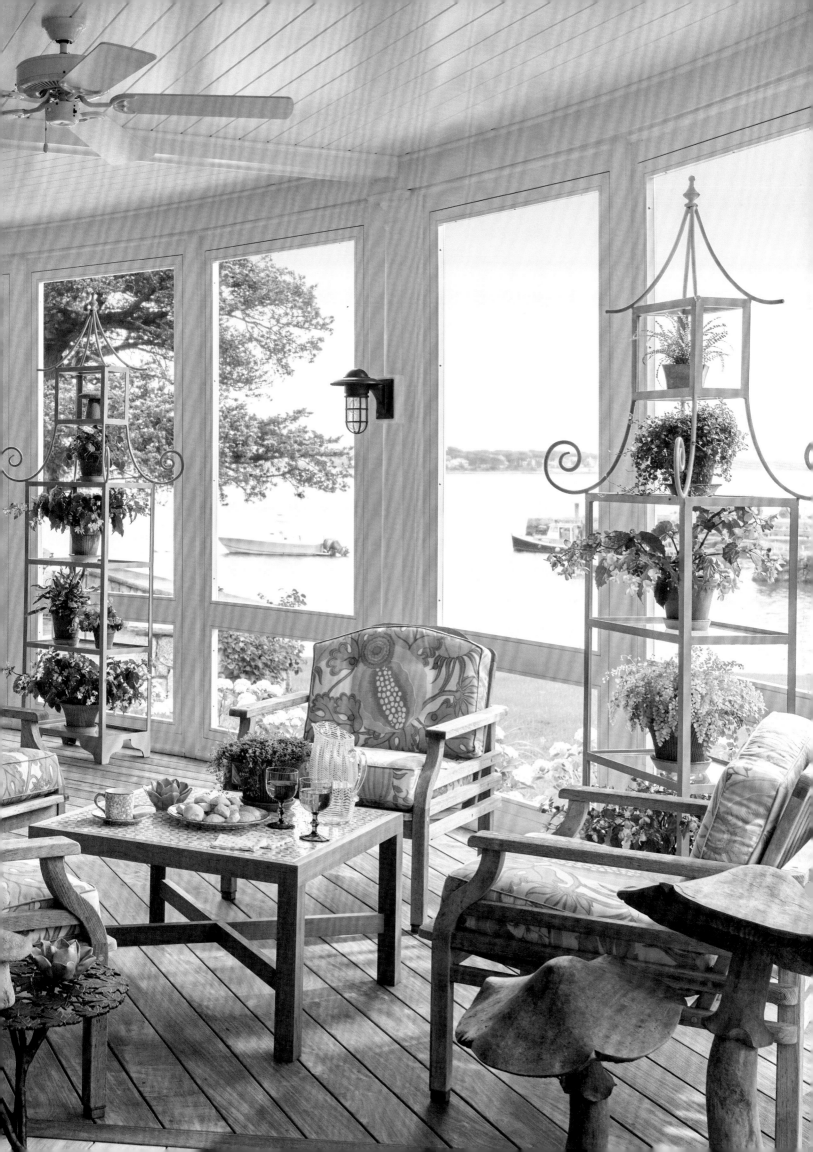

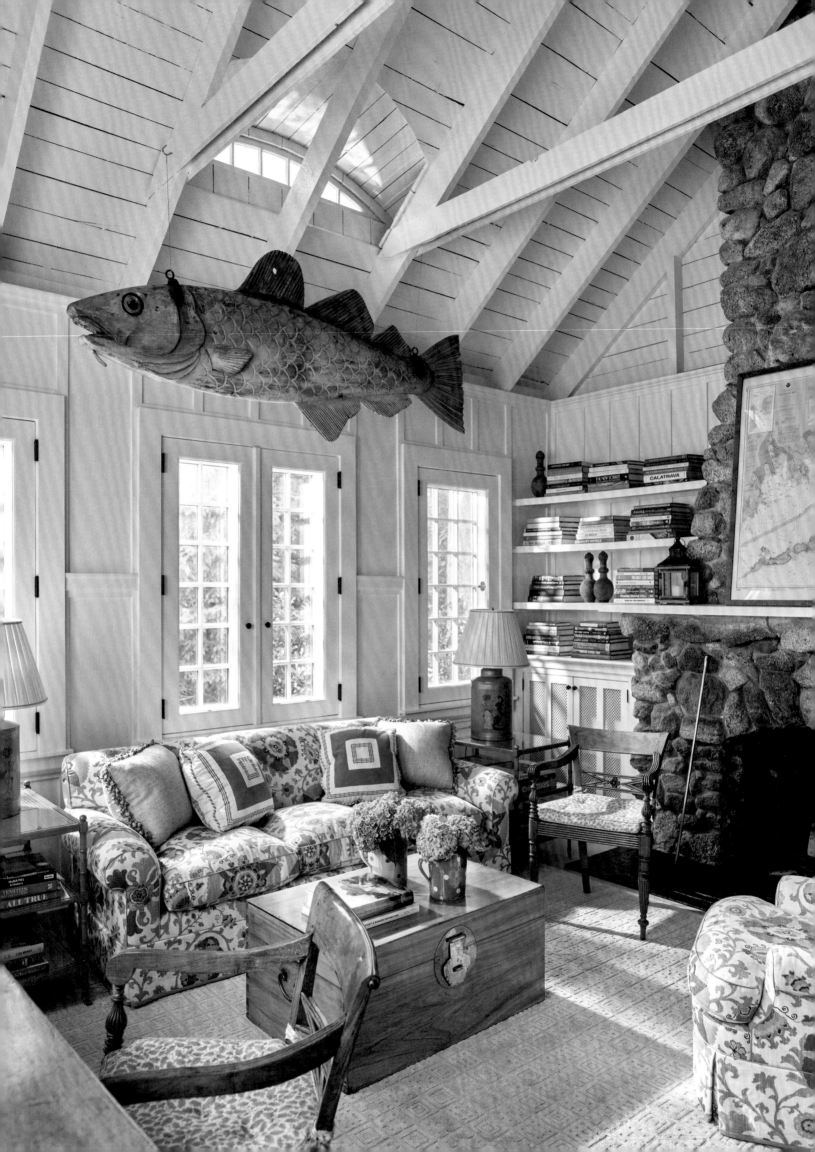

OPPOSITE, AND ABOVE: With some tender loving care, a fresh coat of
paint, and some clever choices, we brought the "Think House"
back into the fold of this family's life. On high is a folk-art carving
of an Atlantic cod, a found object that perfectly suits the setting.

BRINGING THE
OUTSIDE IN

A picture may be worth a thousand words, but no one picture ever captures the full story. The paradox of what is and isn't an obvious design intervention speaks to the backstory of our design for this serene Palm Beach residence. These clients have a very pared-down aesthetic. This led us toward a new interpretation of modernism's maxim—less is more—one that blends our passion for detail with their eye for restraint. Having already built multiple homes, these clients were experienced in and deeply knowledgeable about the process. The wife, who was educated in design, relished taking a deep dive into every decision and detail. The result blends an ocean-inspired palette with carefully selected and placed art, custom upholstery and curtains, and furnishings that mix treasured pieces from the 1940s for adult admiration and catalogue pieces for romping grandchildren. If it all feels effortlessly comfortable and relaxing, as if it occurred by happenstance, we've done our job well.

Our clients worked with Roger Seifter of Robert A.M. Stern Architects to build an indoor-outdoor home that could welcome multiple generations and would make the most of the remarkable waterfront property. In the resulting twenty-first-century two-story glass box, clear, seamless corner windows and retracting glass walls and doors dissolve the distinction between interior and exterior. The layout organizes the main living, entertaining, and private spaces on the second floor to capture

OPPOSITE: From the artwork to the furnishings, the entry hall introduces the influences that blossom in the rest of this house. The ceiling fixture by Hervé van der Straeten speaks to the clients' love of contemporary design, while the Paolo Buffa cabinet reflects their passion for unique vintage pieces. The sconce, one of a pair, was purchased in Paris. The artwork by Roy Lichtenstein makes an opening statement with high impact. Pavers ease in from the breezeway as a preliminary gesture in creating a seamless transition between interior and exterior.

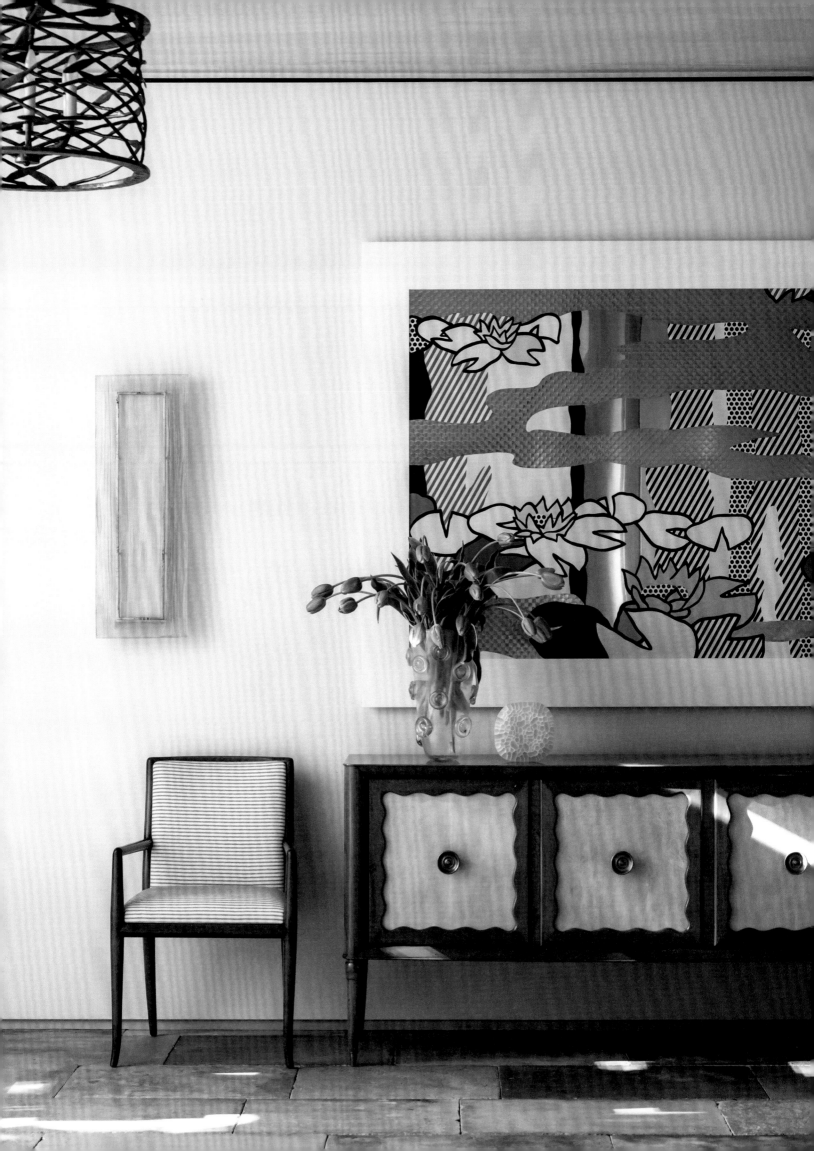

the vista of nature, the pool, and the pool house below. Loggias take further full advantage of the spectacular 360-degree panorama. A through-line of natural materials—pecky cypress, coral stone, bleached walnut boarding, Venetian plaster—creates an extremely cohesive setting. The lushness of the scenery outside inspired the soft palette of creams with touches of blue, which in turn allowed the art—including stellar pieces by twentieth- and twenty-first-century icons, and others—to provide moments of intense color indoors.

Together with our clients, we shopped in Paris and New York, where we found some extremely special pieces—designs like a Gio Ponti cabinet from 1945 that's at once formal and fanciful. Soon after that trip the first grandchild arrived, so the project began evolving into its current casually artful iteration.

In the main communal area upstairs that merges living room, dining room, and kitchen, we worked to tie the three functions together for consistency. This may sound straightforward, but it wasn't, mostly because of the large scale of the room, which expands even farther whenever the couple opens the walls and the interior spaces flow, uninterrupted, into the two loggias. The kitchen island, for example, needed to stretch to fifteen feet, and the sofas to twelve and fourteen feet, to look and feel proportionate to the space. The coffee table likewise needed to adopt the dimensions of a queen-size bed and carry an onyx top a substantial four inches thick to relate well to the room-spanning mantel it sits near.

RIGHT: Pattern plays many roles in design, but in this forty-five-foot-long multitasking space it has a functional as well as a decorative purpose. Curtains and carpets define individual areas and create intimacy within the large great room shaped by the natural neutrals of pecky cypress, walnut walls, and coral stone. An expansive painting by Joan Mitchell focuses the view above the fireplace.

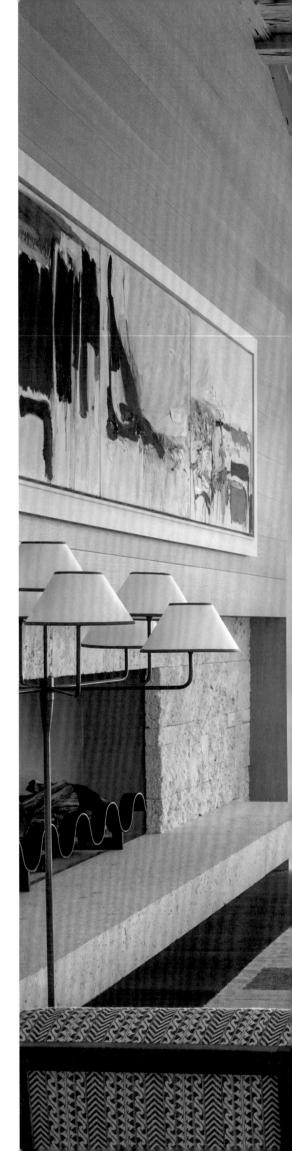

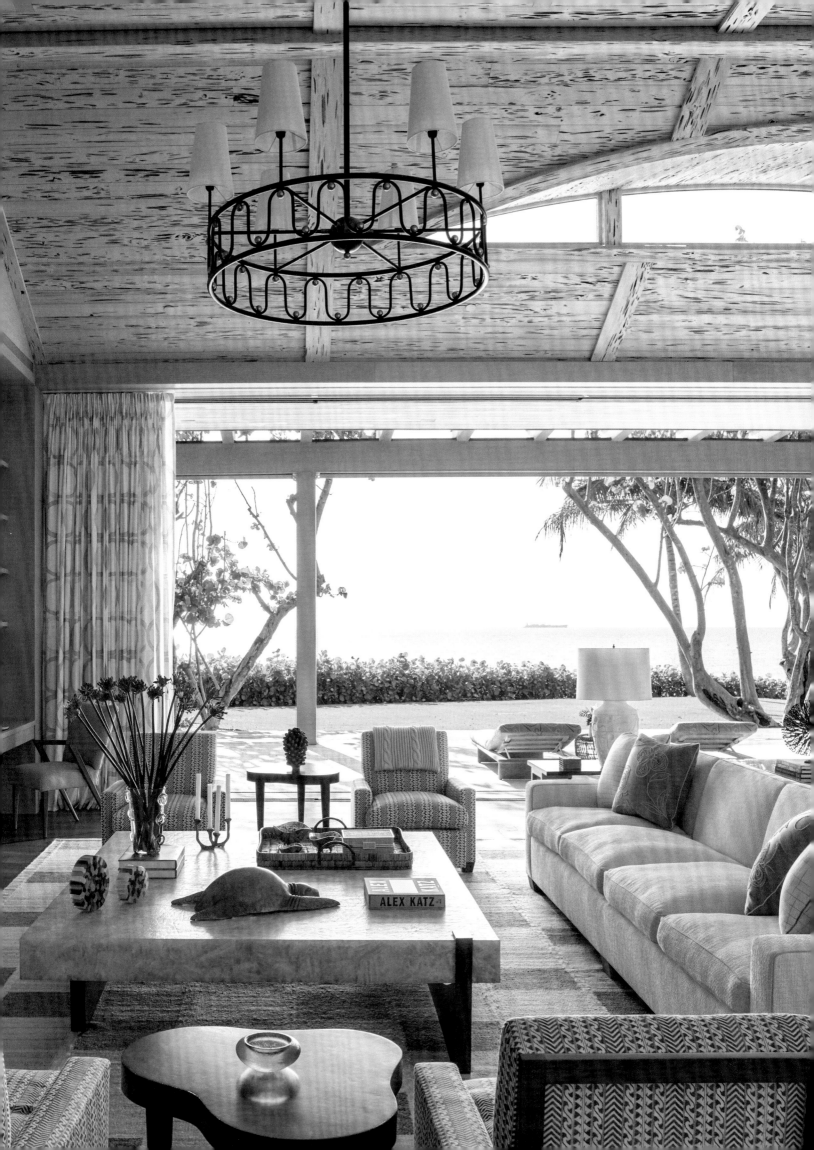

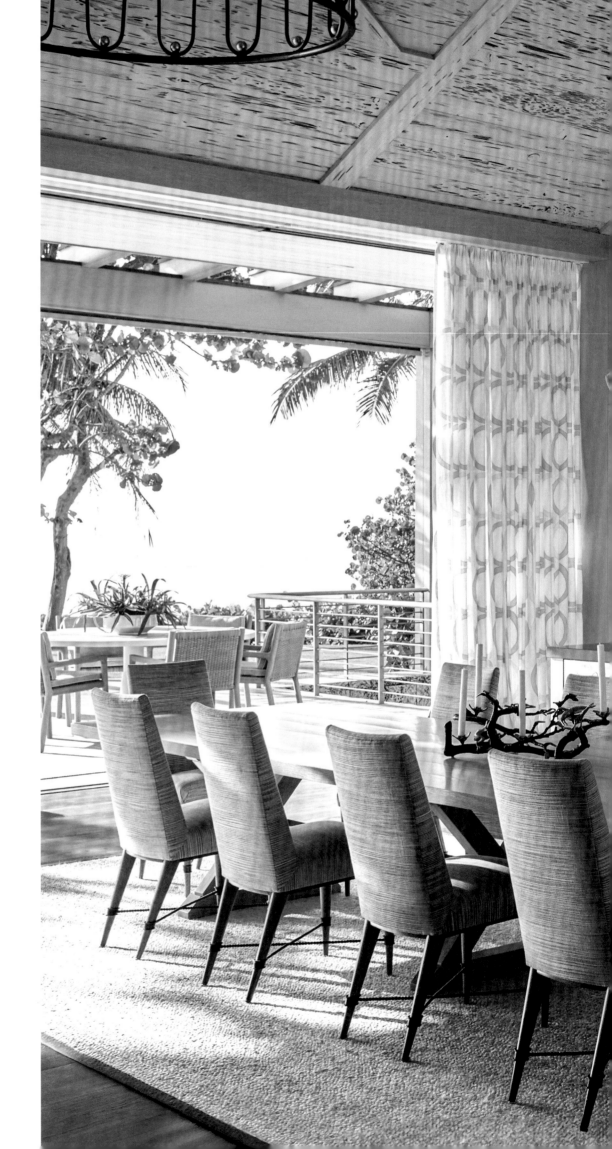

RIGHT: Nancy Lorenz's panel, which fronts the kitchen island, captures the view of the continually churning ocean outside in an abstract vocabulary. Inspired by Japanese screens, this dynamic artwork serves as a spectacular spatial divider between the dining area and the kitchen. A wall of retractable doors conceals the pantry, sink, cooktop, and refrigerator. Dining chairs, by Jean Royère, were purchased in Paris.

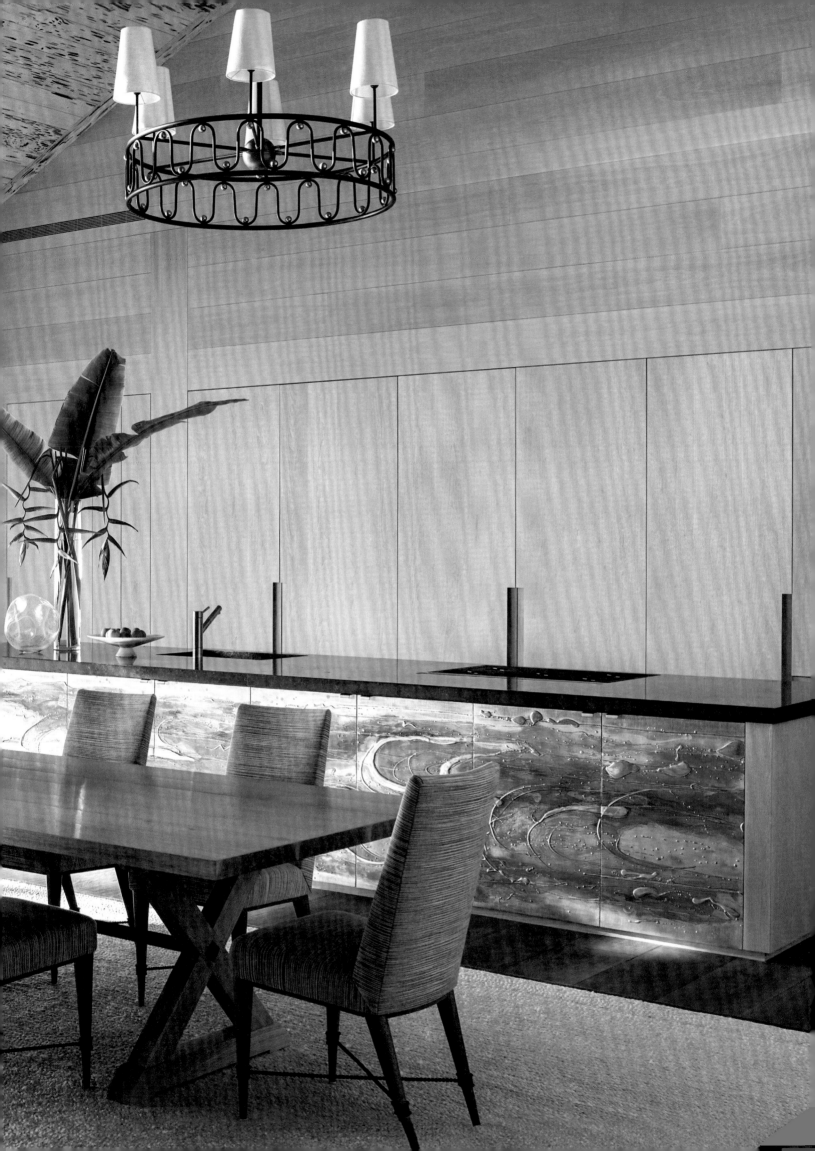

ROOMS THAT MULTITASK

Today's lifestyles are generally more informal than when Cullman & Kravis first opened. Because clients want to use every last square inch of their homes every day, and because today's homes now often host multiple generations, we've become hypersensitive to creating floor plans that respond to the complexity of life in three dimensions.

We typically develop two or three plans for each room. When we sit down with clients to analyze which will be the most successful for their family, their goals for the room and the functions they want it to serve, flexibility is, lately, key. As a result, we choose, organize, and balance the movable and fixed pieces differently. There's more latitude to decide, for example, that an L-shaped sofa will anchor the space, and everything else can and should be movable to suit the day's activities.

The idea of the living room as the home's dressiest space, inhabited only on formal occasions, has been passé for a while. Today's living room more often multitasks as an office, a children's study center, or playroom. This metamorphosis inspired us to toss out at least one rule from our rather rigid old days. No longer do we prioritize a formal sofa flanked by two lamps and a coffee table with a stylistic reference to the sofa's form and period. Now we activate the room with multiple options for comfortable seating and often a TV so the space gets the everyday use it deserves.

For many families today, the formal dining room has also gone the way of the receiving parlor. To replace it, we're often asked to create a dining room/den. But there's still no better place for kids doing homework together than the dining table—the quintessential multifunctional piece for generations now—and if there's no dining room, everyone congregates in the kitchen, so make it comfortable and fun. Evolving functional parameters invite so many intriguing design options. Today, flexibility rules. So there's much more to a perfect floor plan than perfect furnishings.

OPPOSITE: Inspired by Jean Royère's iconic lighting pieces, the ceiling fixtures simultaneously define and unite the individual areas within the spatial envelope. The embroidered pillows were inspired by the Lanvin room in the Musée des Arts Décoratifs in Paris.

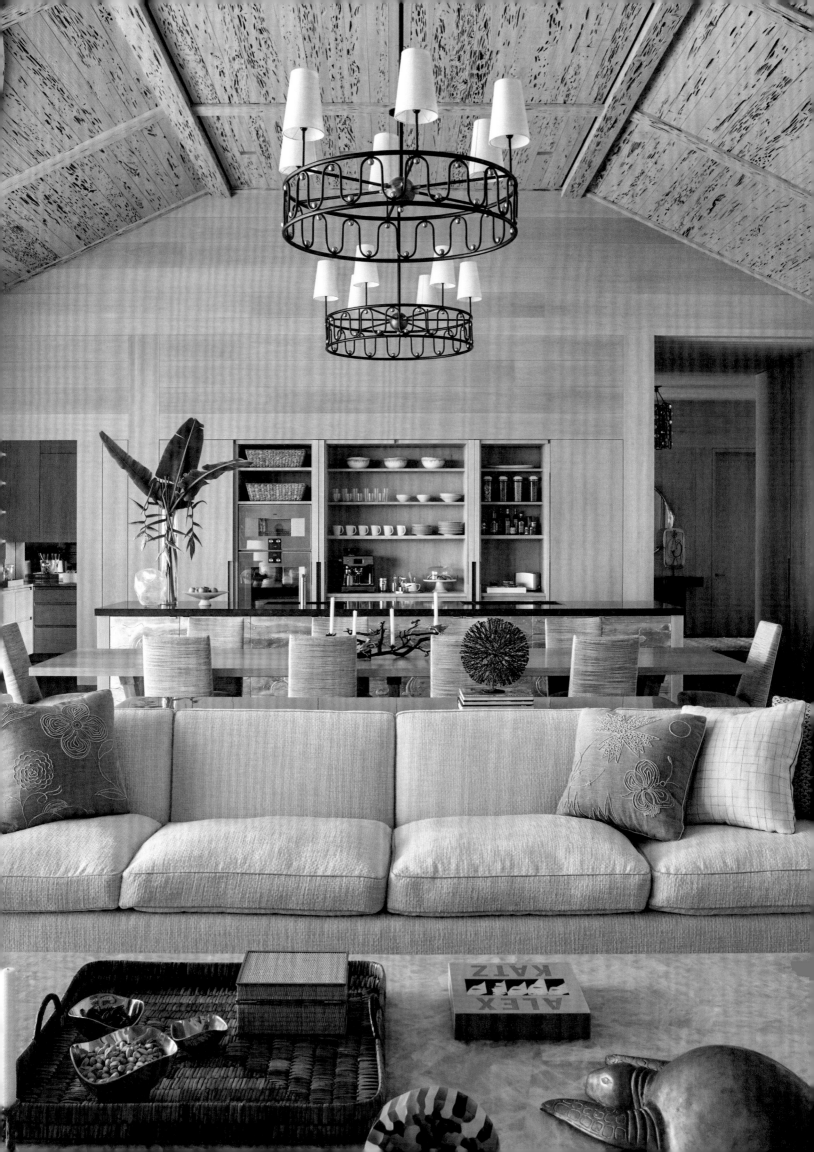

ABOVE, AND OPPOSITE: In shades of pale blue and white, and especially when the corner windows are retracted, the primary bedroom appears to float like a Zen island with nature all around. A parchment cabinet by André Arbus and a 1960s Danish teak chair reiterate the clients' love of midcentury design. In this room, as elsewhere in this house, the artwork—here by Damien Hirst—injects a moment of color and energy.

To get each piece right in its final form, our attention to detail had to be correspondingly minute. The living room curtains are another feat of mathematical and artistic precision: to ensure the pattern repeat would continue without a break, we had the panels custom-scaled and colored, and built to fit the periphery wall. Then there was the dining table, which like all the tables here is larger than the norm. As we worked with the couple on its proportions, we considered all the whys of the design: the reasoning behind the precise location of the legs, studying the metrics of angle, width, and so on. We lavished the same degree of attention on the particulars of the bookcases, discussing the various levels and distances between the shelves, as well as the

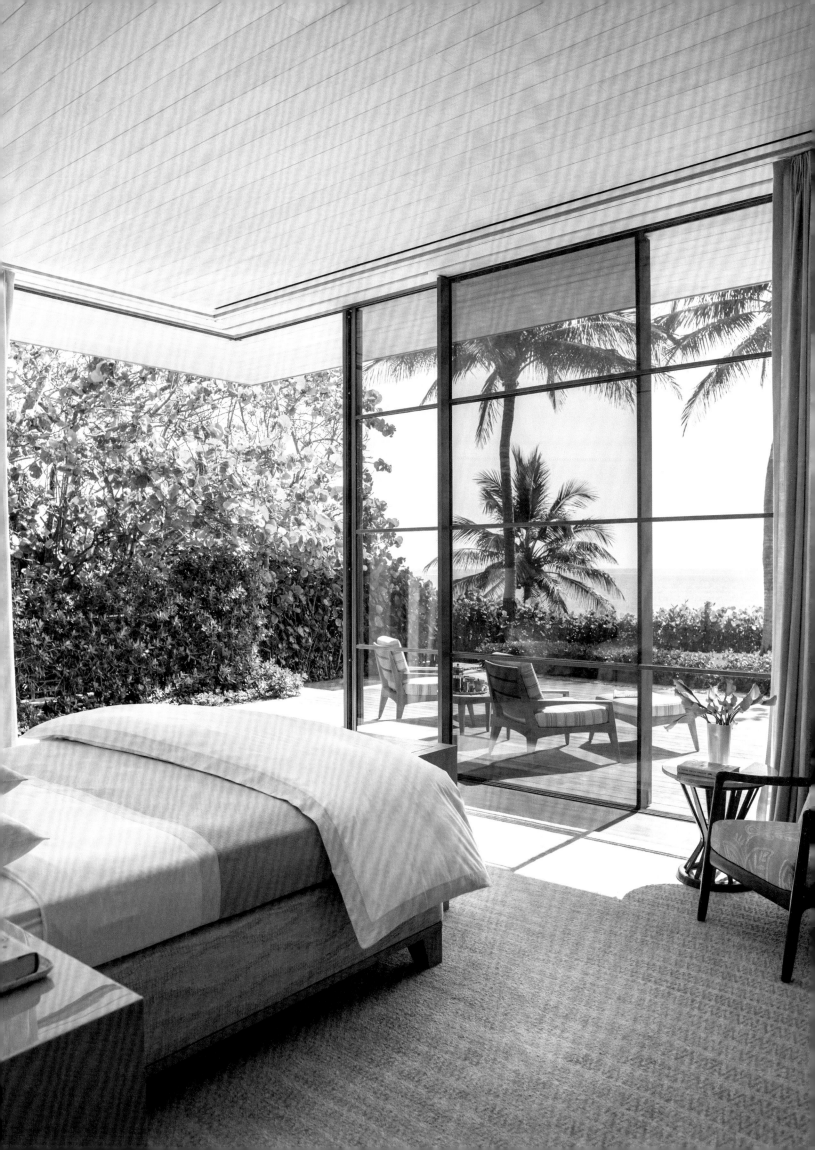

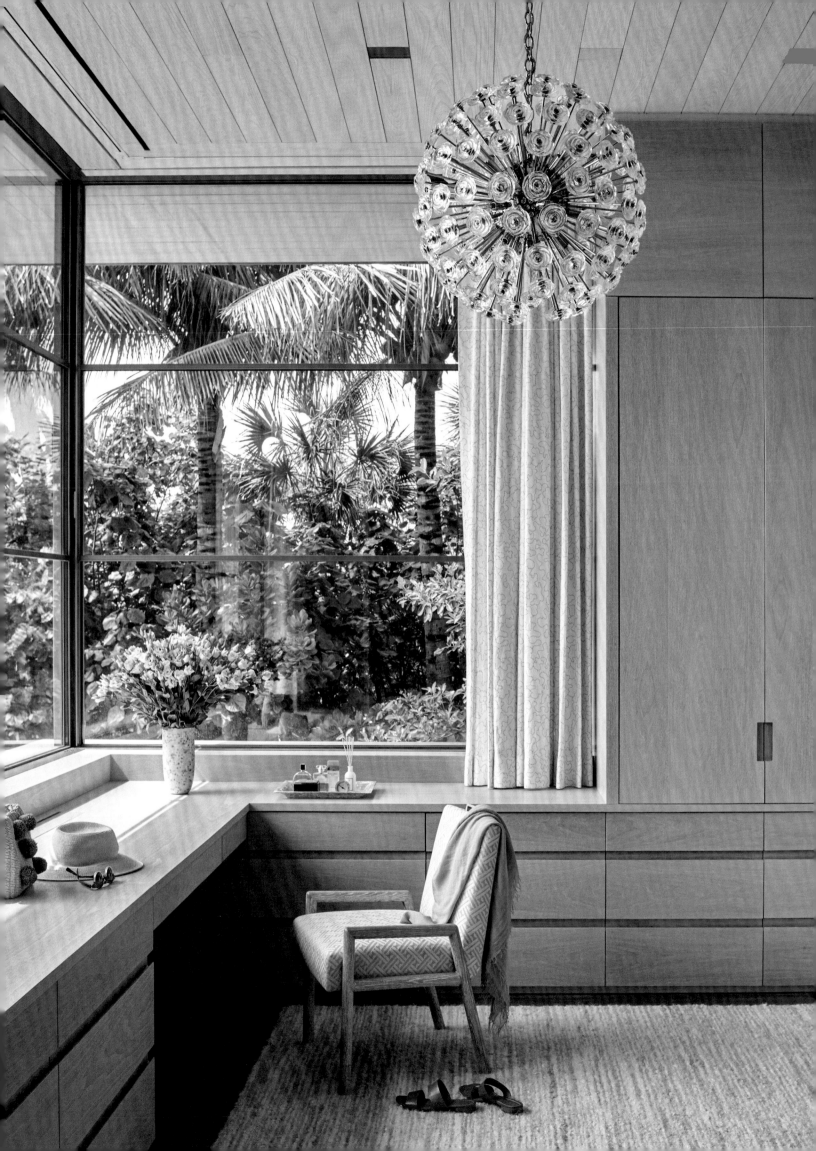

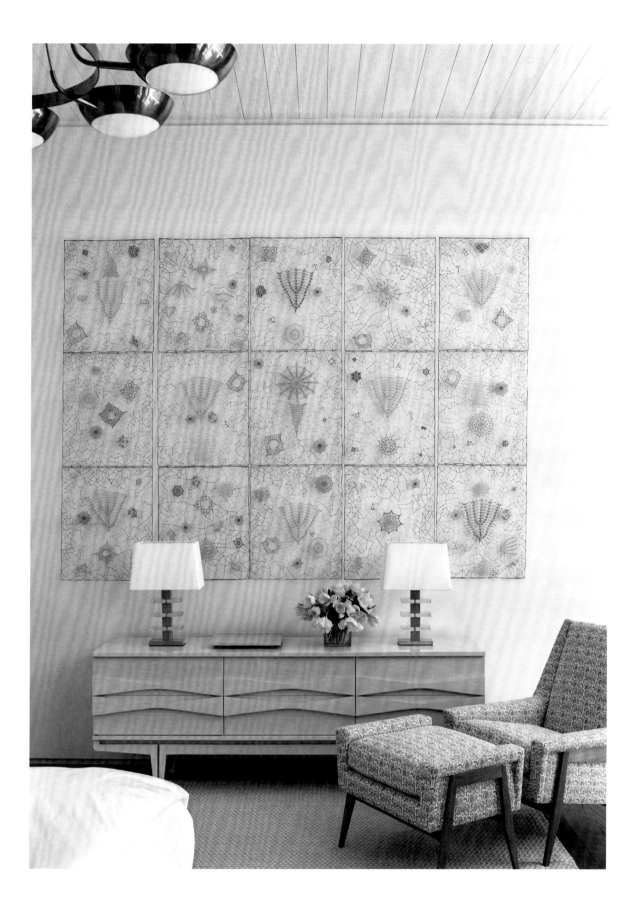

ABOVE: With a dresser from the Paris flea market, modernist lamps with seaglass bracelets, and Gino Sarfatti's ceiling fixture, the guest bedroom is another variation on the modernist-made-very-modern theme. Gjertrud Hals's textile art creates shadow play on the wall. OPPOSITE: Closed doors conceal the storage in this couple's dressing room. The mohair carpet is the softest possible texture underfoot. Molded glass rosettes make the vintage Sputnik chandelier quite unusual. The chair is by Samuel Marx.

forms, colors, types, and placement of accessories that would fill them. Because these clients love modern furnishings, particularly French pieces from the 1930s and 1940s—and the designs of Jean Royère above all we scoured the world for vintage items to fit the specific dimensions throughout.

We designed the primary bedroom to celebrate the dreaminess of the views, with the bed facing the ocean and a pop-up TV cabinet at its foot. This is one of the few rooms where, given the owners' love of textural richness but the strict rigor of their aesthetic preferences, we were able to introduce a patterned fabric, to infuse some softness. The attached dressing room became an exercise in luxurious simplicity brought to life with lighting, thanks to a very rare Sputnik fixture whose bouquet of individual glass flowers adds just the right amount of curve as a counterpoint to an otherwise rectilinear space.

The guestroom is one of the rare places where we deviated from the prevailing palette, dropping in little splashes of yellow and oranges. Though there are a lot of bells and whistles here, nothing screams, which keeps the overall Zen state intact. This room also became the home of one of the first artworks we purchased with the clients, a midcentury macramé fiber piece that hangs several inches from the wall and creates an enchanting play of shadows through the day.

RIGHT: Indoor/outdoor rugs are a game changer for spaces like this loggia overlooking the pool. Because this covered outdoor room incorporates the same natural materials as the interior, it feels both visually cohesive and comfortable with the rest of the house. The swinging sofas, proportioned for naps, are suspended from rope for a nautical twist.

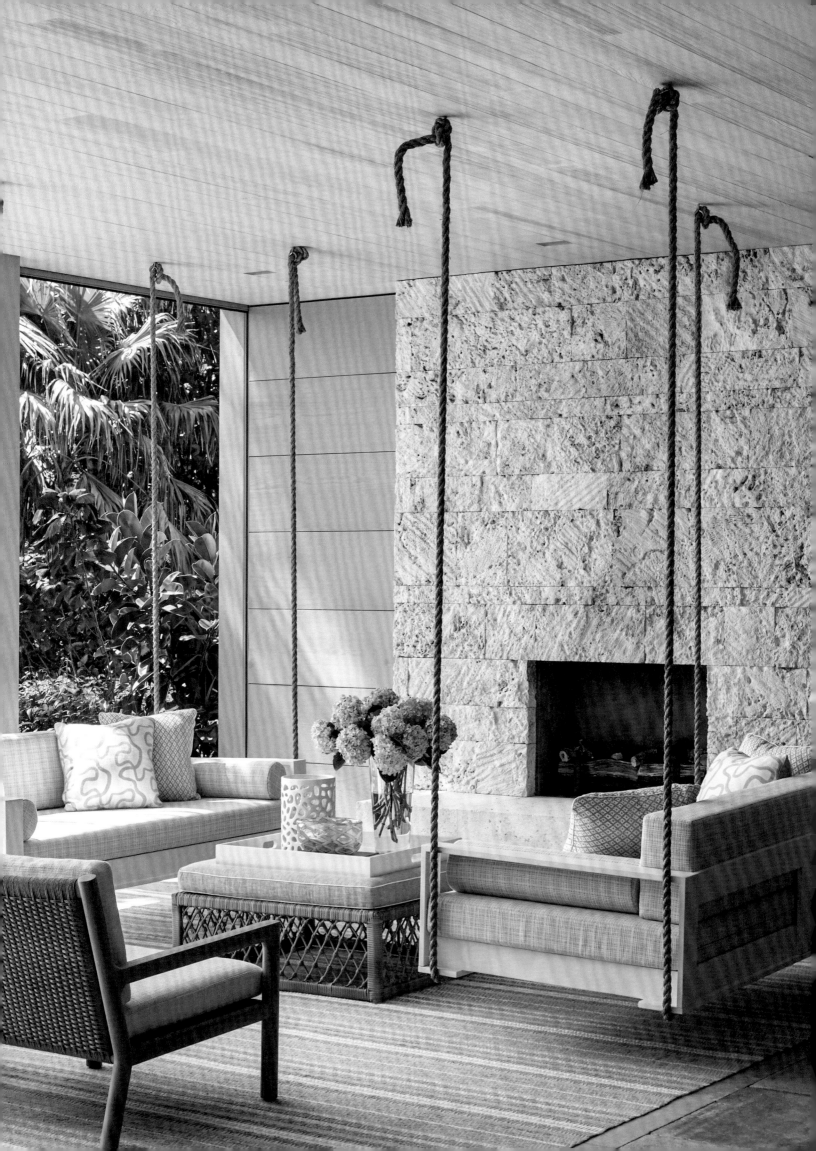

In any project, but especially one built from the ground up, landscape design is critical. The best results occur when the entire design team—architect, interior designer, and landscape designer—works closely together to achieve unity of vision, style, and flow.

For the garden loggia, the clients embraced the idea of porch swings with cushions deep enough for the little ones to be able to nap on–in other words, about the size of twin mattresses. The process of creating this home reminded us how fun, illuminating, and educational it can be to collaborate with enthusiastic clients willing to shape spaces around how they truly live–and how very fortunate we are to be in a position to do so. Thinking through each decision, planning each option, working out each detail to an extraordinarily fine degree–that's not new. But what was different here was the quietness of the final effect, which was very much this couple's vision. They knew exactly what they wanted their home to be. So did we. Our job was to make it look effortless.

RIGHT: Sliding doors with louvers are endlessly practical for a pool house, and so handsome. The louvers telescope the view, and in a climate where the weather changes hourly, they are a critical element for protection from both sun and rain. A close collaboration with landscape designer Mario Nievera ensured that lush foliage creates privacy and enhances the views so the whole property feels like it has been here for years.

180

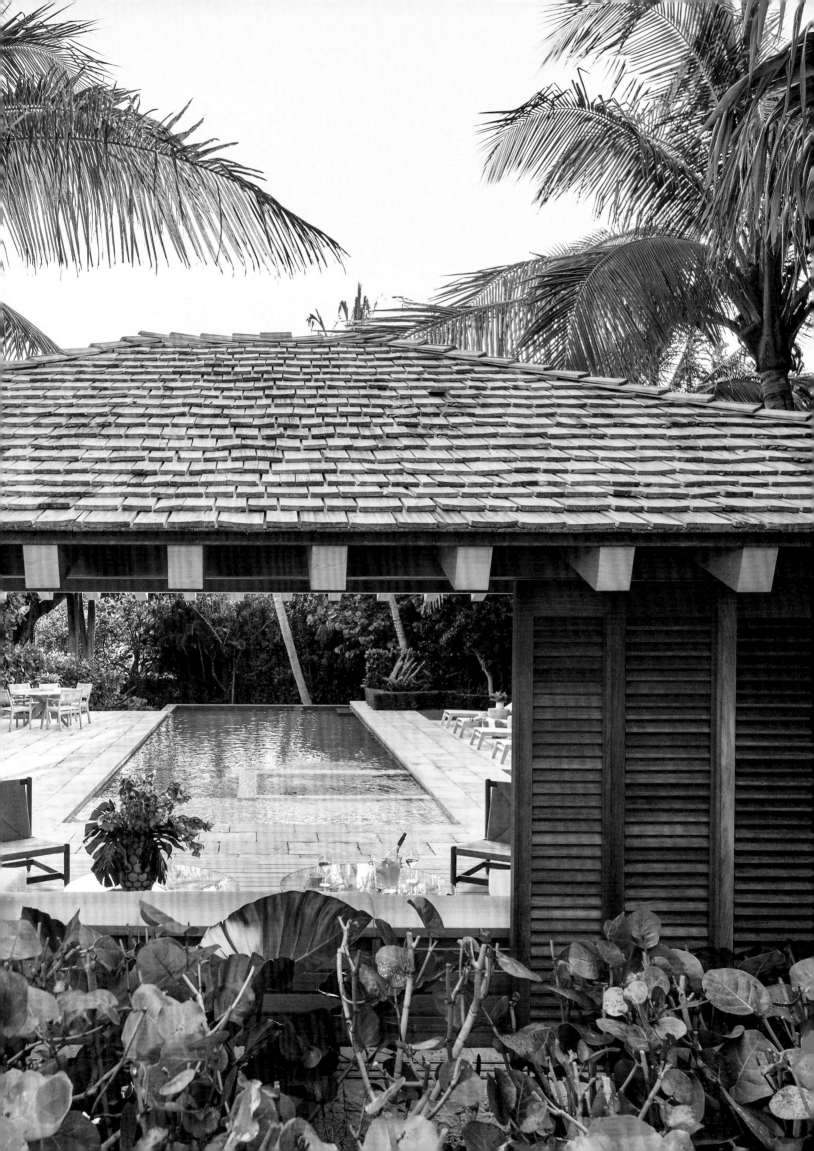

TRADITION
WITH A TWIST

Creating traditional interiors now calls on us to balance yesterday, today, and tomorrow in ways that feel fresh, lively, and modern while also respecting history. These New York clients, for example, share a passion for Old World decoration, nineteenth-century French antiques, and strong color—yet they want to live in spaces that accommodate modern life. After years of calling a six-floor townhouse home, they purchased this magnificent apartment in a land-marked McKim, Mead & White building. Our challenge was to bring their Gilded Age residence into the twenty-first century while incorporating many of their existing antique furnishings, light fixtures, and collections—along with an entirely new treasure trove of art.

With the help of architect Douglas C. Wright, we worked essentially within the original architectural framework, expanding door casings and focusing sightlines to reenvision the rooms for today. We also reimagined the ancillary rooms, creating a new primary suite, media room, and a barrel-vaulted showpiece of a kitchen. It was immensely gratifying to collaborate with the architect and the owners on formulating a design dialogue that spanned decades and centuries. It was also a happy challenge to develop a new decorative idiom within this historic architectural setting because to create something for the present, we were able to bring to bear our understanding of the past.

We used color, art, and detailing to infuse energy into every space from the front door to the primary suite. In the thirty-foot entry gallery, we gave the original ornate plaster ceiling a poly-chrome treatment in shades of aquamarine, ruby, and topaz, painting and gilding the original plaster details to emphasize their dimensionality. The reflection of this jewel-toned ceiling off the highly polished marble floor creates an almost holo-graphic effect that, with the punch of bright-hued upholstery,

OPPOSITE: Originally designed by Stanford White, this majestic apartment dates to 1910 and was at one time the home of James T. Lee, Jacqueline Kennedy Onassis's grandfather. The entry gallery's polished French lime-stone floor and articulated ceiling are original, while the paneling has been replicated to follow McKim, Mead & White's exact detailing. Bold color and contemporary art transform this remarkable period interior into a fresh, youthful home with a twenty-first-century take on traditonal décor while nineteenth-century French pieces add the history the space demands.

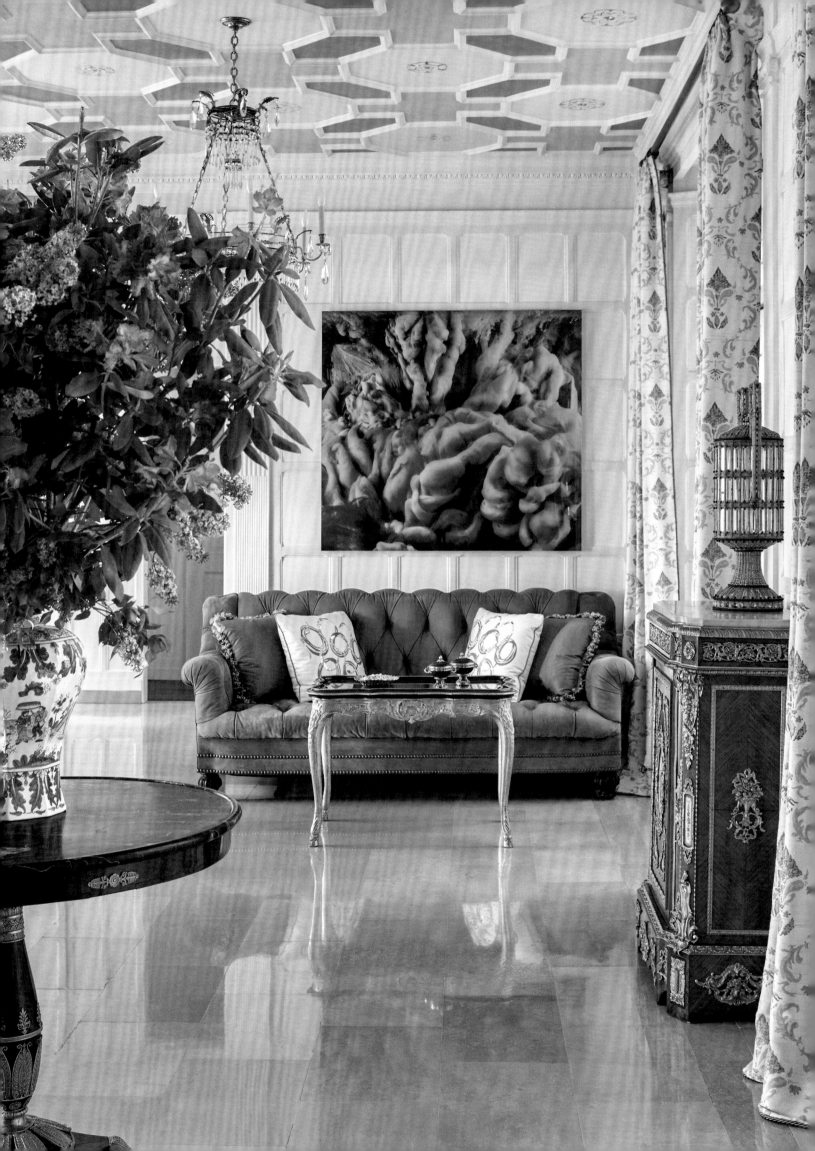

Jewel tones—ruby, canary diamond, and aquamarine—animate the ceiling plane (and, in reflection, the floor) of the entry gallery. In various degrees of saturation and intensity, this trio flows from room to room and brings each living space to life. Royal blue, one of the clients' favorite hues, recurs in this space in all different forms and materials: the chandelier's decorative glass panels, the pair of gilt-mounted neoclassical bowls, the blue-and-white porcelains, the Sevrès medallions ornamenting a pair of marble-topped cabinets, and the Murano cheval glass that stands resolute at the terminus of this space's long axis. Inspired by a period Italian pattern, the hand-printed curtains fit the scale of the original leaded-glass windows.

184

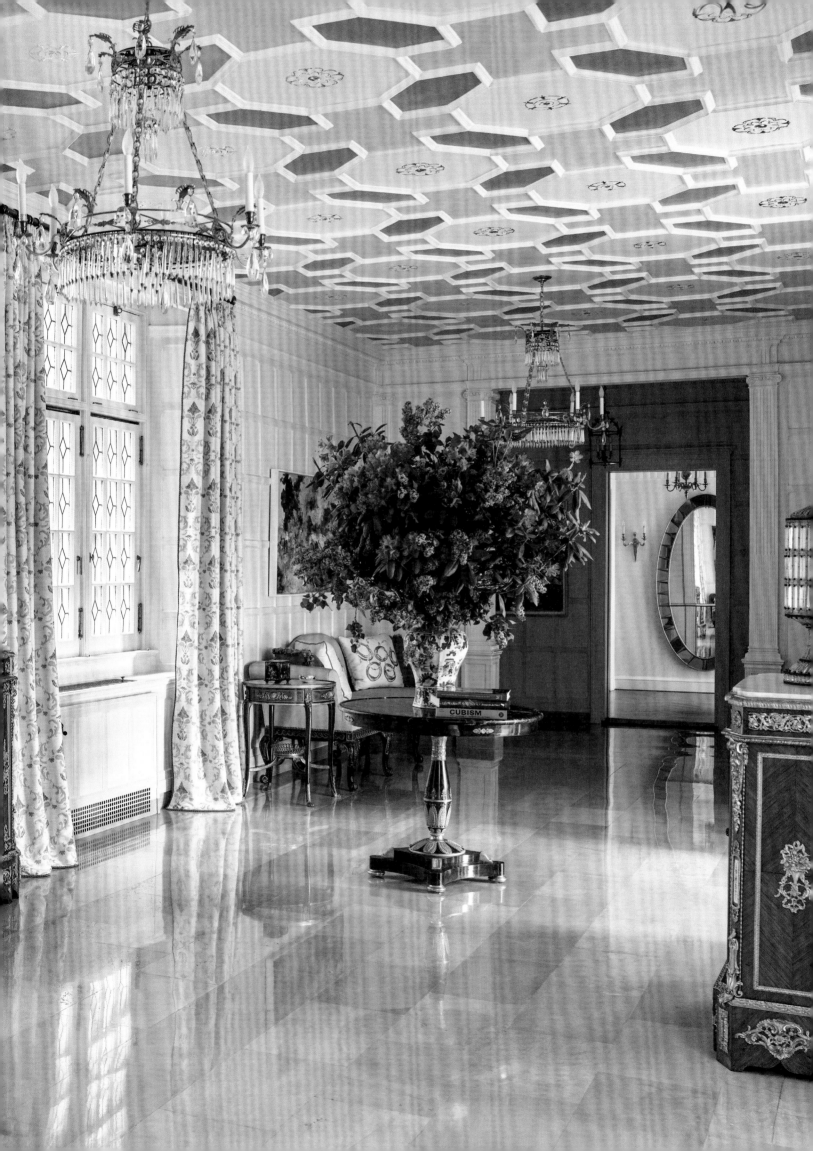

hand-stenciled curtains based on an Italian damask, a pair of Empire chandeliers with blue glass inserts (this couple loves blue), and an almost-wall-sized photograph of colored water, catapults this glorious, Gilded Age space into the twenty-first century.

The living room looks onto both the anigré-paneled library and the raspberry-lacquered dining room, so we carefully considered the room-to-room transitions. The carpet was our starting point here. We took its design cues from an eighteenth-century Polonaise pattern and recolored it in saturated hues. The central seating group, in beige (a necessary calm foil for the prevailing sapphire tones), frames the fireplace. The mantel is original to the building, but moved from the dining room. Their former townhouse also had very lofty ceilings, so we were able to incorporate many of their existing overhead fixtures. These include the Empire basket chandelier, which, though of a completely different era, perfectly balances the heft of a midcentury coffee table with a cubist sculptural base by Paul Evans.

Since even the dining room's raspberry walls didn't fully sate these clients' love of exuberant color, we filigreed a stencil onto the raised parts of the millwork. The custom table and chairs here can seat twenty-four atop the ruby field of a carpet designed after a classic Indian Agra. Gilt-wood mirrors above carved wood consoles reflect light and add gracefully formal notes. The couple's Chinese export porcelain shares color combinations with the abstract modern painting above the new mantel, reminding us yet again how well certain motifs travel intact through time.

Traditional English dark mahogany-paneled libraries tend to feel too stodgy for today's tastes, so we

RIGHT: Even in this very traditional envelope, classic modern upholstery forms and iconic twentieth-century designs like the Paul Evans coffee table feel at home among period classics such as the French Empire chandelier and early nineteenth-century Swedish gilt mirror. The blue tones recur in a pair of cut crystal lamps, the curtain panels, and the armchairs that anchor a seating area naturally centered around the fireplace.

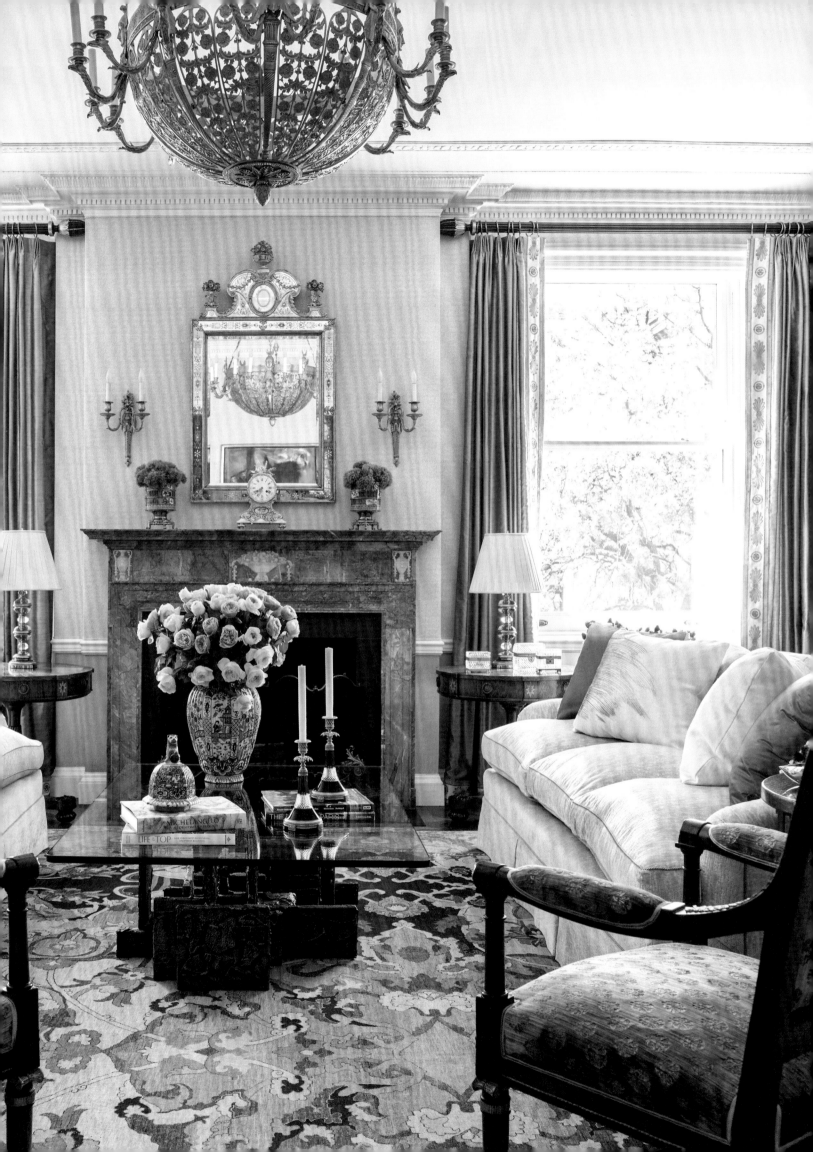

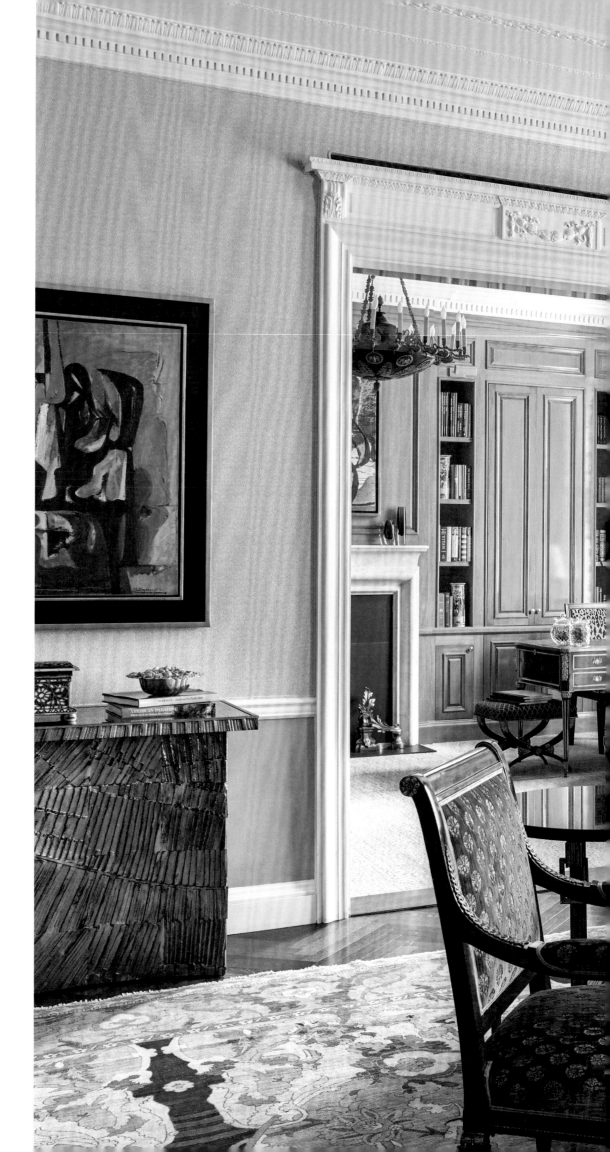

RIGHT: The apartment's enfilade from library to living room to dining room incorporates commanding views of Central Park. As befits the role of this living room as a grand entertaining space, a hammered silk upholsters the walls above the chair rail with a subtle shimmer; the area below is glazed in a light bronze/rose gold hue to create a connection with the paneled library just adjacent. The silk rug, a Polonaise—a style of rug created to appeal to Western tastes, which originated in Isfahan in the seventeenth century—adds slightly more shine underfoot. In the late nineteenth century, as demand for the Polonaise style grew again, weavers in various regions, including India, reproduced many of the designs.

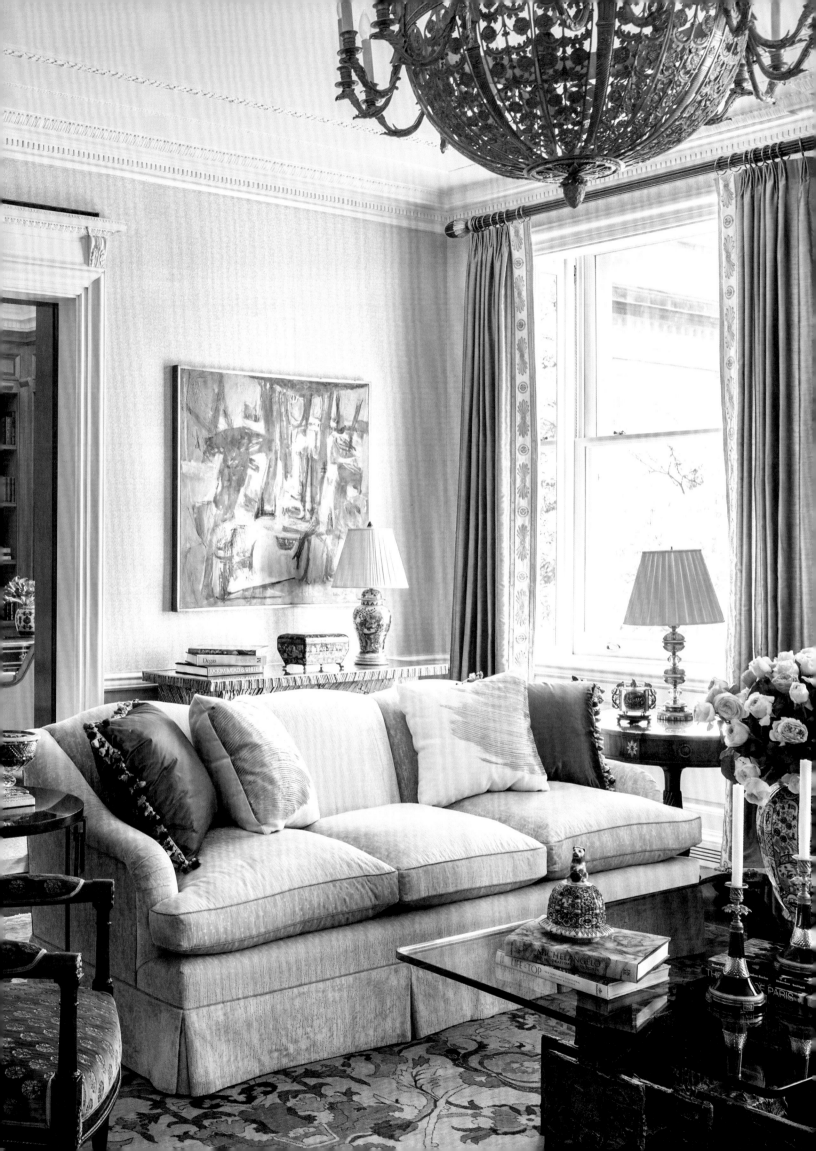

used anigré paneling here to keep a bookish mood while lightening the atmosphere. The wall-to-wall carpet nods to practicality—desk chairs inevitably catch the corner of a rug as they move. The sofa's punch of pattern, calm carpet, plain upholstered chairs, custom coffee table lacquered in just the right shade of cinnabar, and bold contemporary art are all completely present tense.

The barrel-vaulted kitchen is, to our minds, the most fun room in the house. We had originally designed a very nice all-white kitchen, but the owners perceptively asked for a more dramatic space. To that end, we contrasted white and black lacquer cabinetry with fabulous laser-cut stone and metal tilework that subtly echoes the hexagonal pattern of the entry hall ceiling. Glossy metal accents and art deco–inspired fixtures found in London add undeniable glam.

The media room shifts into a more obviously contemporary language thanks to a curved banquette, mirror-faceted walls, and high-gloss lacquer paint. Sometimes, there's just no avoiding an oddly placed structural column. To make the one in this room look intentional rather than invasive, we sheathed it in richly hued, fluted wood paneling and echoed its diameter with two round coffee tables. Finding a shade of blue lacquer that would enhance all the nuances of the blue velvet sofa as it shifts hues in changing light involved a process of elimination to achieve a successful monochromatic effect. A very modern custom rug based on a traditional Chinese design feels at once traditional and liberated. The parchment-and-lacquer coffee table responds to other gilt details, bridges the cream of the rug and ceiling, and carries the reflective effect of the

RIGHT: Patterned sofas were once de rigueur, but many people today are disinclined to make such bold statements. The key to success lies in balancing a room's prints and solid elements, as here. OVERLEAF: Art placement can make or break transitions between adjacent rooms with strong color shifts between them. PAGES 194–195: Twin gilt consoles, Jansen mirrors, and Chinese porcelains flank the fireplace wall, reinforcing the room's symmetry and grand proportions.

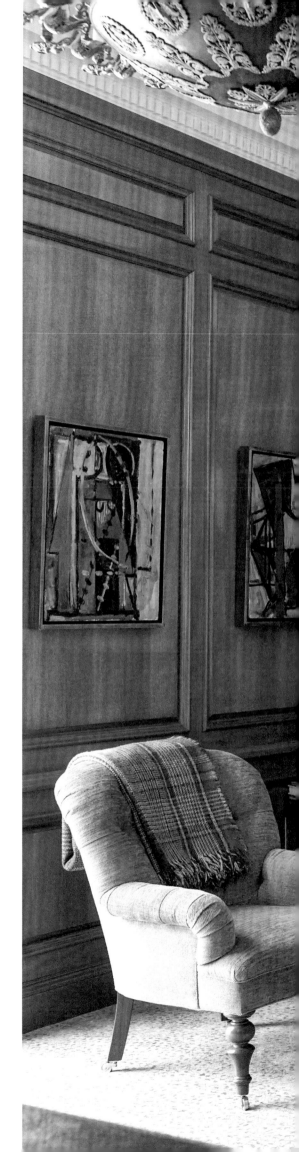

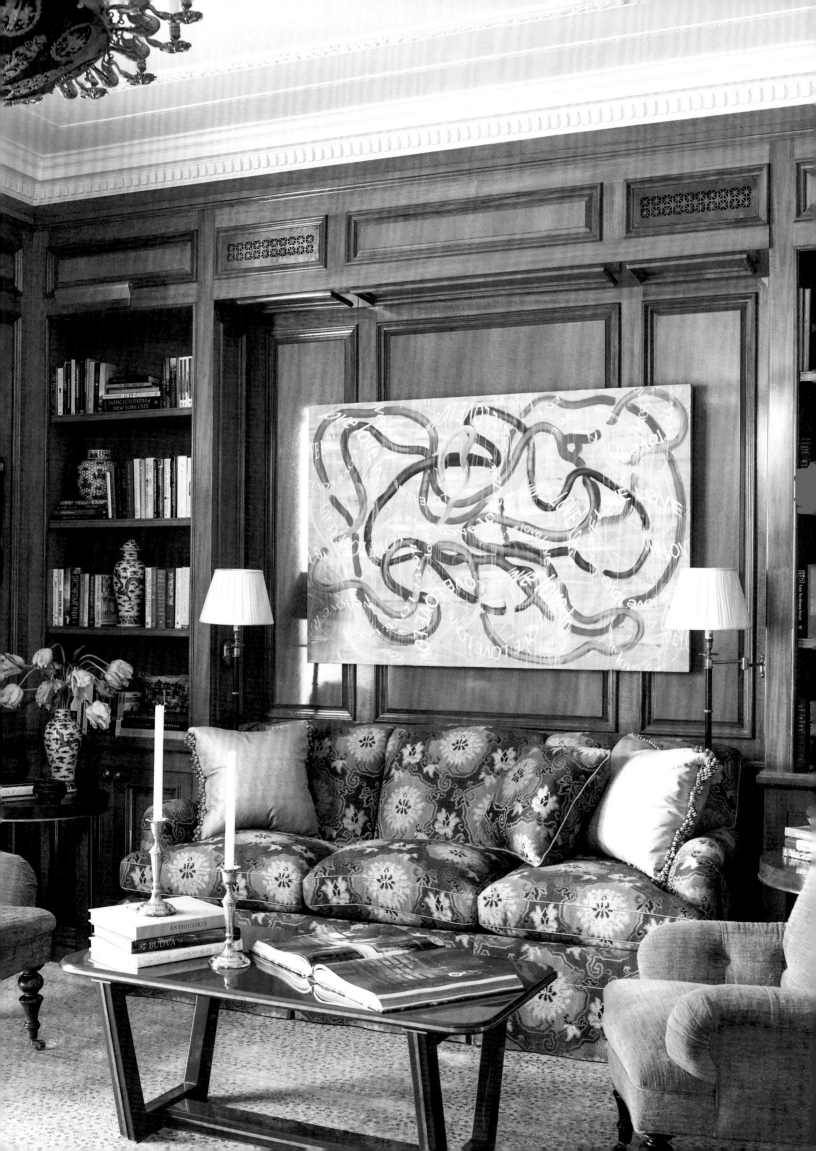

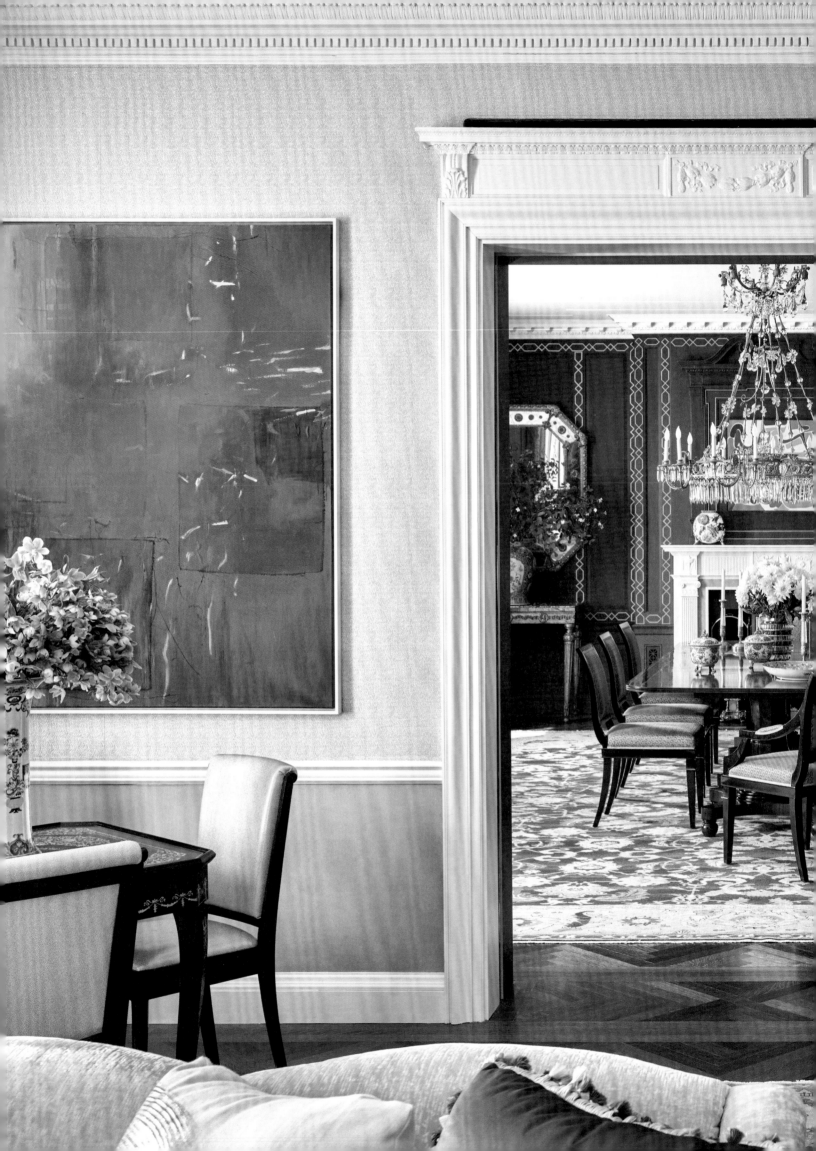

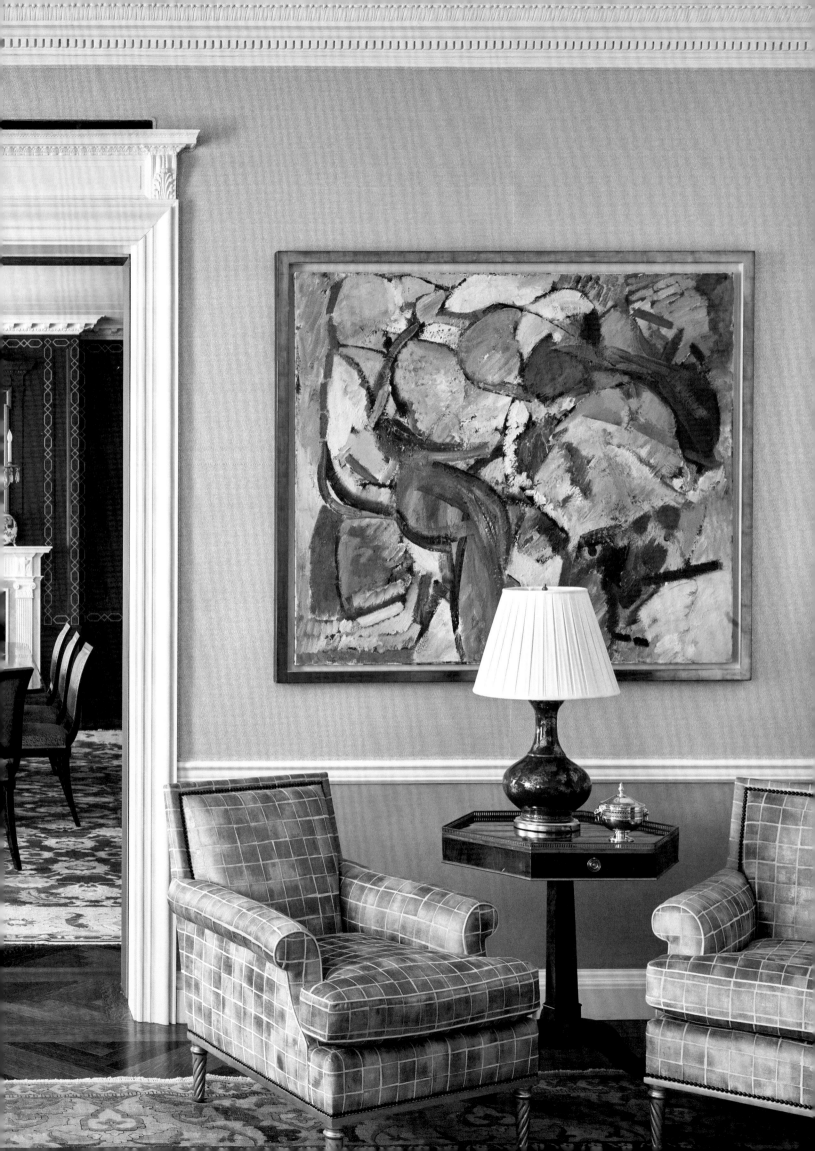

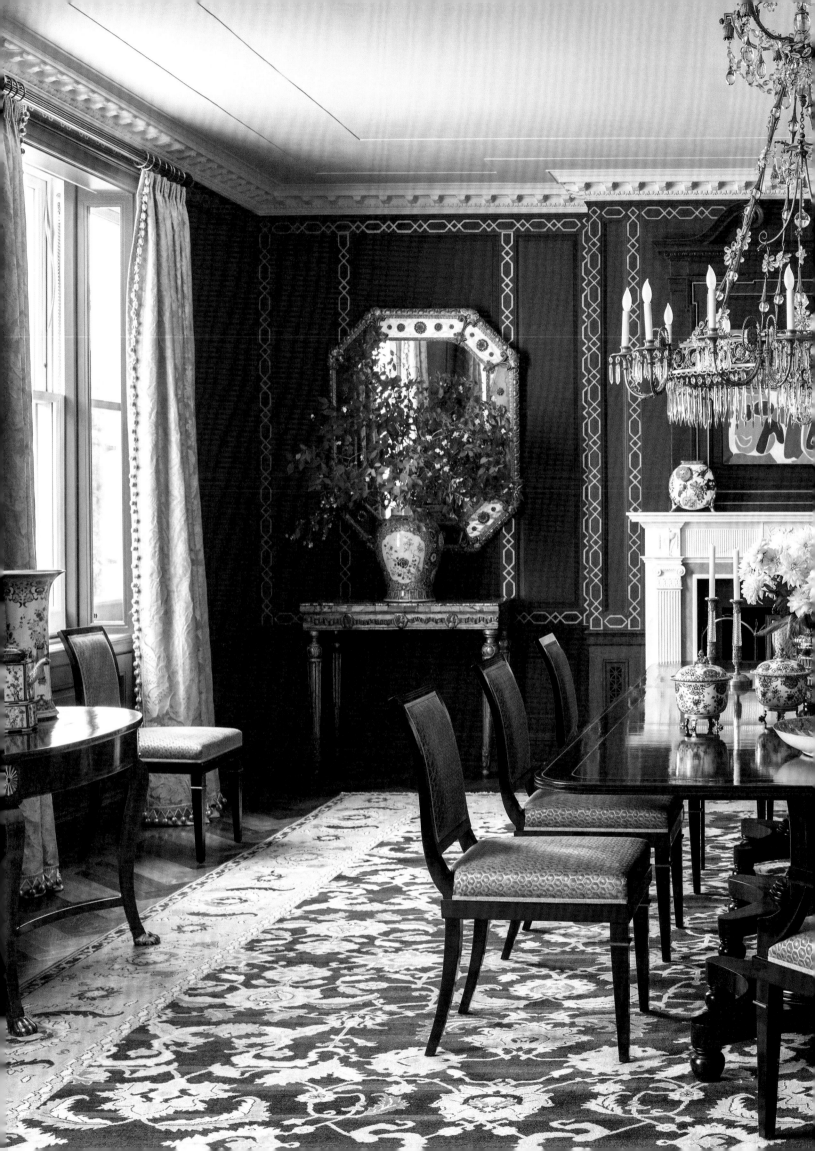

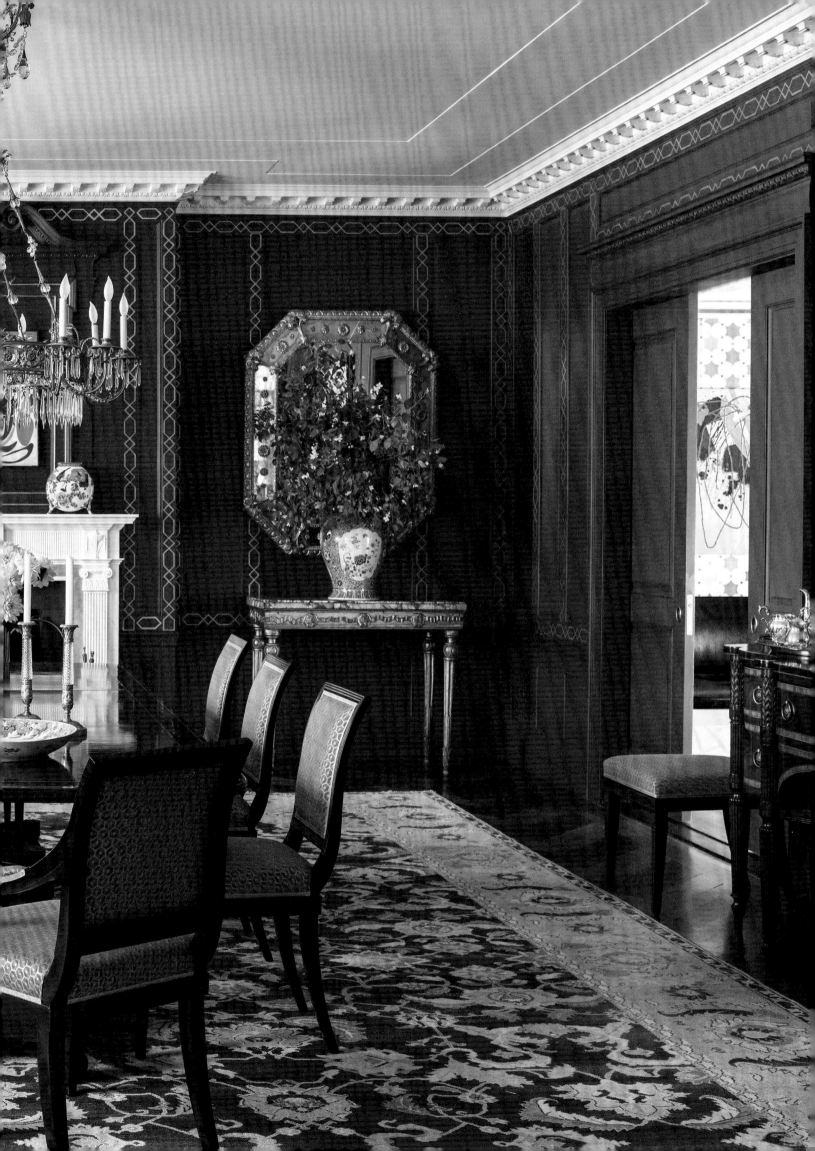

THE ENVELOPE

Great decorating begins with good bones. This is why we cannot overstate the importance of the architectural envelope. Walls, floor, and ceiling—our lives are lived within six defining planes. Doors and windows can shape these in various ways, but these main surfaces are the blank canvases we all have to color and decorate as we develop and layer in the character and personality of a room and bring what we think of as a true home into existence.

It is the envelope that really establishes the broad strokes of a room's aesthetic. We're vigilant about considering it diligently, because while individual pieces of décor are easily changeable, not so a wood-paneled wall or stone fireplace. As we begin to think through our choices for the array of materials, finishes, and colors we'd like to use to activate the different surfaces, we inevitably respond to the shape of the overall volume and any architectural details it contains. Then, editing hat on, we winnow. Our way from the start has been to build up each room from the floor—first the carpet, then the fabrics, and then the paint or wall covering plan—calibrating the nuances of the relationships as they evolve so that no one choice overwhelms those already made or yet to come.

Making the transition from room to room feel intuitive is critical, so considering the view from one room to another through an open door is key to making the eye feel at ease. If upholstered walls cocoon one room, adjacent rooms need a pleasantly contrasting and more detailed surface treatment, perhaps stencil or strié. Some rooms become their best selves with a pictorial finish. Doors and windows factor significantly into this equation because of their commanding spatial presence, and we work to adjust the role they play—large or small—on a room-by-room basis to help achieve one overall visual rhythm.

The ceiling is so often forgotten, but what's overhead is truly a great place for decorating magic. High-gloss paint gives the impression of adding at least a couple of feet of height. Patterned or textured wallpapers that feature an arbor or blossoming branches bursting right out of the crown molding draw the eye up, and tented ceilings (whether draped in fabric or painted in trompe l'oeil) can do the same.

Years ago, we delighted in embellishing the woodwork with faux marble, faux bois, and every other decorative paint treatment in the tool kit. But no longer. Today, even traditionalists like us embrace the influence of the moderns, acknowledge that trends shift in alignment with lifestyles, and understand that no one wants to live in a museum. The cleaner envelope? It's what works now.

OPPOSITE, AND OVERLEAF: These clients were looking for a black-and-white kitchen—with glam. The final combination of stone, glass, lacquer, laser-cut modern mosaic wall and backsplash, and custom hood delivers the peak of chic. Jewelry-like brass details pull shine into the space at every level. Regency Chinoiserie boxes even bring the bling to the bookshelves.

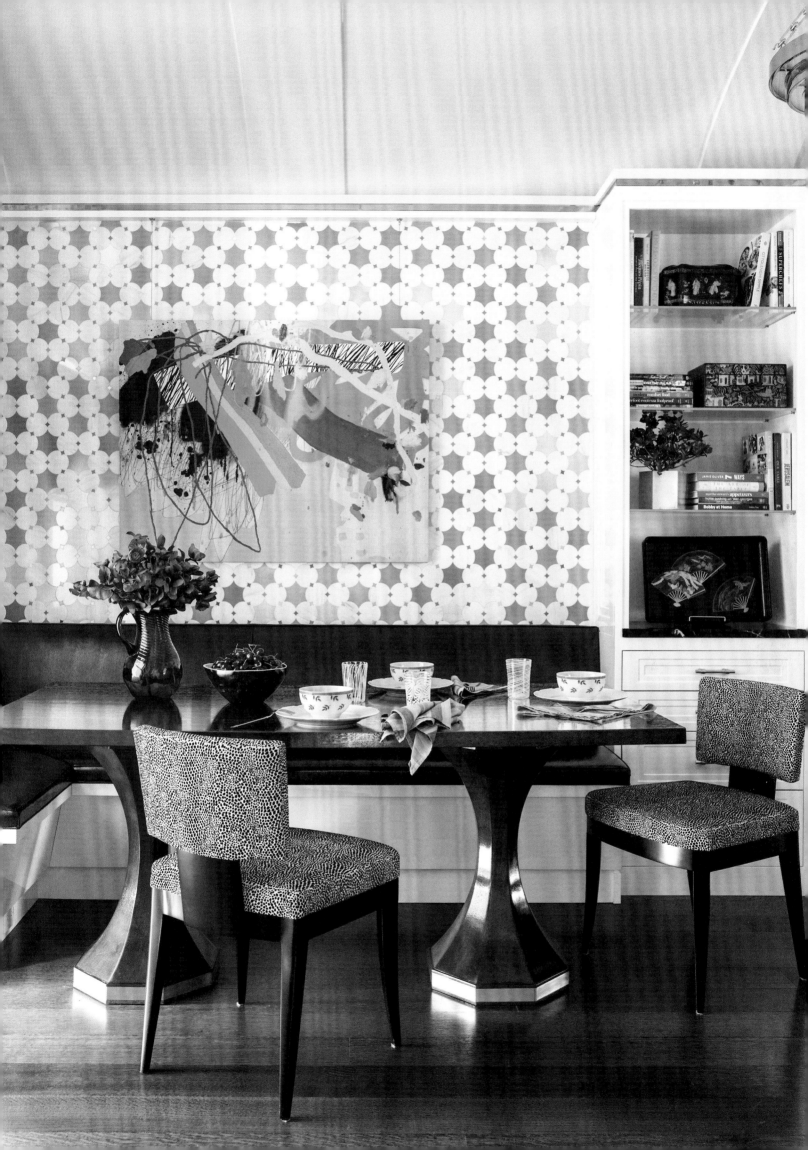

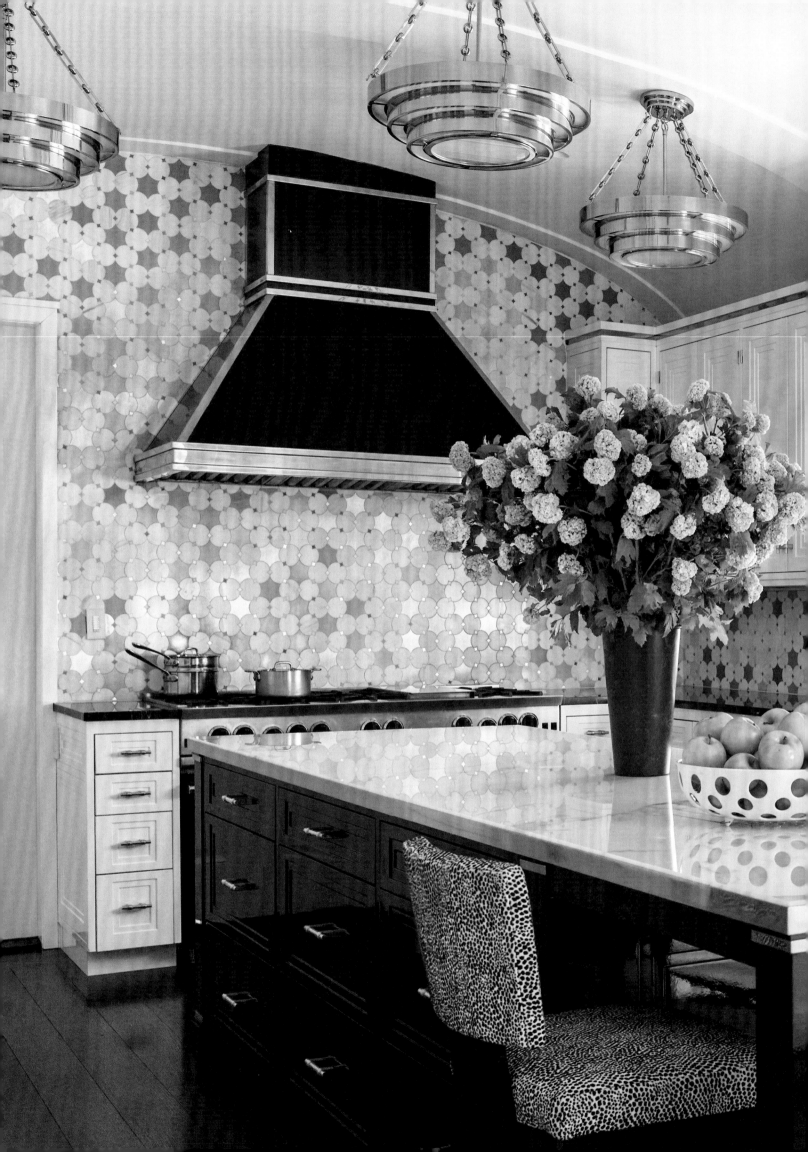

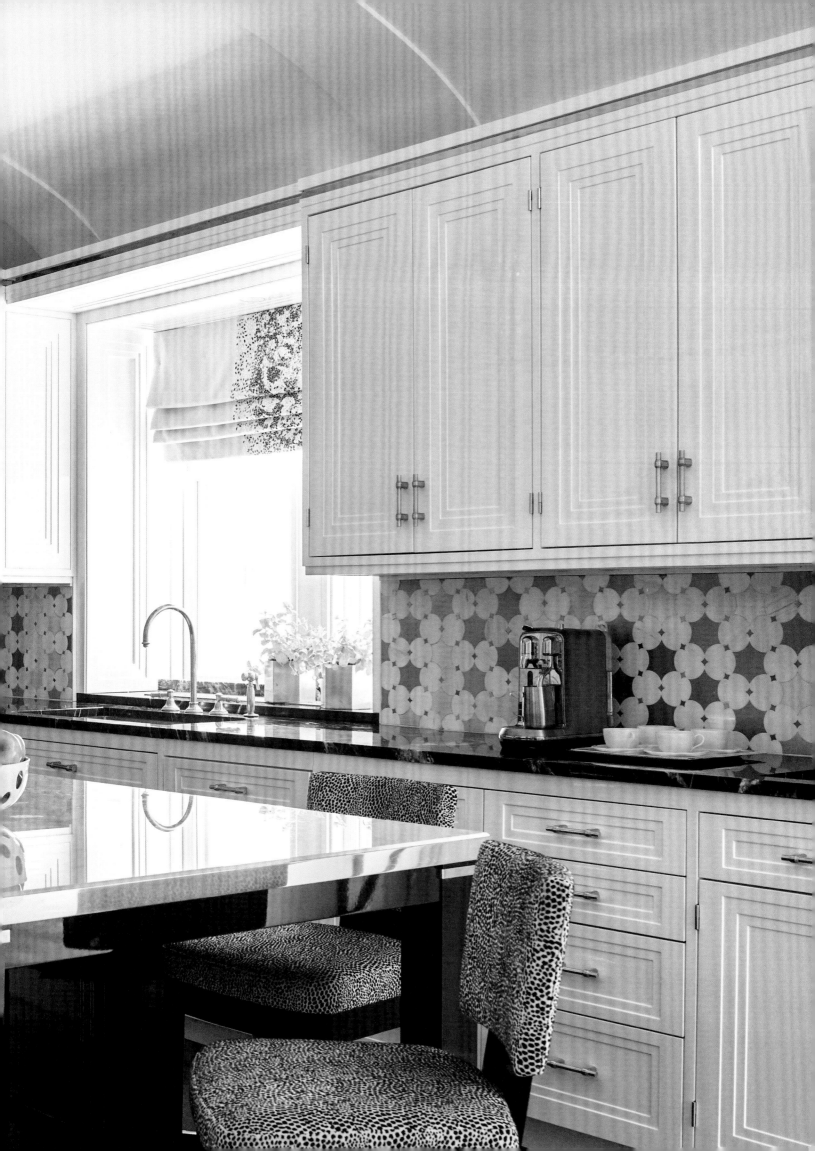

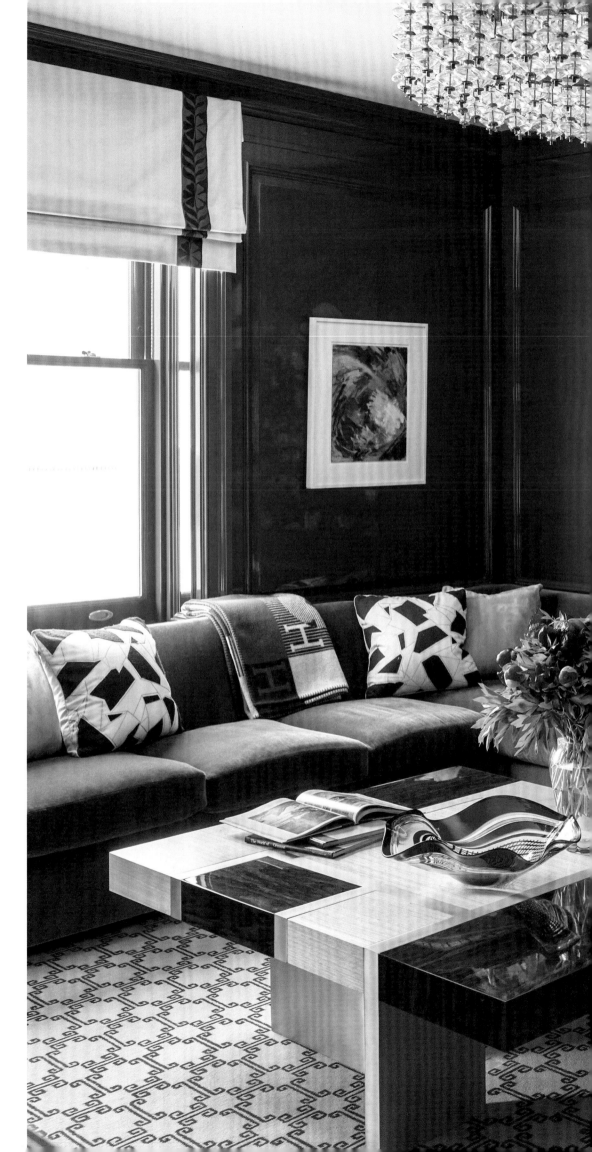

RIGHT: The clients' favorite shade of blue gets the royal treatment in the sapphire-lacquered media room. The coffee table—a confection of glossy wood, brass, and goatskin—brings form, function, and more than a touch of couture to the design directive. The vintage club chairs were purchased at the Paris flea market. At 35 inches in diameter by 21 inches high, the Italian drum fixture with bubble glass beads meets the scale of this space.

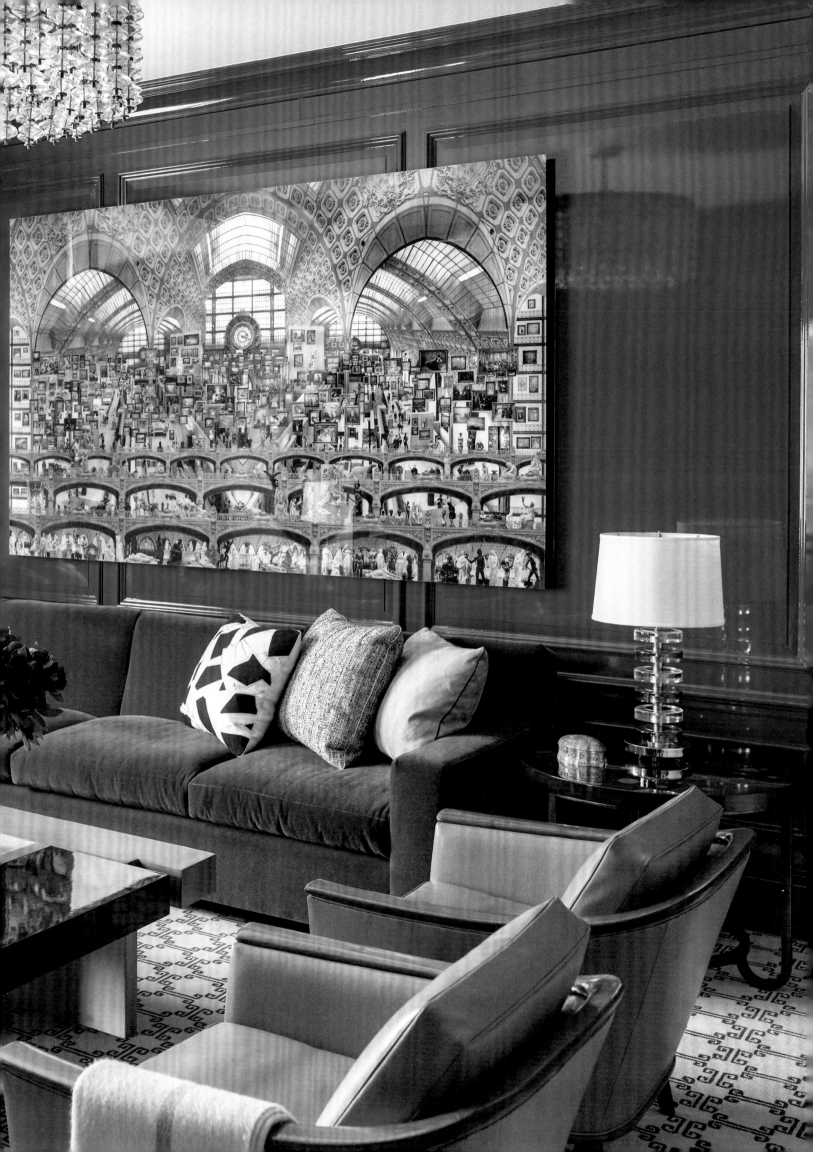

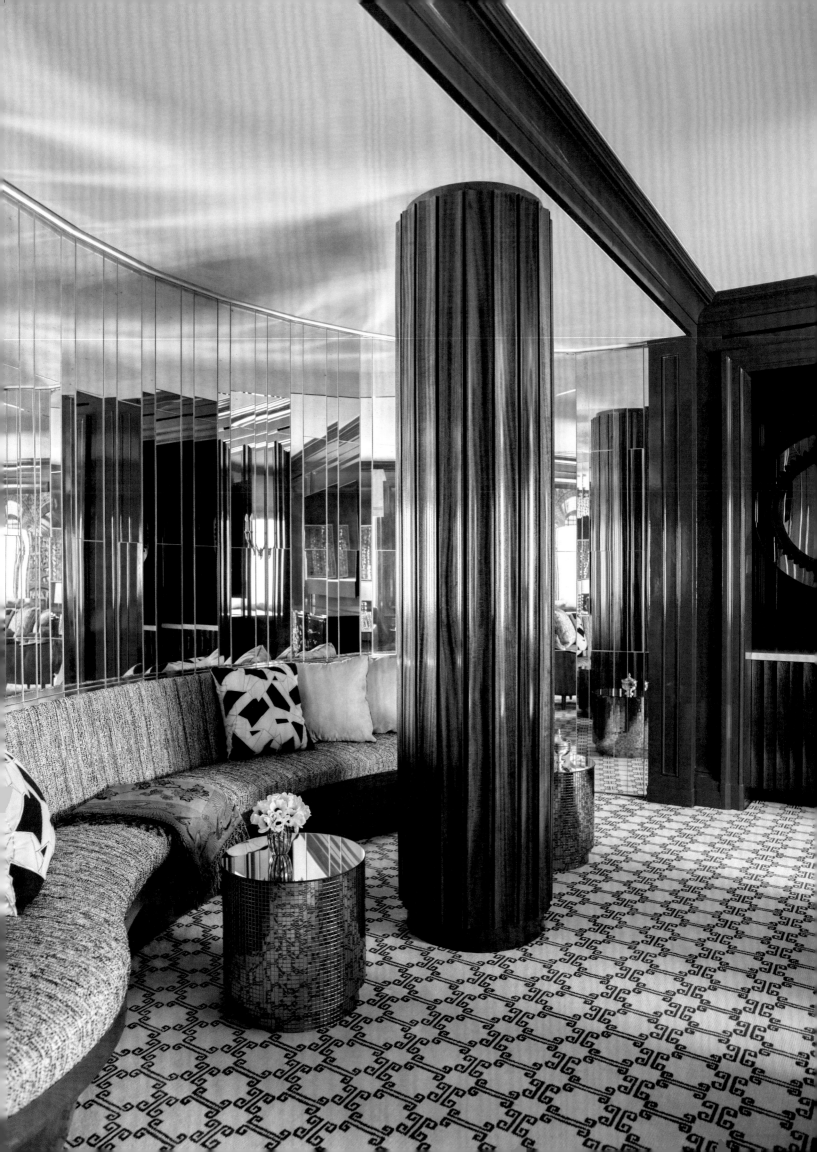

walls right into the middle of the room. When our Francophile clients found Jean-Francois Rauzier's digitalized panorama of Paris for the wall above the sectional sofa, we were overjoyed.

The primary suite, so traditional and ethereal, combines their love of lavender with our affection for pairing lavender with blue. Once we decided to lacquer the ceiling, we made repeated visits at different times of day to decide if the blue we had chosen was precisely the right shade. (We are nothing if not obsessive.) The edges of the handpainted wallpaper are stitched in silver threads, so it shimmers.

This interior resonates with the past, is totally in sync with the present, and still looks to the future. In honoring the cycles of taste and time, it feels traditional—for today.

OPPOSITE: This media room had an unsightly supporting column center stage. Fluted mahogany wrapping transformed the ugly duckling into a decorative swan. Mirrored walls reliably brighten illumination-challenged spaces. Resolving the proportions of the mirror facets for this gently curved wall took considerable thought, plus sharp math skills.
ABOVE: Visual magic can happen with correlating patterns of different scales and materials.

203

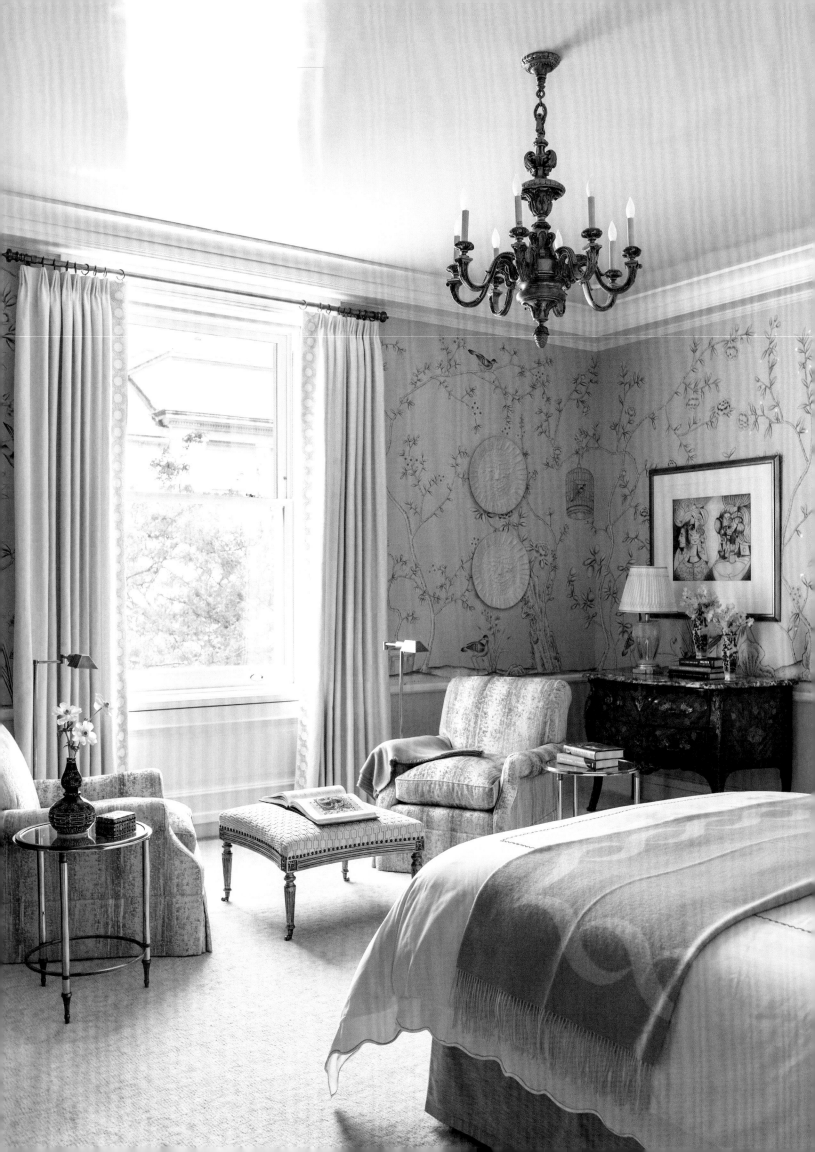

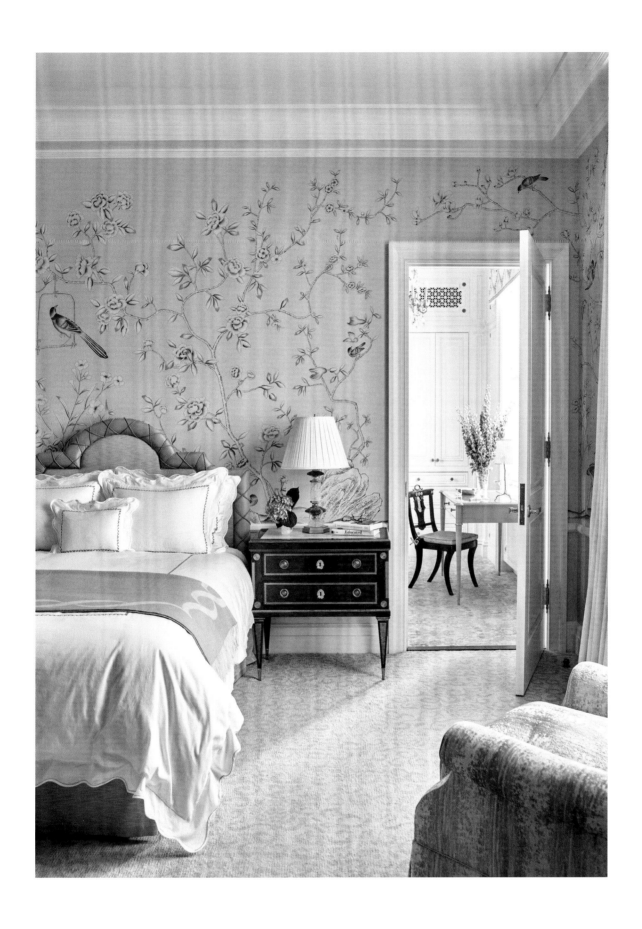

OPPOSITE, AND ABOVE: In this serene primary bedroom and connecting dressing room, silver bugle beads on the curtains and rock crystal bedside lamps catch the light. A silk-and-wool carpet and brushstroke velvet chairs add plushness and sheen. OVERLEAF: This feminine bath makes the most of the delicate curves imparted by pink onyx accents and Maison Baguès crystal fixtures purchased in Paris.

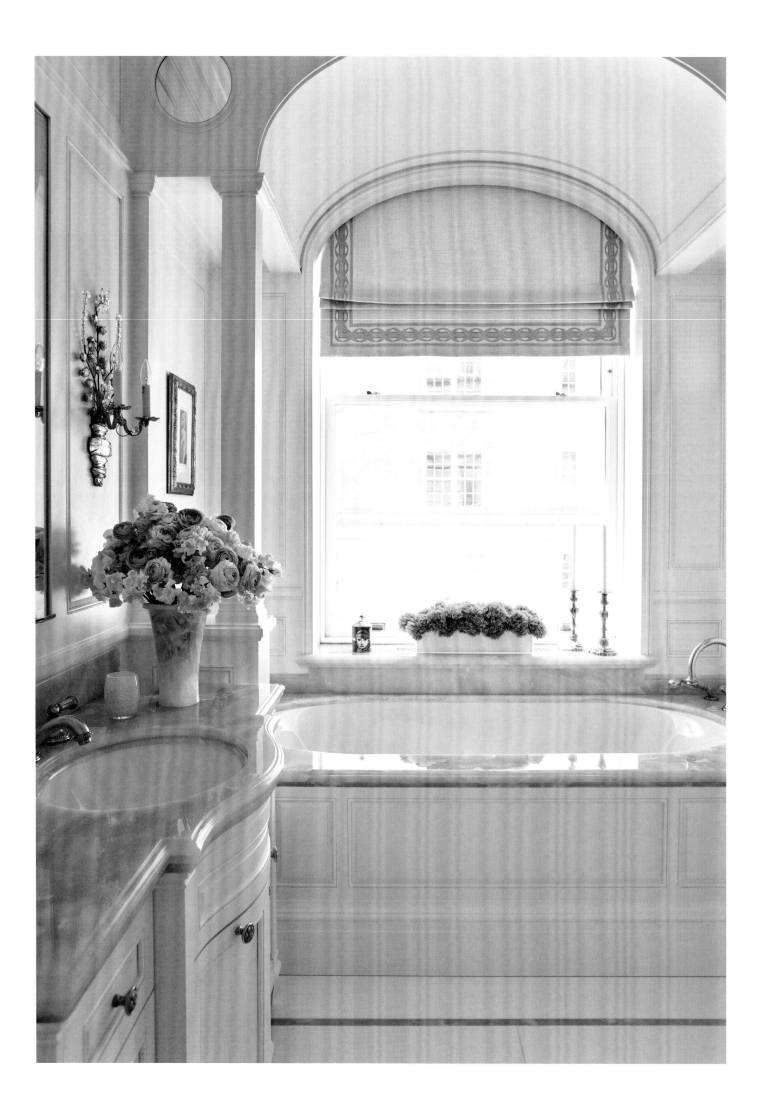

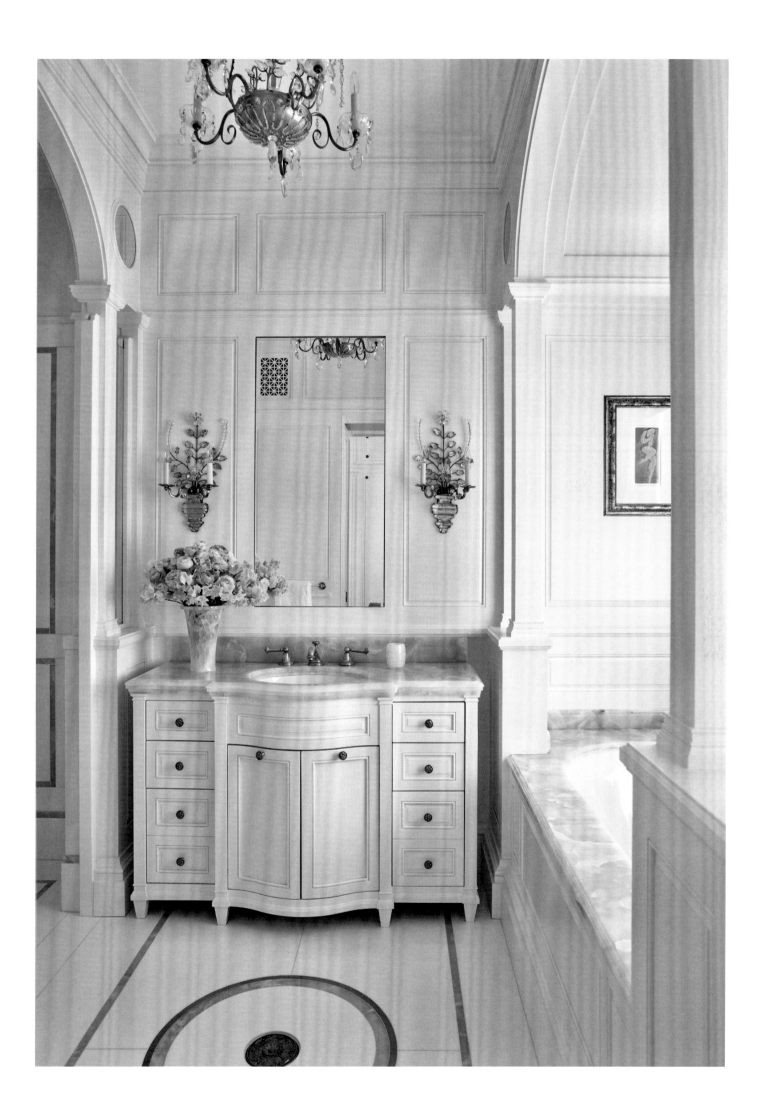

A NEW LOOK

Sometimes skipping to the last page of a story isn't really cheating. It's just like having dessert first. Flipping the narrative arc here shines a light directly on the many complexities of updating an early twentieth-century neo-Georgian estate on the Connecticut waterfront for longtime clients who have a deep respect for the site's Revolutionary Era history but also a desire to live with today's conveniences. So here's the spoiler: at this project's conclusion, the clients inscribed a cornerstone to mark the additions to the house and commemorate the date, burying a time capsule inside with project memorabilia from all members of the team for future generations to uncover.

The home itself is an expression of the lightness of being. The planning we undertook with the clients and architect John B. Murray surrounded an idea that really came into focus during the renovation process: thinking forward for multiple future generations. When, after a long search, these New York–based clients found this house, they already had a clear vision for an interior style that would match the lifestyle they envisioned living on the water, with more space.

In New York, they embrace all things traditional: notable English antiques, gilt-edged art, the color red, an iteration of classic stripes in every room.

Here, the clients imagined a style swing in polar opposite directions: fresh, youthful rooms that would be casual, contemporary, and serene. They favored blonds, beiges, and blues to reflect the waters of the sound, with easy transitions between indoors and out. They wanted the details kept very simple. And they embraced exuberant, joyful art by up-and-coming talents to infuse the house with attitude. With the team, we worked to gut the original paneled spaces and open the living areas more organically to one another and the mesmerizing views. We also excavated the lower

OPPOSITE: The airy three-story entry hall set forth the aesthetic of this house both in terms of its architectural amplitude and its fresh, contemporary approach to decoration. Given the house's breathtaking waterfront views, the client's love of blue was kismet for enhancing the interior-exterior connection. From the floor with its two-tone, four-foot travertine pavers to the three-tier lantern of our design that descends from above in one connected sweep, scale took precedence in the decision making.

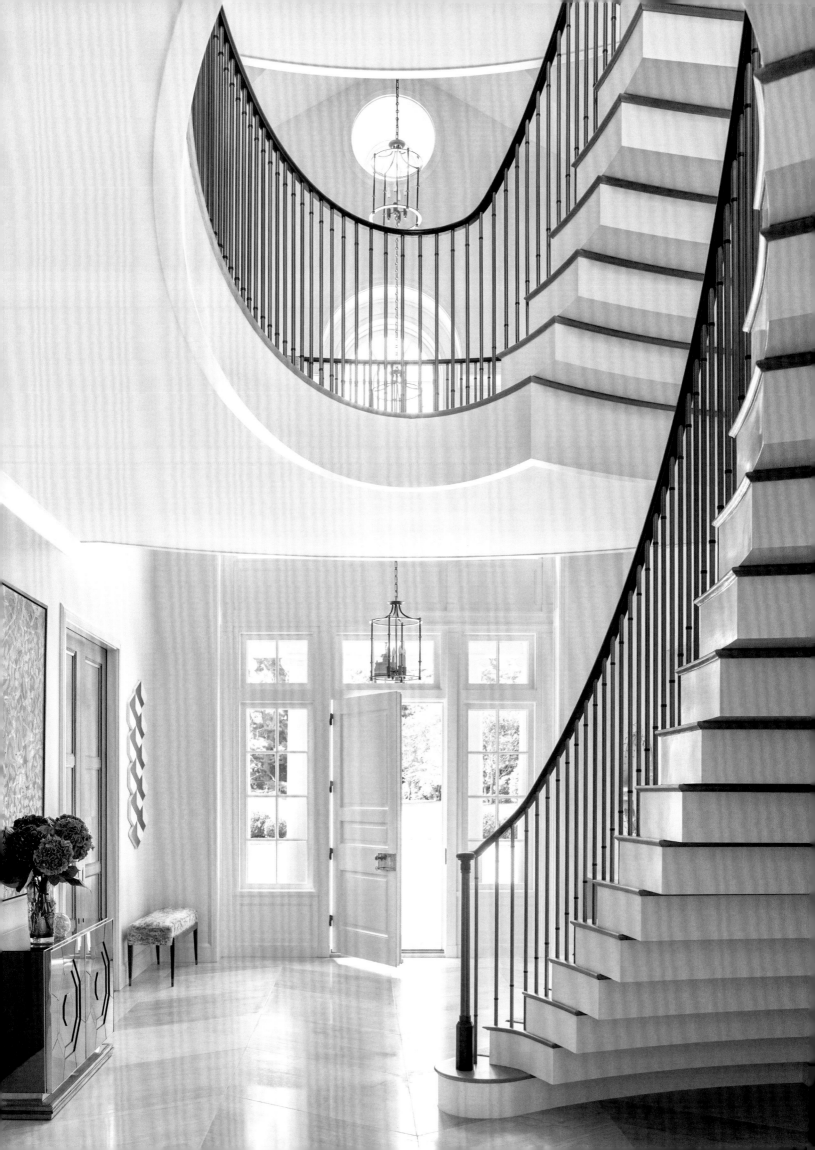

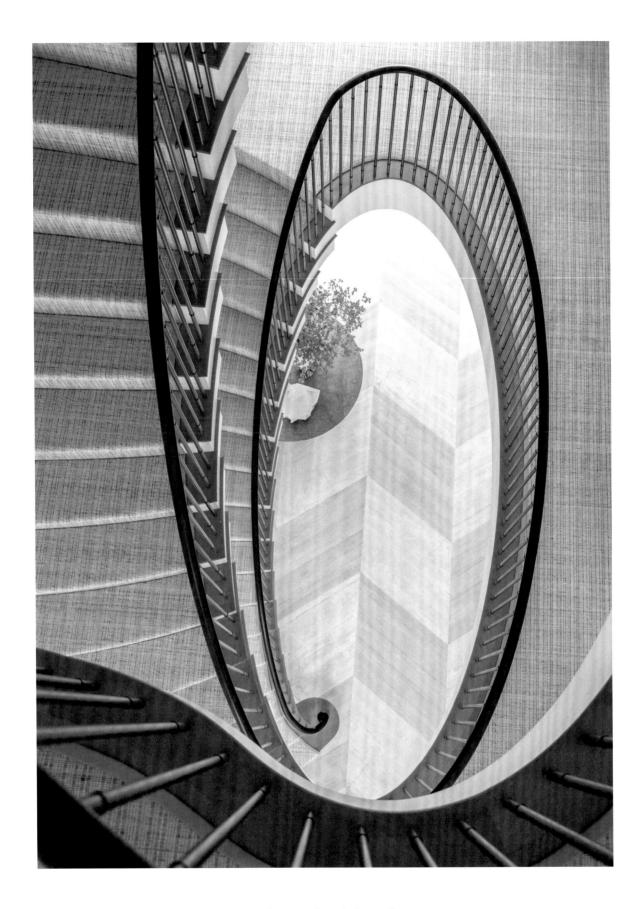

ABOVE: The floor's chevron pattern contrasts dramatically with the oval stair's curves.
OPPOSITE: A hammered metal table and the art deco chair's satin upholstery play into the mix of light-reactive materials. The painting is by Heimo Zobernig. OVERLEAF: Amid a predominance of creams and beige textures, blues soothe while oranges add energy. The custom, glass-topped bronze coffee table keeps things light in the living room's core.

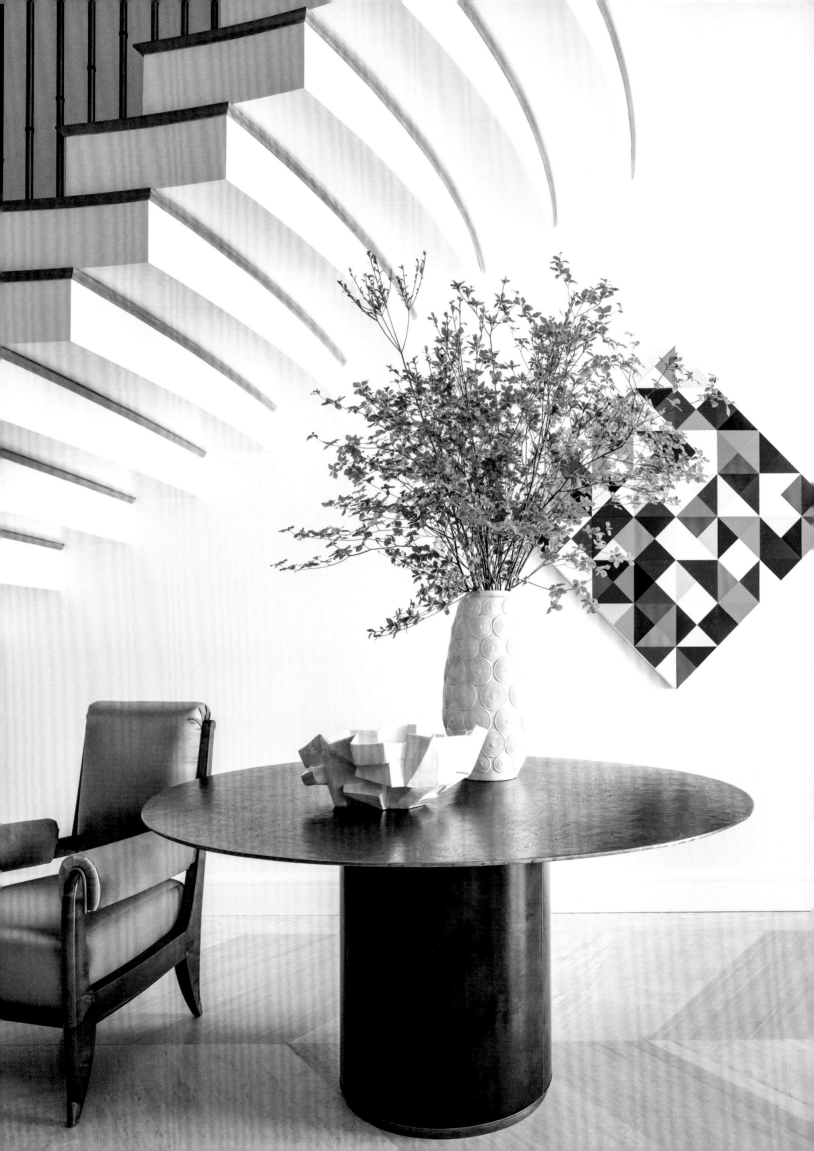

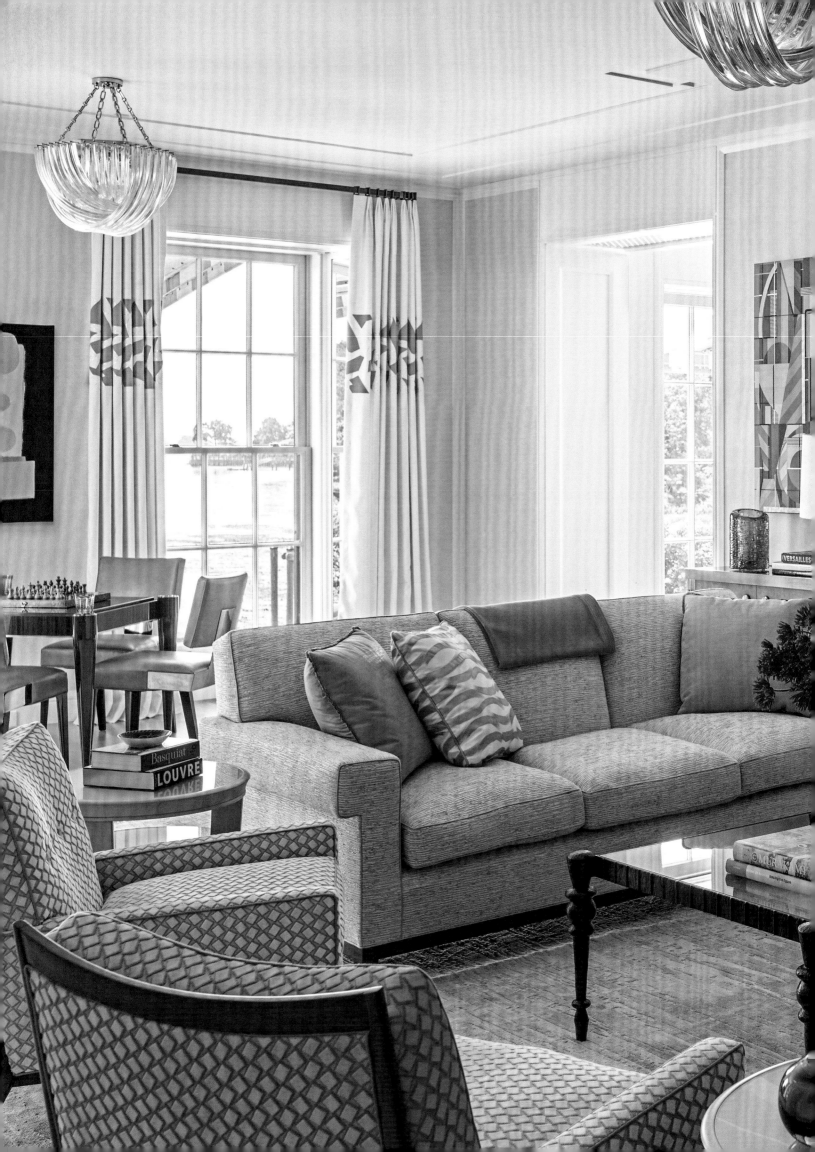

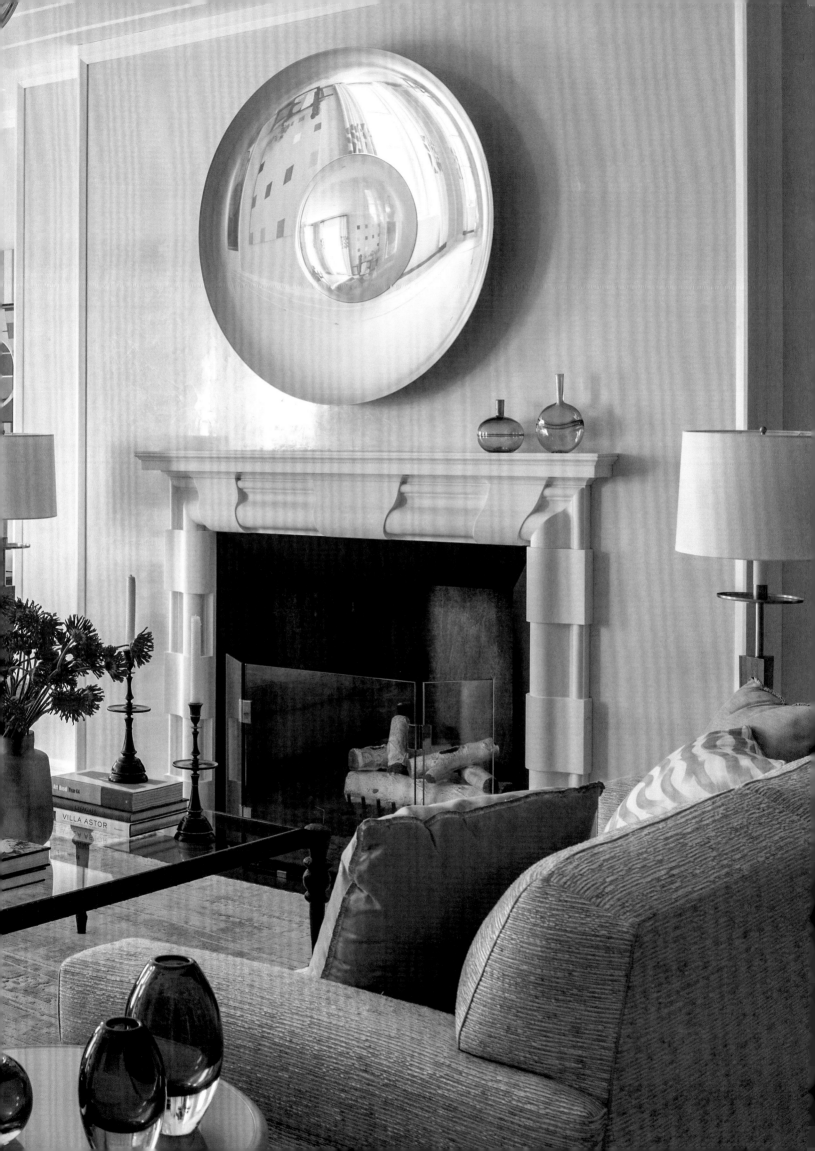

ABOVE: Many modern traditions happily cohabit in this traditional house. The fine vintage Italian sideboard and contemporary Italian vase feel at home with Bernard Piffaretti's abstract painting. OPPOSITE: A 1980s Seguso chandelier presides over the custom table and 1930s De Coene Frères chairs re-covered in a mosaic-like velvet reflecting all the house's blues. The rug's updated Greek key responds to the geometry of the articulated ceiling.

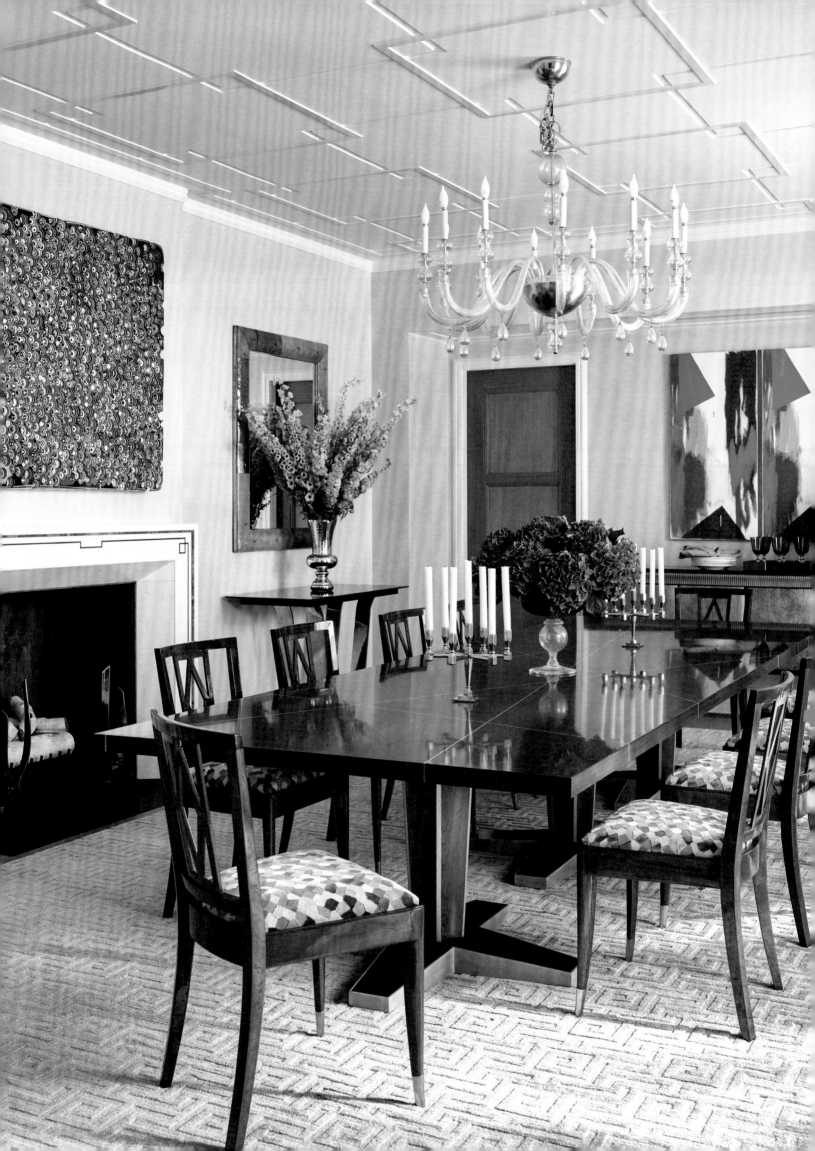

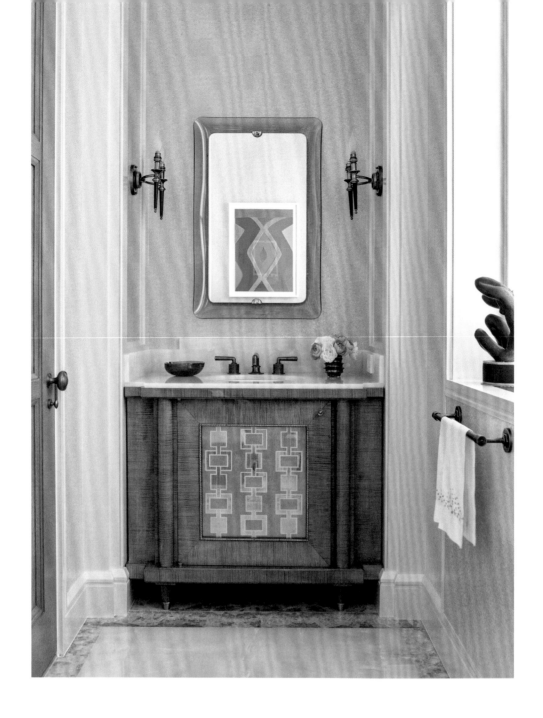

level to buy more vertical space between floor and ceiling and create more light-filled living areas. We expanded the overall footprint with a glassed-in exercise room addition. A significant part of the comprehensive scheme involved refining and streamlining the indoor/outdoor connection with the addition of a wraparound terrace, large fire pit, expansive dining pergola, and moving the pool from the front to the side of the house.

As passionate as we are about composing the big picture, we confess to adoring the small details. There is something both revelatory and revealing in the process of creating just the right balance of simplicity, complexity, personality, and beauty. Here, we had the opportunity to envision and create

everything from light fixtures—including the three-tiered lantern that dangles in the front hall like a statement earring—to the stylishly restrained stair balustrade with two-tone metal fittings to the elegantly understated stair runner quietly elevated by a tailored leather binding.

Light oak and travertine surfaces—and restrained blasts of bright blue—begin to make their statement in the lofty entry. A very subtle blue rolls like a gentle tide into the living room, which, even with three seating areas, a game table, and a chaise lounge meant for daydreaming while rapt in the view, is airy and uncluttered not just to bring the expansiveness home, but also so babies can crawl and toddlers can play unhindered.

The glassed-in library addition overlooking the water houses the husband's study and incorporates nods to Thomas Jefferson's Monticello, including the circle-in-the-square motif that the dome creates. These clients love to help select natural materials, especially stone. With them, we found an onyx for the bar shelving in shades of browns and grays that recall the rocky Atlantic coast, and a white onyx for the top and border. So many different artists and artisans—woodworkers, metal workers, glass artists, and more—collaborated with us to bring the elements we designed for this room into three dimensions.

This family loves to entertain. In the city, they have a three-pedestal dining table that they can extend with leaves for large groups. Here, they requested a table always ready to seat sixteen so they would never have to navigate putting in a leaf again. The one we designed and had made for them in sycamore and walnut picks up on the balustrade's dark-and-light

OPPOSITE: In his study, each decorative choice responds to the architecture's happy meeting of circle and square. At the heart of the luminous, high-gloss dome is a 1960s Barovier & Toso chandelier; the rug underneath quite literally radiates comfort and pattern. Our custom-designed, art deco-style club chairs resonate with the twentieth-century spirit of many of the house's furnishings, including the desk's 1940s Saint-Gobain lamp.

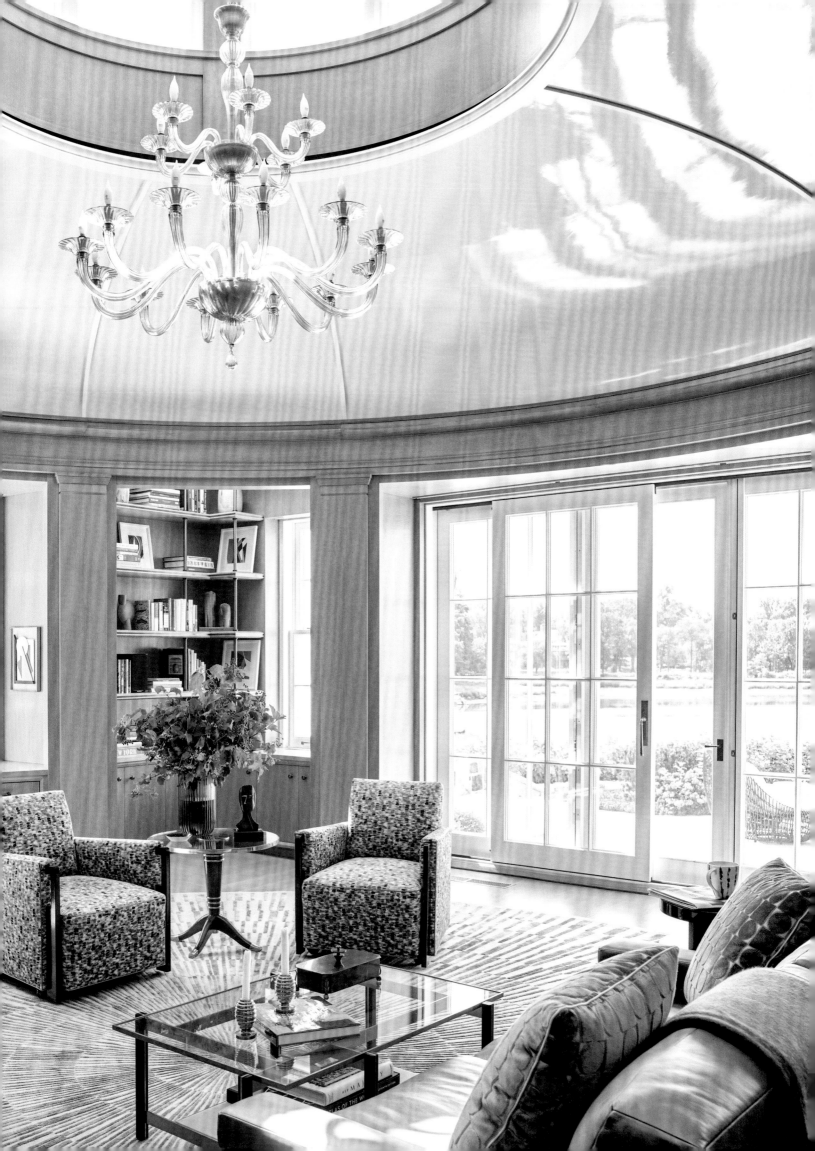

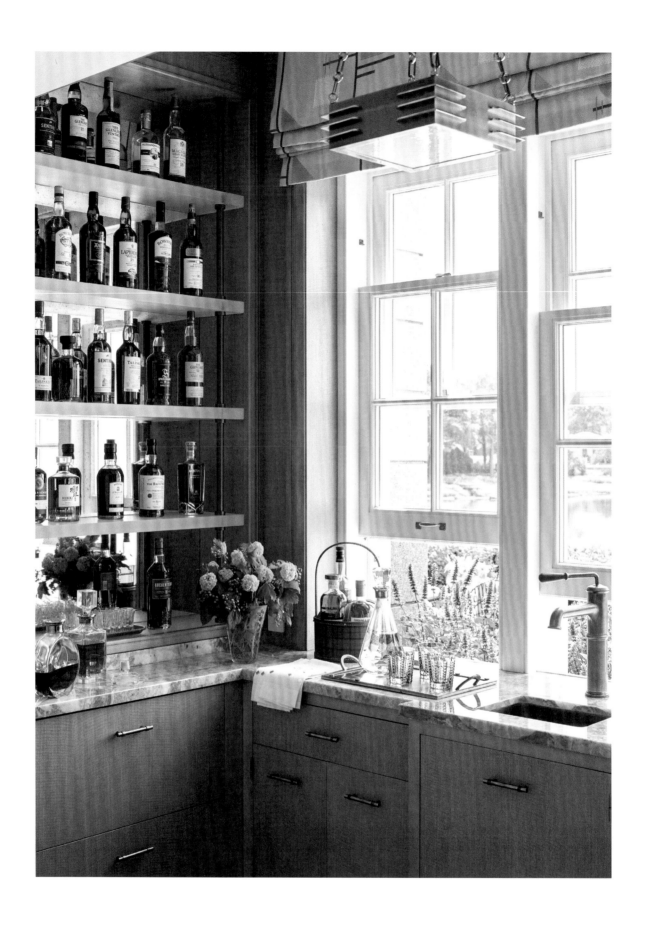

ABOVE: Adjacent to the study, the bar features materials that celebrate the distinctive hues of the owner's Scotch archive. OPPOSITE: The study's 1930s American side table provides a handy surface. The leather-swathed sofa calls for guests with plush geometric throw pillows. "Book-scapes" beckon just beyond, combining horizontal and vertical stacks with artwork.

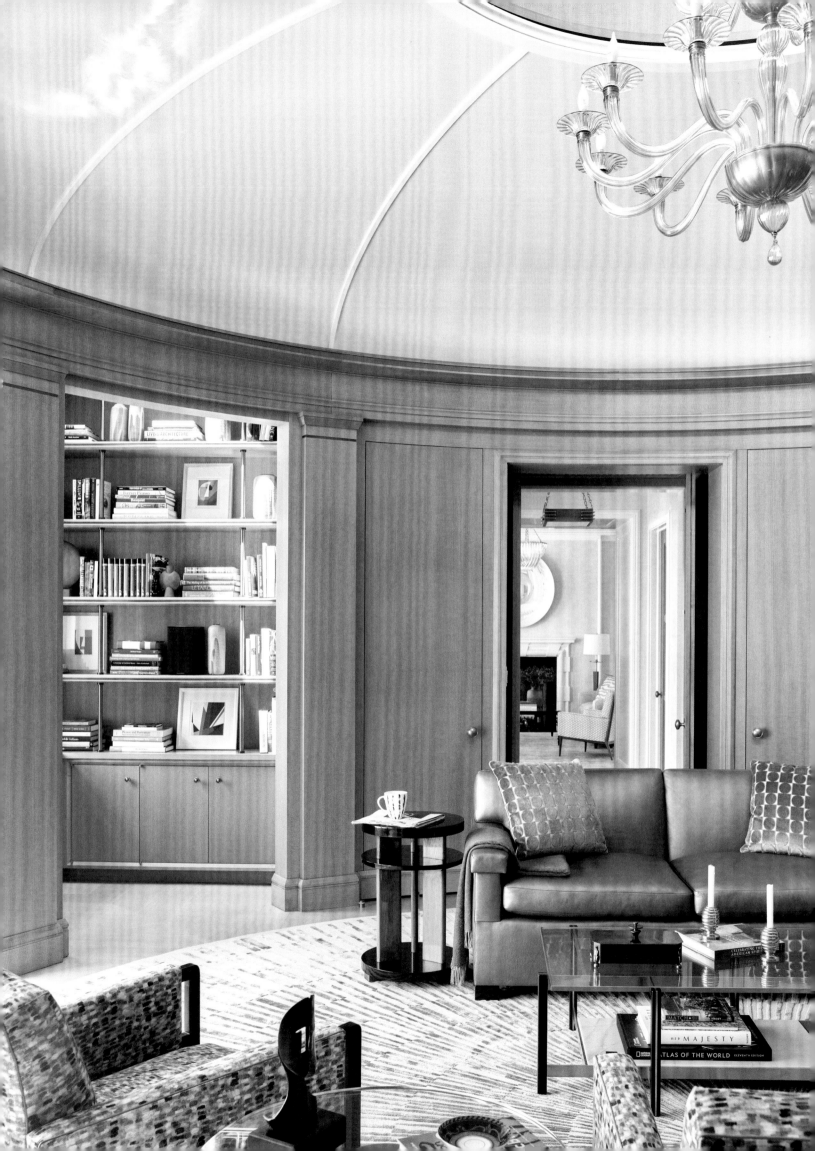

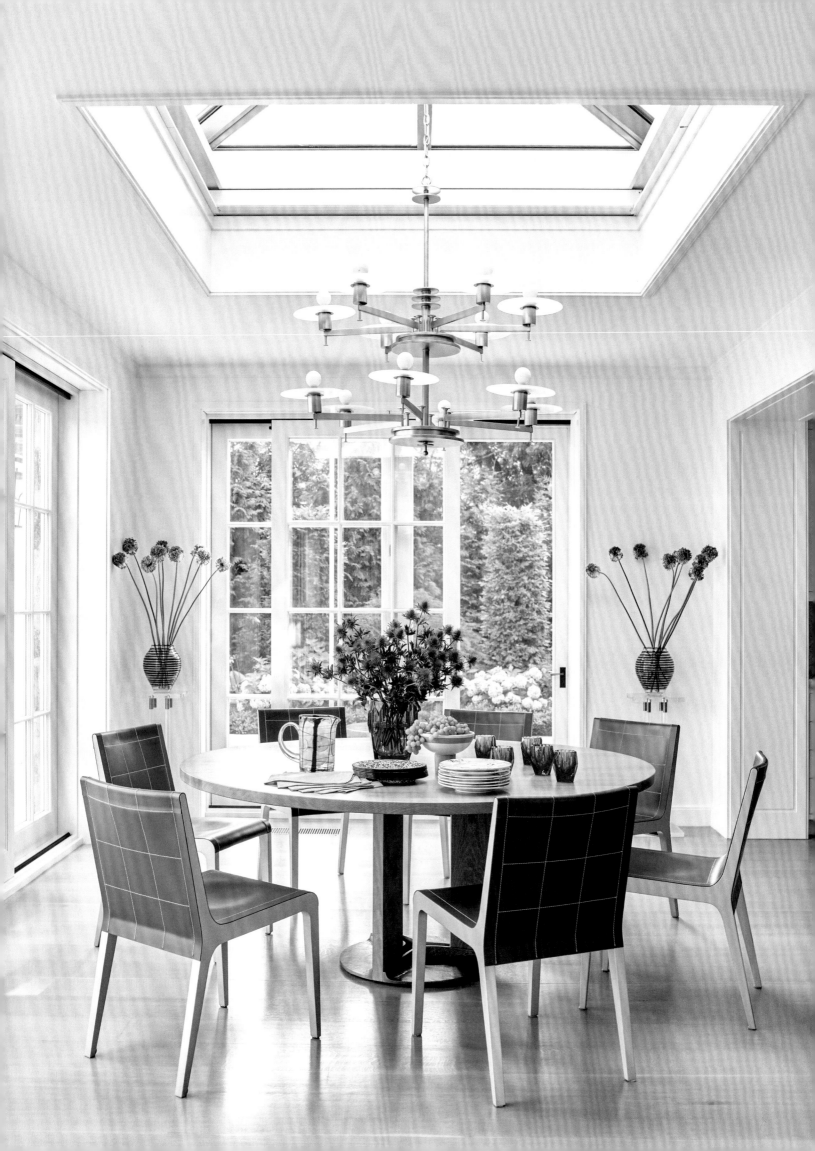

metal motif. Walls glazed in a soft, misty hue whisper with shimmer thanks to a silvery finishing plaster. With the lacquered ceiling and luminous hints provided by silk drapery, the room glows enchantingly at night.

The family room also looks onto the water. Relaxed and cozy, it happens to house the longest sectional sofa we have ever designed. (Speaking of embracing change, it's worth noting that years ago, we considered sectionals completely taboo; now, they're a favorite part of our twenty-first-century vocabulary!) At about fifteen feet, it's lengthy enough for grandparents, parents, and grandchildren to all squish in together. The kitchen virtually doubles as a second family room since the family loves to cook together and spends a fair amount of time at the breakfast table, which seats twelve easily. The over-island lights we chose here cheekily resemble saucepans, wittily breaking up the large ceiling plane. It's hard to overstate what a change of pace this weekend residence on the waterfront encourages for all generations of this New York family.

The wife's study sits at the top of the stairs on the second floor, set slightly apart from the household activity behind a glass partition. The primary suite beyond offers the couple an airy private retreat, with a bedroom almost as sprawling as the living room, oak-paneled dressing rooms, and an ethereally sparkly white marble bath.

The bunk room is a happy place for the littlest family members—and so practical. Safe stairs between the beds double as storage and pop off railings make changing bed linens easy. The lower level is just as fun, with a billiard room, theater, and bright, cheery game room/playroom awash in color, including some flashes of red. To accommodate so many anticipated young guests, we found ourselves trying new combinations of high/low materials, including durable, easy-to-replace commercial carpet tiles, cut up and jigsawed into a zesty pattern for the playroom floor.

The past meets the present meets the future in this residence for a family that wishes to remember yesterday, live for today, and create a homestead for tomorrow.

PREVIOUS PAGES: This three-generation family is always in the kitchen together, so the space accommodates all. The custom metal hood picks up the island's metal accents. The rectilinear fixture is from Stilnovo. The breakfast room chairs match the island's leather stools, connecting the adjacent spaces. OPPOSITE: The oak-topped, bronze-based breakfast table pulls in materials from other rooms. We added a second tier to the 1930s Schwintzer & Gräff chandelier to balance the pop-up ceiling and left the windows bare so as not to block the views. The naked floor makes for easy clean-up after young grandchildren.

RIGHT: The family room called for a fifteen-foot sectional, one of the largest our office has ever specified, so the entire family could be on it together. As ever, Joe Calanga, our beloved upholsterer, mastered the form and fit of each piece perfectly. With all that length, the sofa needed more throw pillows than usual; these are a mix of custom and ready-made. Multitiered nesting tables with colored glass tops are easy to move at will; their colors repeat in the twenty-first-century Murano fixture with custom glass inserts in the perfect shade of ochre. The asymmetrical stripe appliqué on the Roman shades reflects the sense of relaxed family fun. The artwork is by Cameron Martin.

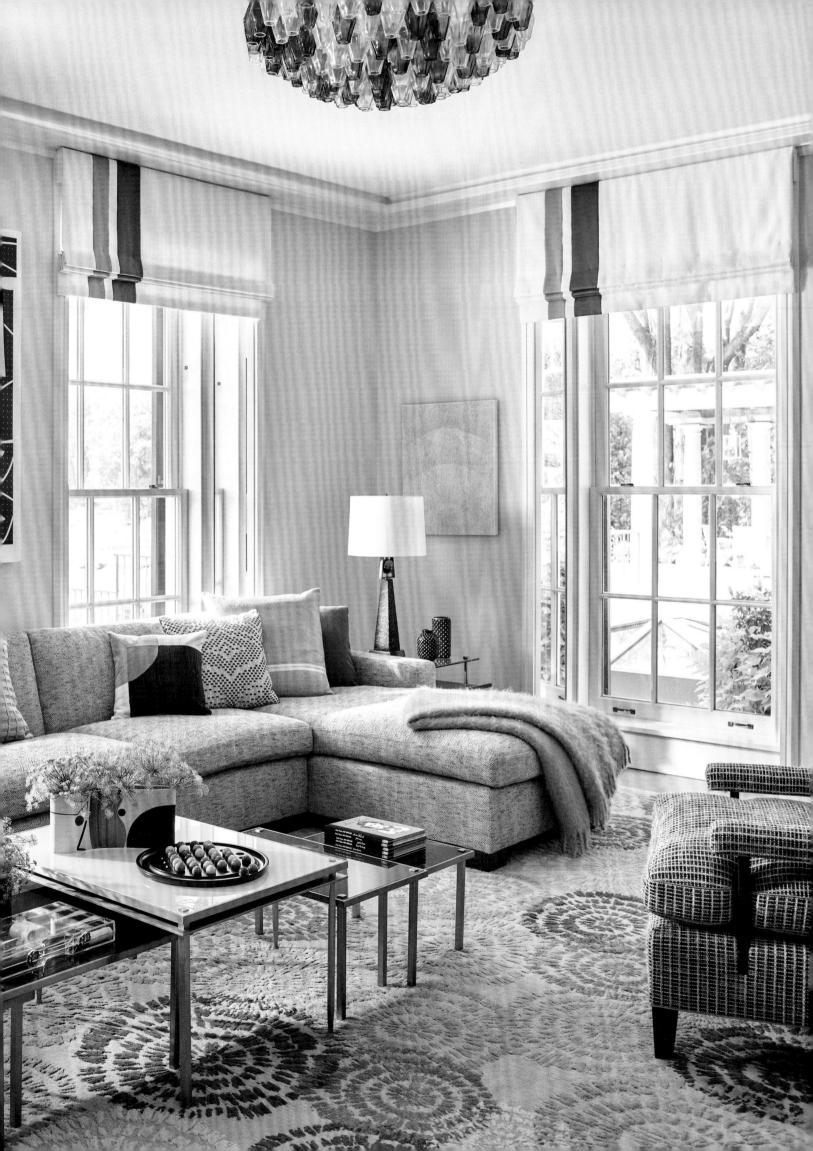

RENOVATION

Let's talk about bone structure and the role it plays in beautiful spaces. When a home is already well configured, we can't wait to adorn it with maquillage, as it were. Otherwise, we want to renovate as well as decorate. The coin toss of aesthetic sensibility starts with a deceptively simple decision. Should the interior décor and style of the exterior be obviously sympathetic? Or not? There's no right answer. But there is a right way, which is to make consistent choices, whatever the point of view and the architectural concept. This is why we prize close collaborations with architects and clients.

Updating spaces for today's lifestyle usually involves finessing the flow from room to room, capturing as much of any available view as possible, and expanding square footage as parameters permit. All cosmetic surgery can get a bit tricky, but it's especially delicate when the home has history. If the past has already been stripped by someone else, do we restore it? Or do we enhance what's survived and balance the mix? These are two of endless possible scenarios—and always, the owners' preferences are the most important. What if the house is an early twentieth-century neo-Georgian on the water, everyone's dream of a summer retreat? Its original windows would have been small, to keep interior spaces cool during hot, humid days. Today, we crave light and airy rooms. Modern technology, fortunately, allows us to beat the heat, so we can enlarge windows all around.

Many of our clients hope their second homes will become family compounds for future generations, so we're always casting forward. If the house sleeps ten now, will that be enough when all three children are married and have kids of their own? Can we excavate down to carve out the modern spaces modern people now expect, like playrooms and home gyms, while making these lower levels light-filled and cheery?

In our core philosophy, renovation is often preferable to new construction, not least because it's an environmental plus. We try to use antique or vintage furniture wherever possible for the same reason. Really, we just love bringing new life to old things.

OPPOSITE: The second-floor landing marks the entry to her office and the primary suite. Églomisé panels provide privacy without blocking light. The curtains, an airy, open weave with slubs for interesting texture, were handwoven in Guatemala and incorporate alternate bands of blue-gray stripes that seem to blend organically into the view of the landscape beyond. Solar etchings of water views by MaryBeth Thielheim bring a high tide of color to the third-floor landing.

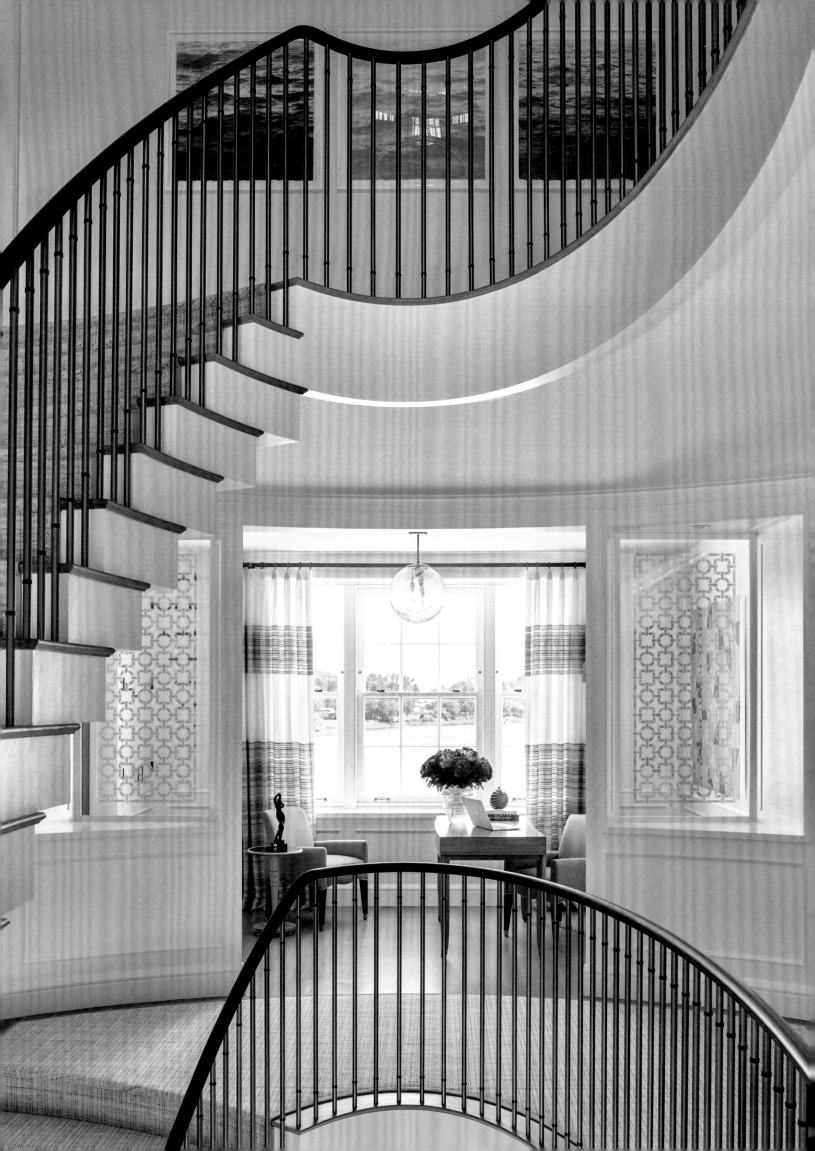

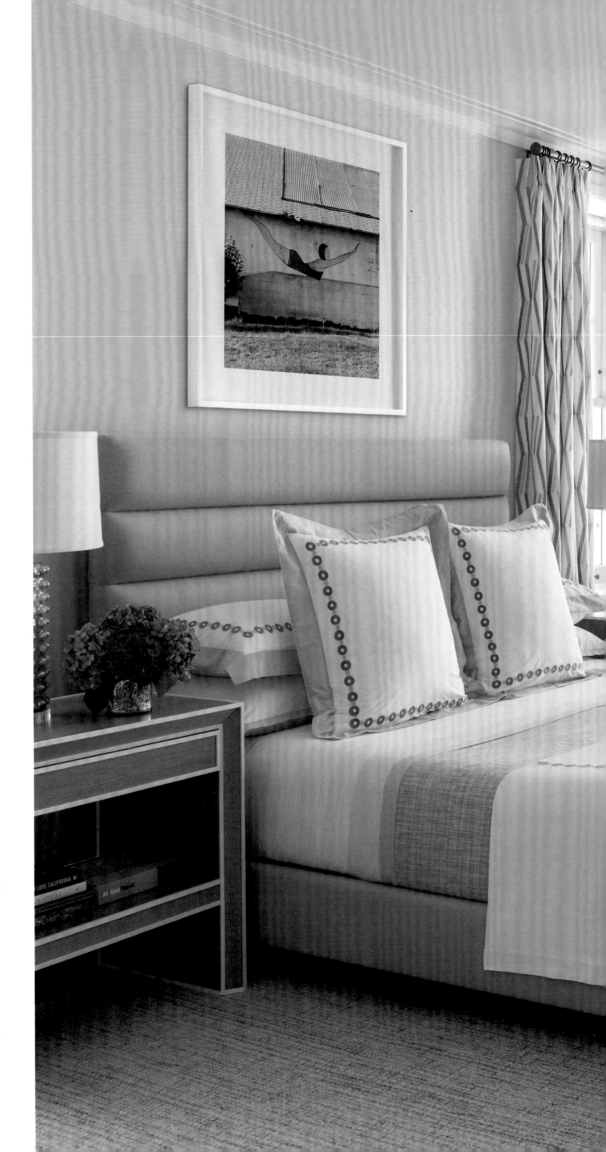

RIGHT: The primary bedroom is an oasis that provides respite from the high energy of family life with multiple generations. Not all curtain embroidery has to be custom stitched; here, we were fortunate to find the perfect fabric off the rack. Custom oak and faux-ivory bedside tables of our design have more than one kind of storage built in, which enhances their function. The wishbone-style bench adds expected seating while the midcentury lounge chair in blue leopard is the curve ball that keeps the room from being too staid. The contemporary Murano glass ceiling fixture diffuses captivating light through its two shades of glass panels.

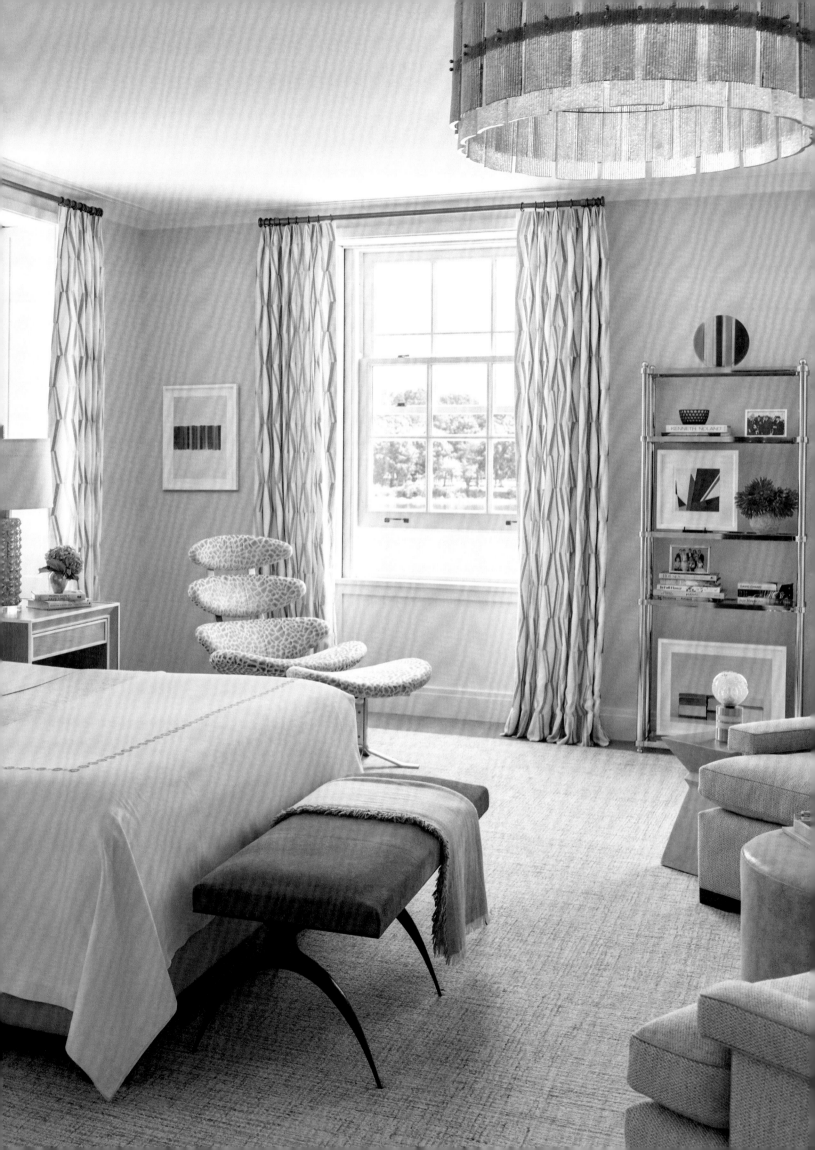

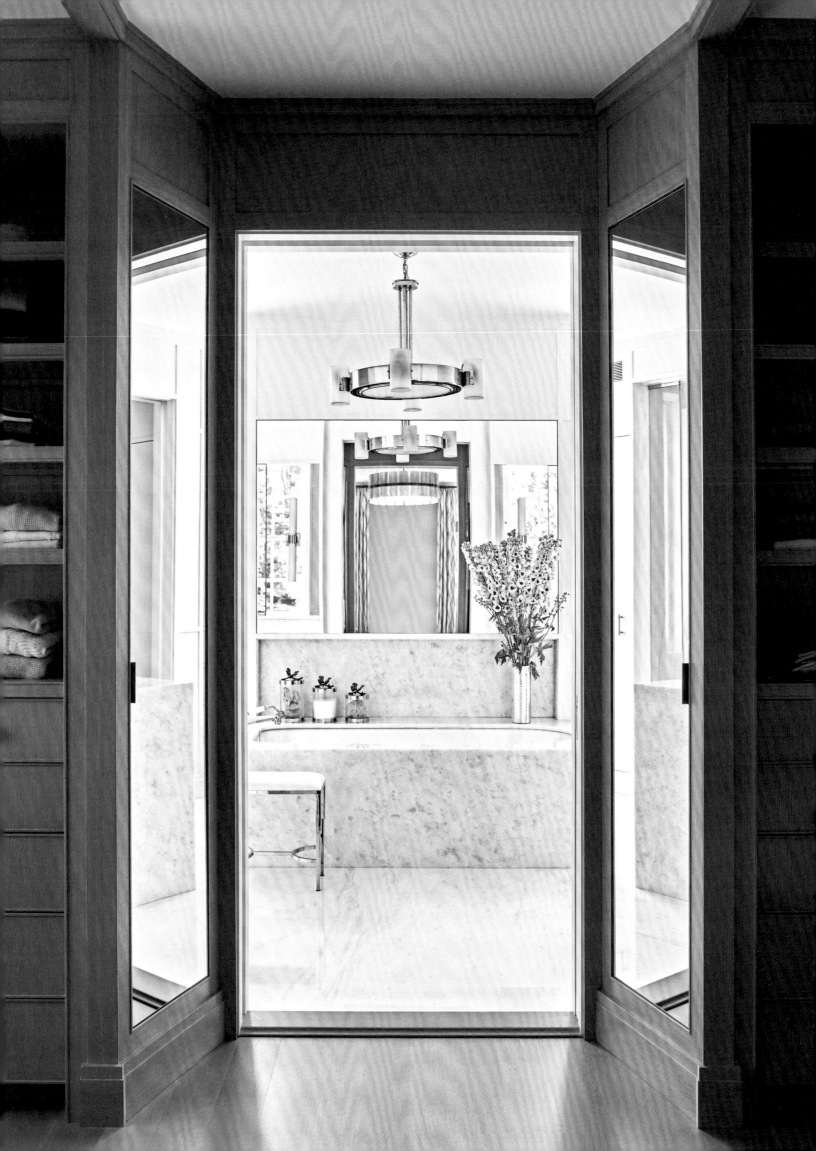

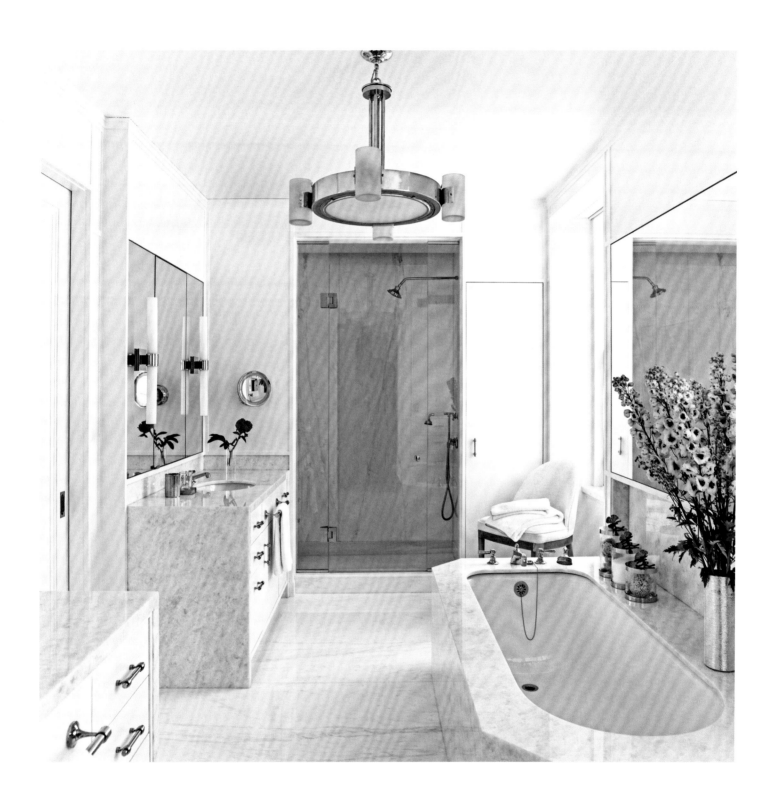

OPPOSITE: Their his-and-hers dressing rooms open to the primary bath, creating a contrast of light and dark between the two adjoining spaces. ABOVE: The rigorous, minimal design of the primary bath sheathed in slab marble is in keeping with the light-filled aesthetic of the house. The tub surround picks up the geometric motif established downstairs. The light fixture is French, circa 1935.

233

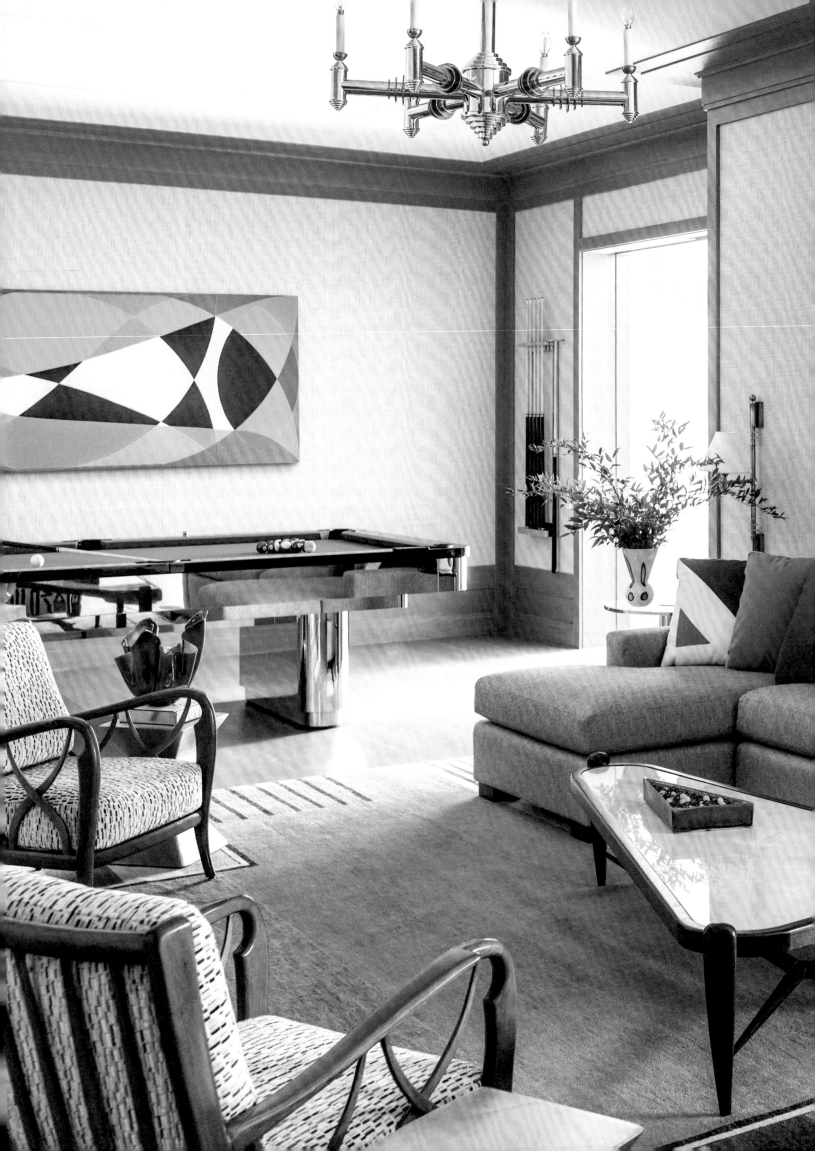

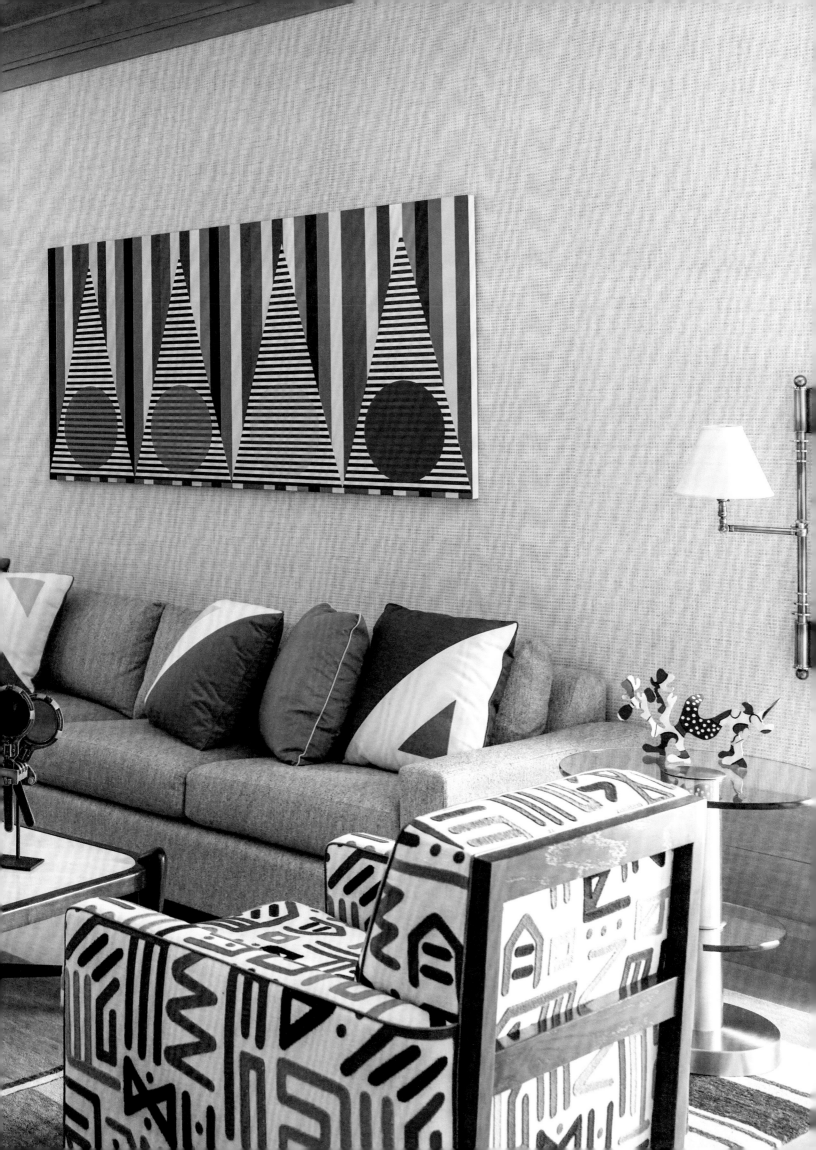

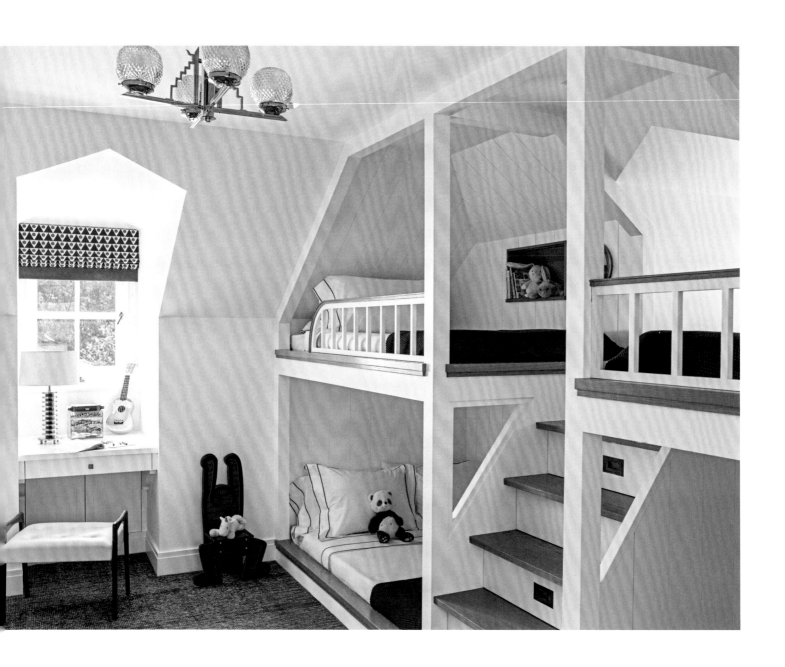

PREVIOUS PAGES: The lower-level family room is an homage to asymmetry, as the 1950s coffee table and midcentury Italian armchairs underscore. The stainless steel billiards table is custom. The chandelier is by Atelier Petitot. ABOVE: The bunkroom emulates a ship's cabin with removable bed rails and stairs that house drawers. OPPOSITE: Pieced together from commercial floor tiles, the playroom carpet is practical and fun.

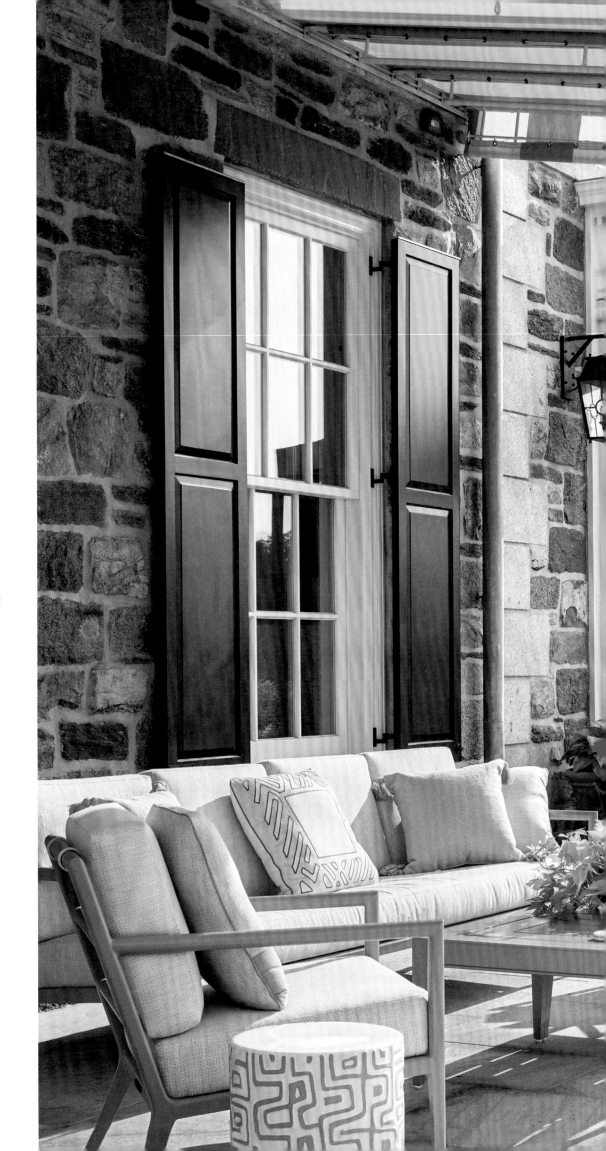

RIGHT: We collaborated closely with landscape architect Janice Parker on all the exterior spaces. Instead of one continuous awning across terrace outside the living room, we opted for two to maximize the light during the season. The furnishings, which can be rearranged easily as the occasion requires, bring some of the design motifs as well as elements of the interior color palette into the exterior. OVERLEAF: The placement of the sculptural fire pit and its seating area consciously embraces the ideal of extending the living space as far as possible into the landscape—in this case, all the way to the waterside.

238

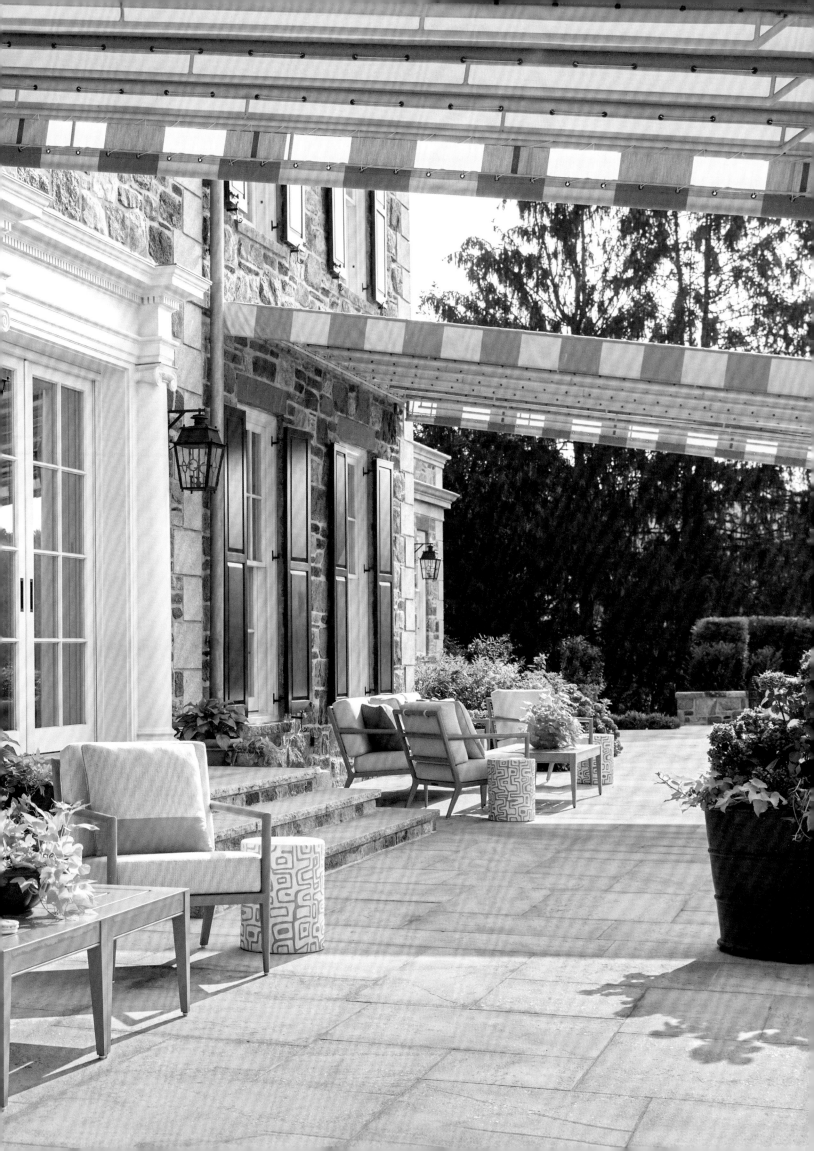

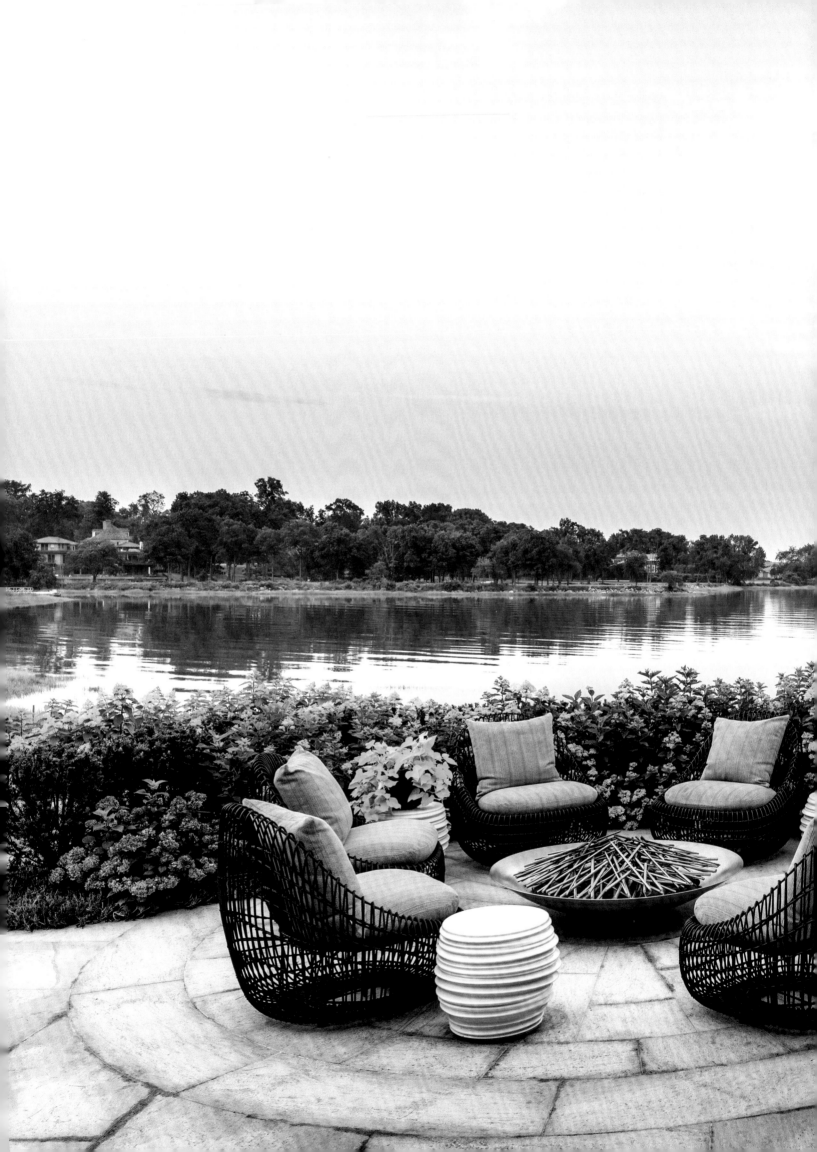

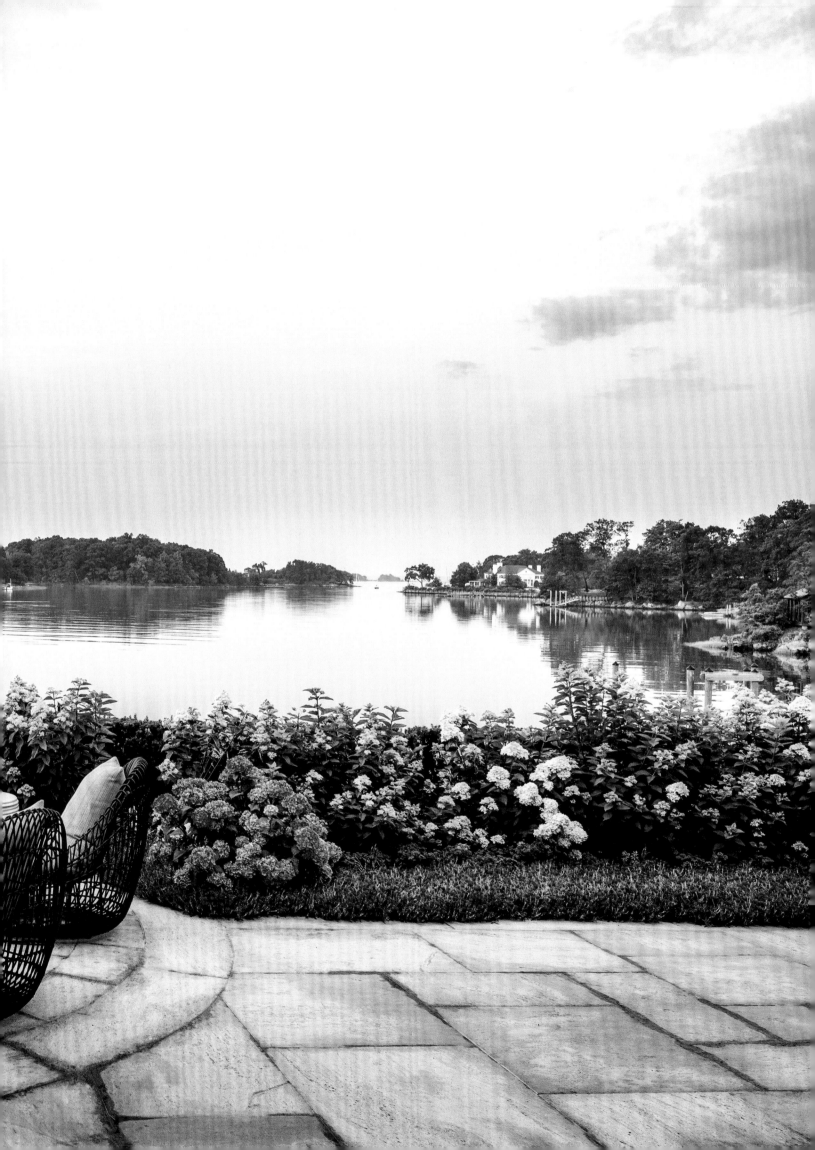

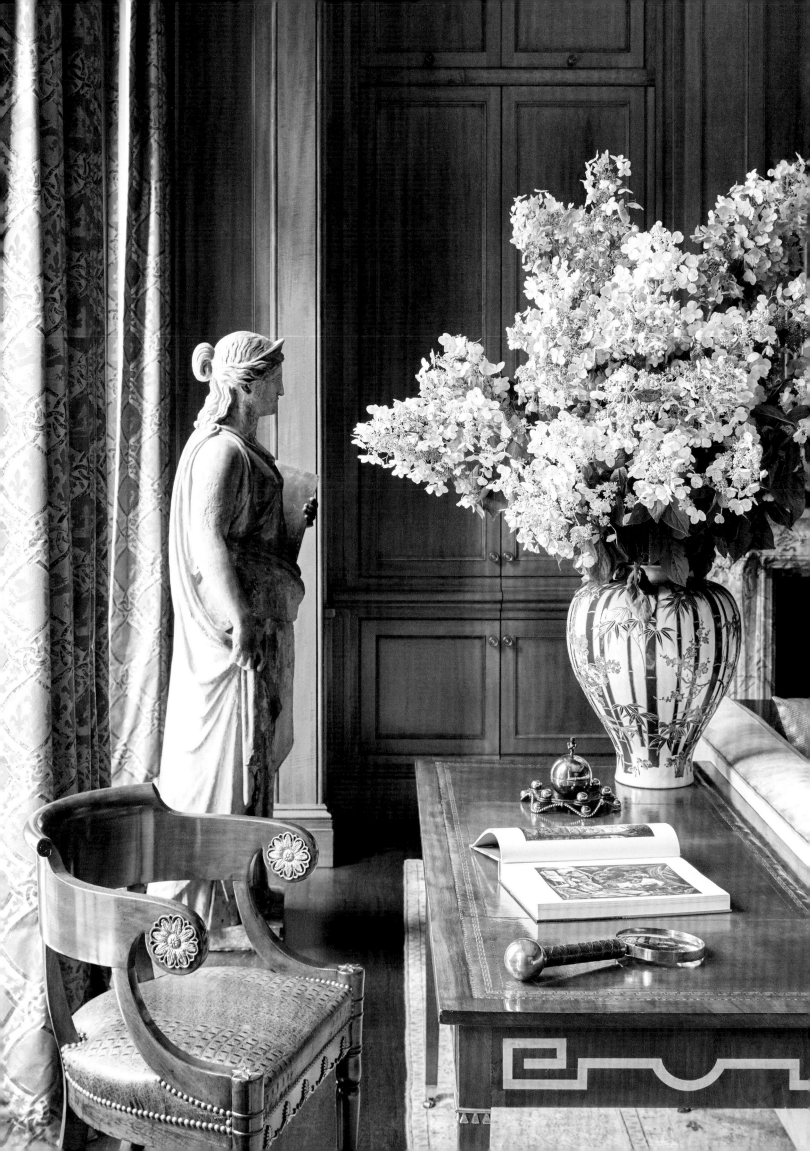

HIS AND HERS

Minimalist and maximalist? Traditionalist and modernist? Couples often have differing, even opposite tastes. Our goal, always, is to coax each marriage of mixed sensibilities past an entente cordiale into a harmonious, nuanced, refined decorative language. It's an enduring challenge, and an especially fascinating one when the couple's aesthetic styles are truly miles apart. Here, the husband loves all things traditional—Italian, French, English, antiques, you name it—and wanted the family home to embrace the full panoply in rooms that had an Old World ambience and looked collected over time. The wife favored a very clean-lined modern look, with light colors. She also wanted to ensure the interiors of their 40,000-square-foot residence by architect James Paragano felt inviting, fresh, and fun for their youthful family of five. With formal spaces on the main level, private areas on the upper floors, and recreational areas on the lower level where they actually spend most of their time with guests, it was important that the circulation spaces—the entry hall, four-story stairwell, and upper hallways—cohered into corridors that wove the house together in a consistent way. We decided to sheath the hall walls in natural bark paper cut in squares to add warmth, texture, and interest. With its inherent tonal differences between pieces, the paper imbues this backdrop with a modern, stylish vibe that still feels richly layered.

Incorporating elements with age was a necessity here, both because of the husband's passion

OPPOSITE: The library expresses the husband's love of tradition and passion for history, translated through the decorative arts. The late nineteenth-century French terra cotta figure depicts one of the Greek muses. The Italian desk dates to 1780; the French chair, circa 1860. The Japanese satsuma vase is Meiji Period. We had the curtain fabric hand stenciled with a pattern admired at Palazzo Davanzati in Florence.

for antiques and because new houses, particularly large ones, need the tempering of patina. We shopped with the couple in Europe, at auction, and with all our favorite dealers, as well as commissioning pieces from artisans worldwide. Three antique rugs got us started in the dining room, living room, and library. Seven antique or custom-designed mantels and an array of extraordinary, mostly nineteenth-century chandeliers brought an infusion of character.

The octagonal entry sets the tone for stylishly leavening the past with the present. Here, the bark paper is reminiscent of traditional French limestone block entries, but treated in a way to echo Jean-Michel Frank's art deco stylishness. The gilded center hall table and grand crystal chandelier pose in a contemporary formation, flanked by a pair of Louis XV bergères dressed in an embossed, gold-dusted velvet.

The long, narrow living room was a reminder that even the best-laid floor plans occasionally call for adaptation in the moment. We had designated one sofa for the middle of the room, facing the fireplace. During installation, we realized that if we shifted it to one side, we could better reinforce the axial pathway into the billiards room across the hall. The gold-flecked Venetian plaster wall finish was another invention that took many hands to find the perfect balance. Touches of burgundy picked up from the carpet and the extra dimension of the uplifting animal print fabric help to ground the surrounding shimmer of gold and cream. A

RIGHT: The entry hall epitomizes the marriage of eighteenth- and nineteenth-century antiques with contemporary items and art that shifts in counterbalance throughout the house. With its organic tonal variations, the handmade bark paper that swathes the walls reinterprets the concept of the classic limestone running bond entry into the twenty-first century. The hand-painted gaufrage velvet on the Regency giltwood armchairs extends the theme. The German cut-glass chandelier dates to circa 1800.

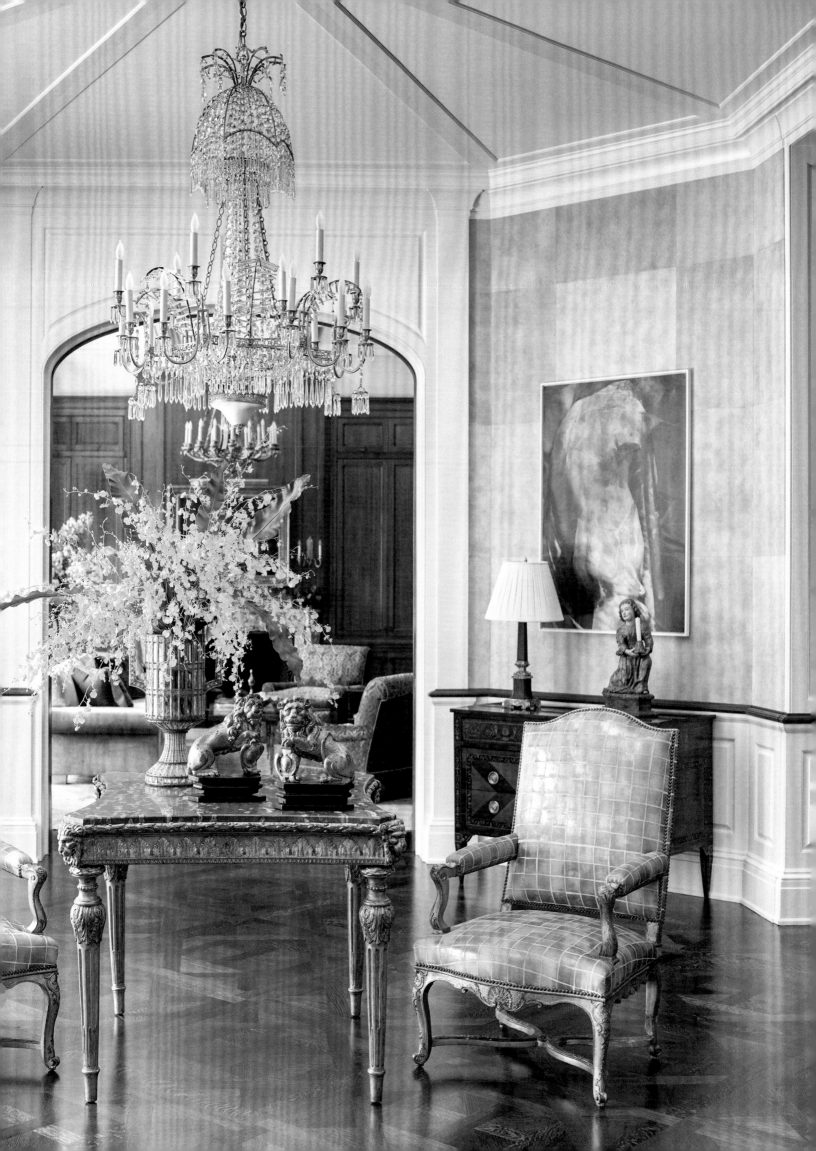

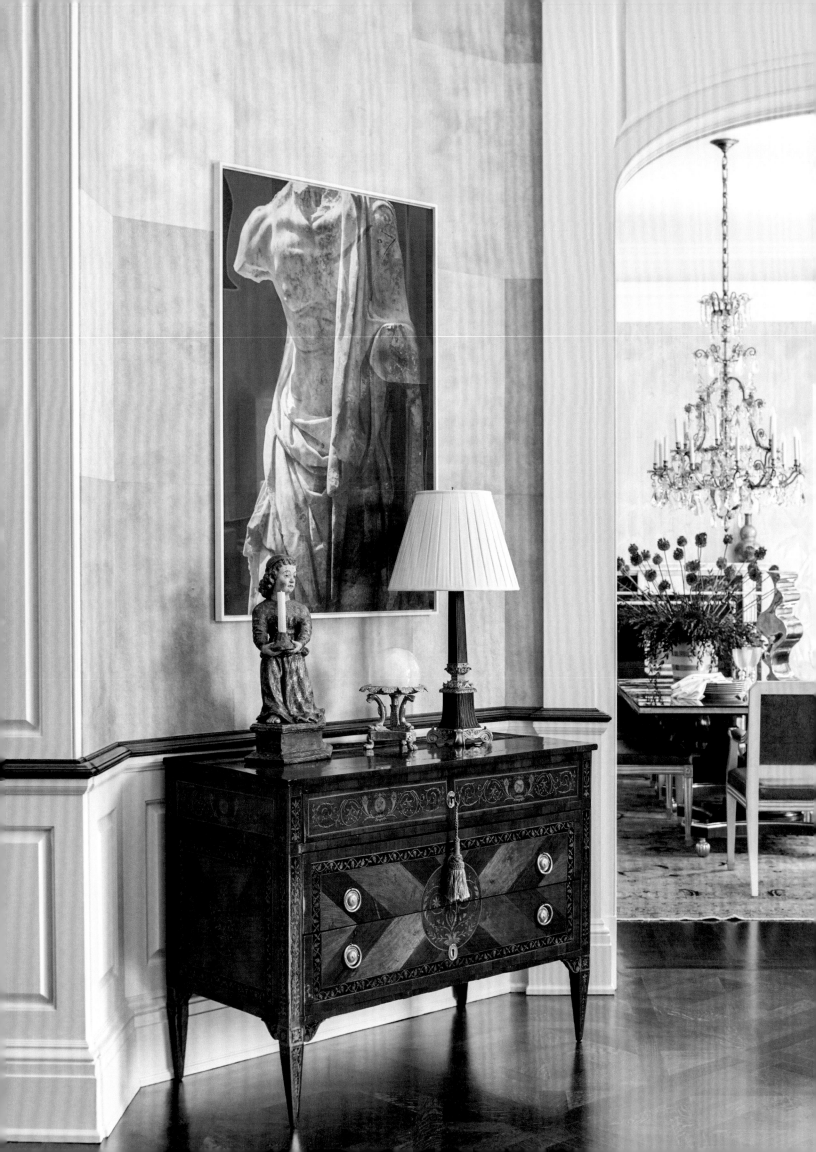

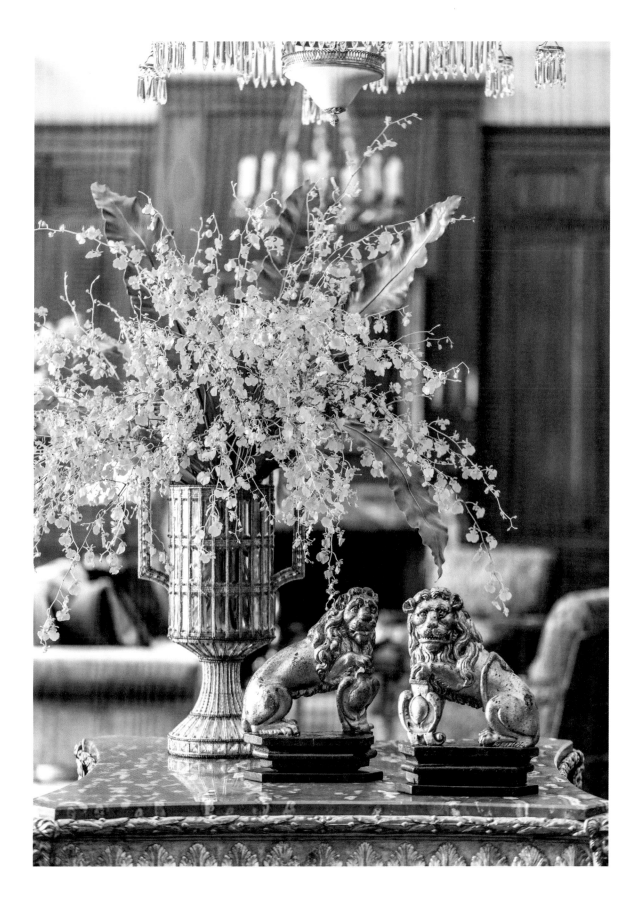

OPPOSITE: A pair of Giuseppe Maggiolini's nineteenth-century marquetry commodes anchor opposing sides of the octagonal entry. The artwork by James Welling reinterprets a classical figure through today's eyes and photographic techniques.
ABOVE: Atop the eighteenth-century center hall table, a crystal beaded vase and pair of Charles I carved lions—a favorite family motif—mix in a modern way.

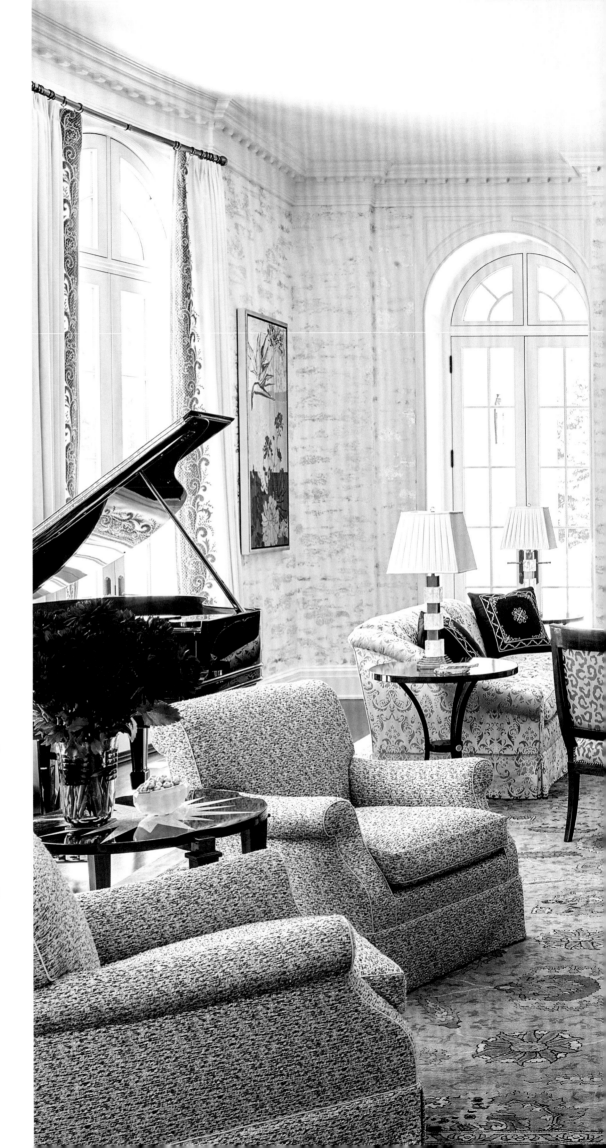

The owners wanted their children to begin to learn world history through art and objects, a desire that informed many of the decorative decisions throughout. The rug, a late nineteenth-century Indian Amritsar, was one of three antique rugs purchased for the project, and the starting point for the decoration here; with the antique mantel, it inspired the color palette. It's rare to come across a pair of antique chandeliers, so finding these two Genoese carved wood and glass chandeliers from 1810 was a high point. A piano neatly divides the room into two seating areas that mirror, but do not mimic, each other in forms and arrangement.

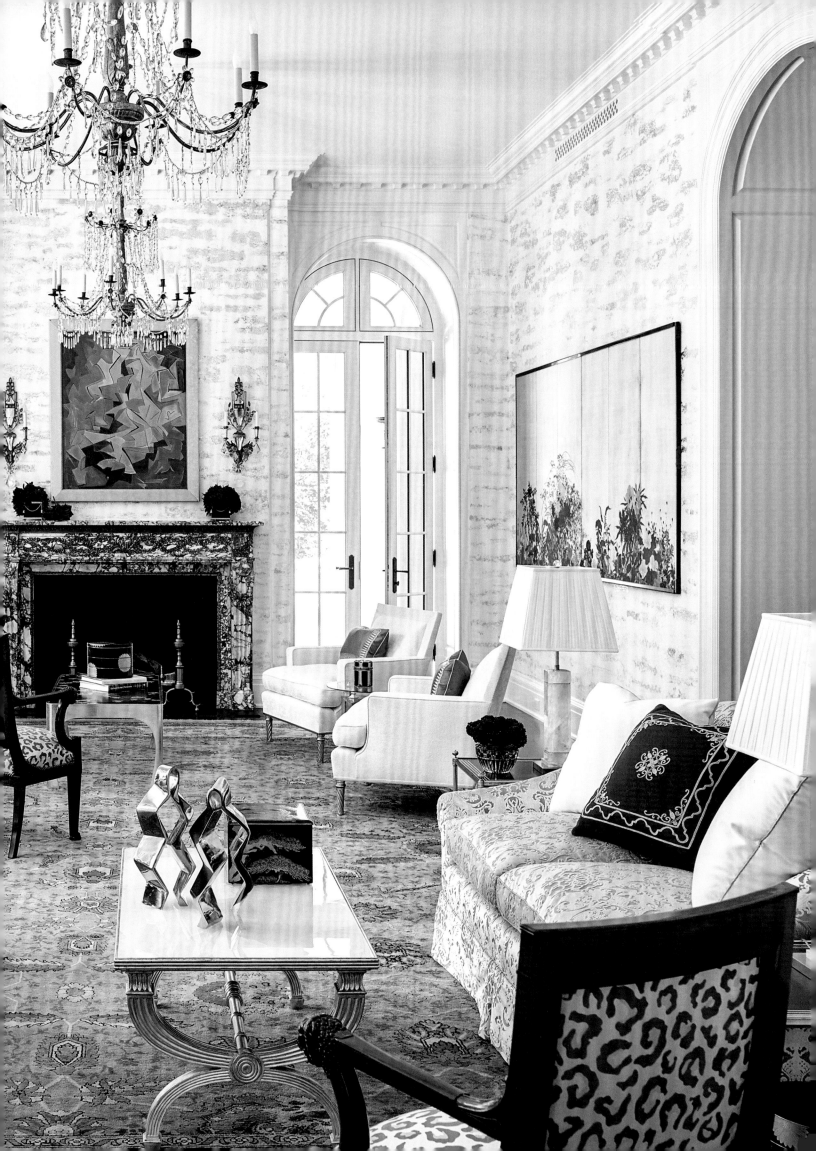

ABOVE: Based on an antique textile, the curtain trim's embroidery and appliqué reveal the triumph of handwork. OPPOSITE: The French eggshell-and-lacquer drinks table dates to 1940. Plaques of brass and 24-carat gold leaf ornament the contemporary Murano glass mirror. The collage is by Robert Kushner.

pair of early twentieth-century Japanese screens bring a corresponding glow to the walls while adding age; artwork spanning the twentieth and twenty-first centuries draws the focus to other points around the room.

For the library, the husband envisioned walls bathed in honeyed wood; an antique carpet underfoot; and antique furnishings, including nineteenth-century terra cotta figurines that hold tremendous personal meaning. He requested green accents pulled from the rug and the suede-covered, hand-stenciled tables custom made in London. As a result, this room provides a perfect contrast to the formal dining room directly across the hall, where most of the pieces were newly made for the couple and the house.

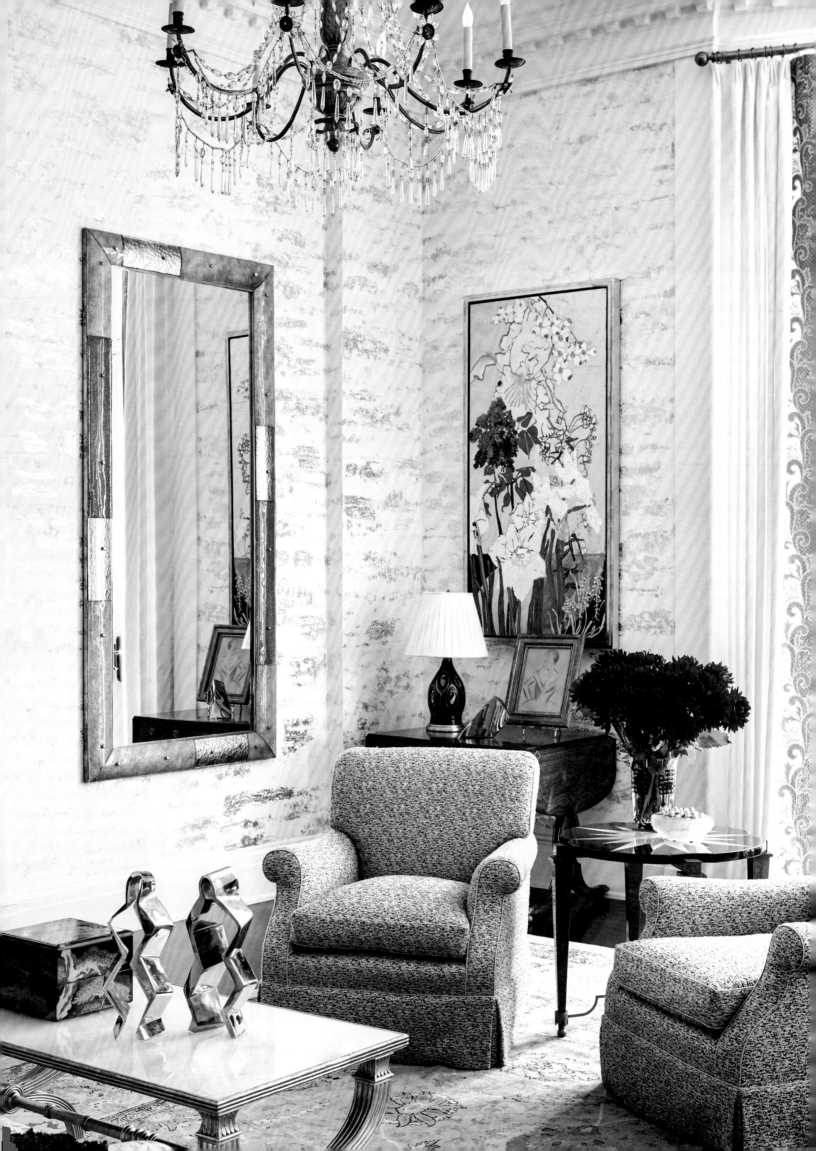

CRAFT

Design, in its way, is discovery. So many masterful decorative leaps forward often spring from the research involved in looking back. Innovation can be a delicate, iterative process. Happily, coaxing the unique into being involves great, collaborative adventures. The revival of the craft tradition in America, as well as the way communication technology facilitates working with those who practice the treasured traditions of the hand at the highest level around the world, has exploded the boundaries of what's creatively possible today.

It's fascinating to meet and work with the next generation of talents who have fallen in love with weaving, printing, metalwork, decorative painting, fine woodworking, glassblowing, and so much more. To have one-on-one contact with artisans who have very specific skills, boundless imagination, and facility for invention with materials old and new, is beyond exciting. When gifted artisans come into the office with something we've never seen before that answers a particular need or addresses a matter of decorative function in an exceptional and unexpected way, we are always in awe. Together, we can ask: "What would you think about trying X?" Together, we can feel the passion about the ideas that emerge.

Many of our own talented team are trained in the visual arts, so it's no surprise that we have a heightened appreciation for craft. But there's something to be said for the idea that this deep dive into our traditions to remake them in new forms truly does begin at home. It resembles what's happening in our kitchens, where we now routinely search out an artisanal cheese here or the best bakery there.

Collaborating with local artisans and skilled practitioners around the world has never been easier, and we encourage everyone to do a quick search for an artisan before choosing off-the-shelf items as well. Whether they're based in the Brooklyn Navy Yard or in Mumbai, we do our best to support them because imagination is one thing, but bringing beauty into material being, quite another.

OPPOSITE: The family wanted to cast a wide net in terms of international design and designers. The fauteuil by Georges Jacob, one of a pair, dates to the early nineteenth century; its animal print fabric, pattern's universal donor, works with everything. The 1920s Japanese screen, which depicts the four seasons, faces the garden; the broad expanses of negative space express its modernity.

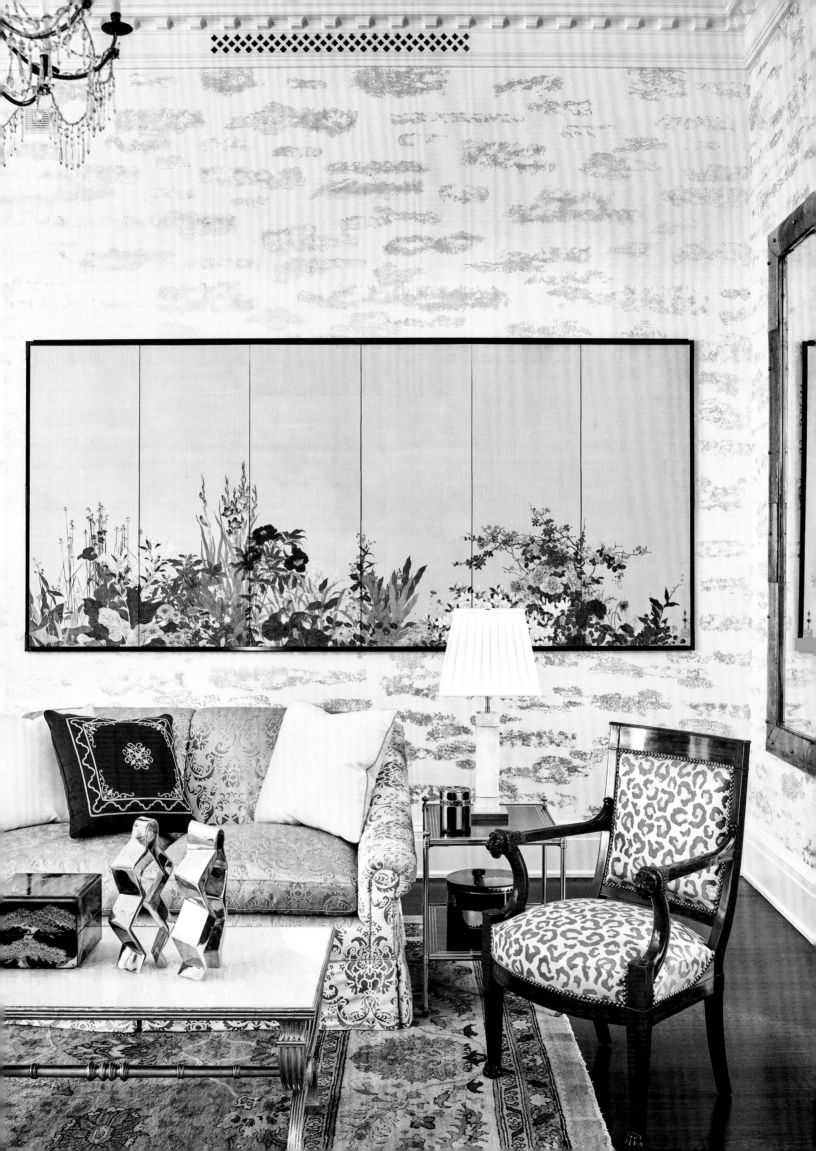

There's nothing more traditional than a Chinese scenic wallpaper in a dining room. But the tools of design give us many ways to update this decorating classic for today, including changing the pattern's scale and palette to meet the contemporary aesthetic. Go big. Go bold. And bring it home.

RIGHT: The dining room recalibrates the balance of this home's marriage of past and present, shifting it more into the modern. The mix embraces the traditional elements of Chinese scenic wallpaper, a late nineteenth-century Maison Baguès chandelier, a late nineteenth-century Persian Khorasan rug, and late-eighteenth-century gilt console. But with its blown-up scale and metallic gold background, this reenvisioned Chinese paper from Gracie shifts the space into a modern mode. The Louis XVI–style dining chairs bring in clean lines consistent with contemporary minimalism. The Maison Jansen–style marble-topped chest also meets the moment.

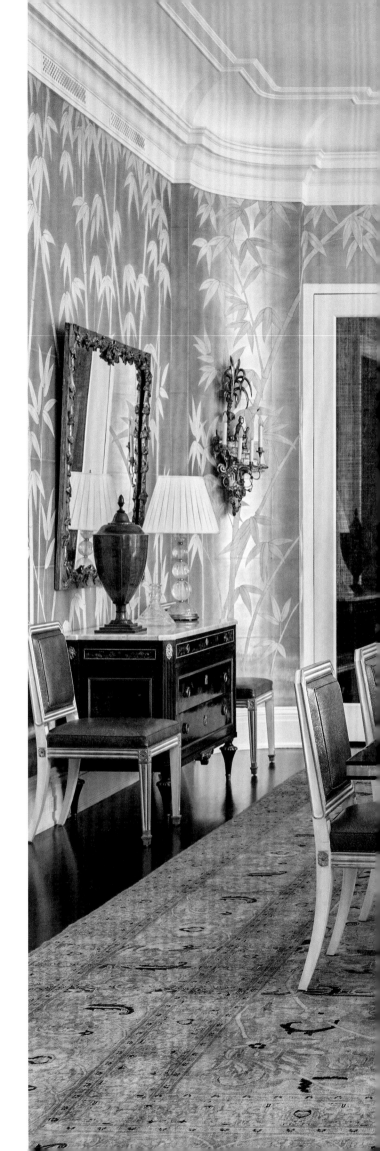

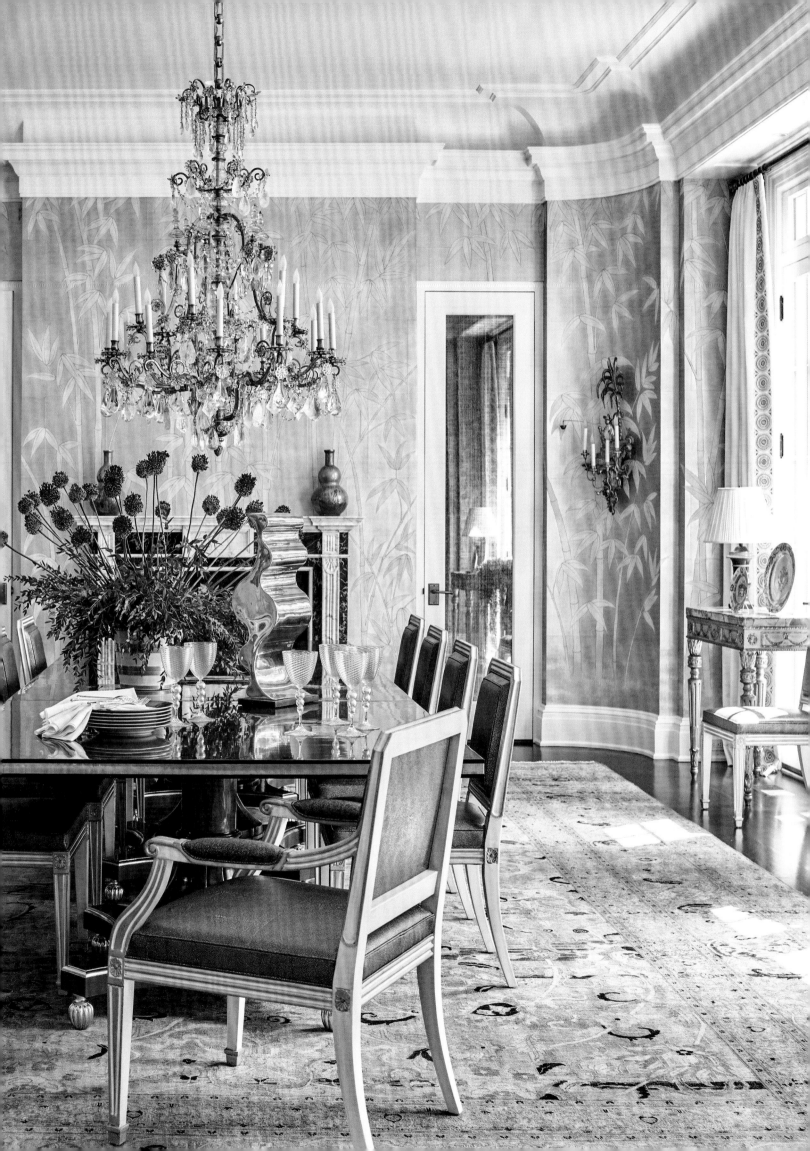

Sheathed in its tonal forest of bamboo on a golden background, the formal dining room could have become a too-traditional chinoiserie-style environment—but pumping up the pattern's scale instantly makes it more contemporary. The antique rug sets the foundation of quiet restraint that allows the elements of ornament to sing. The dishware introduces red grace notes that we enhanced with touches of cinnabar; the sconces purchased at auction from the Brooke Astor estate add history and whimsy at once.

In an expansive house, it's imperative not to neglect the ceilings. This came to the fore wonderfully in the great room, where the articulated plaster overhead adds textural

ABOVE: Embroidery by Maison Lesage epitomizes couture. OPPOSITE: The late eighteenth-century mantel adds patina.

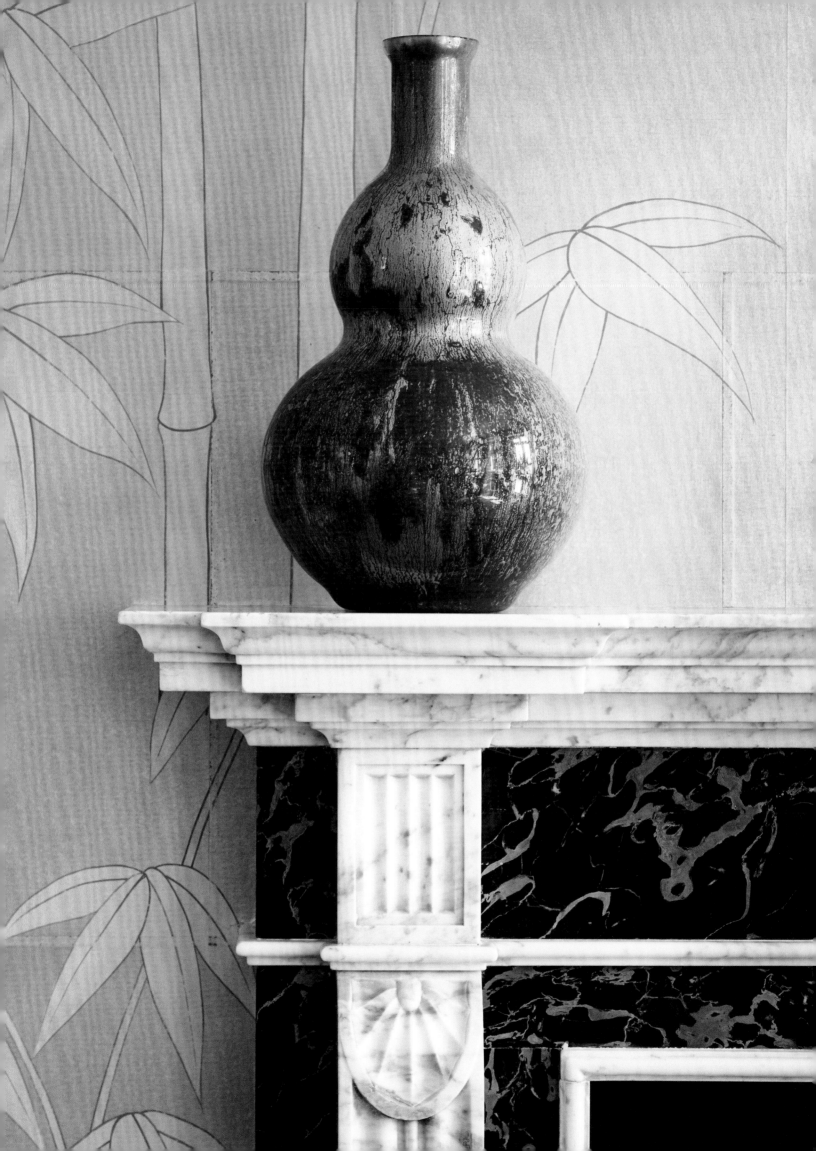

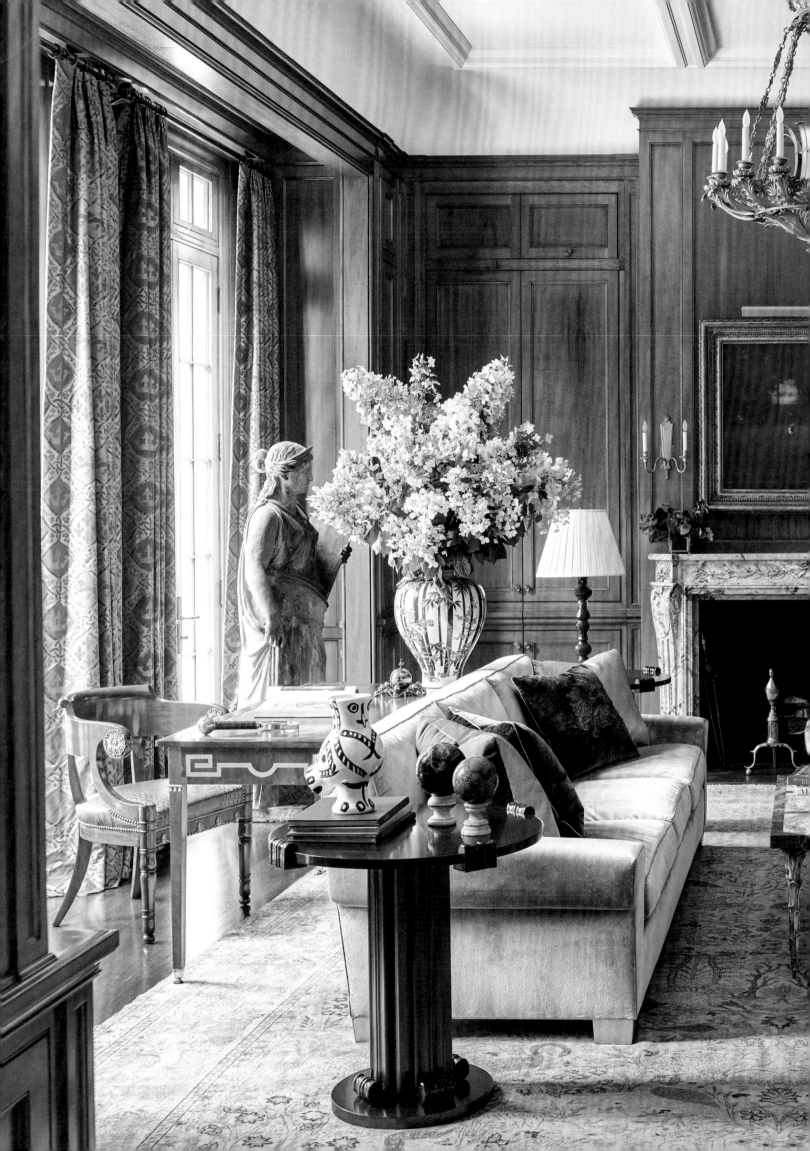

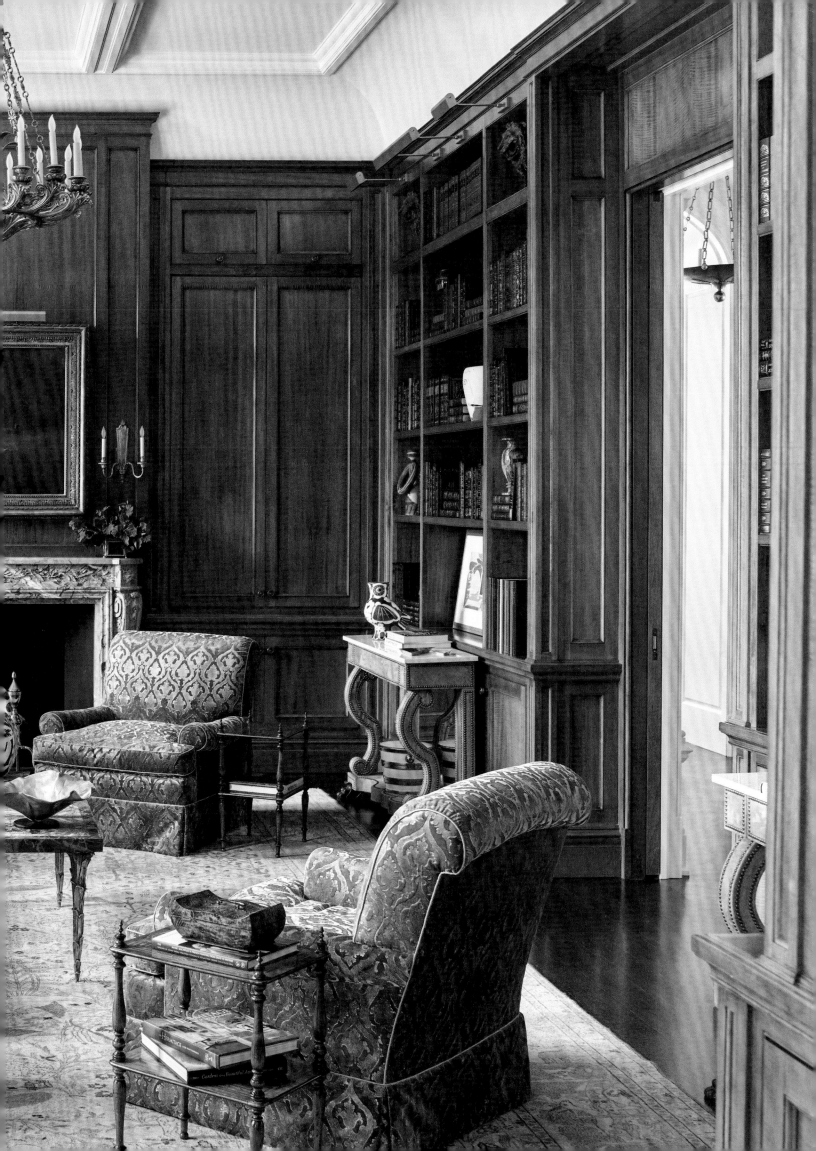

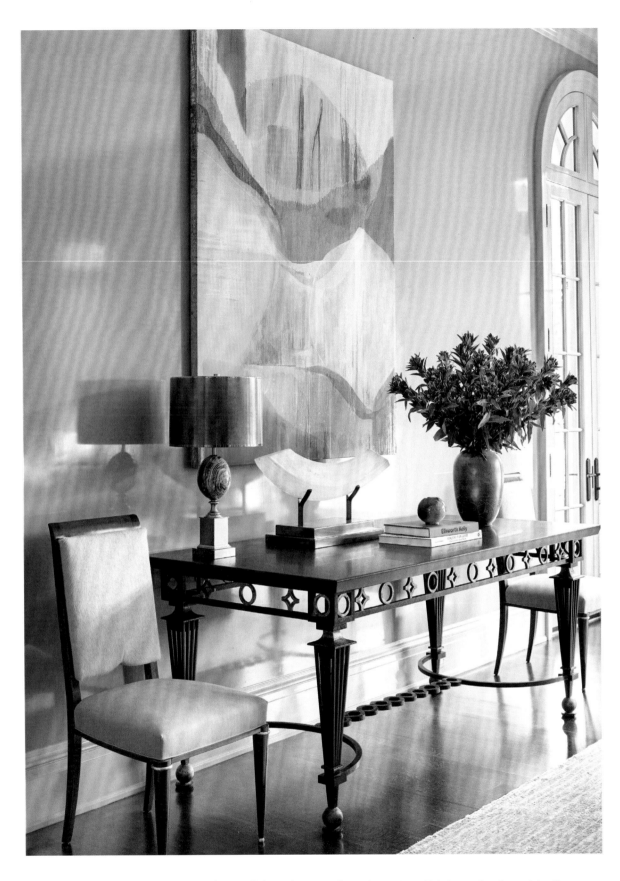

PREVIOUS PAGES: The owner requested we pull the pale green from the antique Tabriz rug for the sofa's silk velvet and custom consoles that pop against the paneling. Sabina Fay Braxton's handcrafted velvet covers the lounge chairs. The Picasso pottery brings a bracing contrast. The George Innes painting honors the home's location. ABOVE, AND OPPOSITE: The great room swerves contemporary with its fresh palette, comfortable upholstery, Poillerat-style console, 1980s ostrich-egg chandelier, and abstract painting by Victoria Morton. A cache of Primavera Ceramics adorns the bookcase, where stacked volumes nod to a more relaxed arrangement style.

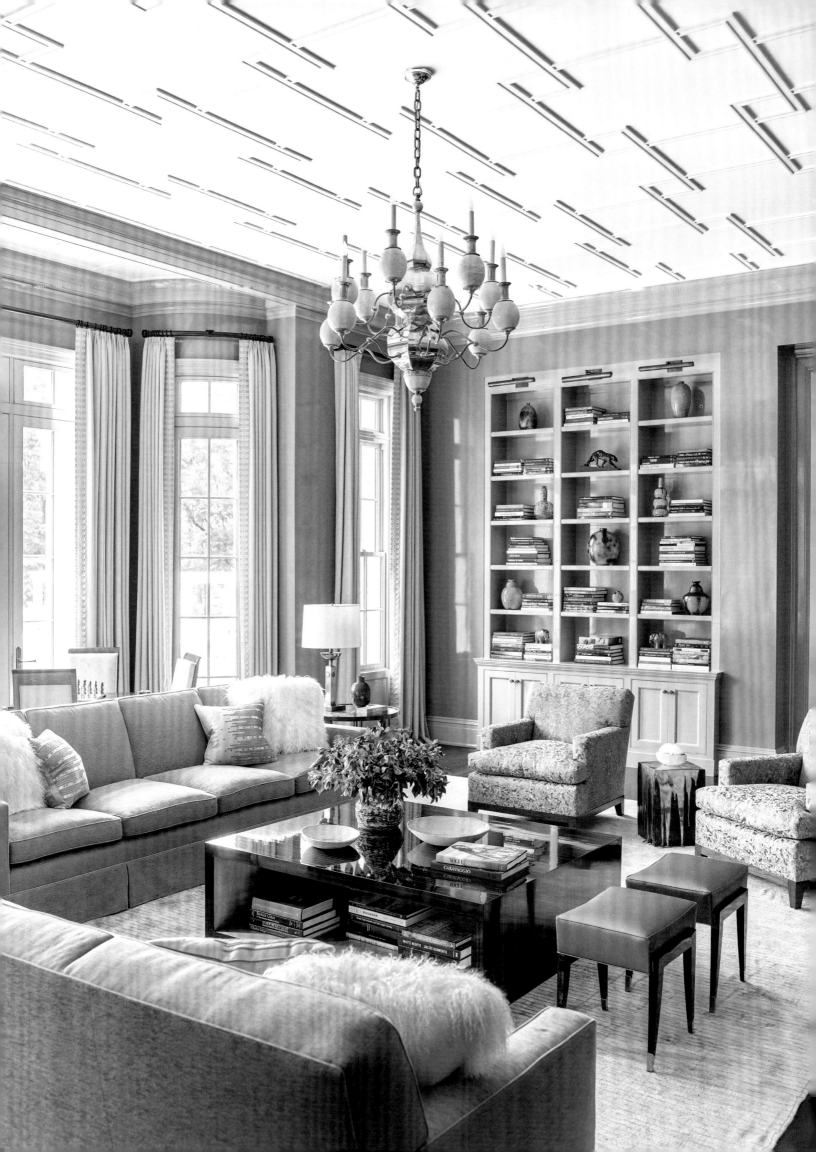

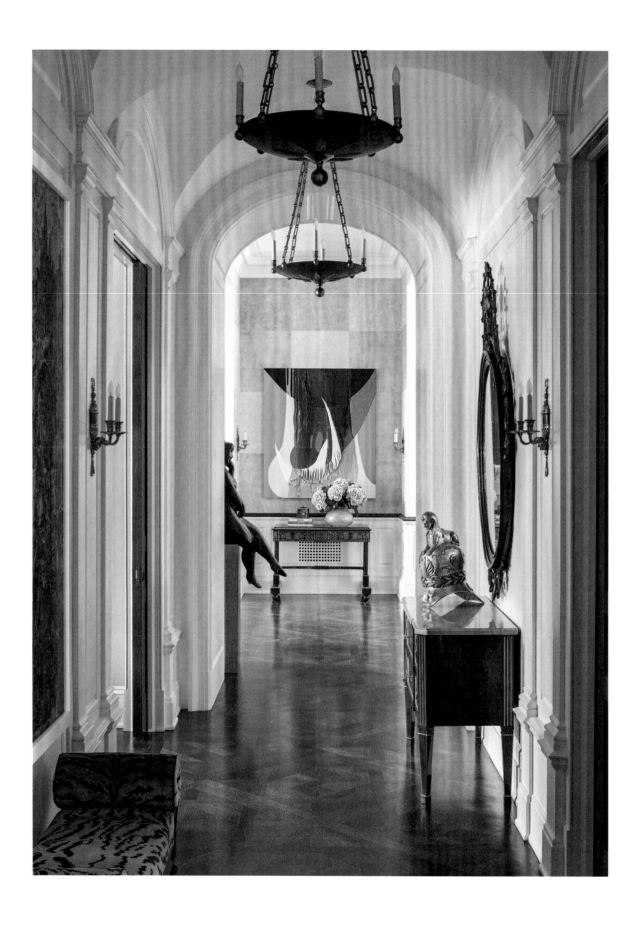

ABOVE: Like sculpture overhead, Regency light fixtures march down a transverse corridor, emphasizing each of the groin vaults. OPPOSITE: The billiards room's barrel-vaulted ceiling offers a respite from the usual rectangle. This cabernet-colored billiards table was a first for us; a nineteenth-century beauty, it embodies the aesthetic of the room. The painting is by Nick Goss.

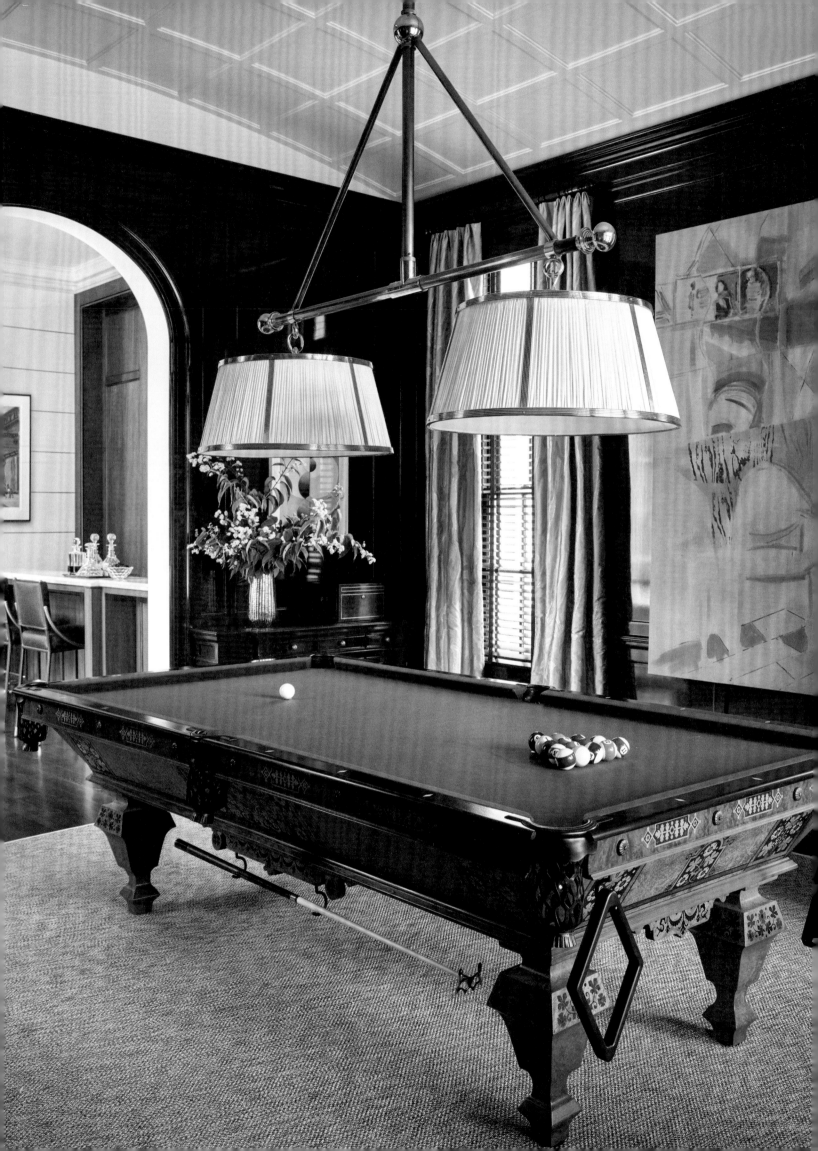

contrast as a foil to smooth walls lacquered a pellucid blue and trimmed, for definition, in a shade just a hint lighter. At thirteen feet, the ceiling height also changes the entire metrics of scale: the curtains, light fixtures, and furnishings, many of them made to measure, had to be designed proportionate to the dimensions.

The flow of color from room to room plays such a key role in creating both variation and continuity. Here, for example, we used the wine-dark hue that was the living room's accent shade to drench the billiard room opposite it. This monotonal approach along with the billiard table itself—an aesthetic period work of artistry—gives this space its singular presence.

The family room and breakfast room unfurl from the kitchen, a dream of a gathering space with two marble-topped islands, laser-cut tile backsplash, and goldenrod accents. The breakfast room was glassed in, so it almost had to be white. The family room—intended for the kids to do homework, hangout, snack, and watch TV—is robed in yellow to glow in the borrowed light. The wife's study, conveniently nearby, takes on her spirit with feminine prints and furnishings.

The primary bedroom, with a unique scale and layout, welcomes its particular mix of French pieces, chinoiserie, flea market finds, custom upholstery, family treasures, and artwork—but its palette is the key to uniting all harmoniously and in setting a relaxing mood. The husband chose the chartreuse from a curtain fabric they loved. The wife's private spaces—boudoir, dressing room, and bath—became celebrations of her love of pink, soft curves, glowing stone, Lucite, and silver. In the husband's dressing room, office, and bath, we returned to the masculine sycamore paneling and honey onyx accents he prefers.

The attraction of opposites may well be a given in so many aspects of life. For this family and this home, it was not only the alpha and omega that bookended the entire design scheme, but also a true wellspring of imagination and source of creative invention.

OPPOSITE: In this essentially all-white kitchen, gray accents and pops of yellow add some spice. In the core of the space, the two islands—one for cooking, the other for casual dining—are clad in natural wood for contrast.

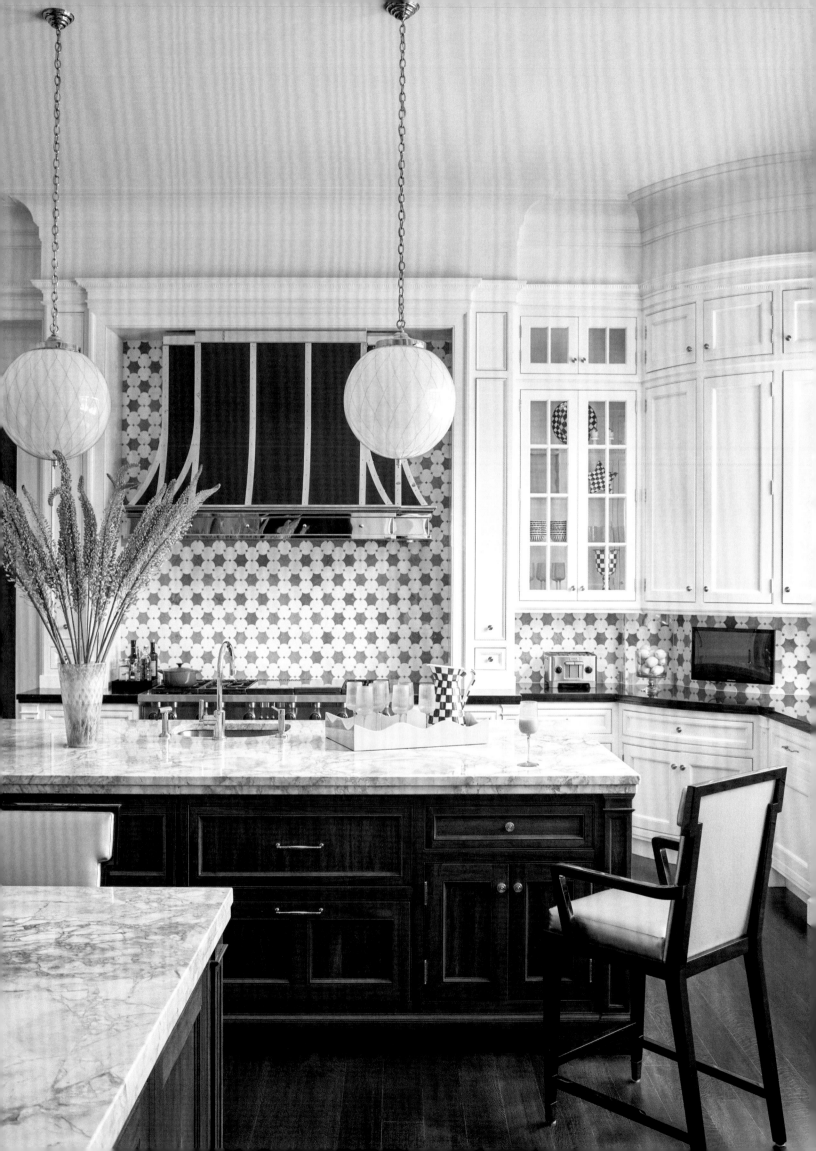

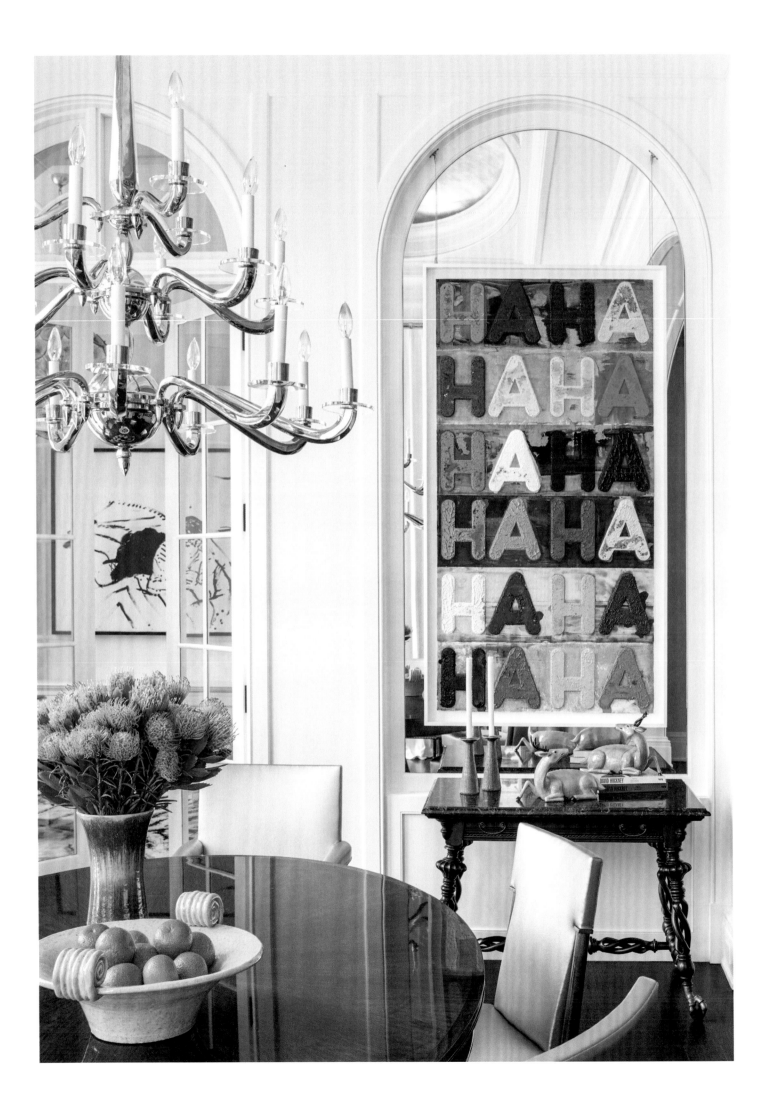

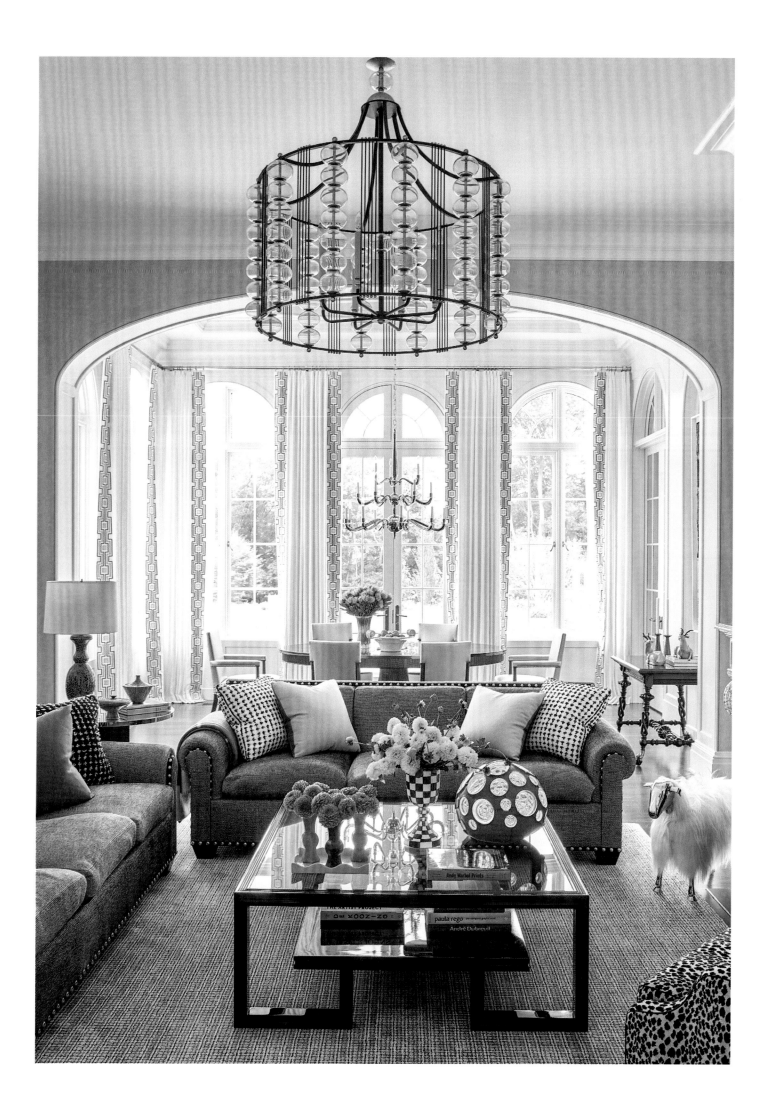

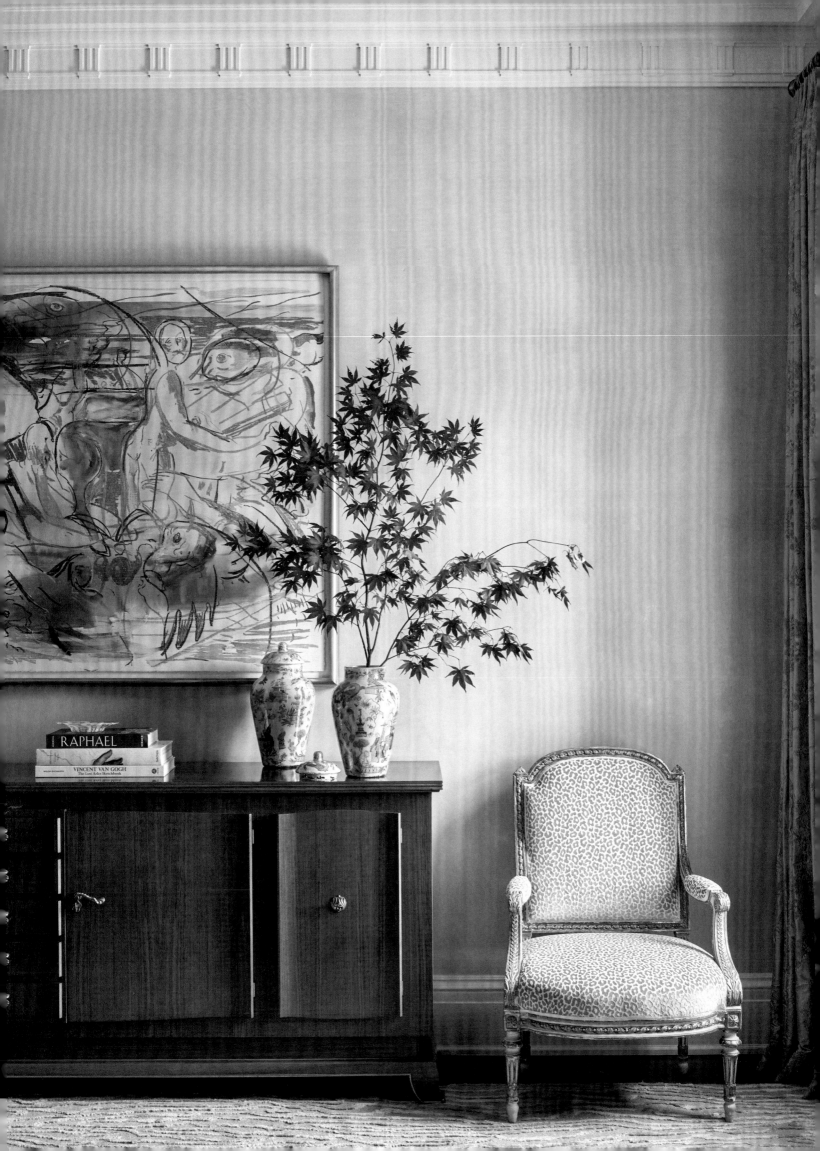

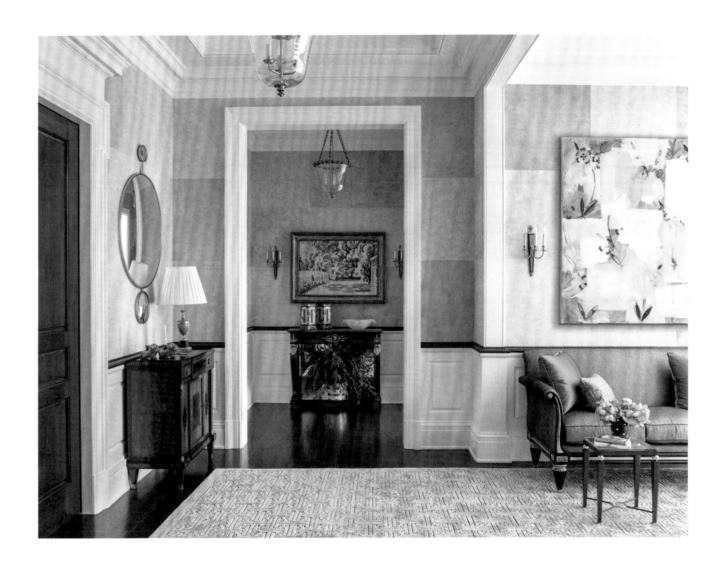

PREVIOUS PAGES, LEFT: Yellow is the visual tie that connects the kitchen, breakfast room, and family room. The breakfast room's artwork by Mel Bochner hangs on a mirror. The chairs are covered in faux leather, so practical, especially with young children. PREVIOUS PAGES, RIGHT: The family room anchors this children's corner of the house, and its black-and-white woven rug couldn't be more durable. OPPOSITE: Cecily Brown's painting commands one of the primary bedroom's walls, above a Jules Leleu cabinet. ABOVE: The upstairs landing rebalances the mix with Jacques Hervouet's three-piece brushed and polished convex mirror, called "The Pearl," nineteenth-century Dutch cabinets, Empire-style settee, and contemporary rug. OVERLEAF: We call the primary bedroom's pop-up TV cabinet a "double toaster" because it houses two TVs—one facing the sofas, the other, the headboard—so the couple can watch separate programs. The amethyst rock crystal bedside lamps pick up on the room's lilac palette.

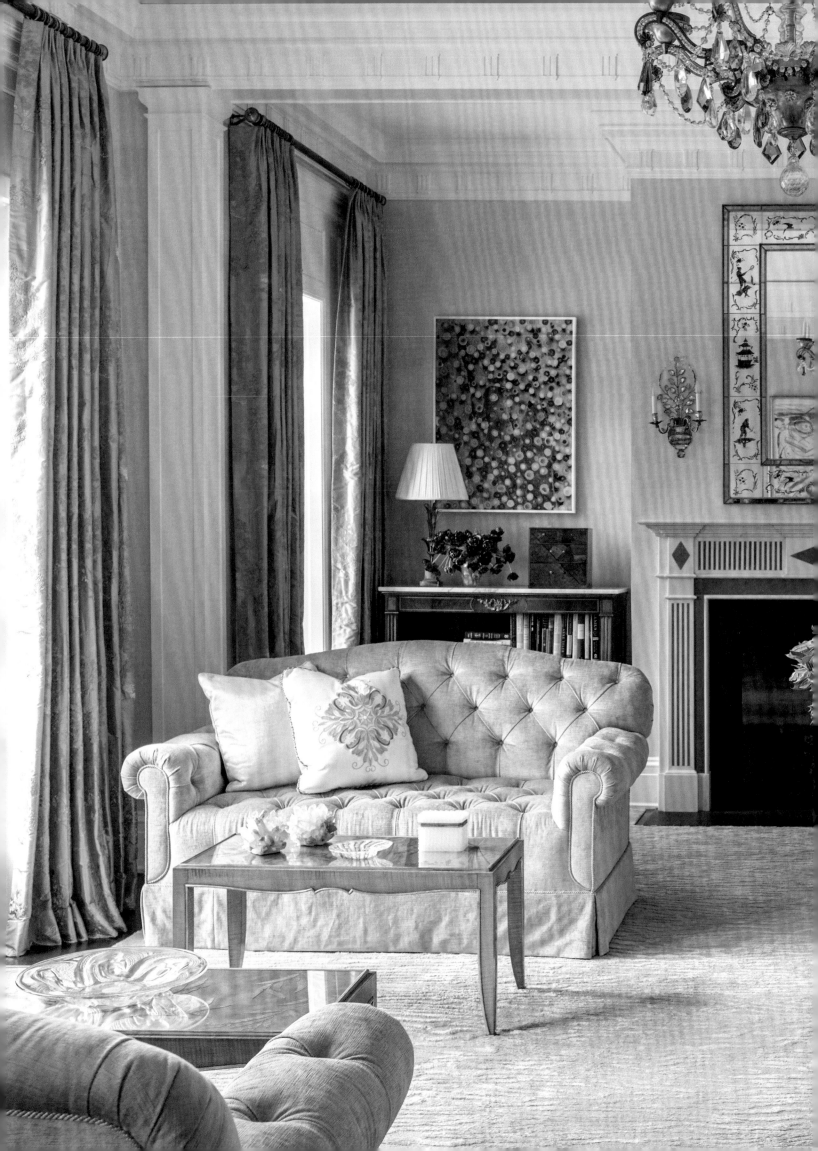

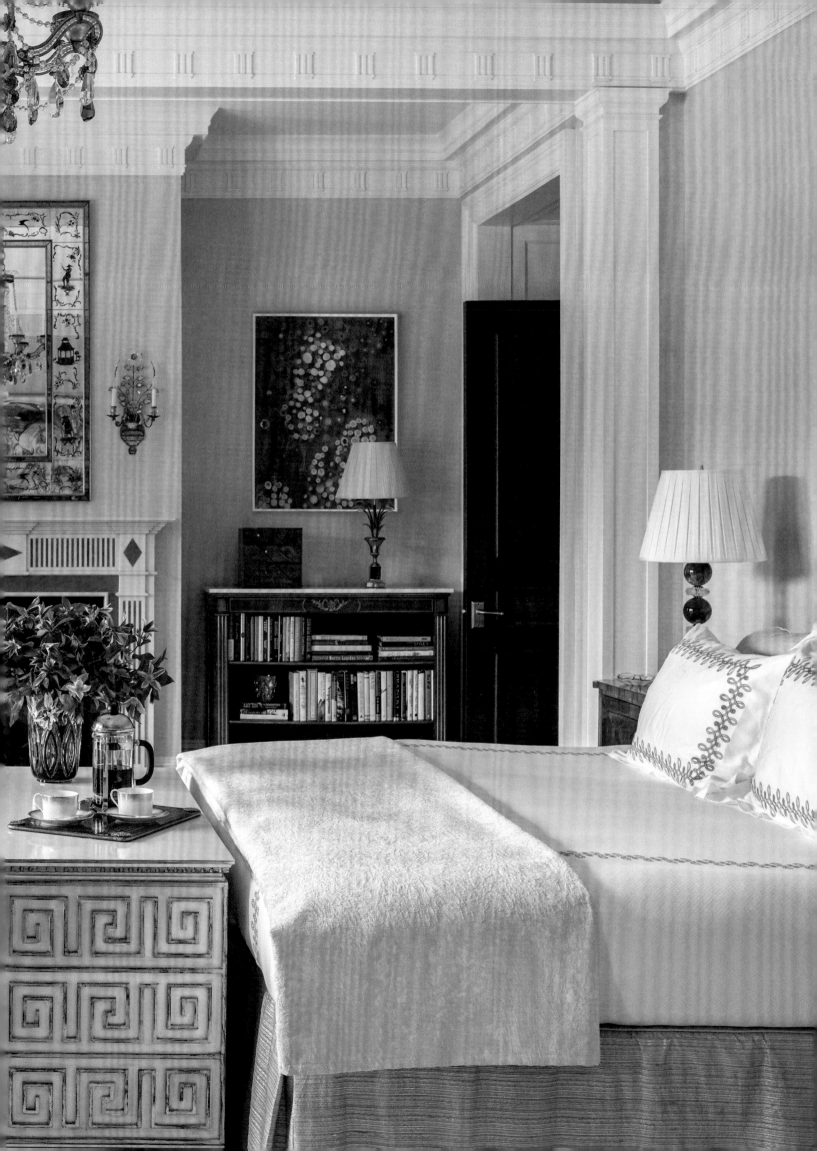

ABOVE: For this client who favors pink, blush tones bring the feminine touch to the pre-entry to her closet. For conversations with the kids, the tête-à-tête is as practical as it is pretty. OPPOSITE: Her bath varies the menu with delicacy. OVERLEAF, LEFT: The high-gloss ceiling in her closet takes the glow literally to the next level. OVERLEAF, RIGHT: The American 1930s settee was the first piece purchased for the home. The Murano glass in the Sputnik fixture is a custom color.

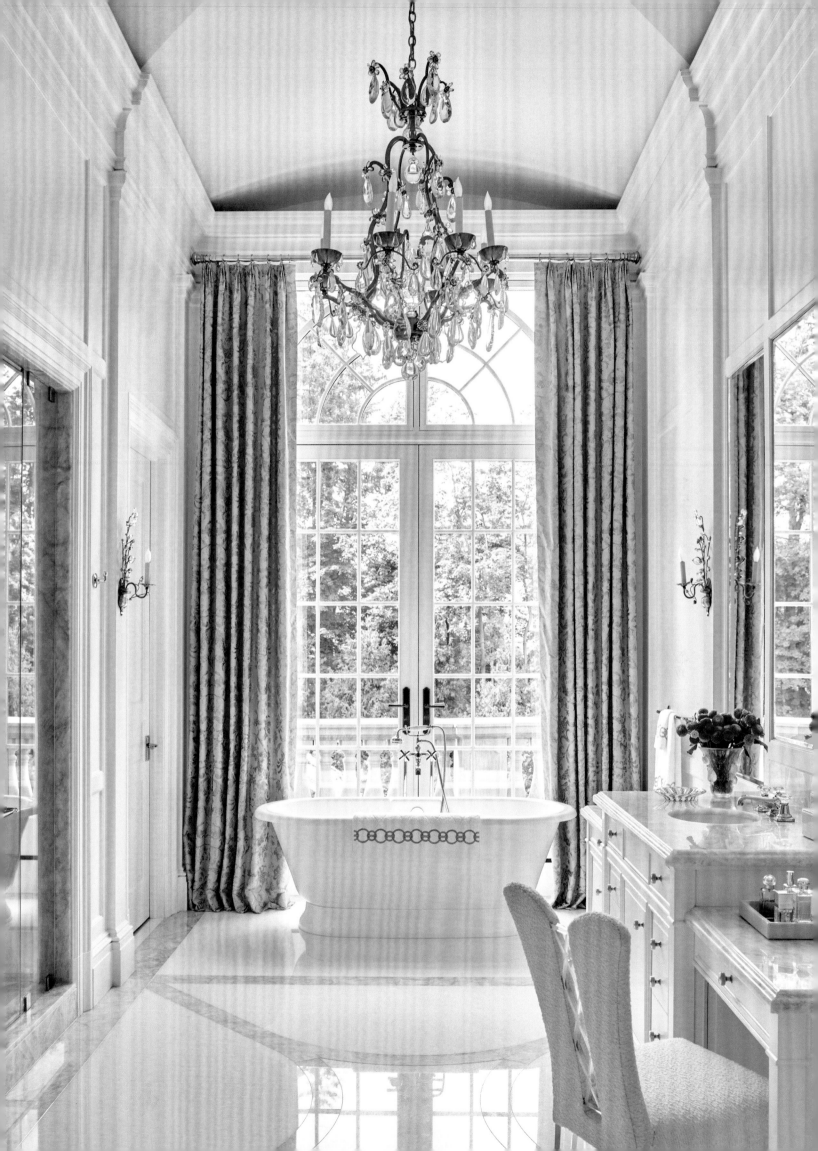

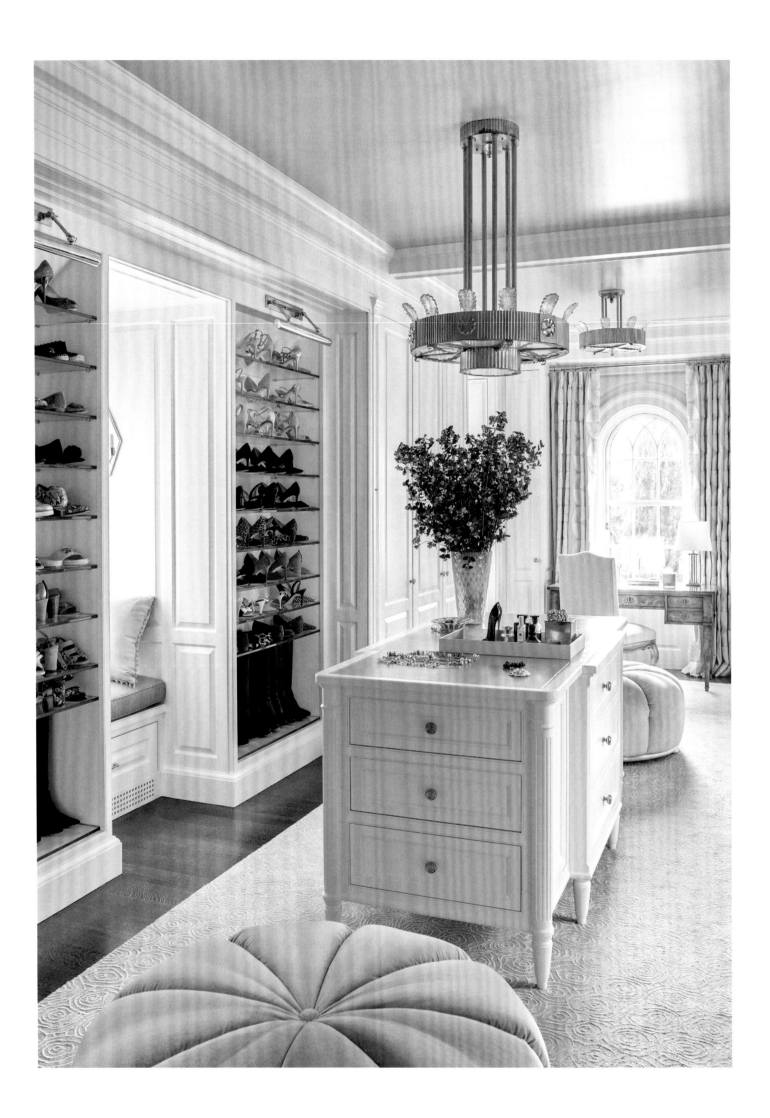

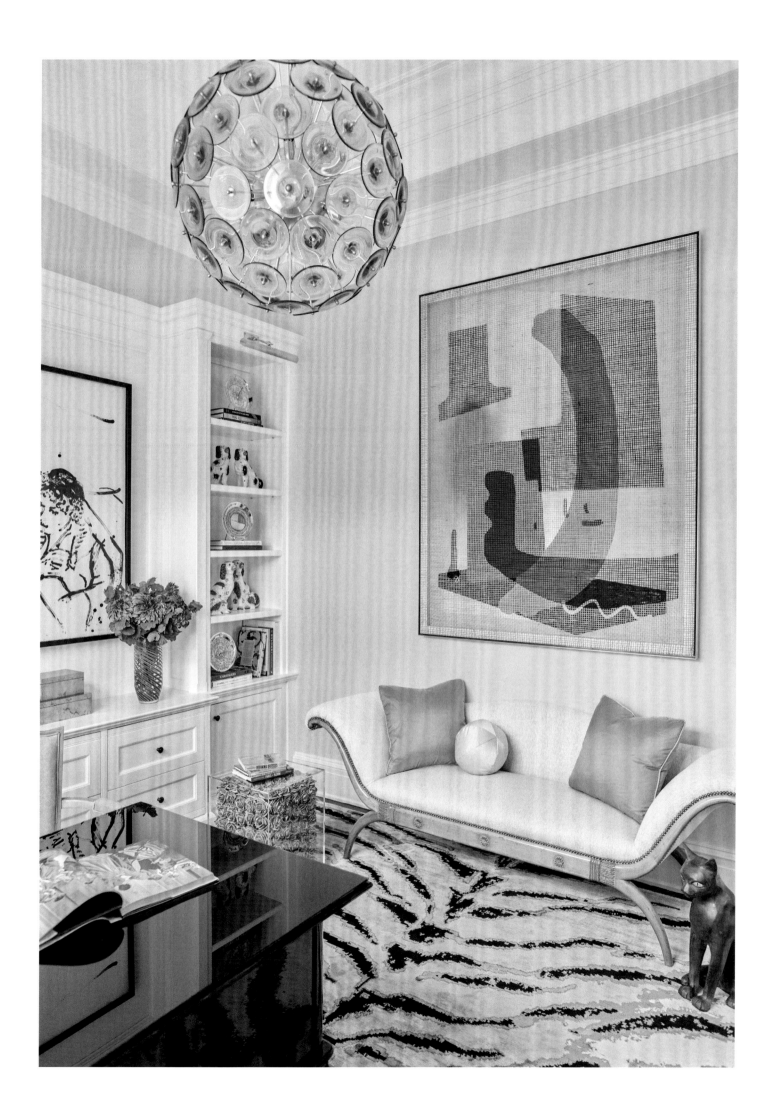

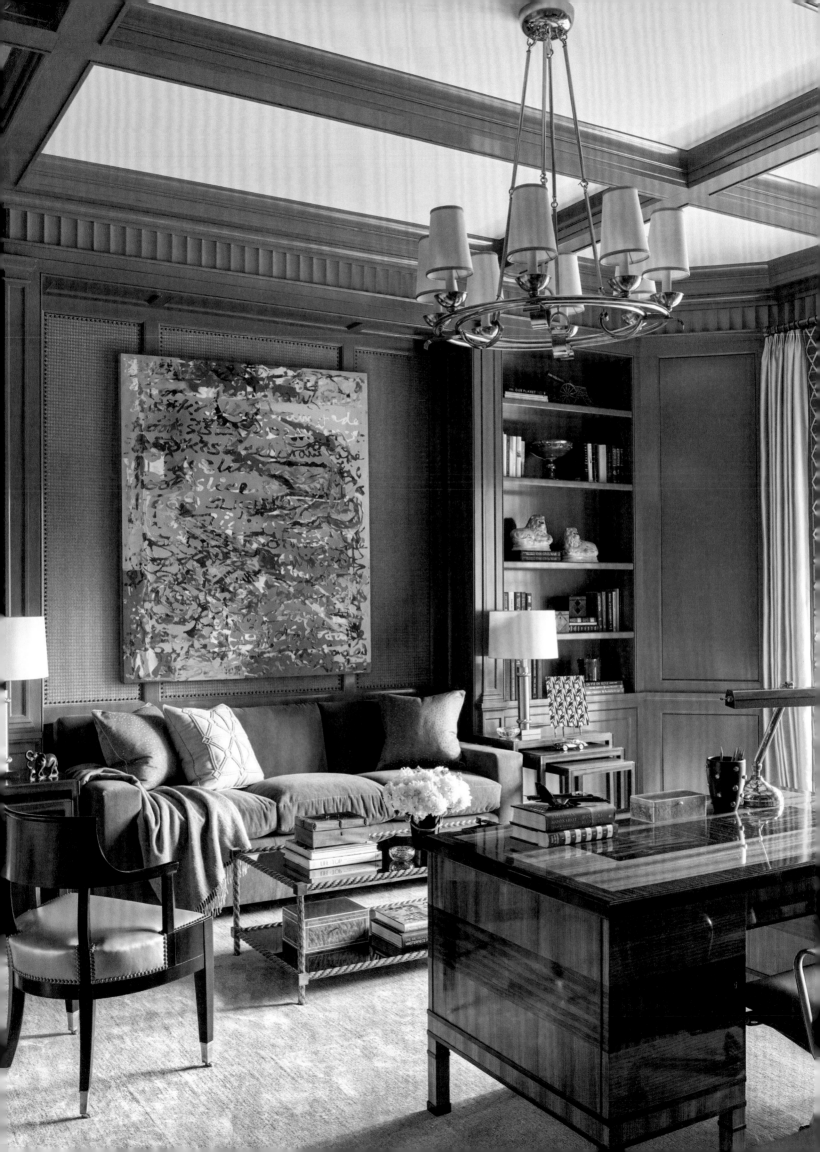

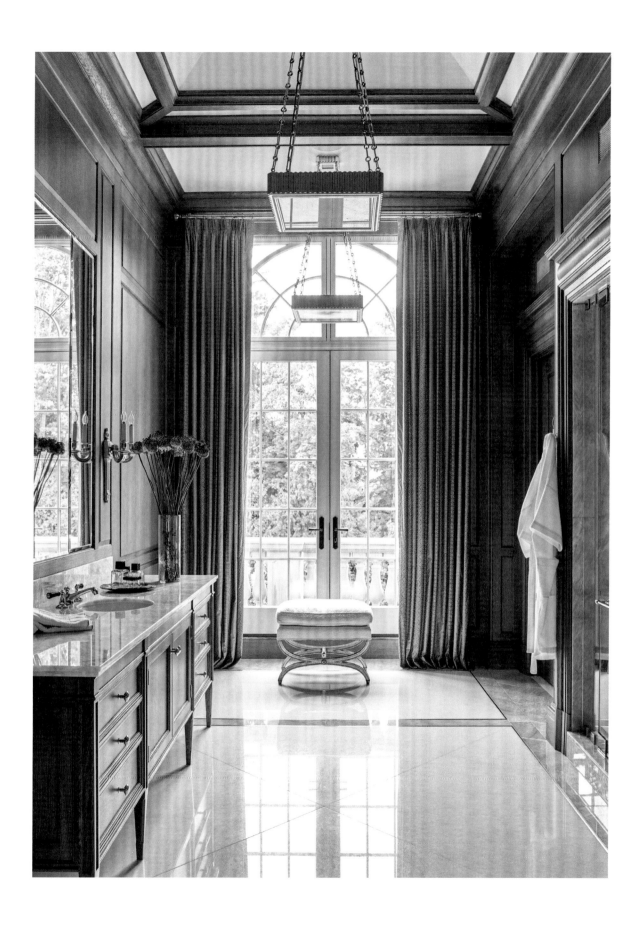

OPPOSITE: High-gloss lacquer moldings and upholstered panels create a framework for contemporary art in his study. The Swedish Grace desk is very rare; the Swedish armchair is late eighteenth century; the 1950s overhead fixture is Italian. ABOVE: His bath is paneled in anigré, just like the library. Delineating a floor makes it more interesting; here, the sections reflect the ceiling plan.

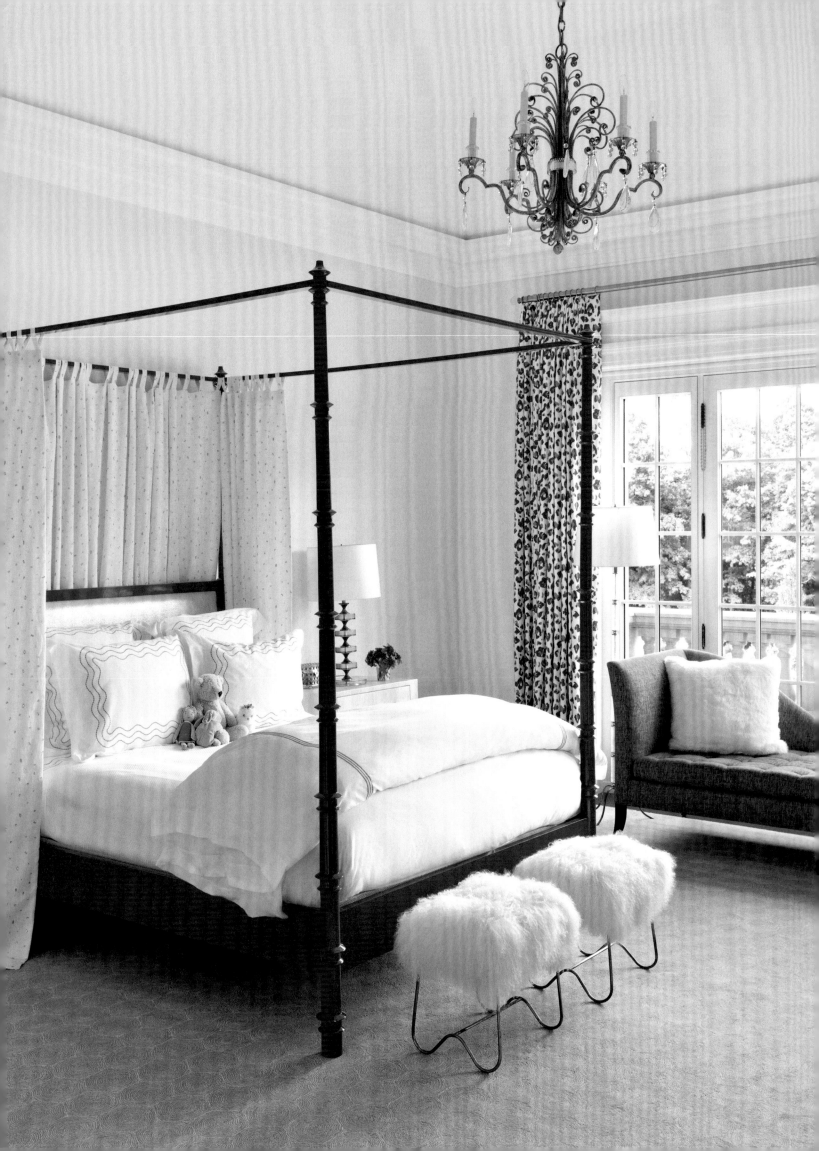

OPPOSITE, AND ABOVE: Blush pink walls are typically beloved for girls. When glossy white trim, white bedding, and raspberry accents provide the balance, the room can grow with the child.

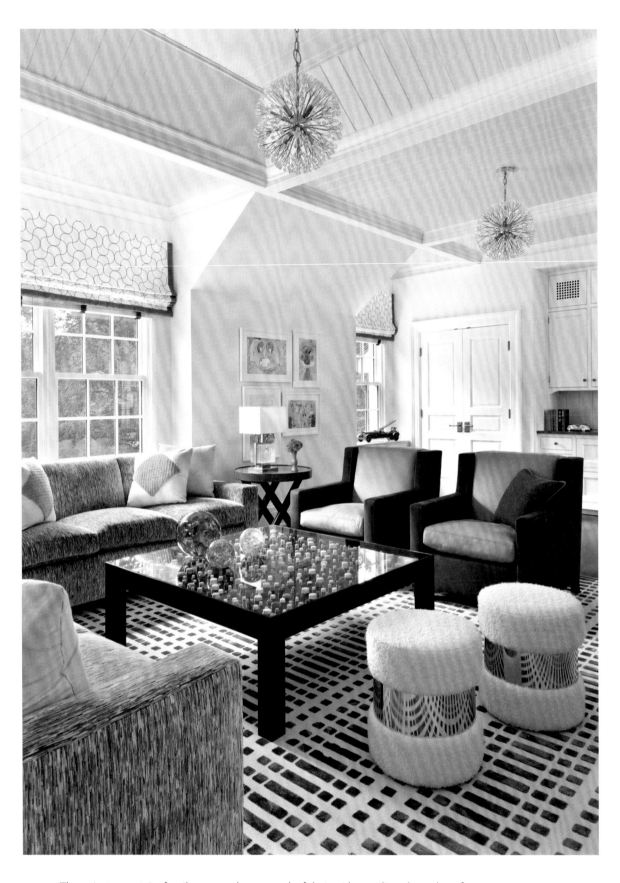

ABOVE: The private upstairs family room takes on a playful air with a ceiling the color of sunshine, bright sofas, and the children's artwork on display. The glass tabletop is a repurposed piece, a fun find made of buttons. OPPOSITE: The pool room on the lower level was a journey. Though flooded with natural light during the day, it still needed artificial illumination. Years ago, hanging decorative light fixtures over water was against code. The fiber-optic technology that we used in this custom lantern solves the challenge.

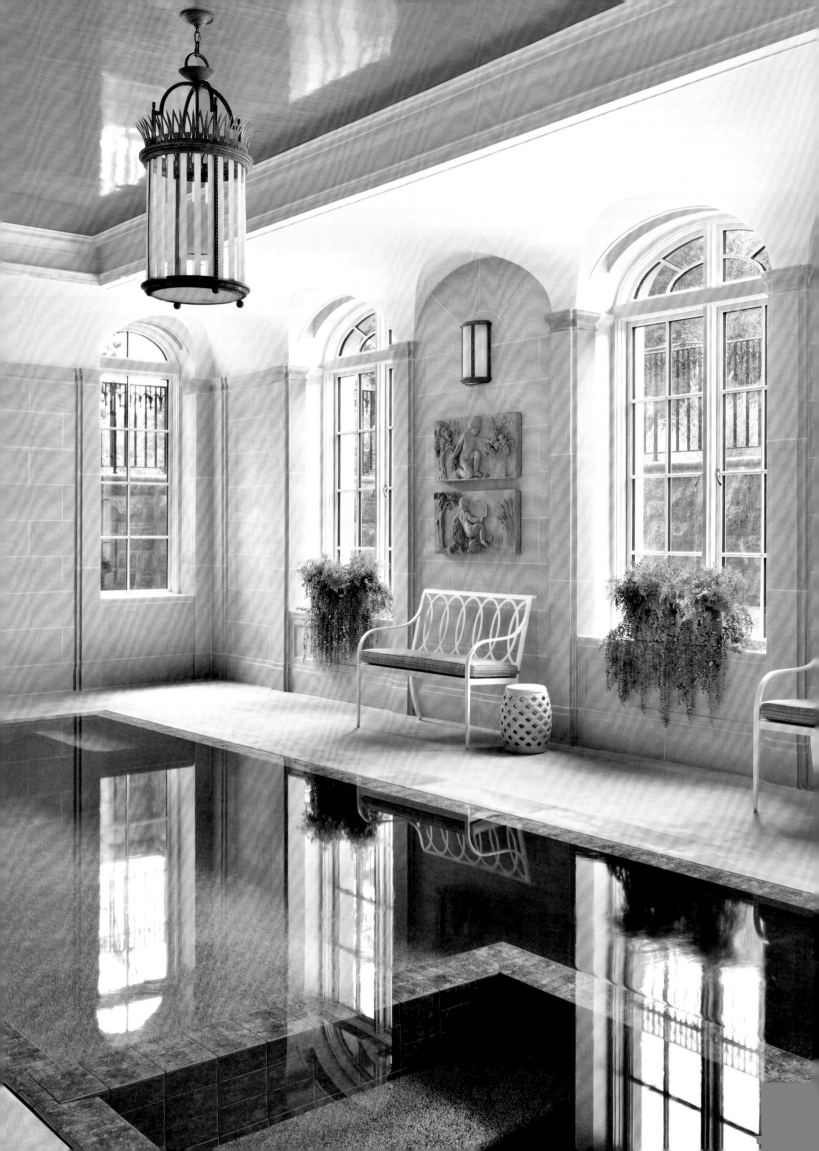

AFTERWORD
—Tracey Pruzan

In 1993, I was hired as an assistant at Cullman & Kravis. I was overqualified for the entry-level job, with a bachelor's in fine arts from Wesleyan, an associate's degree in interior design from FIT, classwork at Parsons, and a deep connection to the history of the decorative arts garnered from the now-iconic classes at NYSID. Ellie and Hedi's business cards said that they specialized in decorating with fine art and antiques, and my portfolio showed projects aligning with their aesthetic of vintage furniture and rugs, patterned fabrics, and passementerie. I was nevertheless thrilled to begin my career working for the two kindest, funniest, smartest, chicest decorators I could imagine.

Over the years, while decorative trends came and went, C & K remained a steady presence in the field, and I believe that is because they know inherently that decorating is about more than a current style. Decorating is about upholding the basic tenets of good design. Whether the finished homes were traditional or modern, city or country, the standards of excellence that Ellie expected were unwavering. While shepherding countless young women through intern and assistant positions to coveted jobs as senior designers and partners at the firm, Ellie made certain to make us wade through the weeds of budgets and fabrics—in the field, with clients and architects. Gaining that deep knowledge was always a beautiful part of working here.

Cullman & Kravis is more than an AD 100, Elle Décor A-List, and Luxe Gold List firm, and far more than any of the homes it has designed, awards it has received, or books and articles written about it. It is a real family of beloved clients and dedicated professionals. We mark engagements and weddings, babies and divorce. We sample and rate the various ratios of buttercream on cupcakes from bakeries near us in NYC. We celebrate holiday dinners at Peter Luger's and console each other when times are tough. The C & K staff is a network of friends from Richmond to Los Angeles, from Denver to Austin, from Hong Kong to Australia. These relationships are a testament to Ellie's support and love for (almost!) everyone who has walked through the doors at 790 Madison.

I am beyond lucky to have stayed on in so many different capacities, and I count myself one of the lucky few to have also become a client—and a repeat one at that.

OPPOSITE: The concave mirror sculpture by Christophe Gaignon couldn't be a more eye-catchingly modern point of focus for the symmetry of this seating area around the fireplace, not to mention that it creates a fun reflection above the contemporary mantel.

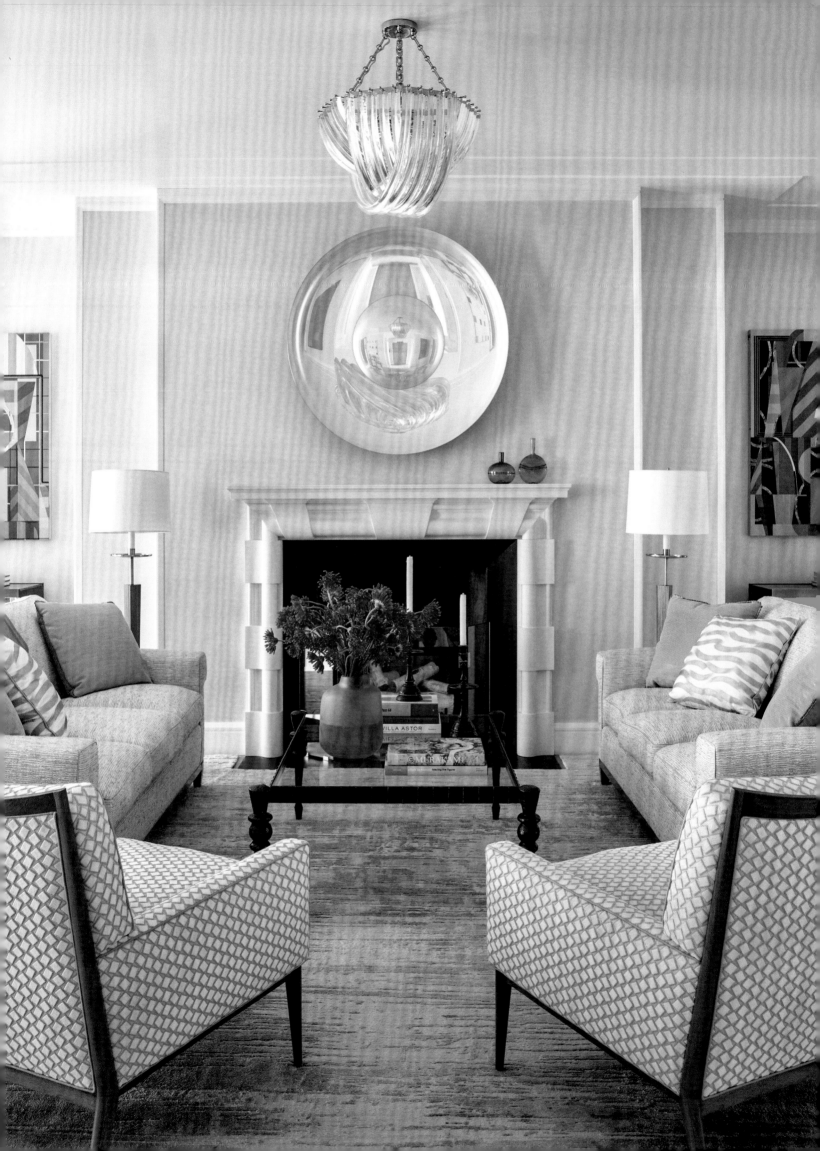

ACKNOWLEDGMENTS

We feel so grateful to work in a profession that prizes innovation and tradition; that celebrates creativity, community, and craft; and that never ceases to challenge, teach, and inspire us.

To our wonderful team of talented, hardworking colleagues, former and current, who from the start have been instrumental in helping shape C & K's design approach, decorative aesthetic, and pathway forward.

To our clients, whose deep trust in us inspires us to take the most incredible journeys together, literally, imaginatively, and artistically. You make it all worthwhile.

Creating a book is one of the most rewarding experiences a designer can have. This one would not have been possible without our gifted team:

Charles Miers for the honor of publishing our work

Jill Cohen for being our ardent champion and expert guide

Melissa Powell for her constant encouragement and boundless energy

Doug Turshen and Steve Turner for their creative vision

Stacee Gravelle Lawrence for her keen editorial insight

Judith Nasatir for her beautiful words

To the special creatives who capture, reveal, and enhance our work by filtering it through their own distinctive lens, especially photographers Eric Piasecki and Joshua McHugh, and stylists Stephen Pappas and Helen Crowther.

None of the homes in these pages could or would have come to fruition as you see them without the talents and skills of our remarkable collaborators. Thank you for your continual inspiration, and for working closely and harmoniously with us always to bring our visions into reality: Jean Alliaume, Atelier Modern, Jason Beam, Beauvais, Charles Beckley, Francesca Bettridge, Charles Burnand, E. Braun, Crosby Street Studios, Doris Leslie Blau, Miriam Ellner, M. Gabaree, Pedro Gomez, Holland & Sherry, Lamptouch, Larrea, Anthony Lawrence, Le Studio Anthost, Lesage, Lowy, MTS Express, MZ Movers, Gregory Newham, Olicore, Passementerie, Penn & Fletcher, Phoenix, Pintura, Ranjit Ahuja, Remains Lighting, Eli Rios, Stark, Sterling, Sublime Studio, Tafford, Alan Thorp, Mark Uriu, Collier Webb, and Dave Williams.

Finally, to our families, we treasure your infinite support and the boundless joy you bring us—these are the gifts of home, which we cherish beyond words.

OPPOSITE: In a study swathed in custom silk in shades of coral, opting to cover the sofa in orange velvet was a leap of faith—and a first for us. Appliqué and embroidery bring delicate pattern onto leather pillows and into the palette of luscious-to-the-touch solid textiles.

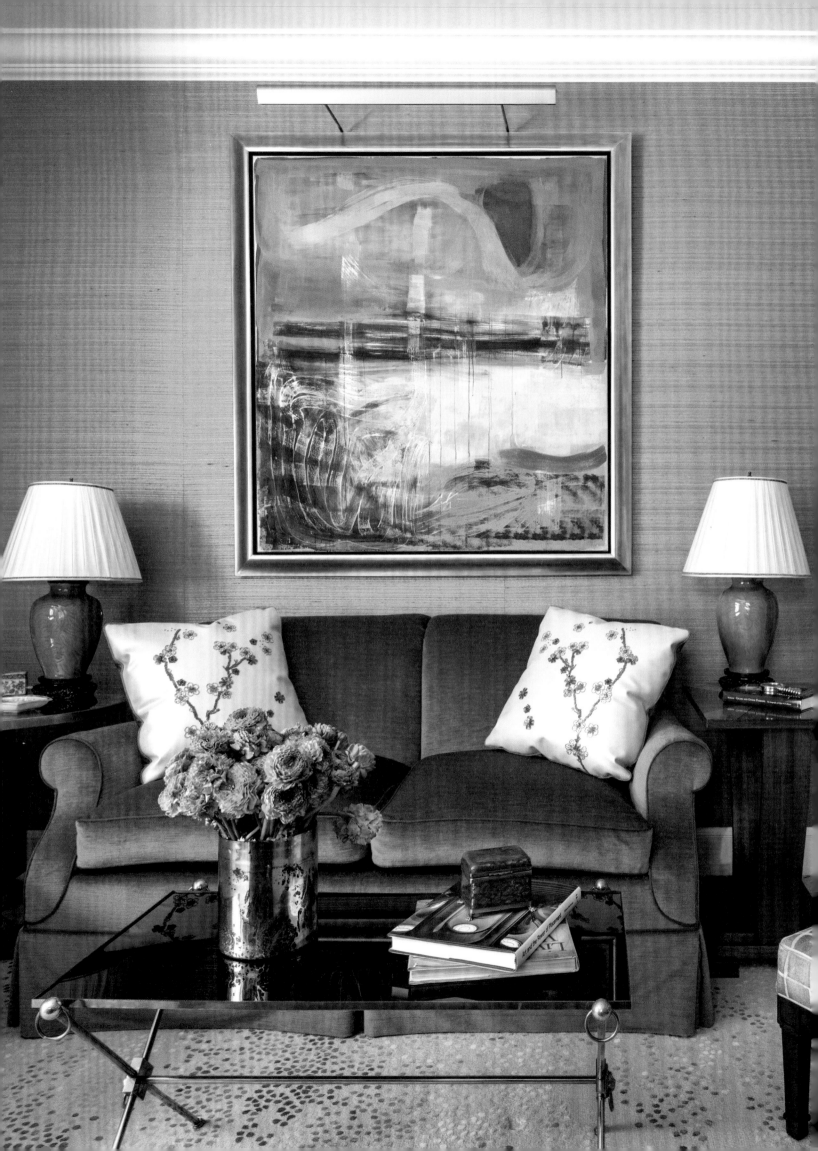

CREDITS

PUTTING THE ART IN ART DECO
PROJECT TEAM: Alyssa Urban, Katie Sutton,
 and Suzanne Vasille
ARCHITECT: Ferguson & Shamamian
CONTRACTOR: Silver Rail Construction

BEACHFRONT MODERN
PROJECT TEAM: Alyssa Urban and Katie Sutton
ARCHITECT: Tom Kligerman
 Architecture & Design
CONTRACTOR: Men At Work Construction Corp.
LANDSCAPE DESIGNER: Hollander Design
Landscape Architects
ART CONSULTANT: Ruth Catone Goulding

A REVERENCE FOR CRAFT
PROJECT TEAM: Claire Ratliff, Dani Haas, and
 Kathleen Fitzgerald
ARCHITECT: David Scott Parker Architects
CONTRACTOR: Prutting and Company
LANDSCAPE DESIGNER: Janice Parker
Landscape Architects

DELIGHTING THE EYE
PROJECT TEAM: Sarah Ramsey and
 Magee McBride
ARCHITECT: John B. Murray Architect, LLC
CONTRACTOR: Peter Cosola, Inc.
ART CONSULTANT: Graham & Friedrich LLC

COMING HOME
PROJECT TEAM: Sarah Ramsey and Paige Gaston
ARCHITECT: Douglas C. Wright Architects
CONTRACTOR: Silva Building Contractors, Inc.
LANDSCAPE DESIGNER: Martha Baker
 Landscape Design
ART CONSULTANT: Graham & Friedrich LLC

BRINGING THE OUTSIDE IN
PROJECT TEAM: Claire Ratliff, Sarah Ramsey, and
Kathleen Fitzgerald
ARCHITECT: Robert A.M. Stern Architects, LLP
LANDSCAPE DESIGNER: Nievera Williams Design
CONTRACTOR: Davis General Contracting
 Corporation

TRADITION WITH A TWIST
PROJECT TEAM: Sarah Ramsey and
 Magee McBride
ARCHITECT: Douglas C. Wright Architects
CONTRACTOR: Integkral Design &
 Construction LLC
ART CONSULTANT: Waterhouse & Dodd

A NEW LOOK
PROJECT MANAGERS: Lee Cavanaugh and
 Andrea Ashe Tutt
ARCHITECT: John B. Murray Architect, LLC
CONTRACTOR: Hobbs Inc.
LANDSCAPE DESIGNER: Janice Parker
Landscape Architects
ART CONSULTANT: Ruth Catone Goulding

HIS AND HERS
PROJECT TEAM: Alyssa Urban, Katie Sutton,
 and Dani Mazza
ARCHITECT: James Paragano Architects
CONTRACTOR: Longeri Construction Inc.
ART CONSULTANT: Ruth Catone Goulding -
 Rachel Goulding

PHOTOGRAPHY CREDITS

Donna Dotan: 278-281

Eric Piasecki/OTTO: 8-9, 45-47, 57-64, 67-277, 283, front cover

Francesco Lagnese: 7

Joshua McHugh: 4, 12-43, 49-55, 65, back cover

Nick Johnson: 285

Nick Sargent Photography: 2-3

Robert Rauschenberg Foundation / Licensed by VAGA at Artists Rights Society (ARS), NY

ART REPRODUCTION CREDITS

First published in the United States of America in 2024 by
Rizzoli International Publications, Inc.
300 Park Avenue South
New York, NY 10010
www.rizzoliusa.com

Publisher: Charles Miers
Acquiring Editor: Kathleen Jayes
Project Editor: Stacee Gravelle Lawrence
Design: Doug Turshen with Steve Turner
Production Manager: Maria Pia Gramaglia with
 Barbara Sadick
Managing Editor: Lynn Scrabis

Printed in Italy

2024 2025 2026 2027 / 10 9 8 7 6 5 4 3 2 1

ISBN: 978-0-8478-3798-4
Library of Congress Control Number: 2024935710

MIX
Paper | Supporting
responsible forestry
FSC® C084761

Visit us online:
Facebook.com/RizzoliNewYork
Twitter: @Rizzoli_Books
Instagram.com/RizzoliBooks
Youtube.com/user/RizzoliNY

END PAPERS, TITLE PAGE: Mark Uriu, our principal decorative painter for almost forty years, delights in experimenting with new wall techniques, such as this one. PAGES 2–3: A recent Kips Bay Decorator Show House room in New York was a rhapsody in blue and gold. PAGE 4: Art plays a significant role in the design of this art deco–inspired Manhattan interior. PAGE 7: In this Greenwich Village residence in the recently converted St. Vincent's Hospital, bronze details serve as the interior jewelry; the mirrored wall that visually expands the narrow entry gallery shares an affinity with 1930s décor. PAGES 8–9: An innovative painting technique energizes the living room of this New Jersey estate throughout the day and night.